Prospect Heights Public Library Prospect Heights, Illinois

The Pewter Collector

The Fewter Collector

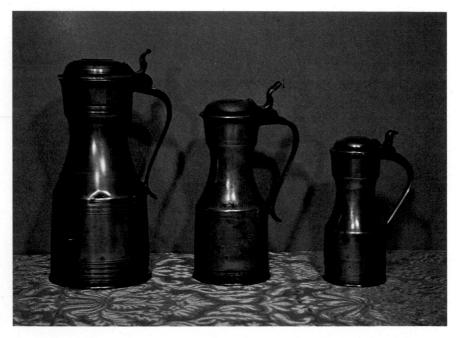

Frontispiece Three Scottish 'Tappit Hen' Measures, comprising the Scots pint (3 pints Imperial); the Chopin ($1\frac{1}{2}$ pints), and the Mutchkin ($\frac{3}{4}$ pint). Late eighteenth century.

The Pewter Collector

a guide to British Pewter, with some reference to foreign work

by H. J. L. J. Massé Revised, with additions by Ronald F. Michaelis

Original edition first published by Herbert Jenkins Ltd, 1921

This revised edition first published in 1971 by Barrie & Jenkins Ltd 2 Clement's Inn, London WC2

© copyright Barrie & Jenkins Ltd All rights reserved. No part of this publication may be reproduced, stored in a retrieval system, or transmitted in any form or by any means, electronic, photocopying, recording or otherwise, without prior permission of the copyright owner

Designed by Peter Davis
Text set in Monotype Van Dijck
Printed and bound in Great Britain by
W & J Mackay & Co Ltd, Chatham

ISBN 0 214 65255 6

Contents

List of Plates	vii
Preface to the new edition	ix
Preface to the original edition	xii
I. On Collecting	I
II. Rubbings	10
III. Displaying Pewter	12
IV. The Cleaning and Repairing of Pewter	15
V. A Few Don'ts	26
VI. The Craft of the Pewterer	30
VII. The Standards of Pewter	50
VIII. The Ornamentation and Decoration of Pewter	55
IX. Pewter in the Home	63
X. Church Pewter	80
XI. Pewter Marks	95
XII. List of the Names of Pewterers	105
XIII. The London Touchplates	180
XIV. Prices	264
Glossary	268
The Reference Literature of Pewter	274
Index	278

and mo

		The same and the same
	The state of the s	
	er en skriver en	
	West bear	
100	ik is i i i i i i i i i i i i i i i i i	
	the state of the s	

List of Plates

Frontispiece Three Scottish "Tappit Hen" Measures

All between pages 98 and 99

- I Two Dishes with bossed centres at Mildenhall Church, Suffolk
- 2a Two Quaichs
 - b A set of six rare "thistle-shaped" Scottish Spirit Measures
 - c Tappit-hen Scottish Measures, "crested" and unlidded
- 3a A group of Tappit-hens, plain domed covers
- b A group of Scottish pot-bellied Measures
- 4 Measures of the Channel Islands
- 5 Irish Flagons and Measures
- 6 Baluster-shaped Measures
- 7a Stuart period Tankards
 - b English Tavern Pots
 - c Georgian domed-lidded Tankards
- 8a A "garnish" of Tableware
- b A bevy of Flagons
- 9 Four rare Plates and Dishes
- 10a Bristol Tankard and Measure with gadrooned Plate
 - b Two English Ale Pitchers
- 11a Scottish Communion Pewter
 - b A pair of wriggled Marriage Plates
- 12a Three Stuart Flagons
 - b Two York straight-sided Flagons

- 13a Charles I period Flagon
 - b Flagon of Cromwellian period, with "beefeater's hat" cover
 - c Two rare acorn-shaped York Flagons
- 14a Footed Plate or Paten
 - b Three unusual Tankards
- 15a Rare Stuart Candlesticks
 - b Assay Tool, owned by the Worshipful Company of Pewterers, dated 1728
- 16a An array of fine pieces
 - b Living with pewter: a room in an old cottage

Preface to this new edition

The cult of pewter collecting had only a very few followers in the first few years of the twentieth century, and had it not been for the two exhibitions which Massé himself staged in 1904 and 1908, and for the two or three books he had published between 1904 and 1911 (i.e. Pewter Plate, 1904, which went to a second, revised, edition in 1910, and his Chats on Old Pewter, in 1911), there would have been little authoritative literature for the pewter enthusiasts. Thus, the late H. J. L. J. Massé could rightly be termed "the father of the hobby". Strangely enough, Massé did not amass a large collection, although the opportunities to do so in his day must have been very great indeed; instead he interested himself more in the history of the craft, both in this country and on the Continent, and in repairing "down at heel" pieces which he then passed on to his friends or colleagues. His love for pewter was so great that he would spend literally days in carefully restoring even a comparatively worthless object for the pure joy of seeing it in its pristine state, and his honesty was such that, on every piece which had been through his amateur workshop, he placed his initials H.J.L.J.M. in miniature form in some inconspicuous place, so that posterity should know that that particular item had received some attention after it had left the original maker's hands. What an object lesson to those less honest traders and others who made a practice of "improving", altering, embellishing, and even faking, pewterware for the collector in later years!

The publication of *The Pewter Collector* in 1921 came just at the right time to cater for the rapidly growing thirst for knowledge, and there is no doubt that it was instrumental in interesting many more collectors to the joys of pewter collecting. It was, for instance, the first book on the subject which I, myself, ever owned, more years ago than I care to recall, and I can confirm that it was read over and over again until I knew it almost by heart.

When I was first asked by the present publishers to cast an eye over the text with a view to their producing a new edition my first reaction was that there was little work necessary to bring it com-

pletely up to date. How wrong I was!

Massé wrote at a time when today's rare pieces were to be picked up for the proverbial "song", and thus much of the advice he gave the collector fifty years ago just cannot hold good today, for the simple reason that the whole field has changed. A few examples from his original text will illustrate the point—in the first chapter of the 1921 edition he said: ". . . He (the collector) may pick up occasionally a damaged tankard of the time of Charles I; more frequently a tankard of the period of William and Mary, with the characteristic floral engraved ornament . . . "; in the same chapter he wrote: ". . . No one would for a moment think of collecting candlesticks or beer mugs of the nineteenth century." Still on the same subject, in his list of "Don'ts for Collectors", he wrote: "Do not collect pint or half pint pots . . . there is very little interest attaching to them. . . ." Today's collectors will know that a tankard of the time of Charles I (in almost any condition) would cost him virtually his life's blood, and that an engraved William and Mary tankard would cost him as much as £500—perhaps even more -so one can see that Masse's casual references to such things being "occasionally picked up" needed careful revision. So, too, his disparaging comments on late tavern pots-many of today's collectors will have to be content to acquire little else!

Indeed, the more one studies these later lidless pots and measures the more interesting they become; the variety of shapes of body and handle; the sizes in which they can be found, and the purposes for which they were made, i.e. whether for ale or wine; for liquid or dry measure, or whether, in fact, they were drinking pots at all, or were merely measures for retailing the correct amount over the counter—all these imponderables, in combination with the various capacity seals which can be found upon them, can form an almost endless (and certainly a profitable) study. In other respects Massé's writings will prove a spur to anyone hesitating on the brink of collecting this fascinating metal, and his love for its history and associations transmits itself to his readers.

In revising this particular book I have endeavoured to retain as much of Massé's "chatty" style as possible, and have rewritten only those paragraphs or sections to correct statements or opinions which can no longer be sustained in the light of more practical study.

I am convinced that the book, in its present form, will continue to give pleasure even to those who have, perhaps, outgrown Masse's teachings, but who will, nevertheless, find it useful to have so many of the forgotten, or little-known, facts carefully brought together from various sources, and printed in such useful form. For the beginner I hope the book will give the same fillip to his interest that it did to me so many years ago, and that it will form the basis upon which he will decide to mould his future as a pewter collector.

Denton, Nr. Newhaven Sussex 1971 R. F. MICHAELIS

Preface to the original edition of 1921

It is usual in a preface to express a hope that the book may fill a long-felt want. One may hope that it may, and that is all; but one cannot say that it will.

There is a difficulty in writing from the point of view of the collector because there is now so little good pewter generally available which is fit to collect, and that little is being sold at such ridiculously fancy prices that the average collector cannot hope to enter the lists and compete.

The main interest in pewter must be historical and archæological, for its metallurgical side can be dismissed in a few sentences and will not interest the ordinary reader.

The writer, in 1885, saw a round dish lying in the gutter in Bruges near a stall in the market-place, and as the dish had a crack in it, and its rim was rather badly battered, the writer became the owner of it by handing over to the dealer the sum of five francs.

This was the genesis of his interest in pewter. He cleaned it and many years later—for in 1885 he did not know how to do it—repaired it. Two years later, merely because he was the only one present at a committee meeting who owned a piece of pewter, he was constituted a sub-committee of one, with power to add to his number, to arrange for Pewter as a subject for discussion by what was then a small Society of Artists, and to find someone to read a paper on the subject. He failed to find this someone, and his own

notes made the basis of a contribution to the evening's discussion. That evening meeting, however, bore fruit—he was told that two friends who had begun to collect information on the subject had been forced by other work to give up any idea of going on with it, and would gladly hand on their notes and sketches to him.

The upshot of this was that after some years' work at the subject *Pewter Plate* was published by Messrs. Bell in a very sumptuous edition in 1904. The same year the writer organized an Exhibition of Pewter in Clifford's Inn Hall, followed by another in 1908.

All this may or may not be of interest to the reader, but it may just be worth noting as the record of the genesis of the writer's interest in the subject.

A preface, however, is the only place in which I can thank all the friends who for many years have contributed any new marks or touches that they met with or acquired. They are contributed here to the common benefit of all collectors, and if the fact of the mark or the name being recorded here for the first time helps a collector to identify and date his piece or pieces, the work involved has not been wasted.

Anyone may parade his new knowledge acquired from my laboriously compiled lists, but if he has merely a rudimentary notion of honour (and even thieves are said to have that) he may surely take the pains to acknowledge the source of his indebtedness. After all, working with scissors and paste is not so laborious that it leaves no time for a due acknowledgment.

Here the writer may plead guilty to an absorbing interest in the marks and touches, especially those which are as yet unassigned to any known pewterer, either because they have initials only, and are so common in their combination that they may be those of half a dozen or more pewterers, or because they are in part or wholly illegible or indecipherable. He has received hundreds of marks, and though he may not expect to write another book on pewter he would be glad to receive rubbings of, and information as to, new discovered marks and touches so that he may leave his own copy with many additions for the next generation of pewter-lovers. His collection (he has none) is on the shelves and dressers of his friends.

Another word of thanks is due to all who sent me at various times photographs of collections in whole or in part of special pieces,

and especially Dr. Young. Some of them I have used in spite of the fact that I cannot now identify the sender. It is easier to remember touches than photographs, and if I have unwittingly offended by using them I must ask for forgiveness beforehand, and in justification or, better perhaps, in extenuation, say that as I never thought I should ever require to use them I made no special record of them.

Lastly, too, a preface is the best place to make a humble bow and ask to be excused if the little word "I" comes in too much. In any account that is personal, it is difficult to keep it out, but it may be excused if there be humility rather than egotism in the back-ground. There is no room for theories in a book like this, and one can write only from personal experiment and knowledge and from practical experience.

My special thanks are due to the Worshipful Company of Pewterers for permission to use my verbal descriptions of the touches from the second edition of *Pewter Plate*, 1910, and for permission to include drawings by Miss Sheila McEwan of all the legible touches, and also to Mr. Howard H. Cotterell, F.R.H.S., and Mr. M. S. Dudley Westropp for very kind permission to check and augment my imperfect lists of Irish pewterers from their joint article on the subject in the Journal of the Proceedings of the R.S.A., Ireland, June, 1917, Vol. VII, Series VI.

H. J. L. J. MASSÉ

On Collecting

Why does anybody want to collect pewter? This is the question which seems to be in the minds of the people who light upon any collection of pewter, either in a friend's house or in a properly organized museum.

What possible interest, ask they, is there in stuff that looks like lead, and that requires perpetual cleaning to keep it in good condition?

These two questions depend upon one another, and the answer to both is in the word—interest. It should be interesting to any thoughtful person to study and try to learn more about a material which has been in use from the first ages in which tin was alloyed with other metals to make it more workable, and incidentally to render it more profitable to the maker.

It is not possible to divide the art of the pewterer into sharply defined periods, or according to any improved method or process. Pewter was always made in the same way and of the same ingredients or nearly so. We may divide the history into Roman, Medieval, Elizabethan, Stuart, and *late* if we like, but the forms themselves are the real guide to the periods, always assuming, of course, that they

are genuinely old pieces we are handling.

Pewter differs from other wares coveted by collectors in that it came in as a substitute—more or less plausible—for more precious metal, and also formed a rather important link in the long chain of

development of domestic table and other ware from wood to china. Pewter plates seem to have been in existence concurrently with "treen" or platters of wood. Then pewter took the place of wood altogether in the cottages and even in some of the better-class houses, and was later superseded by foreign china. This foreign china was later on ousted by home-produced wares, which gave place eventually to the various kinds of earthenware and china which are with us today.

English pewter developed on rather different lines from the pewter of the Low Countries and of France and Germany. In England the quality was the thing that was aimed at beyond all others—the shapes remained simple and remarkably free from all added ornament. Abroad the quality was neglected as compared with our makers' high standard, the shapes often developed into eccentricities and very often there was too much ornament.

There is nothing in England to correspond with the Hanaps or Guild-cups of Germany or the Netherlands: nor have we any elaborate altar candlesticks to compare with those of foreign make. Our pewter was domestic in style rather than ecclesiastical, but what was made for church use was extremely good, severe and dignified.

The keynote in the history of the pewterer's art has been imitation, and as a rule imitation of the work done by the goldsmiths and silversmiths. Church and domestic plate were made in pewter on the lines of similar plate made in silver. It was allowed in the case of church plate when poverty was the reason, and it was done in the case of domestic ware because there was no authority to stop it, or even to hinder its production.

Two glaring instances will make it clear. The fine silver candlesticks of the Stuarts were slavishly copied by the pewterers; the same thing happened in the case of the tankards—every detail in the pewter examples was a copy of those in silver, whether the tankards were of temp. Charles II or William and Mary, or later. In the case of spoons we find the same thing happened; every change of silver fashion was copied by the workers in pewter, and also by the spoonmakers working in latten.

To digress for a moment, it should be stated that latten (so called from the old French *laton*) is the ancient term for brass, which at one time was composed of copper with a small proportion of tin (and,

thus, was virtually bronze), but which was later made of the amalgamation of copper and zinc (the zinc obtained from calamine).

Some pewterers made spoons in latten, although at times this was expressly forbidden; in the main, however, the pewterers and the

braziers worked quite independently.

Although it has been stated that the pewterers copied the silver fashions, this is wholly true only in so far as the types of bowl and stem are concerned, and partly true so far as some only of the ornamental knops of spoons made up to, say, the end of the seventeenth century are concerned. The pewterers made some of their spoons with knops of quite distinct patterns which have never come to light in silver, and, vice versa, some in silver have not turned up in pewter.

It is probable that the cry of the public for all their pewter to be made "to look like silver" was too strong for the pewterers to resist, and one pewterer found himself in trouble in 1652 for making spoons which he called by the suspicious name of SILVORUM. The pewterers, as a rule, knew the limitations of their material, and produced work which was beautiful because of its simplicity, and durable because of its good quality.

Pewter is the name given to an alloy of which the chief ingredients are tin and copper, or tin, copper and lead. Fine pewter has no lead in it at all, but consists of tin with nearly 25 per cent of copper; the more tin there is in the alloy the better the quality.

As tin, though not a precious metal, has always been relatively costly, it was found advisable to reduce the standard by adding some lead when the metal was required for the production of such things as large wine measures, organ pipes, candle moulds, etc.

Bismuth (or antimony) was occasionally added for the purpose of

hardening, but only in very small proportions.

Pewter is made today as it has ever been, that is by casting in moulds. These moulds were usually made in a good-quality hard bronze or gun-metal, although other materials, such as plaster of Paris, sand, stone or iron may be used when only a small number of castings are required.

Pewter is now comparatively scarce, as it was never looked upon as a thing to be treated with reverence or handled with care; moreover it was constitutionally unfit to stand continued hard usage, if

not bad treatment, at the hands of servants.

Countless plates have been destroyed in part by being carelessly overheated too near a flame, and countless candlesticks have been ruined by the socket ends being thoughtlessly thrust between the bars of a kitchen fire. The same thing has no doubt happened in the case of teapots and posset-cups, and to them destruction was bound to come if they were left empty on a hob.

The advice generally given to a collector about to interest himself in pewter is that he must specialize. Quite good advice, but not easy to follow, for the older and rarer pewter is becoming year by

year more difficult to find.

Some may think of collecting beer mugs of the late eighteenth or early nineteenth century—the interest which can attach to them, apart from their great variety of shape and style, can lie in the fact that many of them bear engraved evidence of former ownership, or a name and locality of an alehouse that has long since disappeared. Even badly damaged or incomplete examples are useful purchases, and should be set aside to use as repair material for better pieces; perhaps a handle can be used to repair a similar damaged pot, or the metal itself used as "solder" to repair holes or cracks in others.

Pepper- and mustard-pots, again, may appeal to some collectors; the former, in particular, will be found in a variety of pleasing shapes, and can make an interesting display. Some pots, especially of larger size, may well have been intended for use as pounce-pots; "pounce" is a fine powder used by letter-writers to sprinkle over, and dry, the ink. After use the powder was collected in a fold of the paper and poured back into the shaker after removal of the screw cover.

Salts are also interesting, and the earlier they are the better; the earliest which the lucky collector may hope to find could be of the seventeenth century, and will have only a very shallow depression for the, then, somewhat precious commodity. As time progressed, and salt became cheaper, the bowls of salts became larger, and containers of the mid-eighteenth century and after were usually of a form not unlike the conventional champagne glass, set on a short stem and circular moulded foot—these were known as cup salts.

In the early years of the nineteenth century many other types emerged, including some of Britannia metal, i.e. an alloy of tin and copper, to which was added a fair proportion of antimony, to form a hard thin sheet of metal from which the bowl was made up, and then lathe-turned to its final shape. Snuffboxes, too, are of surprising interest; the metal is usually good, the workmanship is careful, and some of the designs are excellent. It is a curious thing in relation to these small articles that they seldom bear marks of identification and very rarely the name of a maker. They do not give the impression that they were made by any ordinary workman in pewter, but rather that they were made by a silversmith, or at any rate a professed box- or locket-maker. It requires a skilled workman to make a metal box, locket or watch shut properly, easily and securely. Inkstands again may be worth collecting. The makers copied the patterns of the silversmiths to a great extent, but the workmanship as a rule is good. The weak point in many types was the insertion of a drawer, and the consequent weakening of the side where the drawer was fitted.

Tankards and beakers may occasionally be met with at reasonable prices, especially if slightly imperfect. A defect is no real occasion for refusing a chance of adding a good specimen. No one would refuse to buy Elizabethan silver or other early work merely because of some slight imperfection caused by hard usage or by accident.

Plates are interesting and the earlier the better. Those with broad flat plain rims are difficult to find, but they have a dignity that is hard to equal. Reeded rims, especially multiple-reeded, also are desirable, and on small plates once in daily use they gave a

modicum of strength where it was wanted most.

It may sound almost heretical in a book ostensibly for collectors, but it is bona fide for all that—the best way to begin collecting pewter is at first to collect from the decorative point of view. Anyone who begins in this way will derive more pleasure ab initio than a period-bound dry-as-dust collector who will collect only Stuart candlesticks or absolutely perfect spoons. From this decorative point of view the collector will be wise to buy at first some ordinary plates of good quality. These will usually have excellent touchmarks, but their main purpose at this stage will be as "background pieces" to the display.

If one or two larger dishes can be added the effect is enhanced. In plates and dishes there are many varieties of rims, from the narrow plain rim (and deeply curved well and "bossed" centre) of the sixteenth century, through the broad plain rim of the early- to midseventeenth century, and the later broad, reeded rim, taking us up to the end of the century. About this time a small group of plates with very narrow rims, no more than three-quarters of an inch wide and composed almost entirely of mouldings, was fashionable, but lasted only for about ten years. About the year 1700 the first of the single-reeded plates emerged and remained in constant use until about 1760. During the period of their popularity, about 1740, there was produced the plain rim, quite distinct from those of earlier types, and these remained the "standard" for the next seventy or eighty years.

There were other types of plate rims in use in the eighteenth century, including that known to collectors as "wavy edged"—these have a "lobed" or "petalled" shape to the edge of the rim,

and may be found with a variety of mouldings.

These, and the octagonal and decagonal rimmed plates, were first produced about 1750; they had a comparatively limited popularity in their period, but are considered eminently desirable today as collectors' items. It is impossible to lay down a hard-and-fast rule for the vogue in rims, due no doubt to the great cost of the gun-metal moulds.

A collector of pewter must become thoroughly acquainted with the feel of the metal. He must be introduced to it, he must get to know its qualities and its limitations, and in time he will love it. It is a pity that the specimens in our museums are all under glass. So much can be learned about pewter by handling and by close examination of the ware, but of course glass cases are the only thing possible in public collections.

Access to the collection of a private collector of experience is also desirable, and if the budding collector has an elder brother collector, i.e. one who has been singed in the fire of his ardour for pewter, to whom he can apply for advice when required, so much the better for him. One often hears the old saying that one should buy one's experience, but in pewter collecting the buying may turn out to be very expensive and most discouraging.

As has been said above pewter is, as a rule, cast in moulds, and then the castings worked up and perfected by turning and polishing. The use of moulds made the pewterers conservative, as a new

mould was an expensive item. Hence we find articles varying but little in form if we look at them from the point of view of the mould, but varying widely in details such as the rim of plates and basins, the lids, handles and thumbpieces, etc., of tankards and flagons. The rim of a plate or dish was finished while the item was revolving in a lathe, and variations, in an age when micrometric measurements were unknown, were bound to occur.

A pewterer would not turn out a dozen plates with the same mechanical exactitude as the wood turner or modern lathe worker who can produce his selected object by the gross or thousand with a tool that cannot make anything but the pattern for the making of which it was devised.

One always regrets that the English stone-pots, and their lids, so often mentioned by Mr. Welch in his *History of the Pewterers Company*, have not come down in number to our time. For beer a stone-pot, i.e. an earthenware vessel with a lid, was just the thing. Thick enough to keep the beer cool and not too heavy to handle.

Abroad, in Germany for instance, the museums are full of them, pots of a pleasant grey colour with blue ornament, capped with a simple pewter lid, and very often fitted with a pewter rim round

the roughly finished base.

Pots of the same type were made of blue-white pottery in Holland, with the tops framed in pewter rim, and with pewter hinges and mountings.

In Germany there used to be many types in use by students, all

with pewter lids and mounts.

German guild-cups are often of great beauty, especially the early ones. One of the finest known was formerly in the Gurney collection, and was on loan at the Victoria and Albert Museum for several years. It is now the property of Lord Swaythling. The workmanship is quite Gothic in feeling, especially in the handle and the thumbpiece, and the cup is a fine specimen of inlaid work, strap ornament in brass being carried round the body.

Many of these cups have had ball or lion feet added to them.

There are difficulties in the way of the collector which are not likely to diminish as time goes on. It is but rarely that one comes across Elizabethan pewter. Roman pewter of undoubted authenticity is known to the writer, who has had the handling and the

repairing of it. Pewter of the period of Henry VII, and said to bear the badge of Prince Arthur, his eldest son, was dug up when the ground for the foundation for the new buildings at Guy's Hospital was being excavated. Pewter, too, from Tobermory, salved from the Spanish ship that went down there after the flight round the north of Scotland, has been retained in one or two collections of note.

The chances are quite small that any collector will find bargains consisting of pewter of this early date. He may pick up a covered tankard of the time of George I; more likely, perhaps, a porringer with an ornamental handle, or possibly a paten, or a communion flagon, of the end of the seventeenth century. Chance finds of rare or desirable items can happen in the least expected places, and at the least expected times, so be on the look-out all the time and have the confidence to buy at that moment—it will be gone tomorrow!

There is a tradition that the royalists who gave up their silver plate during the Civil War were partially compensated for the loan by being allowed to have pewter copies of the borrowed pieces, and that these copies were hall-marked as a kind of guarantee that they were to be redeemed at some future date. This seems to be nothing more than a pretty story, for not a single specimen of such hall-marked pewter has come down to us, nor has there been traced any reliable written evidence to corroborate the legend.

There were, however, a certain number of rosewater dishes with central enamelled bosses bearing the arms of Charles I and Charles II. Six were said to have been sent to Charles I while at York in 1642. Some of these are certainly in existence, but whether of this actual group or not cannot be stated. One is a fine dish 19½ in. in diameter, 2 in. deep, and it is ornamented, a rare thing in English pewter, by means of lenticular blobs made by a repoussé worker from the back. All these are rarities, and with them one could class candlesticks and salts of the same reign.

They are never likely to be found in numbers, and they can never be common.

Occasionally one runs up against Roman pewterware; the most well-known collections being housed at the British Museum and at the Spa Committee Museum at Bath. Its former use is quite problematical. It may, or may not, have been ecclesiastical—but as pewter of good quality it must always be of interest, though the

collector as a rule may not reasonably expect to become the possessor

of any such finds.

The analyses of Roman pewter seem to give the reason for the lasting quality of the ware. There was no antimony in the Roman formula, and hence there was none of the efflorescence caused by the decaying of the antimony. There were, however, other impurities but they were not important.

In later years, in both England and abroad, the quality of the alloys to be used had to be very much more stable because a rigid control was maintained by the guilds, especially in London, to ensure that only the grade of metal decreed should be used for the

production of specified types of ware.

II

Rubbings

There is one thing that a collector may always do, and that is take rubbings of all the pieces that come into his possession or that pass through his hands on their way elsewhere. It is better to take several rubbings of the marks, as they vary so in their perfection, and spare copies may always be sent on to other collectors.

Rubbings with heelball are all very well for church brasses, but quite out of place for tiny marks which may be no larger than a pea.

For all pewter marks thin paper with a fine grain, such as bank post, is preferable, and the finer the quality of the lead pencil the better and clearer the rubbing. Copying-ink pencil is often better

than blacklead and gives a better rubbing.

The ideal material, however, is thin tinfoil rubbed smooth first on a piece of glass to remove any pattern or chance scratches. The rubbing may be done with any hard rounded article such as a bone or ivory penholder; and it will be found that the underneath side of the rubbing will often reveal some detail which is not so apparent on the upper side. Tinfoil rubbings must be carefully handled and are best gummed in a book for reference, and if indexed properly require very little handling. To protect the indented foil it is a wise precaution to paste a "wall" of cardboard around the area bearing the mark, then no part of it can come into contact with the overlying page.

Very often a mark which seems to be hopelessly illegible can be

read better if the article from which it is taken be warmed very carefully with the flame from a spirit lamp.

A piece of hard metal such as silver, when the design upon it has been deliberately hammered out of all recognition, will, when reheated, still show the original design. In the case of the pewter there must naturally be no overheating. Photography, too, may be called in to aid the collector, and a glossy print from a good photographic negative of a mark will sometimes give a satisfactory clue to the name that cannot be read with the unaided eye.

In the cases where the mark is so faint that a rubbing is useless, and it is thought that it cannot be photographed with any success, it is recommended that a careful drawing be made of *all that can actually be seen*, and no more—do not attempt to add portions on the assumption that the unseen area is necessarily symmetrical with the rest. With each rubbing, foil impression, photograph or drawing keep a record of the type of article upon which it was found, and the approximate date, if known. In the case of drawings always record the actual size of the mark.

The editor of this book has spent his best part of twenty-five years in collecting together marks, names and locations of pewterers which have, hitherto, not been recorded, with the object of eventually compiling a monumental tome for publication. None of the existing printed literature can claim to be anywhere near complete in this respect, nor, of course, will be his own effort, for the simple reason that there will always turn up "out of the blue" another name or mark. All collectors can help to ensure the utmost coverage, however, if they will kindly pass to him details of any which come to their ken.

III

Displaying Pewter

The obvious method of displaying a collection of plates and drinking vessels is to use a dresser, preferably an old one; but failing that on a modern but not too flimsy copy. Plates on a dresser have to be tilted at an angle which helps the metal to reflect any light which falls upon it. In some cases the owners of a garnish did not trouble themselves about the decorative effect of pewter and more often than not turned the plates to face the wall so as to have the dust on the under side instead of on the face. The long-term effect of this, of course, was that the backs were kept clean and bright for all to see (and the marks gradually disappeared!). This practice seems to have been particularly prevalent in Wales, and if one is able nowadays to check back to the source of his plates which are worn at the back rather more than at the front, there is more than an even chance that they were once owned by a cottager there.

With the plates there can obviously be no objection to a few flagons, measures or tankards, but the dresser must not be over-crowded. Overcrowding is unfortunately a very common fault. Nothing gives a worse impression than to see all kinds of incongruous articles massed together on the table of a dresser or on the narrow shelves.

Church plate should preferably be kept strictly by itself, either on a shelf or in a small cabinet. If it is old and in a crumbling condition it is better to have it under glass to prevent any handling. The same applies to any delicate pieces which are of sufficient rarity, such as spoons of known authenticity.

Spoons of a common type may be kept in a rack something after

the manner of a pipe-rack.

Foreign spoon-racks were evidently designed to help the house-wife to check her stock of spoons with the minimum of trouble. The symmetry of the arrangement of the spoons in the rack was at once marred by the gap left by one absentee.

In our return to the simple life and the use of a living-room the mantelshelf and the ingle-nook both form convenient places for the display of large plates and dishes. The play of firelight on pewter in a real ingle-nook is a sight to gladden the heart and the eyes too.

Dishes and plates are often bought as decoration, but it seems a pity to sky good plates and dishes on a frieze in a large room where no one can touch them except the housewife who climbs a ladder at

stated intervals to dust, or once a year to spring-clean them.

In the Nürnberg Museum there is a living-room reconstituted so as to show the latter-day folk what the rooms of their forebears were like. The idea is good, but more or less Utopian, for it is manifestly impossible to have one room of this kind historically correct in all its details. To do the thing properly there would be required a series of rooms of various centuries, and space would not allow it.

If no dresser is available a set of shelves may be contrived which will answer the purpose, but the background will have to be considered.

The effect of pewter is certainly best when it is massed together. If the room is light a dull background may be used, but if the room is dark the background must be bright. One fine collection was shown in London in a dark room in a semicircular recess of which all the woodwork was enamelled white and the lining paper of the recess a brilliant pillar-box red.

In another room, also in London, all the woodwork was painted white, and the pewter which was lovingly cared for by its owner, who had begun to collect long before most of us who are alive now were born, looked remarkably well in its surroundings, both when dull and awaiting its regular day for cleaning, and when fresh from the cleaner's, i.e. the owner's hands. The latter always maintained that the modern servant could not be safely trusted to clean either

plate or pewter. Certainly the pewter soup plates cleaned by the owner rivalled the silver spoons and forks cleaned by his manservant.

Brown paper as a background looks well with pewter, so do some shades of green; but the exact shade must be experimented with on the spot and with a pattern of reasonable dimensions.

A distempered wall is the cheapest, and possibly there is more variety to be obtained in the shades of any colour by means of judicious blending.

In museums the makers of show-cases seem always unable to get away from cheap blue or rusty black velveteen, both of which so soon look shabby; but perhaps the official mind prescribes these materials as being the most generally useful.

Dishes should never have holes bored in the rim in order that they may be hung from a wall. The boring depreciates the value of the dish or plate and the wire which is put through will last only a limited time and then disaster comes when the plate falls. Similarly, a wire framework is not the best thing in which to hang a pewter plate or dish, nor, in the present writer's opinion, any other plates even in pottery or porcelain—it seems quite wrong for a plate to be suspended in mid-air without any apparent support, like a meteorite or a space-ship!

A narrow shelf with a ledge to it is far safer, and with proper brackets to support it may be decorative as well. There should be a raised beading tacked to the shelf to hold in the plates at the bottom and perhaps a panel pin driven into the wall and bent downwards to serve as a hook at the top.

IV

The Cleaning and Repairing of Pewter

When pewter is not kept bright the surface slowly oxidizes, and assumes a very pleasing subdued tone, not the least like the hard black tarnish which discolours silver. This colour is peculiarly its own.

On some specimens of old pewter a kind of efflorescence will be found resembling rust. It is probably due to some change or decomposition in the antimony used in the pewter, as tin itself is not liable to changes of this nature. If severe it cannot be removed by cleaning and it will make holes in the metal eventually.

To keep pewter free from blemishes in olden times it was found necessary to oil it, and in 1661 the Pewterers' Company paid

19s. 6d. for a year's oiling of their pewterware.

If pewter has to be left exposed for any length of time without being occasionally cleaned, it is a good plan to rub it over with a rag or cloth saturated with vaseline. There is no necessity to leave a thick deposit of vaseline upon the pewter, as a very thin coating is all that is required. Unlike anything in the nature of a lacquer, it only requires rubbing to remove it.

To remove the obstinate black oxide or scale that has formed on pewter that has been lying forgotten for any length of time there are two methods, the one drastic and the other slow. Care is required in the former, and it is best to proceed by having a brush with which to apply hydrochloric acid to the parts affected. If a rag is preferred it should be held in a piece of bamboo split at one end;

with a rag so held more pressure can be applied than with a brush. After applying the acid its action must be watched, and as the scale softens, the part so cleaned should be rubbed with a mild abrasive; what is commercially known as "wet and dry" emery is good, so, too, is fine-grain wirewool.

It is absolutely useless for a novice to attempt to remove the oxide by scraping, as a series of ugly scratches will be the only result.

It is sometimes thought that glass-paper and emery-cloth must never be used on pewter. The prohibition is too sweeping and too vague. The very finest glass-paper glued on to a flat piece of wood makes an excellent file for the removal of the efflorescent crust from the surface, a defect which is found occasionally even in the best pewter.

As to emery-cloth—there is emery-cloth and emery-cloth. That sold by the oil and colourman for cleaning rusty fenders and neglected fire-irons is of no use at all to the pewter collector, but emery-paper and especially 00 or 0000 is of the greatest use to the owner of good pewter. By its help deeper scratches can be removed with very little trouble.

The crust that is often found on pewter can be removed, but the process requires great patience. It is an excellent plan to rub paraffin oil or vaseline into the whole plate or dish and let it work its way in as paraffin can do, and to give the dish an occasional warming. The oil seems to be able to get under the scale or crust, and with the aid of the warming to spread in all directions and assist in the final removal of the scale.

Oxalic acid dissolved in water, by itself or with the addition of jewellers' rouge or sifted rotten-stone, is a good cleaning medium; but it is a poison, and makes the nails rather brittle and so it requires caution in use.

Cleaning or "scouring" pewter was a branch of the trade, and it was not supposed to be done elsewhere than in the pewterers' workshops.

The regulations quoted by Bapst from Boissonnet for the cleaning of church plate, if of pewter, are very precise: "It must be washed every three months in hot soapsuds, and be rubbed with oats or other husk-bearing grain, or with broken egg-shells; then washed in clean water, dried and wiped with a clean cloth."

Pewter is often ruined by injudicious cleaning and by cleaning by inexperienced people. All cleaning and polishing really results in scratching the surface in such a way that the scratches are not apparent to the naked eye. As soon as the general direction of the scratch lines changes, the scratches become painfully visible. It is quite easy to take scratches out of a gold ring with very fine emery paper and a burnisher, but the scratches would be quite visible if the direction were to be changed. It is easy to try this. Take a piece of fine emery cloth, o or oo, and rub a piece of scrap pewter or the under side of a plate several times one way only, and then follow with the same number of rubbings with the lines at right angles to the first set and the scratches will be seen at once.

It is not always easy to rub regularly in a circular direction, but it can be done in a lathe—if it is big enough—or by means of a polishing lathe. Hand cleaning, as a rule, should be enough for most of the pewter in an ordinary condition.

Cleaning is dirty work at the best of times and certainly is so with pewter; and the more lead there is in it, the dirtier will be the hands of the cleaner.

There are many cleaning nostrums, and all are probably equally efficient as cleaners; but pewter seems to tarnish more quickly after some than after others. Much good pewter has been ruined by being cleaned with sand. Sand is right enough for scouring saucepans and for other purposes, but it is a mistake to clean pewter with it. Many tankard hinges have been ruined by sand getting in between the leaves of the hinge and into the hole of the hinge-pin.

Powdered bath-brick and oil is a good cleaner for obstinate stains, especially if the powder be sifted first; but a better one is made by mixing soft soap and rotten-stone together till it makes a dry mixture and then by moistening slightly with turpentine. Very fine ash, such as collects behind firebricks or in the flues in a kitchen boiler, moistened with vinegar, is an excellent cleanser.

When the pewter is clean enough, it should be easy to keep it so by the help of regular rubbing with a soft duster or an old silk handkerchief or silk stocking. The rubbing will prevent the formation of the oxide or sulphide in some cases.

In cleaning a simple thing such as a plate—it is a good plan to stand up with the pewter on a rather low table, in such a way that

the hand and arm can move with a circular motion. The more the movements approximate to perfect circles, the better will be the polishing. Sitting at a table it is difficult for the cleaner to put sufficient weight on the object, or for him to give the necessary regular rotatory motion.

In a workshop, of course, the plate would be fixed to a chuck in a lathe and would be polished while revolving at a considerable speed, but the resulting polish lacks the effect produced by good hand

polishing; it is too monotonously uniform.

A polishing head, or a "buff", used in moderation is all that is necessary to give the smoothness which is desirable for modern needs.

Scratches, if not too deep, can be easily removed with a suitable burnisher, providing that the latter is spotlessly clean and free from

any suspicion of rust and grit, and properly lubricated.

If the scratches are deep, or are in the nature of vertical cuts into the surface, as happens in the case of the plates—which are often scored on both sides—scraping is the only way to reduce the depths of the cuts. To be effective the scraping must not all be in the same direction, but continually varied so as not in itself to cause slight shallow depressions.

Remember that it is no good at all to treat pewter violently—patience is the only thing that will succeed in the end, and do not be discouraged if the metal should become scratched here and there; as has been said above, these are things that can be removed—with

patience.

During the process of cleaning very old pewter, especially if the piece has been long buried, it will often be found that the metal has corroded to such an extent that it is holed in many places. Where this is the case it is best to clean the front or the outside first, and then to consider if the piece will stand being cleaned on the other side or in the inside.

A valuable piece which may be too thin may be backed, or coated on the inside with plaster of Paris, or adhesive paper, and so preserved from destruction.

Portions of pieces may be set up with plaster of Paris supports, or missing pieces made good in the same material.

The question whether pewter should be cleaned regularly or not

is often raised. The point may be settled quite easily in this way. If the piece is obviously a museum specimen and unfit for use, clean it by washing, dry it carefully, put it in a case, label it and have done with it. If, on the other hand, the piece could be used for display or handling, then keep it regularly dusted and free from decay.

The late Mrs. Gerald Walker—whose large collection was dispersed in the autumn of 1919—once showed me some small pieces of pewter which had been originally in a deplorably dirty condition. She had had them boiled for some hours in water containing several handfuls of hay, and the pewter looked exactly like new as far as brilliancy and cleanliness were concerned.

It is a method worth trying, especially with fragile and delicate pieces, but at the owner's risk! It goes without saying that the pieces should be suspended by a string from a stick during the boiling. Continued vibration for hours would quite alter the shape of pewter in a hot condition.

Sometimes pewter is so thin and corroded that repairing is a matter of great difficulty. Some Roman pewter that was submitted to the writer for examination and report, previous to undergoing repair, was found to be $\frac{1}{10}$ in. thick in some places, $\frac{1}{50}$ in. others, and with many holes, especially where the pewter had been exposed to continuous moisture, while the rim was consistently thick, and only superficially corroded. It is very difficult indeed to fill holes in such thin metal, the chief drawback lying in the getting of the necessary clean edge on to which the new piece may be soldered. The heat of the blowpipe, or copper bit, whichever is used will, unless great care be exercised, melt the thin paper-like metal very quickly. One portion of one dish had to be cut out altogether and replaced with new metal. In a second dish several portions of the flat rim and the booge had to be removed and restored by the substitution of new metal.

The two Roman dishes were nearly alike in section; one was ornamented with incised concentric circles obviously done in a lathe, or on a turn-table, as there were traces on the back of the method in which the dishes had been fastened at three points to the chuck or to the revolving table on which it was worked. Both were very corroded—some parts entirely missing—though the rim, which was thick, was intact in both cases. This particular pewter,

though distinctly sonorous, was rather soft and more lead-like in appearance than much other Roman pewter.

The weak points in the construction were the rather heavy rim and the thinness of the dish, which was 15½ in. in diameter. It is between B and C that most of the disintegration had taken place, though corrosion was fairly general all over the surface. The whole of the original surface, top and bottom, had come off in the process of repair and subsequent cleaning, but they will never look new. The new pieces inserted enable the safe handling of what was before rather precarious and risky.

It is quite easy to say that Roman pewter should be left alone and under glass, but there is this to be said also—that a piece honestly restored has a much better chance of surviving than it would if left in a precarious condition with portions about as strong as sponge-cake. Both these dishes were unsafe, even to examine with care; they can now be handled with impunity and passed freely from one connoisseur to another for his criticism.

Sometimes a plate is so badly scratched and cut about that it is well to have the whole surface treated by an expert. One of Charles II date was treated in this way and the result was most gratifying to the owner. All the scratches which interfered with the ornament (all wriggled work) were removed, and the plain parts were burnished by hand. All blemishes or discolorations and efflorescences were erased, and where necessary the surface made good; where there was no hole a little répoussage was enough. The result was that when finally cleaned the plate, a large and handsome circular dish, looked, not like a new dish fresh from the workman's hand, but like a dish that had been well handled and looked after with care.

Before a budding repairer of pewter tries his hand on a dish or plate, let him bore a few holes in a scrap of pewter, the more irregular the shape the better, and repair them. When he can do them so neatly that the repair is invisible he may begin on a useful plate or dish. The steps are as follows: with fairly large holes to be filled make the hole of convenient shape, level the surface, and then cut a piece of pewter of the same quality, or as near it as may be, to fit the hole, and make it a tight fit, tight enough to stay where it is put without dropping out. Support it on a damp cloth or felt, and solder it with a blowpipe or iron, using an easily fusible solder, *not* tinman's or plumber's solder; preferably a piece of another plate of as near the colour and quality. It is better to work from the face downwards to the back, not from the back towards the face or upper surface. Any excess of metal can easily be removed by filing or scraping.

In dealing with smaller holes in old pewter the hole must be treated as a dentist treats a tooth. The hole must be excavated until bright metal is visible on every side, then the filling is easy enough. This may have to be done two or three dozen times on one small plate; this calls for patience, more patience and still more patience.

In the case of cracks in the booge or in the rim, it is best to saw

or file out all the dirty part and then go on as above.

In replacing missing parts care must be taken to fix what is left so that the missing portion may be fitted very carefully. If the piece missing be a part of a rim and part of a booge it is better to repair the rim first and then add the booge in another operation.

In repairing a tankard rim it is best to make a mould from the rim where it is perfect and cast a piece of the size required. Plaster of Paris will do quite well to cast the metal in, or a piece of strawboard softened in water and pressed to the required shape, but of course dried before use. Papier mâché can be used in the same way.

There is, perhaps, a still better method which the repairer may choose to use, and that is: when the mould has set hard it may be slid round to cover the affected part (after the edges of the latter have been well cleaned and are bright); a pouring hole will need to be drilled in the mould.

The bright edges of the hole will need to be "fluxed" and when the new molten metal is poured in it will adhere readily, and will need only a final trim when cold.

Handles of tankards can be made in the same way or holes in them repaired by filling.

Knobs should be cast rather larger than are required, and then turned down on a lathe to the required size.

When a plate or dish is very badly scarred with knife-cuts a dealer who is ignorant is sure to recommend that the dish should be refaced, i.e. have the scarred surface removed by being turned down in a lathe. It is a drastic process and is certainly to be condemned. Some ware may be able to stand the thinning down from the fact that it is not likely to be used, but as a general rule it should be avoided.

Much of the character of early pewter lies in the reeded rim of the plates and dishes. These rims by age become clogged with dirt and corroded at times, but they respond as a rule to careful cleaning with a stiff brush. In places it may be necessary to restore the lines of the rim, when battered by a blow or a fall, with a graver or a scorper. Either tool demands practice first, or confusion of line may become worse confounded, and sharply made deep cuts will require a great deal of treatment in their removal.

Dents or hollows are bound to come in plates and dishes, just as they are in jugs and tankards. In the case of plates they may be removed by careful hammering, with a hammer having a polished pane, on a smooth and clean flat iron from which the sharp edge has been removed by filing or grinding. In tankards the removal is effected by the use of a weight with a curved or rounded edge; the knob of a poker or some such similar implement is a useful adjunct to the repairer's toolkit.

Pewter, as already stated, is subject to a disease of an irritating kind. The metal develops imperfections in places, and these effloresce and eventually become holes. This efflorescence seems to be due to impurities in the alloy, and is developed earlier in some

cases where heating or overheating has taken place.

It occurs, however, in vessels which have had no need of heating at all, as in the case of rose-water dishes and Communion flagons. There is only one remedy, and that is the expert's knife or drill and the restoration of the parts cut out. The disease occurs in the most perfectly made and kept pewter. Recently a flagon was brought to me in which there were nearly sixty blow holes which had to be excavated, or rather, drilled out and then filled separately. Moreover, when some of the drilled holes were being filled the heat of the blowpipe flame caused other defective places to blow through the surface, so that in the end there were over one hundred and eighty

holes to be made, filled and finished off, both in the inside and on the outside of the flagon. There was nothing else to be done; but it was a pity, for the surface patina was very fine, and that is a thing which takes years to form again.

It is not everyone who is gifted with the patience to repair a flagon or a dish with missing portions, but small repairs are well within the capacity of anyone skilled in the use of soldering tools.

Pewterware, though of a soft alloy, has survived some very hard treatment. One may see a candlestick in which the tubular stem has been battened down till it touches or nearly touches the level of the base, or the foot of a chalice, or a salt, similarly affected. This battering down has partly been caused by undue pressure upon the object

while it was being cleaned, or by ill-usage.

The depressed section must be patiently treated if it is to be restored to its original form. It can be done, as most things in the world, with care and patience. The pewter should be kept as hot as the hands can bear to handle, and should be hammered with a boxwood mallet, raw-hide or rubber hammer, shaped for the special purpose all over the part which has been battered in. Progress will naturally be slow at first, but it will be found that by degrees the hammering will do what is required. The hammering must be evenly distributed all over the surface, and twenty gentle blows are far more efficacious than two hard ones.

It is quite possible that in the process a crack may develop, especially if there was a sharp angle in the part compressed by battering down. A crack can be ignored at the time, and can be

filled up later when all hammering is finished.

It is not proposed to give any detailed directions here for soldering pewter. The process can be learned from many manuals of workshop practice. Success comes after much experience. The writer prefers a blowpipe worked by the mouth, as in that case the flame is always under perfect control, and occasionally uses a small copperbit heated on a gas jet, or "bunsen" burner.

Soldering pewter is very risky, therefore most fascinating. Just as joy and tears, love and hate, are intimately connected, so success and failure are separated by but a hair's breadth. One puff more with a blowpipe than is necessary may make a hole ten times bigger than the original rent that was to be repaired.

Cleanliness, i.e. chemical cleanliness of all abutting areas is essential, and a piece of good pewter should be used as a solder.

Experience may be gained on some old plate or tankard, using one of the various paste fluxes now obtainable. It is possible to join two pieces of pewter with pewter without any solder or flux, by the aid of a blowpipe, if every part of the metal to be joined is absolutely clean.

Pewter is sometimes in such a decayed state that the question of what is to be done with it becomes rather a difficulty. A pilgrimbottle that was dredged up somewhere was found to be corroded all along the seam, for the bottle, owing to its shape, had been cast in two pieces and then joined, quite a legitimate process. It was the solder that had corroded, so the obvious way to treat the bottle was to saw it in two, do all necessary repairs to the two halves, quite an easy thing when the piece was dismantled, and then, carefully, to join the two halves.

In another case, also a pilgrim-bottle or powder flask, it was so battered and worn that nothing would have been gained by taking it to pieces—for it would have been most difficult to join the halves together again. There were many pieces missing, and through these holes it was possible to force the battered-in portions outwards. When all had been done in this way plaster of Paris was poured in to form an inner lining of about a quarter of an inch. Strapping plaster was used to cover the holes through which the plaster might otherwise have run out. After the paster had set and the strapping plaster had been removed the plaster was tinted with water-colour—Payne's grey was the basis—to resemble pewter.

In another desperate case—a thirteenth-century paten from the tomb of an ecclesiastic of high rank who had been buried in one of our cathedrals—the writer made it fit to handle by coating it with many thin coats of a special white creamy cement like dental plaster till the back looked like a backing of porcelain. Without the backing the piece could not have been safely handled except on a piece of glass. Today one can obtain excellent epoxy adhesives which will make such a job very much easier.

In the case of tankards it often happens that the part of the drum which takes the pull and the thrust of the handle is too weak structurally in proportion to the weight of the tankard even when empty. If the tankard is to be preserved the best plan is to reinforce the back by fixing at the top a strip about 1½ in. wide of good pewter, soldered to the inside of the body of the tankard. It need not be unsightly and the lifetime of the tankard will be prolonged indefinitely.

Holes in dishes are not so dangerous as cracks, and the latter should always be attended to at once, as they are enlarged by any chance bending at the damaged spot by cleaning. A crack can be filled so that the repair is virtually invisible.

Prospect Heights Public Library
Prospect Heights, Illinois

V

A Few Don'ts

Don't begin to collect pewter (or anything else for that matter) because there is a craze for it. Boys at school will collect anything that anybody else is said to be collecting, and then in a short time drop the idea and collect something else. A person who is grown up should certainly find out if he (or she) is interested in the thing to be collected and studied. Without study the collecting is apt to be unintelligent and useless in consequence.

Don't attempt to secure a specimen of all the objects that have been made in pewter. Many of the later wares were badly designed

and unsuitable for the metal.

Don't jump at conclusions in investigating touches which seem at first indecipherable. It is a branch of the subject which is highly fascinating—the writer (and the editor, too) has given years of study to it; but it is very easy to be venturesome—and to be wrong.

Don't decline a good piece of pewter merely because it has no marks upon it, or because they are indistinct. By comparison, or by reference to the analysis of the touches, a date can often be assigned

to a doubtful piece.

Don't buy church pewter of the sexton or other unauthorized person, nor of the clergy unless they have a "faculty" by which they have the power to sell granted to them. Don't be a party to this wrongful traffic in pewter.

Do not ignore pint or half-pint pots. There is much interest

attaching to them, and the names engraved on them. A couple are useful as measures in the kitchen, and even damaged ones make good solder if they are of good quality.

Don't think that everything sold as a tappit-hen, even if several

pounds are asked as the price, is really what it seems.

A Normandy measure can look somewhat like a tappit-hen to the uninitiated, and also there are reasonably good copies of tappit-hens and other Scottish measures being made today for decorative purposes.

Don't pay fancy prices for plates with engraving on them, unless you know that what you are buying is genuinely old. An engraved coat of arms, or a date, or some other ornamentation, might well be

added to catch the unwary.

Do not buy circular or oval dishes with salamanders (in so-called repoussé work) as the emblems of François I and other similar decoration. They are being made every day somewhere in France. They are usually made in very heavy, leady metal, and have nothing to recommend them to the serious collector—they may, however, appeal to those interested purely in decoration. The genuinely old examples in this form are rare.

Don't believe anyone who tells you that pewter cannot be repaired. It can if you yourself are expert in soldering or hammering, or if you will take it to an expert pewterer who knows his art, and if you are prepared to pay him for the time involved. Don't expect good work for nothing.

Don't refuse to buy a good old plate because it has a hole or holes in it. These can be repaired easily and honestly, and the plate will be

the better for it.

Do not hesitate to buy a good piece of pewter when it is badly crushed and even broken in places. A dish with the rim off and crushed flat can be successfully restored with patience. Even a dish badly corroded by being under the sea since the time of the Armada in 1588, showing daylight through 250 odd holes, can be restored by an expert, if it is thought advisable and also worth the expense.

Do not buy a plate merely because it has armorial bearings on it. Armorial bearings on the rims of plates are usually those of the owner, but they could have been added by a faker to give a fictitious

value to the plates.

Don't buy from a dealer who is known to handle faked pewter. (Don't, however, proclaim in public the fact of his so dealing.)

Don't pay high prices at auction for a small object like a pewter spoon merely to be known as a collector and to have your name advertised as the owner of the —— collection. It is not worth it! If you were a millionaire and were making a collection for the nation it might be excusable.

Don't believe anyone who tries to sell you pewter at a fancy price on the ground that it is *silver pewter*. There is no such thing! Early pewter *may* be found to show traces of silver when analysed; but if so, it was introduced accidentally, having been added (in ignorance) with the lead (if and when lead was added), for in old-times there were no well known processes for extracting the silver from the ore.

Don't buy pewterware without seeing it first; provincial auctioneers sometimes catalogue quite worthless articles as rare pieces, simply because they are not experts, and may have accepted the owner's erroneous description. Always endeavour to view before the sale.

Don't buy a "Collection of . . . pieces of pewter" which may be advertised in a local newspaper without examining it carefully; very frequently such an advertisement is merely a "catch phrase" to entrap the unwary, and upon further examination of the so-called "collection" it will be found to be nothing but an assortment of normally unsaleable pieces, like late Britannia metal teapots, or coffee-pots, mustard-pots, egg-cups and suchlike which are better put into the scrap sack.

Many of the articles thus bought are not worth the money, and in many cases they will supply much disappointment whether sold in the purchaser's lifetime or by his heirs, or executors after his death.

Much of the pewter exposed for sale in the dealers' shops today is of quite modern origin, made by firms specializing in good reproductions of older forms.

Scottish pewter is almost always of good quality; so too is Irish, but there is far less about, even in the countries of origin, than there is of the pewter of England.

Don't buy a lot of tools and think you are thereby qualified to become a pewter repairer. You certainly want tools, and intelligence, but patience is the one thing that is most necessary.

Lastly, don't be discouraged when you find that you have been mistaken in a find, or have been taken in by a plausible rogue. Such things will always happen in collecting; they are part of the game. The thing to be sure of is that you learn from your mistakes.

VI

The Craft of the Pewterer

The craft of the pewterer is one of the oldest in the world and must have been practised wherever tin was an article of commerce. Our own Scilly Isles and the counties of Cornwall and Devon were *probably* the scene of the earliest attempts in this country in the art or craft of the pewterer. It is probable that the invading Romans first set up their manufacturing centres close to the source of the tin.

The tin-miners of the West of England were granted charters by King John in 1201 and by Richard I. A century later (1305) Edward I by his words in a charter addressed to the miners of the west gives a proof of the existence of what is a regular guild organization in this

country.

Though there is no official record in the possession of the Pewterers' Company earlier than 1348, there were certainly pewterers and men too who were anxious for the reputation of the craftsmen and the wares produced by them.

Pewterers did not invariably constitute a separate craft. As early as 1320 we find mentioned William the wiredrawer who lived at

York and did work in pewter.

In his earlier writings the late Mr. H. H. Cotterell noted that in 1344 one Walter the Goldsmith was paid for making pewter for the Prior of Holy Trinity Priory, Dublin.

In England pewterers seem to have worked in brass on occasions, but these were probably only the spoon-makers. In Scotland we find craftsmen of various kinds grouped under the comprehensive title of hammermen. In Ireland too, in 1687, Mr. Cotterell mentions smiths, goldsmiths, silversmiths, cutlers, glaziers, braziers and other hammermen who work by fire are to take out and pay for a new charter. Mr. Cotterell in his notes on Irish Pewterers says: "The early

Mr. Cotterell in his notes on Irish Pewterers says: "The early history of the Pewterers' craft in Ireland is shrouded in almost impenetrable mystery and while one sees the Pewterers' Guilds of London, Edinburgh and York existing as flourishing institutions, governed by their own reputations and ordinances, each controlled by its own Master and wardens, yet no such guild, so far as is at present known, existed separately for the *Pewterers* of Dublin or Cork, or even of Ireland. In Dublin they formed one of the trades comprised in the Guild of Smiths, and in Cork they were one of the units embraced in the Society of Goldsmiths."

These ordinances or regulations look as though they were based on the rules of the Paris Corporations described by Etienne Boileau in the early part of the thirteenth century, but it seems safer to assume that the London workmen merely had put down in writing the customs of their trade which previously had been in a floating condition, and were probably more or less identical with those of the pewterers working on the Continent.

Ordinances of the Pewterers, 22 Edw. III., A.D. 1348 (mainly from Riley, "Memorials of London", pp. 241–244, translated from the Norman French).

"In the first place—seeing that the trade of pewterers is founded upon certain matters and metals, such as copper, tin and lead, in due proportions: of which three metals they make vessels, that is to say pots, salers (salt-cellars), porringers (esquelles), platters, and other things by good folks bespoken: which works demand certain metals and certain alloys according to the manner of vessel so bespoken: the which things cannot be made without good knowledge of the pewterer, expert and cunning in the craft; seeing that many persons not knowing the right alloys, nor yet the mixtures or the right rules of the trade, do work and make vessels and other things not in due manner, to the damage of the people, and to the scandal

¹ Journ. of the Proceedings of the R.S.A., Ireland. Part I, Vol. XLVIII. Series VI (Vol. VII) half-year, June, 1917.

of the trade, therefore the good folk of the trade do pray that it may be ordained that three or four of the most true and cunning in the craft be chosen to oversee the alloys and the workmanship aforesaid: and that by their examination any assay amendment may speedily be made where default has been committed. And if any one shall be found rebellious against the Wardens and Assayers, the default may be sent, with the name of the rebellious offender, unto the Mayor and Aldermen: and that by them he may be adjudged upon, in presence of the good folk of the trade, who have found such default.

"And be it understood, that all manner of vessels of pewter such as porringers, saucers, platters, charges, pi[t]chers square, and cruets squared, and chrismatories, and other things that are made square or cistils [ribbed], shall be made of fine pewter, with the proportion of copper to the tin, as much as of its own nature, it will take. And all other things that are wrought by the trade, such as pots rounded, cruets rounded, and candlesticks and other rounded vessels . . . to be wrought of tin alloyed with lead in reasonable proportions. And the proportions of the alloy are to one hundredweight of tin 22 lb.¹ of lead: and these are always called 'vessels of pewter' (vessele desteym).

"Also, that no person shall intermeddle with the craft aforesaid, if he be not sworn before the good folk of the craft, truly to work according to the points ordained: such as one who has been an apprentice, or otherwise a lawful workman known and tried among them. And that no one shall receive an apprentice against the usage of the City. And those who shall be admitted therein are to be

enrolled according to the usage of the City.

"Also, that no person, nor stranger, shall make or bring such manner of vessel of pewter into the City for sale, or offer it for sale before that the material has been assayed, on peril of forfeiture of wares. And if the material be allowable upon assay by the Wardens made, then let the goods be sold for such as they [are], and not otherwise. And that no one of the craft shall work privily in secret places vessels of lead, or of false alloy, for to sell out of the City at

¹ Welch, Vol. I, p. 3, gives 26 lb. of lead. Hazlitt in *Livery Companies of the City of London*, says, p. 585: "We gather from some proceedings at the Guildhall in 1350, that the alloy of tin and lead, allowed and recognized by the custom of the trade, was in the proportion of 16 lb. of lead to 112 lb of tin."

fairs or markets, to the scandal of the City, and the damage and scandal of the good folk of the craft: but let the things be shown, that shall be so sent to sell without the City, to the Wardens of the trade before they go out of the same, and by them let the things be assayed. And that no one shall do any work in the trade if he will not answer to his workmanship, upon the assay of his work, in whose-soever hands it be found. And if any one shall be found from henceforth carrying such wares for sale to fairs or to markets or elsewhere in the kingdom before it has been assayed, and, before the Mayor and Aldermen, shall be convicted thereof, let him have his punishment at their discretion, according to his offence, when he shall be so convicted at the suit of the good folk of his trade.

"Also, if any one shall be found doing damage to his master, whether apprentice or journeyman, privily in the way of theft, under the value of 10 pence; the first time let amends be made unto the master by him or by his surety in the craft; and if he offend a second time, let his punishment be inflicted by award of the craft; and if he

offend a third time, let him be put out of the craft.

"Also, as to those of the trade who shall be found working otherwise than is before [set forth], and upon assay shall be found guilty; upon the first default let them lose the material so wrought; upon the second default let them lose the material and suffer punishment at the discretion of the Mayor and Aldermen; and if a third time they shall be found offending, let them forswear the craft for evermore. [Welch, i. 4, "he shalbe foringed of the craft for evermore."]

"And also, the good folk of the craft have agreed that no one shall be so daring as to work at night upon articles of pewter; seeing that they have regard among themselves to the fact that the sight is not so profitable by night, or so certain, as by day,—to the common pro-

fit.

"And also, that if any one of the said craft shall be found in default in any of the points aforesaid, he shall pay 40 pence for the first default; for the second default 6s. 8d.; and on the third, let it be done with him at the discretion of the Mayor and the Aldermen:

¹ It was enjoined in the Statutes of the Streets against Annoyances, printed by Stow, No. 25, that "no hammerman, as a smith, a pewterer, a founder, and all artificers making great sound, shall work after the houre of nine in the night, nor afore the hour of foure in the morning, under pain of three shil. foure pence".

and of these payments let there be given one half to the Chamber, to maintain the points aforesaid, and the other half to the Wardens of the said craft, for their trouble and their expenses. And that no one of the trade, great or small, shall take away the journeyman of another man, against the assent and will of his first master, before he shall have fully served his term, according to the covenant made between them, and before the said journeyman shall have made amends to his master for the offences and misprisions committed against him (if he has in any way so offended or misprised), at the discretion of the Wardens of their craft; and whosoever shall do to the contrary of this ordinance, let such person have his punishment at the discretion of the Mayor and Aldermen.

"Also, that no one of the said craft, great or small, shall be so daring as to receive any workman of the craft if he have been not an apprentice, or if he be not a good workman, and one who can have the testimony of his master or of good neighbours of good condition; and can show that well and truly he has served his master for the

time assigned between them."

These ordinances clearly show that a guild in some form or other was in existence; without a guild there was no need for officials such as wardens, and a search would have been a farce.

These ordinances of 1348 made two qualities of pewter legal, one called fine pewter, which consisted of tin with the addition of as much copper as the tin "of its own nature will take". Of this kind of pewter was made almost everything that was made in pewter, i.e. esquelles (écuelles or porringers), saltcellars, platters, chargers, salvers, pitchers, cruets, chrismatories and any other articles that were made square, ribbed or fluted.

The other quality of pewter was tin and lead in the ratio of 112:

26, and was used for rounded or hollow pots and measures.

An early restriction in favour of keeping up the quality of pewter provided that no pewter should be brought into the city of London for sale without being assayed. The city of Rouen up to 1660 had the right of assaying all imported tin that came to Rouen, or was going to Paris by boat up the Seine.

The Pewterers' Company up to the time of the Reformation was a religious as well as a commercial or craft guild, as is shown by the mention in an inventory (1465), quoted by Mr. Welch, i. 33, of a gift

to "the bretherhed of our lady thasumption of pewtrers crafte", i.e. the brotherhood of Our Lady of the Assumption of pewtrers' craft.

Again, in an inventory (1489–90) of the goods of "the Crafte of pewterars within the Cyte of London" (Welch, i. 68), there is mention of "the Corporacon of the same brethirhode and crafte under the Kynges Seal, and the Common seal of the same . . . with the ymage of thassumpcon of our blessid lady gravyn theryn of sylver".

The fact that the Virgin Mary was regarded as the patroness accounts for the adoption of the "lely pottys", or lily-pots, which occur in the illuminated border of the grant of arms shown in fac-

simile by Mr. Welch (i. 127).

At the same time the freemen or the yeomanry had a guild of their own dedicated to the Archangel St. Michael. They had their own organization, but were in dependence upon the craft or mystery,

i.e. the senior guild.

This fostering of the real spirit and wish to do genuine work was the outcome of the feeling of fellowship, and it was this wish for good honest work which banded the pewterers against foreigners, a comprehensive term that included "aliens", as well as natives who wished to interfere with the trade. That this feeling of good work was strong is proved by the severe punishment that was sometimes inflicted on dishonest and on obstinate offenders, viz. expulsion from the trade.

From this religious side of the guild or mystery there developed originally the very strong bonds of union between the members of the fellowship. The same religious feeling urged the members to attend the funerals of deceased craftsmen, and led them to dine together after the funeral: to relieve distress among those of their own circles, as well as among those who on the face of it had no better claim than their own want for the time being.

Under the guild system, loyally maintained both by masters and by men, the "lock-out" or the "strike" was not a possible event. The relation between the employer and the employé was too close; and that between the master and the apprentice was almost parental

in character.

The general good quality of English-made pewter was the immediate reason why so many systematic evasions of all rules regarding it were made by those of a fraudulent turn of mind. As long as

pewterware was sold in the town where it was produced, it was easy to have some check on the quality of the ware; but as soon as it got into the hands of hawkers and tinkers, the perfect control was at an end, and the door was opened for the introduction of foreign wares.

In the reign of Richard II (1377–1399) the pewterers complained bitterly that their business was being injured by pedlars and tinkers going round the country and recasting the worn-out or damaged articles of their customers. The pewterers complained that these pedlars ruined the alloy with lead so that it was "not worth the fourth part sold for".

This adulterating with lead seems to have been a source of secret profit to these pedlars, as they charged very little for their recasting.

It seems probable that they recast principally the articles in every-day use, as plates and dishes of small size: they could hardly have carried on their backs a considerable stock of moulds, as moulds were heavy and very costly.

At the time of the granting of the charter to the Pewterers' Company in 1473 the trade was of an importance which it is now difficult to realize, for wares in that metal were then becoming every day

of more general use.

To assist in keeping up the quality, and detecting those who cheated by selling articles of light weight, a definite weight was fixed for the various articles usually made by the pewterers in 1430.

These weights were as follows:

			Weight per doz. in lb.
	Chargers	(the largest)	84
	0	next size	60
		middle	39
		small hollow	33
	Platters	largest size	30
		next size	27
		middle	24
		small middle	22
	Dishes	largest size	18
		middle size	14
		king's	16
		small	12
		hollow	II
		small hollow	10

			Weight per doz. in lb.
	Saucers	largest size	9
		middle	7
		next the middle	6
		small	4
	Galley dis	hes and galley saucers (greatest size)	12
	Also xiiij o		
	next g		
Small dishes of galley and galley saucers			12
	Cardinal's	15	
Florentine dishes and saucers (greatest size)			13
Next Florentine dishes and saucers			12
	Small boll	es (bowls)	13

In 1444 the Warden of the Company acquired the right to preempt a fourth part of all tin brought into the city, whether by land or sea, at the current price. At the same time the Company obtained the right of assaying all the tin because of the complaints of "the multitude of tin which was untrue and deceyvable brought to the City, the defaults not being perceptible until it comes to the melting".

The Charter of Edward IV to the Company confirmed the right of assay, and also gave the right of searching pewterers' premises.

As soon as this charter was made known in the country many country pewterers joined the ranks of the London Company.

The right of search, when carried out in counties so remote as Yorkshire, Derbyshire and Somerset, was costly and troublesome, but it helped the Company to maintain the high standard of English pewter.

This regulation was similar to that under which the Nürnberg and other foreign pewterers worked.

Men were known by the particular branch of the craft in which they worked. Sadware men worked at heavy articles, such as plates, dishes, chargers and trenchers. The hollow-ware men, as the name implies, worked at large pots, measures, pint pots, quart pots, tankards and flagons of all names and sizes. Triflers worked in trifle metal and plate metal on lighter wares—spoons and, later on, forks, buckles, toys, buttons; but by 1612, from the list given by Mr. Welch, they had taken to make much hollow-ware.

The pewterers, coppersmiths and brasiers were all included among the "hammermen", and had full privileges. They formed, however, a separate and smaller organization.

The lay-men worked in lay or ley, i.e. tin alloyed with lead. Hollow-ware was sometimes made of plate metal and sometimes of

lay.

Metal confiscated on the ground of being bad in quality was generally stamped with a *broad arrow*. Mention is made of this mark towards the end of the fifteenth century, but, as Mr. Welch aptly remarks, "As it was doubtless the fate of all vessels marked with the broad arrow to be forfeited and melted down without delay, it is not probable that any example so marked is now procurable as a treasured specimen by the collector of old pewter" (i. 47).

Mr. Welch's book teems with references to seizures at fairs in all parts of the country, and with the records of the brass and pewter

thus confiscated.

It is not more than a century since pewter was advertised to be sold at various fairs in the country. Dugdale's "Traveller" (quoted in the *Reliquary* of 1892, p. 150) mentions that at Nantwich fairs were held thrice yearly for "cattle, horses, clothes, flannels, hardware, pewter and bedding"; at Billesden the fair was held for "pewter, brass and toys"; at Hallaton, for "horses, horned cattle, pewter and clothes"; at Brigstock, "for sheep, brass and pewter"; at Rockingham, "for horses, cows, sheep, hogs, pewter, blackhats and clothes"; so too at Weldon, four times a year. In Yorkshire, Askrigg, Bedall, Coxwold, Grinton, Hedon, Kirkham, Malton, Reeth, Keighley and Stamford Bridge were all places where fairs were held, and at each of them pewter and pewterwares could be bought.

The marking of pewter by the maker was first made compulsory by Act of Parliament in 1503 (19 Hen. VII c. 6), and the same act prohibited the sale of pewter and brass anywhere but on the premises of a pewterer, except in an open fair and market. This Act also provided that the makers of pewterwares should mark the same with several marks of their own, to the intent that the makers of such wares shall avow the same wares by them to be wrought.

The use of false scales and weights was forbidden by this same Act.

Complaint was made in the Act, 4 Henry VIII, c. 7,1 "that many simple and evil disposed persons . . . using the said crafts [i.e. of pewterers and brasiers] daily go about . . . from village to village, from town to town, and from house to house, as well in woods and forests as other places, to buy pewter and brass. And that knowing thieves and other pickers that steal as well pewter and brass . . . bring such stolen vessels to them in such places to sell, and sell it for little or nought, . . . and bring it to privy places or into corners of cities or towns and there sell much part of it to strangers which carry it over the sea by stealth. . . . Also the said persons so going about, and divers others using the said crafts use to make new vessels, and to mix good metal and bad together and make it wrought, and sell it for good stuff where indeed . . . it is not worth the fourth part of that it is sold for to the great hurt, deceit and loss of your subjects. Also divers persons, using the said crafts have deceivable and false beams and scales that one of them will stand even with 12 lb. weight at the one end against a quarter of a lb. at the other to the singular advantage of themselves and to the great deceit and loss of your subjects, buyers and sellers with them."

To remedy this it was enacted that the selling of pewter and brass, new or old, was to be restricted to open fairs and markets, or in the craftsmen's own dwelling-houses, unless they were desired by the buyers of such wares. The penalty for this was to be £10 and for-

feiture of the metal.

At the same time the quality of any pewter wherever made was to be "as good fine metal as is the Pewter and Brass, cast and wrought after the perfect goodness of the same within the City of London". Here the penalty was forfeiture and sale, half the proceeds to go to the King, half to the finders.

No hollow-ware of pewter, i.e. salts and pots of ley metal, was to be made unless of the size, i.e. assize or standard, of pewter ley metal wrought within the City of London. More than this, "the makers of such wares shall mark with several marks of their own, to the

¹ These extracts are taken from a book in which the Pewterers' Company caused to be reprinted (in 1741) the various "Statutes established in divers parliaments for the Mystery of the Pewterers of London; and concerning the search of Pewter Brass and untrue Beams and Weights and for deceivable Hawkers . . . with the renewing and confirming of the same Statutes".

intent that the makers of such wares shall avow the same wares by them to be wrought".

All wares not sufficiently made and wrought and marked, found in the possession of the maker or seller, to be forfeited. If it had been sold the fine paid as well as the ware was to be forfeited.

As might be expected, the compulsory marking of pewterware led to abuses, the chief of which was the counterfeiting of well-known pewterers' marks by other workmen, notably so by country makers.

As for the "deceivable hawkers", they were to lose their beam and be fined 20s., with the alternative of the stocks till the next market day and the pillory all market time.

This Act, which was in the main a renewal of 19 Henry VII, c. 6, was sought by the Company to be made perpetual instead of

lasting to the end of the then Parliament.

These statutes, duly put in execution, caused the said craft to increase and multiply, to the great profit and utility of a great number of the "Kings subjects". It had the disadvantage, however, of causing "divers evil disposed persons, being the Kings subjects born, which have been apprentices and brought up in the exercise of the said craft of Pewterers", to repair, "of late, for their singular lucre, into strange regions and countries, and there exercise the said craft, teaching strangers not only the cunning of mixing and forging of all manner of Pewter vessil", but "all things belonging to the said craft of Pewterers".

The craft felt their trade might quite go from them if foreign pewter could be freely imported, so they sought that all foreign ware pewter should be forfeited.

Some amplifications of the Act were made in 25 Henry VIII, chiefly in the regulations as to the method of searching, which was to be lawful "for the Master and Wardens of the said craft of Pewterers as well within the City of London, as within every other City, borough and town, where such Wardens be, or to persons most expert in knowledge", appointed by the head officers or governors of the various places.

It was also to be enacted that no strangers born out of this realm were to be retained as apprentices or journeymen. Here the penalty was £10, and the ware made, "in whose hands soever it may be taken or found", was to be forfeited.

Englishmen working beyond sea, "in any strange country or region", were to have three months' notice to return, and "continually from henceforth dwell and inhabit", or else "shall be taken and reputed as no Englishman, but shall stand and be from henceforth out of the Kings protection".

The enactments as to hawkers did not seem to have much effect, as the Company complained of their misuse of royal letters patent and placards, and their continual use of "deceivable weights and beams", and sale of pewter and brass which is not "good, nor truly nor lawfully mixt and wrought". The Company sought to have the Act, previously temporary, made perpetual.

To check unlawful dealing with the metal it was agreed in 1555 that any one buying metal by night, or of tylers, labourers, boys or women, should be dismissed from the Company if the metal were found to be stolen property, and brought up before the Lord Mayor and the Aldermen for punishment.

On one occasion in 1591 the Company, for 5s., bought out a hawker, one John Backhouse, on the ground of his forestalling the Company and deceiving the Queen's subjects. He found a surety to swear that he would never hawk again. The 5s. was for him to buy pewterers' tools, with a view to becoming a pewterer (Welch, ii. 8).

The "deceivable hawkers" still gave trouble, and in March, 1621, the Company were again demanding further measures for their own protection, and "it was decided to introduce a Bill into Parliament for suppressing hawkers and the practice of buying of tynn and old pewter by brokers and others not pewterers, selling of old pewter, and transporting and uttering it".

Towards the end of the reign of Elizabeth, the Company in 1598 obtained letters patent confirming their privilege of charging a royalty on the smelting and casting of tin. Hazlitt assigns the reason to the pressure of foreign competition, which seriously affected the export of bar-tin.

There was always a strong feeling that trade secrets were not to be divulged either by word of mouth or by working in public. It was this feeling that inspired the prohibition against Englishmen working in foreign parts and the exportation of English moulds. A species of *esprit de corps*, too, led the London pewterers to keep certain

¹ The "strange regions" were France, Flanders and Germany.

methods of procedure from their country brothers in the trade. 1601–2 (August 13), "by the generall consent of the whole Company it was ordered uppon the abuse of dyvers of the Company who worketh openly in the shopes with their great wheles which is ane occasion that pewterers of the country and others shall come to great lyght of farther knowleg, to the great hindraunce of the Company as well at this present as hereafter, now there is comaundement that presently before bartelmew day [August 24th] they do reforme it, and if in case any of their shopes be unreformed at bartelmewtyd they shall pay 13s. 4d., and at the next fawlt they shall pay 20s., and after they shalbe banyshed, and that no brother of the Company shall buy and sell with them" (Welch, ii. 34).

By the beginning of the seventeenth century the domestic use of pewter had grown far more common, and from the lists of "trifles" given by Mr. Welch (ii. 68–69) in the year 1614, there is much more variety of the ware to be had, in addition to the older patterns. We read of "deep vessells, basons, bowles, pastie plates, new fashion basons, danske pottes, pye coffins, limbecks, thurndell [new fashion of various sizes], and other pottes, hooped quarts, cefters and lavers, still heads".

At the time that the prices of these articles were fixed, the amounts of rebate allowed to chapmen was also fixed, usually 1d. less in the lb. The price to be paid for giving old pewter to the pewterers in exchange for new was also arranged.

Most of the articles above mentioned were to be sold at a price per lb., tin at £4 7s. the cwt. being taken as the basis of the calculation. A small profit was fixed as a rule, 2d. per lb., or 1d. if the ware was sold to chapmen, except in the case of wares which were of

recent introduction or which were sold singly.

But it was in the early years of the seventeenth century that the Company began to lose their control over the trade; they no longer admitted country pewterers to the freedom, and thus provoked a flowing tide of irregular competition which it vainly endeavoured to check. The chief concern of the Company under the Stuarts, and indeed up to the middle of the eighteenth century, was to secure from Parliament a higher degree of protection to the trade. They objected to the royal practice of farming the Cornish tin-mines to influential syndicates, which raised the price of the metal. The Com-

pany feared, and not without reason, that England would lose the valuable export trade in pewter to the Dutch, who brought tin more cheaply from the East Indies and were in the habit of manufacturing a debased pewter threepence in the pound below the English standard. But the tin-miners were too powerful in Parliament, where Cornwall, with its many rotten boroughs, was of course much over-represented, and the Pewterers' Company expended much money in approaching various members of Parliament without result.

Self-advertisement was always sternly repressed by the Pewterers' Company, as they seem to have held that a man's reputation in the trade, and in the world at large, must depend upon the quality of his wares. The adding of *London* or an address was at one time specially forbidden, but the prohibition was repealed later, when it was found that the country makers, for the sake of a slightly larger profit,

stamped London on their wares.

For many years the touches were quite plain, and some of them, it may be noted, were especially fine specimens of the die-sinker's art. Towards the end of the eighteenth century labels used in addition to the main touch will be found to contain statements as to the

quality of the metal employed.

In 1727 it is clear from his own punch that Samuel Smith described his pewter as "Good mettle made in London", and in 1736 a pewterer named John Jupe was not afraid to mark his wares "Superfine French metal"; while Edward Box, in 1745, has on one of his punches "No better in London". This may have meant that his was the best, but the boast shows how the pewterers were beginning to do as to them seemed best.

Puffing of wares was as much deprecated as puffing of self, and it was mentioned as a thing to be avoided in an early regulation.

Taudin's nephew (Jonas Durand) was forbidden to add to his touch "Nephew of Taudin", and even the addition of an address, common enough later, was thought in the case of one maker, who merely added "Newgate Street", to savour too much of advertisement.

It was the right of search which originally gave the Company such an enormous hold over all the pewterers both in town and country. This hold was maintained as long as the search was effective and regularly carried out. During the Civil War, as might be expected, the actual searching became partial and less frequent; this fact, coupled with the discontinuing of the ready admission of country pewterers to the freedom of the Company, led eventually to the total loss of real control over the trade. The search had caused much opposition in the fifteenth century, was tolerated in the sixteenth, partially dropped in the middle of the seventeenth, and its attempted revival caused a renewal of the opposition. It may have been that the feeling of personal liberty was opposed to it altogether. In 1729 it was reported to the Company that much bad pewter was made at Bristol. But the Company were already beginning to feel somewhat uncertain of their position, and they hesitated to make a search at Bristol, not feeling sure whether their jurisdiction extended to places so remote from London. With the dropping of the right of search, the usefulness of the Company practically ceased. As soon as every man did what was right in his own eyes, the quality of the pewter began to deteriorate.

As to the definite position of foreign workmen in England there is very little direct evidence. There seems to have been much more jealousy among the exclusive pewterers than among the goldsmiths. The latter were, as their records show, much more willing to receive a stranger into their ranks. Entries occur, quoted by Herbert, to show that German, Dutch and Swiss goldsmiths were admitted, with due precautions and restrictions, to serve as workmen, and as masters. From Mr. Welch (i. 51) it is clear that a pewterer who was a Fleming was settled in Tower Hill as early as 1477, in which year a "pottle" (price 6d.) was bought of him to be tested for quality.

Undoubtedly there must have been others.

From the provision of the Acts of Parliament passed in the reigns of Henry VII and Henry VIII, it would seem the jealousy and the exclusiveness had reached an acute stage, the enactment as to for-

feiture of ware being very stringent.

Some few foreigners seem to have made ware approximating the English standard of goodness, but the fact that a man was a foreigner was certainly against him. Taudin's case is certainly a case in point (cf. Welch, ii. 122). Eventually he became a freeman of the Pewterers' Company, but was ordered to employ English freemen.

When English pewter was prohibited abroad, as at Bordeaux in 1658, the English workers did not like it, as it seemed to be an inter-

ference with their trade. Their policy was that of the open door, so long as it only opened outwards to allow English wares to go abroad! The Dutch on one occasion prohibited the sale of English pewter, but not the importation of it, which seems rather a curious regulation.

Another instance of a Frenchman wishing to work over in England was that of Mark Henry Chabroles. He was told in August, 1688, that he must not keep any "shopp, by reason he is a stranger and an alien". In 1690 the Court, learning that he was a Protestant refugee, gave him leave to work for "some time longer". This is vague, for he was in England and at work for two years longer. He was then advised, June, 1692 (Welch, ii. 165), to leave the trade of a pewterer, as "the Laws of this kingdome are against his exercising it"; but he was allowed to continue till the 24th of August—a very significant date to a Protestant refugee.

In 1700 W. Sandys wished to have as his apprentice a "ffrench

youth naturalized"; this was opposed by the craft.

In 1709 the question arose as to the extent to which foreign pewter was adulterated, and the Pewterers' Company caused experiments to be made with various alloys, and they found (Welch, ii. 177) that 4 oz. tin with $\frac{1}{2}$ oz. lead was $6\frac{1}{2}$ gr. worse than the tin bar they took as their then standard.

4 oz. to 1 oz. lead was 13 gr. worse 3 oz. to 1 oz. lead was 18 gr. worse 2 oz. to 1 oz. lead was 25 gr. worse

Some foreign ware tested was found to be from 14½ to 29 grains worse than fine, French and Spanish being the worst. Some English pewter, selected at hazard from a shop, was 1½ grain less than the test piece at Pewterers' Hall.

Pewter-making in England was apparently limited to a few centres, such as London, York, Newcastle, with later, Exeter, Bideford, Barnstaple, Birmingham, Bewdley, Beverley, Bristol. In Scotland, Edinburgh and Glasgow were the chief centres; in Ireland, Dublin and Cork.

Bewdley was perhaps at one time the most important centre of the pewter industry in the Midlands. The moulds used in the trade there by J. C. Crane were sold and passed into the hands of James Yates of Birmingham in 1838. James Yates had formerly been a partner in the firm of Yates & Birch, and Yates, Birch & Spooner, and successive partners continued to use the Bewdley moulds; in fact, the firm of Gaskell & Chambers continued to make pewterware to the Yates pattern up to the year 1970, when their pewtering business was transferred to Messrs. James Smellie, Ltd., also of Birmingham, who have inherited many of the moulds of their predecessors—one, at least, dated 1729.

In France the manufacture was widespread. Besides Paris there was early work done at Lyons, Limoges, Poitiers, Laon, Tournay, Besançon, Troyes, Tours, Amiens, Rouen, Reims, Dijon; also at Chartes, Saumur; in the south, at Nîmes, Montpellier, Angoulême, Chinon, Bordeaux, Angers, Toulouse.

In the Netherlands and Flanders the chief centre was undoubtedly Bruges and then Ghent, Mons, Namurand Liège. Much, too, was made at Brussels and Antwerp; also at Amsterdam, Breda and elsewhere.

Tin was largely used at an early date by the goldsmiths in Greece and Italy, the supply being forwarded to them *via* Venice, always an important centre.

In Germany, Nuremberg and Augsburg were the two chief centres, and mention of pewter-work can be traced back there quite as far as in France or elsewhere, one of the earliest records being an enactment made in 1324 at Augsburg, providing for visits of inspection made to the workshops by the sworn masters. These masters were empowered to test or assay the metal from the point of view of purity, and to inflict a fine upon those whose work was so bad that it had to be rejected and destroyed.

In Spain, Barcelona seems to have been the headquarters of the tin and pewter trade, and the place is well suited, by its natural position, for a distributing and manufacturing centre. No trace, however, of any corporation or guild has been found prior to the fifteenth century. The statutes resemble those of the workers in more northern nations.

The Italians used large quantities of tin, pewter having been made at Bologna and in other towns, possibly for tinning other metals. Much of the trade was in the hands of itinerant workmen—stagnarini—who travelled from place to place, very much after the manner of our tinkers, a set of men who were at one time indispensable to the housewife.

English pewter seems to have always enjoyed a good reputation both here and in foreign countries. This was mainly due to the naturally good quality of the English tin from Cornwall (it being practically one of the purest varieties of tin that is obtainable as an article of commerce), and also to the restrictions imposed upon the workers, whether masters or journeymen, as to the quality of the metal they used. Mr. Welch (ii. 137) mentions an instance of a master who broke up twenty dozen plates because they were not quite up to the standard required by the Company.

As to the reputation and skill of the English pewterers Harrison

As to the reputation and skill of the English pewterers Harrison says: "In some places beyond the sea a garnish of good flat English pewter [of an ordinarie making] (I saie that, because dishes and platters in my time begin to be made deepe like basons, and are indeed more convenient both for sawce [broth] and keeping the meat warme) is esteemed almost so pretious, as the like number of vessels that are made of fine silver, and in manner no lesse desired among the great estates, whose workmen are nothing so skilful in that trade as ours, neither their mettall so good, nor plentie so great, as we have here in England."

One branch of the many into which the foreign pewterers' trade was subdivided was that of the nailmaker. These pewter nails were used for many purposes where we should now use safety-pins, and sometimes, possibly locally, for decorative purposes, being used as studs in leather.

Pewterers who did not make their wares up to the proper standard were, after being warned and fined, ordered to bring in their touches, which were then confiscated. They were then ordered to use a new touch, either bearing a knot or a double f(cf. Welch, i. 254). This enforced use of a punch, in itself bearing the visible sign of disgrace, was tantamount to compelling the offending pewterer, if a master, to shut up his shop and become a journeyman again.

In the lists of the yeomanry there are several entries of women's names, but their names do not appear in the lists of the livery. As

¹ Welch, ii, 92, mentions that Katharine Wetwood was sworn and made free of the Company; and, on p. 179, Mary and Elizabeth Witter were admitted to the freedom; and again, p. 191, Mary and Elizabeth Cleeve were also made free of the Company.

the original guild or mystery was a religious organization as well as a craft guild, there is nothing surprising in this, and mention is made of both brethren and sustren. The latter could employ

apprentices, but were not allowed to work themselves.

Among the touches of the Pewterers' Company is that of William Fly; his widow, Martha Fly continued the business after his death, and at first used William Fly's distinctive mark, of a fly with outspread wings—in due course she incorporated her own name in a somewhat similar touch, which has been found on a goodly quantity of excellent plates and dishes, two of which are in the collection at Pewterers' Hall, London. In the same collection is another plate, bearing the touch of Elizabeth Boyden.

There were women pewterers in York, as is shown by a list of the Company made in 1684, in which the names of Jane Loftas and Kath. Hutchinson appear ("Reliquary", vol. vii., N.S., p. 205). In 1683 there was another, Emmatt Smith; in 1684, one Jane Waid, and her name comes in again in 1691. No doubt there were others whose names are unrecorded.

Of women pewterers in France¹ there is mention in Bapst's list of the workers of the fourteenth century of a certain Isabel de Moncel (1395). There is no statement made as to her being a widow, so she could have been either the widow or the daughter of Oudin du Moncel, whose date is given as 1383.

In 1462 mention is made of the Veuve Domey (miraclier), but the town is not specified. By the rules of 1613 women were allowed to

keep a workshop so long as they remained widows.

Hawkers and chapmen gave trouble to the craftsmen from time to time; so, too, did the Crooked Lane men. These men seem to have been workers in tinware of a kind which they either made themselves or caused to be made for them, or else which they, somehow or other, in spite of sundry Acts of Parliament, imported from abroad. They had been apparently tolerated for some time, and in 1634 (Welch, ii. 94, 96) measures were ordered to be taken for "suppressing of the excesse and abusive making of Crooked Lane ware, whereby the so doing and counterfeiting of the reall commodity of Tynn is to the greate deceipt or wrong of his Maties subjects." What measures were taken does not appear, but as they

¹ In 1300 there was in Paris "une batteresse d'étain".

cost £50, they were presumably of a legal description. In 1669 the Crooked Lane men tried to get a charter of incorporation, but nothing is known as to their request. As nothing is said of it they probably failed, especially as the Girdlers' Company joined with the Pewterers in paying for a counsel to plead against them.

VII

The Standards of Pewter

The standards of the fineness of pewter at various times are not known with absolute certainty, and the statutes regulating the trade do not enlighten us upon this most important point. Hazlitt states that from some proceedings at Guildhall in 1350, the alloy then used and recognized by the craft appears to have been composed of 112 lb. of tin and 16 lb. of lead. 19 Hen. VII cap. 6 (1503-4) dealing with pewterers and braziers, enacts that all pewter and brass worked or cast within the realm shall "bee as good fine mettal as is the pewter and brasse cast and wrought after the perfyt goodness of ye same within the city of London, and by the statutes of the same ought to bee". It further enacts that no one shall make any "hollow wares of pewter, that is to say, salts and potts that are made of pewter called lay mettal, but that it may bee after the assise of pewter lay metall, wrought within the Citie of London". From this it appears that at least two legal qualities or standards of pewter were then in use, but unfortunately the fineness of either is not specified. 25 Hen. VIII, cap. 9 (1533-34) makes mention of pewter "which is not good nor truely nor lawefully mixt". The ordinances of the York company of Pewterers (Reliquary, v. 2, 1891) ordain that "none of the said Crafte shall hearafter cast anye vessell but of good and fine metell, and shall not put any sowder or leade therein, or amongst the same". The name "vessel" comprised such articles as were then made to hold any liquid, and appears to have been cast in

brass moulds; further on the ordinances proceed to speak of the quality of the pewter to be used for "hollow wares" which, as we see from the Act above recited, were chiefly salts and pots; and were wrought throughout, hollow ware metal it ordains "shalbe of one saye (assay) or assize, viz. of the assize of pewther laye mettle wrought in London".

In the eighteenth century the legal standards for pewter are said to have been as follows:

- Fine or Plate Metal the one containing the highest proportion of tin, of which plates and dishes were made. It was composed of 112 lb. of tin and usually of 6 to 7 lb. of regulus of antimony.
 Trifling Metal or Trifle, the next standard, was composed of
- 2. Trifling Metal or Trifle, the next standard, was composed of pewter of the highest standard lowered one halfpenny in value by the addition of lead. This standard was used for ale-house pots.
- 3. Ley or Lay Metal, the lowest standard, was compounded of the highest standard and a further addition of lead, reducing its value two pence in the pound. Of this winepots were made.

The above proportions and ingredients must not, however, be taken to be fixed and invariable, for from the articles following on the Assay of Pewter it will be seen that the standards were fixed not by the fineness or proportion of tin in the pewter but with reference to the specific weight of the alloy as compared with that of tin. The ingredients used by the pewterers were variable and every pewterer had his particular mixture which he kept secret. Antimony, bismuth (or tin-glass), in small quantities, copper and lead were commonly used and, it is said, sometimes silver. It is probable, however, that the silver, and perhaps also traces of iron and zinc were included accidentally as impurities in the lead.

THE ASSAY OF PEWTER

The assay of the purity of tin and of the quality or standard of fineness of its alloy, pewter, was as early as the sixteenth century conducted as follows:

A mould, such as is now used for casting lead bullets, was taken,

¹ By "wrought" is meant made with care, and well finished after removal from the mould. [R.F.M.]

and a ball of the particular standard of pewter in question was cast therein; then in the same mould another ball was cast of the pewter the quality of which it was desired to ascertain. The two balls were then weighed. If the latter ball was equal in weight to or lighter than the first or standard essay it was of the requisite quality; for the lighter the tin or pewter the purer it is. If it weighed more it was rejected as being of inferior quality. (See the illustration of the assaying mould in possession of the Worshipful Company of Pewterers, on plate 15b.)

From the little book published by the authority of the Pewterers' Company in 1772 it appears that the mould then used was of such a size that a ball of fine tin, absolutely free from any admixture, cast therein, weighed 182 grains; a ball of Plate Metal not more than 183½ grains or 1½ grains heavier; a ball of Trifling Metal not more than 185½ grains or 3¼ grains heavier; and a ball of Ley Metal not more than 198½ grains or 16½ grains heavier.

Another method, but less exact, was sometimes used for the assay of Pewter. It was as follows:

A half-round cavity was scooped out of a piece of what was known as thunderstone and from this cavity a narrow and shallow channel was cut in the surface of the stone about 2 in. in length, the melted pewter was allowed to run along this channel into the scooped-out hole until the latter was full. The quality of the pewter was judged when cold by the appearance and colour of this sample. This method required a practised eye. Another method, and one commonly practised by the pewterers, was to touch the pewter to be assayed with a hot soldering bit; the quality was estimated by the appearance of the streak left by the hot bit.

A collector of pewter will have to learn betimes the difference between pewter and Britannia metal, or he will be paying pewter prices for its rival and substitute. It will be best for him to boldly ask for a piece of Britannia metal, take it home and after cleaning it properly test it by rubbing it on clean white paper, not once but several times, and note the resulting marks or smears comparing them with the marks made by a piece of genuine pewter either genuine antique or genuine new. Both can be got with a little trouble and the tests will teach the collector a lot of useful knowledge.

Next he may try the so-called knife test. To do this it is just as well to get a strip of ordinary commercial sheet lead, a piece of sheet pewter of known quality, and a piece of Britannia metal. Then with the knife—a broken blade is quite useful for this—draw it slowly and steadily along the metals in order, lead I, pewter 2, Britannia metal 3.

It will be noticed that in the lead the knife sinks deepest and with the least trouble. Less so in the pewter and still less so in the Britannia metal. If the furrow that is made in each case be examined with a lens the difference in each will be easily apparent and a similar furrow recognized on the occasion of any future tests.

Anyone skilled in metallurgy will be thirsting to assay his and his friend's pewter, but this is expert's work and should be paid for according to results.

according to results.

It is no use for a tyro to begin a series of tests with strange alloys of which he knows nothing.

Another test which may be applied to pewter is to bend it backwards and forwards holding it close to the ear, listening the while for the characteristic noise made by the metal—the French call it cri de l'étain—while being bent. It is not an infallible test because the addition of a very small percentage of zinc to the alloy will stifle the cry for ever.

Another thing to be remembered is that it is not good for pewter to be bent backwards and forwards indefinitely. It is bound to break at the bend eventually.

In repairing pewter it is advisable to examine the piece, and see whether it has come unsoldered or whether it is broken. Many pots and tankards, especially those with bulbous lower halves, are made in two pieces, and a careful examination will show the line of juncture. If this line has received a hard blow there will in all probability be a cracked joint, and this—after scraping the edges clean—may be resoldered.

If a handle—from rough usage—has come away from the body of the pot or tankard it must be cleaned, bent back and resoldered.

If a portion of a vessel be absent, or has been destroyed by negligence or carelessness the missing portion may be restored either by casting a piece of the required size in a plaster of Paris mould and soldering it when fitted to its place or by fusing pewter, not solder, in the place where the gap is, bit by bit, till the gap is rather more than filled. The surplus metal may then be removed by filing and scraping.

When pewter of approximately the same quality is used for the

repair there is no trace of any join whatever.

When a mercurial solder is used the line is faintly visible and the solder will tarnish slightly more quickly than the adjoining pure metal. This solder is not recommended as its usage will interfere with the free flowing of a better metal on a subsequent repair.

Common lead solder will also show up as darker in colour and

tarnishes very quickly.

VIII

The Ornamentation and Decoration of Pewter

The nature of the metal is not such as greatly to encourage the worker in repoussé or the engraver. Easy as it is to cut and to work this type of decoration it wears away quickly if too lightly done, and any elaborate design soon becomes illegible. Deep-cut lines help to weaken the work, and in view of this, linework proper has generally not been practised by English pewterers. Broken or wavy linework has frequently been done by holding a flat tool, such as a bradawl or small screwdriver, at an angle of 50° or so, and by forcing it forwards in the direction required by the design with a regular rocking motion. It is easier to do than to describe, as anyone interested may see by experimenting on a piece of sheet lead or pewter with a carving chisel, say one-eighth of an inch wide. The quality of the "wriggled" or "joggled" line thus made will vary with the speed and the regularity of the rocking, and with the width of the tool selected. Borders have been produced by the combination of different lines similarly worked.

Sometimes a running pattern is carried all over the object, and at first sight seems to be composed of dots, but on closer inspection the traces of the connecting lines will be seen, but less plainly than the deeper-cut dots.

"Wriggled" ornamentation devised by the above method was used to great effect on tankards during the last quarter of the seventeenth century. It is somewhat puzzling why birds should

have been so frequently included in the main design, and sometimes used as the central theme.

The vogue for decoration by this process seems to have reached the peak of popularity in the time of William III and Mary, during whose reigns many tankards were embellished with portraits of the Royal couple, in a roundel at the front, in most cases supported by naïve representations of tulips, artichokes or tudor roses (with a bird strategically placed somewhere in the overall pattern).

The fashion of decorating in "wriggled" work evidently started in the reign of Charles II, although that sovereign is seldom depicted; James II, however, is portrayed on one fine tankard (now in an American collection).

Plates and dishes, too, received this treatment, and examples dating from c. 1670 may be found. The heyday was around the 1730s, when quite a number of pairs, made by one James Hitchman, all between 8 in. and 9 in. diameter, were embellished with intriguing patterns incorporating birds, tulips, etc., and often two sets of initials; these plates, no doubt, intended as wedding or betrothal gifts to the happy couple whose initials appear thereon. There is some evidence that the "wriggling" was not done by the pewterer himself, but by artists who worked for the trade, for one can occasionally find two or three plates by different makers obviously decorated by the same hand.

Many objects in pewter, in addition to, or in substitution for, the "wriggled" ornament, are decorated with patterns impressed by means of punches. The plates—judging from the backs—have been held on an anvil while the blows were given to the punches, and the resulting inequalities on the backs removed by scraping or by filing. The effect of the combination of the two styles of ornamentation is not always good. Handwork and machine-work, by such close juxtaposition, are too prominently pitted one against the other, and neither is so effective when combined.

As samples of engraved and chased work applied to pewter, the screen of twenty-four pewter plates and dishes in the President's Court at South Kensington may be cited. They are small in size, the engraving (some of it is of unpleasant subjects) is overdone, and overcrowding is the result.

Mouldings in the best pewter-work are very much kept down,

and where they are added for strengthening the rim of a dish or other article are usually underneath the rim. In the Briot and Enderlein type of salver the mouldings are very massive, but not out of proportion to the size and weight of the articles to which they are applied.

In many plates and dishes the simple lines of the circle or oval are broken, and the dish takes a cinquefoil shape often with an elaborate

edge.

Pewter as a rule looks best when quite simple and unadorned, and it is only in rare cases that it has been successfully combined with other metals or materials. A small tankard in the Rijks Museum at Amsterdam has its more prominent mouldings and features in brass. The latter is not allowed to predominate at all, but is carefully subdued, and thereby the pewter vessel, which is in itself delicate in form and workmanship, is enriched. Had the brass been overdone or allowed to overpower the rest, the effect in so small a vessel would have been crude and disastrous. Copper similarly handled would have looked well. There is another similar specimen in the Victoria and Albert Museum, but the effect is lost, as the brass has become quite black.

A far more modern adaption of brass to pewter will be found in the Victorian measures made to the Imperial standard. Many of these had a brass rim applied to the brim; the reason being that, when such a measure was used to scoop up cereals, or other "dry" goods, the brass would protect the pewter edge from damage.

Pewter pierced work applied to wooden vessels never looks quite right. There is no strength in it, and when the wood swells or starts, the pewter cracks, and the days of the vessel are as a rule numbered. Specimens of such work exist, and are included in the generic term *Pechkrüge* the name derived from the coating of pitch applied to the

inside to render them watertight.

Perhaps the height of absurdity is reached in a small tankard in the Victoria and Albert Museum, the body of which is made of serpentine rudely wrought, and mounted in pewter far too slender in section for the weight it had to support and the consequent strain.

A common pewter tankard, tea caddy or snuffbox with shallow scooped cuts in it can look very ornamental; this type of decoration is called "bright cut", and examples exist where the pewter object has been covered with a semi-transparent blue lacquer and the cuts made later, so that they show up in bright metal.

Good pewter will stand good engraving, not the *pointillé* work, nor the wriggled ornament, but regular burin work. There are some excellent examples in most collections, of ordinary plates, with armorial bearings well engraved on the rim.

Nothing, too, looks more decorative than the simple direct lettering on some of the Corporation *hanaps*, whether on the body of the vessel or on a shield on the lid.

Italics do not look so well as the upright capitals, but it is mainly a question of the way in which the engraver does his work, as good simple lettering well done is always decorative. As instances of this the Corporation cups in the Cluny Museum may be compared with the tankards in the Museum at South Kensington. Script well done is unusual on pewter.

The miserable style of engraving on late beer-tankards was probably brought into use by the engraving being required to be on the base, where there was not enough room for the proper use of the graver. When the style was set it was used indiscriminately, even on surfaces where the graver could be used in the ordinary way. This style of engraving consists in detached upright strokes, little or no attempt being made to complete the curves in the loops of any letters.

A shield or a coat of arms held up by a figure on the lid is often added to the lid of a large flagon, especially on a German Guild flagon, and an inscription usually gives a clue to the original owners of the pot, and in this way to its date.

In salvers a boss is usually the centre of the ornamentation, as in the Briot and Enderlein specimens, and in the works copied from them. Occasionally the boss is of another metal enriched with a plaque of enamel, with a happy effect.

A large rose-water dish with a raised boss 2½ in. in diameter, bearing the arms of C. R. (Charles I) on a brass medallion, enamelled in colours, one of a pair belonging to a City church, is to be seen at the Guildhall Museum.

In England the use of gilding on pewter was forbidden, but on the continent gilding was allowed, but was restricted to church plate, chiefly chalices; but in the reign of Louis XIV this restriction was relaxed in favour of pewter in ordinary domestic use.

Another absurdity sometimes committed was the painting and lacquering of domestic pewter. There is a cruet-stand at South Kensington enamelled or painted white and picked out with gold. The effect, combined with that of the gilt incised work on the cruets, is not happy. In the Museum at Nuremberg is a crucifix made of wood overlaid with pewter. The latter has been mercurially gilt.

Silvering has also been applied to pewter and Britannia metal in modern times, though manufacturers do not recommend the practice. A flagon at Higham Ferrers, which has been restored, is thickly plated with silver. Some of the existing alms-dishes of pewter have also been treated in the same way.

As stated, the painting and gilding of tin or pewter was in England always very stringently forbidden. Mr. Welch (ii. 80) mentions "some smallest paynted beakers and salts" which were confiscated at a search made in 1622.

It had been allowed, however (in 1564), to decorate in this manner objects if made for presents, provided that the objects were small, and that it could be proved that they had been given away. Mr. Welch (i. 248) mentions formal warning given to Richard Harrison and Robert Somers for this offence. When Louis XIV confiscated the plate of his subjects, the latter had to choose between pewter and faïence. If the choice fell upon pewter the users of it were allowed to paint and gild it, a concession which hitherto had been reserved to pewter for church use. This decorated pewter did not become very common, and few genuine specimens have come down to us. Henry de Béthune, Archbishop of Bordeaux in 1680, had various vases lacquered black and ornamented with gold. Fifty years later, in the inventory of goods at the Château of Rochefoucauld, mention is made of "a goblet of pewter, gilt".

Pewter was used to inlay furniture and domestic woodwork as early as the fifteenth century, in the same way that buhl-work was used at a later date, and that tin, nearly pure, was used to inlay papier-mâché work.

In the Musée Plantin at Antwerp is a magnificent cabinet in mahogany, all inlaid with pewter of good quality. The dark tone of the wood and the silvery colour of the metal make a fine contrast, and give a far finer effect than the black cabinet inlaid with brass in an adjoining room. There is another specimen in the Cluny Museum in Paris.

In recent years pewter has been used in the same way, but in a very tentative and not always successful manner. The colour of the metal—provided it did not tarnish—would be effective enough; but it shows very little in a light-coloured or stained wood. If protected from oxidation by lacquer, it is apt to look hard and uninteresting, and is very different in appearance from pewter regularly and carefully handled. It looks best if inlaid in a wood of light or medium tone and left unlacquered.

It would be better in pewter-inlay work to keep to a metal of the same composition as that used for the same purpose in the papier-mâché ware of the last century.

Professor Herkomer commissioned for his house at Bushey some doors in which pewter and copper were cleverly combined, the copper being inlaid in the pewter.

Pewter appliqué work was sometimes used to decorate small caskets and coffers. In the "Catalogue raisonné" of Monsieur Darcel, one of these coffers is described as follows: "Les côtés sont formés de trois frises; l'une de griffons, d'aigles éployées, de basilics, de lions passants, etc., dans des disques circulaires reliés par des barres horizontales, bordées de fleurons symétriques dessus et dessous, comprise entre deux frises de rinceaux, à feuilles d'érable. Une bande de cuivre rouge doré, à saillie, forme soubassement."

A form of "wrythen" decoration, cast in the mould, has been used with success, especially by Swiss and Austrian pewterers. The vertical is not so common as the diagonal fluting, but it is used with good effect, especially in cases where the fluting is only done to a portion, say one-third of the body.

There is not much to be said of the ornamentation applied to church plate of pewter. It was, when applied at all, kept particularly simple and restrained. The commonest devices used were the sacred monogram (frequently on the rim), the emblem of the Trinity, the Instruments of the Passion, or a Sacred Heart.

St. Margaret Pattens, to mention one of our City churches, has plain dishes, with, for ornament, an eight-pointed star radiant with

THE ORNAMENTATION AND DECORATION OF PEWTER 61

flames, containing in the centre I H S and a cross above it, with the three nails.

At St. Katharine Cree are some fine alms-dishes 18 in. in diameter, considered by Mr. Philip Norman to be some of the finest pewter dishes in existence. He dates them 1628–31, the date of the rebuilding of the church, and of the silver plate also in the church, and says: "There are three¹ pewter alms-dishes of remarkably fine workmanship, and no doubt all of the same date; they have bosses in their centres; on one are the royal arms and the initials C.R.; on another, a sword in saltire, crowned with a rose (this and the harp crowned), and the initials C.R.; on a third, the Prince of Wales' feathers and the initials C.P. All these embellishments are beautifully worked in enamel. There is a fourth pewter dish, identical in design, with a double rose in the centre, also enamelled, but this has been electroplated."

Of engraved worked the most delicately done is French, as the two specimens shown by Herr Demiani in *Edelzinn*.

Of inlaid work, perhaps the finest existing specimen is the flagon which was once in the possession of a Mr. Gurney, and which now belongs to Lord Swaythling. It was for some time a loan exhibit at South Kensington Museum.

Some Chinese and some Russian pewter is found with very clever inlaid work.

The various relief decorated panels of figure-subjects in salvers of the Briot and Enderlein type were, like other cast pewter-work, sometimes cast separately with a view to their use as decoration, either alone, or as insets in combination with furniture. Sometimes, as is clear from the plates in Erwin Hintze's book, the panels of a salver were simulated in the various sections of a tall flagon. A dish in the Louvre is built up of cast sections, some of them repeated, interspersed with plain pieces.

Arabesques, properly worked and well designed, are most effective decorations on pewter. Nothing can be more dignified and attractive than the work of the Nürnberg master, Nikolaus Horchheimer, perhaps the father of German pewter arabesques. There is no necessity for high relief; in fact the lower the relief,

¹ Only two seem to be in evidence today—one of which is in the custody of the Guildhall Museum in London.

the better the effect. Some very fine specimens are illustrated by Erwin Hintze in his *Nürnberger Zinn*. One good specimen is in the British Museum. It is the design that tells, for when once the mould was finished there was little need of further workmanship.

IX

Pewter in the Home

Pewter nowadays is not found in use in any ordinary household. It can be kept in a condition rivalling silver, but it is rarely so found. Occasionally a pewter tundish or funnel is found in use in a farm in the country; and in some country and even town kitchens there will be found the Britannia metal teapots that delighted our forebears of three generations ago—pots which still enjoy a reputation—some say quite undeserved—for making such excellent tea.

Pewter was, in the end of the thirteenth and the beginning of the fourteenth century, of sufficient importance to be specially men-

tioned in official documents.

In a pipe-roll of Edward I we read that leaden (more probably pewter) vessels were used for cooking the boiled meats for the feast given to celebrate the King's coronation. By 1290 this king had over three hundred pieces of pewter plate in his possession, the pieces consisting of dishes, platters and salts.

In the fourteenth century pewter was used more in the houses of families of rank than those of lesser degree, and it was usual even in large houses to hire pewter services for special occasions, such as

Christmas festivities.

In France, in 1380 Michelet le Breton supplied to Charles VI 6 dozen dishes and 12 dozen porringers, weighing 474½ marks.

In 1390 the households of high dignitaries, such as the Archbishops of Rheims and Rouen, were thoroughly equipped with pewter.

It seems from Jean de Jeaudun that the French pewter had more style about it than that made in England. Mention of everything that could be made in pewter is found in inventories of the time, viz. porringers, flagons, cans, cups and tankards (with or without covers), plates, dishes and alms-dishes, cruets, decanters and candlesticks.

Isabelle of Bavaria in 1401 bought from Jehan de Montrousti for her kitchen 9 dozen dishes and 23 dozen porringers, weighing 782 marks.

Charles VII in 1422 bought from Jehan Goupil of Tours 64 dishes and 158 porringers.

The various City Companies¹ had services of pewter, and it was in general use, in the Inns of Court, in the fifteenth and sixteenth centuries, and, according to Hazlitt, up to a recent date.

At the Universities of Oxford and Cambridge the colleges had their garnishes of pewter, but with few exceptions there is little now remaining. Queen's College, Oxford, has perhaps the best specimens.²

Pewterware began to come into more general use by the gentry in the fifteenth century, but it was in price at first beyond the reach of the humbler classes. Gradually, however, it began to supersede the domestic utensils of wood. Harrison, in his "Description of England", wrote: "The third thing they tell of is the exchange of vessells, as of treene [i.e. wood] platters into pewter, and wooden spoons into silver or tin. For so common were all sorts of treene stuffe in olde time, that a man should hardly find foure pieces of pewter (of which one was peradventure a salt) in a good farmer's house." "Old time" is sufficiently vague an expression, but as Harrison wrote shortly before 1587 it is easy to understand what he meant.

In the Reading Museum there are some wooden dishes (one square, two round) exhibited side by side with the pewter by which they were superseded.³

¹ Cp. the records of the Goldsmiths' Company, 1470: "For a garnish of 2 dozen pewter vessels to serve the company, £1 17s. 6d." (Herbert.)

² Queen's College, Oxford, has seventy-two specimens, mostly made by and bearing the marks of Samuel Ellis. Some of it bears the marks of other makers, such as A. Cleeve, Rd. Norfolk, Thos. Chamberlain.

³ This comment made by W. Massé, but there seems to be no trace of them today. R.F.M.

One of the rules at Clifford's Inn was to the effect that each member was to pay thirteen pence for vessels of pewter, and was bound to have in the kitchen "two plates and dishes of pewter each day for his own use". Some of the Staple Inn pewter is now in the Guildhall Museum, and further specimens are in possession of the Pewterers' Company.

The following four instances of the mention of pewter are of

interest:

In the will of John Ely (1427), vicar in Ripon Minster, mention is made of "di. dus. garnes de vessell de pewdre cum ij chargiours", or the half of a garnish, i.e. of a set of twelve of each.

In the inventory of John Danby of Alveston (1444) mention is

made of "ix pece led and pewd[er] vessall ij.s. iiijd."

By the will of Elizabeth, Lady Uvedale (1487), a bequest is made of "a hoole garnish of peautre vessel, two round basin of peautre".

There were in the inventory of the College of Auckland (1498) "xx pewder platters, xij pewder dishes, viii salters, ii payre of potclyppes, j garnishe of vessell, j shaving basyn".

At the time of the Dissolution of the Monasteries very little pewter was confiscated. In an inventory of the goods of the Cell of Stanlowe (1537) there is mention of "iij counterfettes otherwise called podingers of pewter, whearof on [e] olde"; and in the kitchen were "vij pewther dyshes" (*Reliquary*, vii., 1893, p. 30). At Whalley Abbey there were "iiij garnisste of pewter vessell".

Harrison, who has been quoted before, wrote at the end of the sixteenth century (1577-87) that "Such furniture of household of this mettall, as we commonly call by the name of vessell, is sold usually be the garnish which doth conteine 12 platters, 12 dishes, 12 saucers, and those are either of silver fashion or else with brode or narrow brims, and bought by the pound, which is now valued at sevenpence, or peradventure at eightpence".

When more was required than the limited garnish, additional plate could be hired, called "feast-vessels", and the letting out of such was a source of much profit to the lenders. The pewterers clubbed together and shared the profits if more was required than was in one man's available stock.

The hiring out of new pewterware was forbidden, though no

doubt the rule was, like the other regulations of the Pewterers' Company, often broken.

From the Northumberland Household Book we learn that the price of hiring was fourpence for each dozen articles per annum. For buying pewter the same book contains: "Item, to be payd... for the bying of vj dossen nugh pewter vessels for servying of my house for oone hole yere after vj shillings the dossen."

In the same book (1500) is a note that pewter vessels were too costly to be common.

From the *Ménagier de Paris*, the requisite service of pewter for a dinner of state was 6 dozen écuelles, i.e. porringers, the same of small plates, 2½ dozen large dishes, 8 quart and 12 pint tankards, and 2 dishes for the scraps for the poor.

In the reign of Henry VIII the following was one of the regulations of the royal household (Cap. 20):

"Officers of the squillery to see that all the vessels, as well silver as pewter, be kept and saved from stealing."

This shows that pewter held an honourable position in the furniture of a house, and bears out the note quoted above, that pewter was too valuable to be common.

Harrison (1577–87) wrote: "Likewise in the houses of knights, gentlemen, merchantmen and some other wealthy citizens, it is not geson² to behold generallie their great provision of tapestrie, Turkie work, pewter, brass, and fine linen and thereto costlie cupboards of plate, worth five or six hundred or a thousand pounds to be deemed by estimation."

In the later sixteenth and early seventeenth century pewter may be said to have begun to be commonly used by the people as well as in many households of quality, as the inventories clearly show.

To this period of display pewter must be attributed the appearance of the highly decorated work, beginning with that of Briot (1550) and followed by that of Enderlein, and later by the florid work of the Nürnberg workers (1600–1660). The wares of the ewer and basin type may have been designed for use on ceremonial occasions, but the smaller elaborate plates, such as the Kaiserteller and the plates with religious subjects, though sometimes called and

¹ i.e. scullery, from the O.F. escuelles, i.e. écuelles.

² Uncommon.

possibly used as patens, were no doubt intended to be used as decorative adjuncts to the house.

In the sixteenth century in France, according to the *Ménagier ed Paris*, the *bourgeois* class made brave displays of pewterware on their sideboards and dressers, in imitation of the similar displays of gold and silver made by the upper classes. The *bourgeois* consoled themselves by calling their pewter "à façon d'argent", a consolation for which, no doubt, they had to pay the pewterers.

Matthew Parker, Archbishop of Canterbury in 1575, had 370 lb. of pewter in the kitchen in jugs, basins, porringers, sauce-boats, pots and candlesticks; also pewter measures in the wine-cellars, together with salt-cellars. He had more, too, in his house at Addiscombe.

Lord Northampton's kitchen alone had about 3 cwt. of pewter vessels, and his house may be taken as a typical example of the larger establishments of that time. In households of this size there were yeomen of the ewerie whose business it was to look after the pewter.

In the inventory of Sir Wm. Fairfax's house at Gilling in 1594 (given in *Archæologia*, vol. xlviii.), there were in the "wine-seller one quart pewter pott: in the pantrye 2 basins and ewers of pewter valued at xiijs iiijd and ij pewter voyders trays—valued at xs. In the kytchine xij sawcers, xij dishes, xij great dishes, xij great platters, xij lesser platters, iiij chargers, sawcers xij, dishes xij." Of new vessels there were "xij sawcers, sij sallite dishes, ij dozin great dishes, xviij great platters, xviij lesser platters, and i charger of the greatest sorte. Valued altogether xiiijli. vis. viiid."

In an inventory of Sir Thomas Hoskyns, Kt., of Oxted, in 1615

In an inventory of Sir Thomas Hoskyns, Kt., of Oxted, in 1615, there were in the kitchen "8 dozen of pewter dishes of all sortes, five dozen of sawcers, thirteene candlestickes of pewter, fower pewter flagons".

From a "trew inventory taken in 1618 of the goods and chattles of Sir Richard Poullett, late of Herryott in the Co of Southampton, Knight, deceased", were: "in the pantry and seller 9 pewter candlesticks: in the wine seller a still of pewter with a brasen bottome: in the kytchin and the kytchin entry—one pewter flaggon pott, nyne pewter candlesticks, 14 small sallet pewter dishes". Then follows a list of "Boylemeat dishes, deep platters, large platters, washing bason, pye plates, small do, small saucers and 7 old counterfett dishes, 14 old sawcers, and 18 pieces of severall sortes of old pewter."

At Walton the inventory (dated 1624) runs: "There should be of nyne severall sizes of pewther dishes which came from Newcastle, and have not your name on them, 6 dishes of each size, which in all is 54 dishes"—but of these it states 9 are missing.

"There came with the dishes above 2 long dishes for Rabbittes which are both in place . . . likewise 12 saucers whereof . . . now wanting 8, also 2 chargers, 2 long pyplaites and a voyder which are all in place. All the above . . . are of the silver dishes fashion.

"Other silver fashioned dishes changed at Beverley at severall tymes by Ralph Hickes whereof now in place which are marked with your own and my Lady's name." Of these there ought to have been 12 and a rabbit dish, but 6 were missing. Of "other vessell in the kitchin chest which are now in place", of various sizes, "27 dishes, I charger, 4 pye plaites, one Cullender and one baking pan".

One more inventory of pewter and other ware is that taken at Chastleton House near Moreton-in-the-Marsh in 1632. It is interesting as showing the pewter equipment of a country mansion at that time.

"In the Gallery.

"Item, Pewter platters of divirse sortes, 8 doz and 10 platters, one larger boiler, five basons, two spout potts, seaven pie plates, three great flaggons, two quart potts, one pott costerne, one cullinder, one baie pott, one puddinge coffin, ix candlesticks, nine chamber potts weighinge 443 li."

This was valued then at £22 3s., or just one shilling per pound. The main portion of the Chastleton pewter is now (1921) on a dresser in the kitchen, extending the whole length of one wall. Much of the pewter is of a date subsequent to the making of the above inventory, as the names and stamps of Samuel Ellis (1748), Robert Nicholson (1725), A. Nicholson (?), Townend and Compton (1809), John Home (1771), W. Brayne (1705), clearly prove.

A smaller dresser with plates in better condition is in one of the passages upstairs, and some chargers are displayed in the embrasure of a window on the main staircase.

The pewter is not used, and that in the kitchen has assumed a venerable appearance, in keeping with the kitchen, which has never

¹ From Three Centuries in N. Oxfordshire.

been rewhitewashed since the house was built by Henry Jones in 1611

There is one curiously shaped dish in the kitchen equipment—perfectly straight on one side and oval on the other—like the tinned iron receptacles that are used when meat is roasted on a jack in front of the fire.

Pewter played an important part in the first colonial households in America, as it was the only available ware in many cases. The early settlers, no doubt, carrying this with them from their home country; in later years the moulds were imported, and good pewterware was made there, but the fashion lagged behind that of European makers, so one finds the anomaly of a tankard or a porringer of a type of, say, 1700, made some seventy five or one hundred years later than its style.

New England was the chief centre both of its manufacture and also of the distribution of English pewter. The use of whale oil necessitated the introduction of lamps of a form peculiar to the country.

In the century from 1680 to 1780 the use of pewter was steadily continued, but later, owing to the introduction of domestic pottery from our own Staffordshire works, and elsewhere abroad, began to decline.

A similar state of things prevailed in France, in spite of Louis XIV's appointment of a Royal Pewterer. The King could compel his nobles to give up to him most of their silver plate, but he could not compel them to go back to the use of pewter, even with the grant of special permission (previously restricted to church plate) to adorn it with lacquer and gold. With the middle classes it continued to be used.

Pewter, however, managed to keep its place in the kitchens of houses of the gentry, and in many houses of the middle class. In some of the larger domestic establishments it continued to be used regularly till the early 1900s.

Any inventories taken now of a middle-class house would, probably, contain no mention of pewter at all. It would occur in some old family houses which have not changed hands, and in which the pewter has been reverently laid aside, in some cases with the chinaware by which it was immediately superseded.

Plates and dishes with salvers and chargers of all sizes (and there were many, as may be seen from the list of the moulds of the London and the York pewterers) were made by the men known as sadwaremen. The term is of doubtful origin and meaning, but it is still in use among pewterers where they exist.

Sadware was cast in moulds and finished by the hammer on an anvil or swage. These moulds left the metal in a somewhat rough condition and the hand-finishing was essential. In quality the sadware was good, and to finish it the proper method was by scraping and burnishing. Sadware-men do not seem to have received very high wages, nor to have been held in very high estimation, and, like the humble spoonmakers, tried to do their work as easily as possible, e.g. by turning it on a lathe. This was forbidden in 1681 in very definite terms (Welch, ii. 155).

Sadware from its quality has survived ordinary wear and tear

very well, almost down to our time.

Pewter lingered on longest in the taverns and inns, and in the London chop-houses till the latter were assailed by the introduction of coffee-palaces and tea-rooms.

Pewter platters were in use fifty years ago at the Bay Tree Tavern in St. Swithin's Lane.¹ They were about nine or perhaps ten inches in diameter, and had been well used in their time, as the knife-marks on the upper surface clearly showed. With the rebuilding of the tavern and its conversion into a restaurant these platters would seem to have disappeared.

About the same date some of the many chop-houses in Eastcheap had displays of pewter plate, but they were not then in common use.

Salvers with feet are not unknown. An unusual specimen with three long feet is preserved in the church of Erchfont-with-Stert (Wilts) and a further example will be found illustrated herein. Salvers of this kind have survived in the form of hot-water well-dishes, which were made mainly in Britannia metal and often with china plates inserted.

In these days, when portability and lightness are regarded as so essential, it requires an effort to think of pewter plates having ever been chosen for an officer's camp equipment. However, they were so

¹ The editor has himself eaten off pewter plates at the Old Cheshire Cheese, a tavern in Fleet Street, London, within the past twenty years.

used, and there are many specimens in existence which are said to have been used by Lord Marcus Hill through the Peninsular campaigns.

Small bowls or porringers are very common objects in museums and collections. As a rule they are simple in section, strongly made,

with ears or handles of shaped and perforated work.

Such bowls in various sizes were in common use in England. In the Museum at South Kensington there is a pair of large size, quite plainly finished, but one has graduations engraved in the inside showing that it was a barber-surgeon's bleeding-dish.

These porringers date from very early times. From the Old

French name of escuelles our word scullery is derived.

Harrison, quoted before, writes: "Of porringers, pots, and other like I speake not, albeit that in the making of all these things there is such exquisite diligence used, I meane for the mixture of the mettall and true making of this commoditie (by reason of sharpe laws provided in that behalfe) as the like is not to be found in any other trade."

The eared cups or porringers have often lost their ears or handles owing to defective construction. A projecting handle of such thin metal was bound to get bent, and by being bent back into position was bound to crack. They survived best when cast thick, or in some cases when strengthened with a circular ring, soldered on to the body of the cup and on to the handle.

Blood-porringers, cupping-dishes, or bleeding-dishes were still made in pewter at a quite late date, and the ear or handle is more or less traditional in pattern. It was, however, often found necessary to strengthen the ear by thickening it, and to give a little solid metal at the point of juncture with the bowl.

Scottish "quaighs" are similar in general character to porringers, but the ears or handles (there are always two) are shaped, and not pierced with one pattern.

pierced with any pattern.

Some eighteenth-century vegetable dishes with similar handles seem to be the latest development of these very convenient vessels.

It is to be noted that the number of spoons which have come down to the present time in good condition is comparatively large. This is partly due to the fact that the early spoons had been made, or at any rate finished, by hammering. Although hardened by the

hammering, the pressures put upon it during use and the number of breakages must have been enormous, but because of their small size, a considerable quantity have survived after having been buried for several hundred years.

Spoons were, from the necessity of living, invented earlier than

forks, which are comparatively late-comers.

Wooden spoons were no doubt the first to be made and were contemporary almost with those made of horn. Neither material is ideal. Wood retains a suspicion of the viands or fluids for which it has been used, and horn when heated unduly, either in use or when being cleaned—cracks easily, loses its shape and so deteriorates very quickly. Horn was replaced by *laiton* (brass), and the forms of the latten spoons were at an early date copied by the spoonmakers. These latten spoons were introduced by traders from abroad and very early specimens are extremely rare.

By the end of the fourteenth century the various types of spoons were beginning to come into use, and in the fifteenth century we find spoons with knops shaped to represent acorns, diamond points, or lozenge points, images of the Blessed Virgin Mary called Maidenheads, heads of women wearing horned head-dresses, figures representing the Apostles, hexagonal knops, lions, writhen balls,

baluster-tops, seal-tops and strawberry-tops.

All these were elaborate and were sometimes but rarely gilded or lacquered.

In the next century a cheaper and simpler spoon came into use. There was no ornamental knop or top, but the stem was sliced off at an acute angle. From this kind of cutting or "slipping" (gardeners use the same word today) the spoons are known as slipped tops, or slipped in the stalk. The stalk was irregularly hexagonal as a rule and later tended to become a square and sometimes an oblong in section.

The next development gives us the Puritan spoon. In these the ornamental hexagonal, being considered frivolous, gives way to an

uncompromising square.

The next stage was the flattening out of the square end so as to balance the bowl, and in so doing the chance splitting of the hammered end fixed the pattern and the name given to it was the split end or *pied de biche* or deersfoot.

With this type of spoon the strengthening band, or tongue, or rat's-tail has its genesis, and it prevailed up to 1720 or thereabouts.

The *pied de biche* end was followed by the shield end or wavy end spoons, and the wavy end finally gave way to the simple round end.

Mr. Welch noted cases of men finishing their spoons improperly, i.e. by grating them and burnishing instead of beating them. This was a saving of time, no doubt, but it left the spoons softer than they should have been. In 1686 a maker, Burton by name, was found fault with for using an "engine", presumably a press of some kind for making spoons. Fortunately for him his spoons were well finished, and he undertook not to sell them in the country under six shillings, and in town for four shillings, a gross, so that no injury might be done to the other spoonmakers.

Punch ladles have survived in fairly good condition—they are later in date than the ordinary spoon, and are of fairly hard metal. Frequently, where oval in shape and deep in the cup, they are stronger than the circular type. The handles are usually slender specimens of turned wood.

Pewter toys date back to Roman times, and have been dug up at various places in England and on the Continent. They may have been the actual toys which gladdened the hearts of their actual possessors during life, but from the way they are made they seem, like the chalices buried with deceased ecclesiastics, to have been intentionally counterfeit representations of the real toys used by the youthful deceased during life.

Though hardly toys, it may be as well to mention here that buttons and brooches, some unmistakably Roman, and some others of Anglo-Saxon origin have also been found in excavations.

Tin soldiers would seem to have been used for children's playthings quite as early as Queen Elizabeth's time, for one Anthony Taylor was heavily fined for making "manekins" "10 grains worse than fine".

In the seventeenth century tin and pewter toys were quite common in Germany and the Netherlands, and specimens are to be seen in the Nürnberg Museum and in the Nürnberg dolls' house at South Kensington. This dolls' house is well worth careful study. In France the *bimbelotier*, or toymaker, was a recognized worker in tin or pewter, and his trade was large.

A pewterer in 1668, Francis Lea, was fined ten shillings for "his Toy Pestell and Morter, and other toyes at 5 grains", i.e. not quite up to the high standard of quality required by the Pewterers' Company. As a rule the toys seem to have been diminutive copies of the full-sized articles in everyday use in the household. Dolls'-house furniture constituted a distinct branch in the trade.

In Victorian times a common toy for boys was a pewter squirt; another, perhaps not quite so generally known, was a circular disc with a serrated edge strung on a string that passed through two points in a diameter and had its ends tied. By means of the two loops it was rotated quickly backwards and forwards, to the accompaniment of a siren-like noise which varied according to the speed of the rotation, and the size and method of setting of the teeth; in later years these were made of tinned sheet metal.

Fenders for dolls' houses, tiny mirror-frames and étagères, were objects to please the smaller hearts of the gentler sex, but their attractions paled before those of a tea-set complete on its

tray.

Candlesticks and candelabra for dolls, both based on earlier patterns and pleasing in themselves, were also commonly made. But most, if not all, the dolls' pewter lacks the grace of the old pewter toys for this reason, that the old toys were diminutive copies of the articles in everyday use. Modern toys are for the most part "creations" of the artist.

Tea-cups and saucers, or tea-things, as they are more often called, have long since ceased to be made in pewter, but the traditional shape on a much smaller scale has lingered on in the tiny sets sold for dolls'-house use or ornament. These diminutive sets were cleverly made, and were rarely worked upon after leaving the mould, for the low price precluded any such outlay of labour.

In style they are far superior to nearly all the silver and other metal teapots produced commercially, and make attractive objects for a collection in these days when the more conventional pewter-

ware is so highly priced.

Drinking vessels fall into two main classes—those without and those with handles—and the variety of shape in either class is almost endless.

It was no doubt recognized at an early date that the branch of the

trade which dealt with drinking vessels was important, and worth while fostering.

In 1423 a regulation was made by Robert Chichely, Mayor, "that retailers of ale should sell the same in their houses in pots of 'peutre' sealed and open, and that whoever carried ale to the buyer should hold the pot in one hand and a cup in the other; and that all who had pots unsealed should be fined".1

This extract is interesting from the use of the word "sealed", which points to the stamping of a mark to signify that the capacity had been verified. On early English pots this was sometimes of "hR" crowned, indicating that the capacity conformed to a standard set by Henry VII; in later years a crowned "WR" confirmed the measure to conform to the William III standard. A crowned "AR" (for indicating the Queen Anne changes) is sometimes found, but far less frequently. It was not until 1879 that a uniform type of capacity "seal" was used by Weights and Measures authorities throughout the country—this is the simple crown beneath which will be found the letters "VR" (or "ER" or "GR") and a numeral, or set of numerals, indicating, first the reign, and secondly the town or district. The latter type of mark is found on most of the tavern pots available today.

Drinking cups of the beaker form were probably derived originally from the earlier cups of horn, which were used contemporaneously with those of wood. The outward curves of the lip and of the foot were common-sense as well as decorative additions, as the curves gave an additional element of strength where it was most required.

Pewter pots from a very early date seem to have formed part of the equipment of a cabaret in France, or a tavern in England. They must have been regarded as an improvement upon vessels made of copper, wood, or rough earthenware. That they were found convenient as weapons of offence or defence appears from a case quoted by Bapst, where one Jean Lebeuf in 1396 was charged with hitting his boon companion with a pewter wine measure. The practice has undoubtedly been continued since that time.

Our English taverns had their pewter pots and tankards from a very early date, and the manufacture was certainly profitable—in

¹ Herbert, History of the Livery Companies.

fact, so profitable that when, at the end of the seventeenth century, glass and earthenware began to be used to some extent the Pewterers' Company were anxious (at the request of the Potmakers) to procure an Act of Parliament to make it obligatory to sell beer, wine and spirits on draught in pewter measures, sealed. It was suggested, not altogether from disinterested motives, that the earthenware and other drinking vessels were not good measure. This argument was very ingenious, but it was not successful. It savoured too much of the monopoly system.

Harrison, in his Description of England, wrote: "As for drinke, it is usuallie filled in pots, gobblets, jugs, bols of silver in noblemens houses, also in fine Venice glasses of all formes, and for want of these, elsewhere, in pots of earth of sundrie colours and moulds, whereof manie are garnished with silver, or at the leastwise in pewter."

The "fine Venice glasses of all formes" do not here concern us, nor do the "bols of silver", but the "pots, gobblets, jugs and bols" were made in Harrison's time of pewter. What Harrison quaintly terms "pots of earth of sundrie colours and moulds, whereof manie are garnished with silver, or at the leastwise in pewter", formed in the fourteenth and subsequent centuries a large and important branch of the pewterers' trade.

The pot-lids formed a branch of the London pewterers' craft, and they worked under very special regulations. In 1552 "yt was agreed that all those that lyd stone pottes should set their own marck on the in syde of the lyd, and to bring in all such stone potts in to the hall wherby they may be vewed yf they be workmanly wrought, and so be markyd wt the marck of the hall on the owt syde of the Lyd. Also every one that makyth each stone pottes shall make a new marck, such one as the Mr and Wardens shalbe pleased wtall whereby they maye be known from this daye forward. Theise potts to be brought in wekly upon the Satterdaye and if the Satterdaye be holly daye then to bring them in upon the ffrydaye. And loke who doth the contrary shall forfayte for every stone pott so duely proved iiij^d in mony over and besydes the forfayte of all such pottes as be not brought in according to this artycle" (Welch, i. 174).

In 1548 they were ordered to be stamped with a fleur-de-lys

(Welch, i. 157).

Four years later the Company appointed one Harry Tompson to

have the "vewe and marking of all stone pottes and he should mark none but those that be substancyally wrought" (Welch, i. 190). 1 He was removed from his office in 1550.

The cost of making the lids was fixed in 1581 at two shillings a dozen, unless the customer were a brother of the Company (Welch, i. 289).

Another version of this in the Jury Book says the mark was to be on the outside. This may be so, for in 1559 it was settled that if a lid were badly made the potte was to be broken as well as the lid, and "that from hensforth the makers of stone pott lyddes shall set theire marcke on the inside of the Lyddes" (Welch, i. 202).

There is as great variety in the shape of the body of tankards as in their names, the fashion of the purchase or thumb-piece, the shape

of the lid and the curve of the handle.

Mr. Welch (ii. 61, 62), under the date 1612-13, about twentyfive years after Harrison's time, mentions in a list of pewter wares and their specified weights: "Great beakers, wrought or plaine middle and small beakers, as well as childrens beakers, also wrought or plaine, greate and smale beere bowles, with large wrought cuppes. There were also middle and smale French Cupps, with high wyne cupps, wrought and plaine and the cutt shorte, plaine and wrought." As to jugs and pots for holding the beer there were (p. 62) "'spowt potts' containing a potte, quart, pint and half pint of fluid. Ewres were known as Hawkesbills and Ravensbills, both greate and small, with very little difference in the weight between the sizes, with greate and smale French of the same weight. There were new fashion thurndells² and halfe thurnedells—new quarts, new great, smale and halfe potts, hooped thurndells, great hooped quarts, Winchester quarts and pints with or without lidds, long hooped Winchester pyntes and Jeayes danske potts." The list concludes (p. 64) "with greate middle and smale jugg potts not sized, and measures for aquavitae".

A weak point in many tankards and flagons has been the hinge of the lid. Some of the hinges are quite simple, consisting of three

The price of the marking was a farthing a dozen.
 These are sometimes called thirdendales or thriddendales. Sir W. H. St. John Hope says it is a Wiltshire word, meaning a pot to hold about three pints, hence the name. The editor has a theory, yet to be proven, that it denotes a measure of which three such equalled one gallon.

leaves; others have five. Friction, dust and frequent use have soon caused the hinges to work loose, and have been assisted by occasional falls, the evidence of which is generally clearly to be seen.

To remedy this weakness of the hinge, bone was tried as a substitute, as in the church flagon at Milton Lilburne. Brass or iron pins are sometimes found.

Flagons with feet are common enough in German museums, and there are specimens in the museum at South Kensington, but the practice was not adopted in this country. The feet seldom remained intact for very long, or became depressed into the base and eventually caused havoc to the vessel.

The German glass or pottery beer-tankard is often fitted with a pewter lid, but the weight of the lid is generally carried on an upright pewter pillar, which is clamped on the upper side of a C-shaped handle. The metal employed is rather bright-looking and garish, and is frequently over-elaborately worked, and with the glass or pottery vessel the colour effect is not satisfactory. The metal has the appearance of type metal rather than of ordinary pewter, and the nature of the composition may be influenced by the supposed necessity to have the ornament very sharply cut and clear in every detail.

In most western European countries pewter was largely used for measures either for dry goods or for liquids, and for use in scales where small goods were to be sold by weight, such as salt. Oil, wine, beer, were the fluids most commonly measured in the pewter measures, and the metal, from its capacity of withstanding rough usage, was found to be especially convenient. The ware was in common use for these purposes in the whole of France.

Pewter measures are to this day (1971) still used in France and the Low Countries.

A "Tappit-hen" is the name given to a Scottish measure; the form is quaint, but quite suitable for the metal from which the "hens" are made. In South Kensington Museum there is an early measure which suggests the tappit-hen.

Previous to the Union with England in 1707 the Scottish standard measures were:

¹ Tappit, i.e. with a top. It has been said that they took their name from a breed of domestic hens which had crested heads, but it is more likely that the name originated from the French "topynet".

4 Scottish gills = I mutchkin

2 mutchkins = I chopin (i.e. 1½ pints, English)

2 chopins = I pint (i.e. 3 pints, English)

Tappit-hens are to be found in two forms, i.e. those with plain domed covers, and those with "crested" (or knopped) covers.

The type without a crest is certainly earlier in date; the earliest known being of c. 1700. The same type was in use right up to the mid-nineteenth century. The range of sizes was greater and probably included a $\frac{1}{4}$ gill (a thimble full) and $\frac{1}{2}$ gill.

At a loan exhibition in Glasgow in 1909 there were on view:

I. ¾ gill

5. Small mutchkin (3 gills)

2. I gill

6. Mutchkin (4 gills)

1½ gill
 2 gill

7. Chopin8. Tappit-hen.

and 9 (a very rare size) holding 3 chopins or 4½ pints (Imperial)

All the above were with plain cover—a full range, which would include all the Scottish sizes and also the Imperial ½ gallon (and its diminutives) could run to fifteen or sixteen different sizes.

The "crested" type was made in three sizes only, i.e. the Scots pint, the chopin and the mutchkin.

Some of the larger "hens" were made with a cup fitting inside the top, with a slight rim, shaped to fit the sloping "collar". After 1826 some measures of tappit-hen form were produced without a cover—these are Imperial sizes only.

X

Church Pewter

Early chalices are known to have been made of horn, marble, glass, copper and lead. Horn was forbidden by Adrian II in 867, but it was used in France in the twelfth century; marble, earthenware and glass were found to be rather fragile; bronze and copper, unless tinted or gilded, and lead vessels were found to have an injurious effect upon the wine that was poured into them.

The three permissible metals, then, at first, were gold, silver and pewter, but the last was not supposed to be used unless for economic reasons. In later times pewter vessels seem to have been used as a general rule, and the more elaborate plate kept for festival use.

For the celebrant the usual type was the chalice with or without handles; for the use of the congregation, up to the end of the thirteenth century, large chalices with handles were used. From these the wine was sometimes taken by means of a tube permanently fixed on the side of the cup, or else taken in the usual way.

At the Council of Westminster held under the presidency of Richard, Archbishop of Canterbury, in 1175, it was ordered that "the Eucharist shall not be consecrated in any other than a chalice of gold or silver, and from this time forward we forbid any bishop to consecrate a pewter chalice".

Necessity, however, knows no law, and in spite of the Canon Law the English ecclesiastics had to put up with pewter communion plate after the bulk of the church plate had been collected and disposed of to make up the 100,000 marks required to ransom Richard Cœur de Lion in 1194.

In France pewter church plate was expressly permitted to be used by poor parishes by the Council of Nîmes in 1252, and by the Council of Albi held in 1254. As it was used in some dioceses in cases not necessarily on account of poverty, it must be assumed that the rule had its occasional local exceptions.

Sepulchral chalices of pewter, and others said to be made of pewter, though in many cases more probably of lead, have been dug up in many places during the progress of structural alterations, and restorations. Abbots and bishops were as a rule buried with a crosier, sometimes of gold; priests with a chalice and a paten. St. Birin, Bishop of Dorchester, who died in the seventh century, was buried with a crosier and a chalice of pewter, as was proved when the tomb was opened in 1224. Chalices have been found in graves at Chichester, Cheam in Surrey, in Gloucester and Lincoln Cathedrals, and in other places, quite frequently enough to show that the custom was common. They have been found too, at Troyes in tombs dating between 1188 and 1395, at Jumièges, at Geneva, date 1423, with paten and crosier. It is rare for chalices of a date much later than the middle of the fifteenth century to be found.

When the church at Nassington was under restoration in 1885 a grave was opened in the north aisle, near the third pillar. In this were found a pewter paten and chalice, both much damaged, and three palmers' shells or scallops, each of them pierced with two holes for affixing to the wearer's dress. The vessels were early in date, probably the middle of the thirteenth century. The paten was 4 in. in diameter, and had a single circular depression, the edge being rather broad. The chalice was 4 in. in diameter at the lip, and $4\frac{1}{2}$ in. high, with a shallow bell-shaped bowl, a slender cylindrical stem with a knop and a circular foot.

At Mont Saint-Michel in Normandy, when the tombs of Robert de Torigny and Martin Furmendeius were discovered and opened in 1885 by M. E. Corroyer, crosiers were found, and in each grave a round disc of pewter with inscriptions, showing the rank and names of the former occupiers of the graves. Robert de Torigny was abbot from 1154 to 1186, and Martin, his immediate successor, died in 1191.

These plaques are preserved in the muniment room at Mont

Saint-Michel. They may have been pectoral plaques, similar to the roughly made pectoral crosses, usually of the shape known as Maltese, which have been found in graves of the same date, i.e. the twelfth century. These seem to have been inscribed with a prayer of absolution (scratched on the metal with a stylus) and placed under the crossed hands of the deceased before burial.

The heart case of Richard Cœur de Lion was found at Rouen in 1838, and that of Charles V was found in 1862, and one has been found at Holbrook in Suffolk. All these seem to have been made of pewter.

Large pewter vessels, for conveying the sacramental wine in bulk from cellar to sacristy, and for water for the ceremonial washing of the celebrant, as well as of the sacred vessels after use, were common from the thirteenth century, at any rate on the Continent.

In the fourteenth century the use of burettes, or small pewter bottles for the sacramental wine and the water, is first mentioned. These are called *cruets* later on in England; and in France by many synonyms, such as pochon, pitalpha, vinateria, canette, chaînette, choppineaux, chaupineaux—the last-named suggesting our old word chapnet or chapnut, which was in use in English in 1612–13, as it was specified in the official list of the Pewterers' Company¹ as a vessel of which six were to weigh $1\frac{1}{2}$ lb., and in a smaller size six were to weigh 1 lb.

Pewter candlesticks were used in churches about the same time that the burettes came in fashion, but were apparently of small or moderate size. The larger kind and the hanging candelabra seem to have been of iron tinned or of brass or copper. An early mention of an English chandelier is in the inventory of Whalley Abbey in 1537.

Portable bénitiers were often made of pewter. In shape they resembled small pails, a convenient form for carriage round the church. Mention is made of one in 1328 in the private chapel of Clemence of Hungary; in the inventory of Jean de Halomesnil, 1380, a canon of the Sainte-Chapelle in Paris; in 1430 at Mons, in the chapel of the Hospital of St. Jaques; in 1438 in the inventory of Pierre Cardonnel, canon of Notre Dame at Paris.

It is difficult to say exactly at what time hanging stoups or wallbénitiers of pewter came into use. Those in the Cluny Museum are

¹ Welch, ii. p. 61.

much later than the fourteenth century; in fact those that have come down to our own time are as a rule seventeenth-century work or a little later. From the size they were undoubtedly meant for private domestic use, and in some cases they were richly painted and gilt. There is a plain one in good preservation in the museum at Ghent.

These bénitiers varied considerably, but they generally took one of two main forms, viz. the kind that was intended to stand upon a ledge, table or shelf, and the kind that was designed primarily to be hung upon a nail, but which as often as not had a container with a base, upon which it could safely be placed on a shelf if required. The shape of the container gave most scope for the designer's fancy. An inverted truncated cone was a very common shape.

The pentagon too was, from its solidity, a not uncommon shape. Many of the Flemish stoups have very elaborate crosses, with figures far inferior in execution to the rest of the work. Their containers are of a domestic rather than an ecclesiastical type, and in spite of the lids, or remains of lids, much resemble shaving-brush bowls. Some of the containers seem as though they were the halves of bowls of an ordinary type.

It is the exception to find one of these bénitiers in perfect condition. They have usually broken at the point where the cross is joined to the bowl, the reason being that the cross, when of any height, is disproportionate in weight, and has had a tendency to lean forward, and so in time has been broken.

Font ewers and font basins have been made of pewter, but actual fonts of pewter are rare. Professor Church found a pewter font at Cirencester of thirteenth-century design. It seems to be an open question whether it was intentionally or accidentally made of pewter, as there are many lead fonts in existence in this country. A lead font, of course, will last perfectly well if properly designed and made thick enough to stand usage. Thin lead or pewter that could be bent backwards and forwards would last but a very short time. A baptismal ewer made of pewter, and gilded, was scheduled by Mr. R. C. Hope at Ashwell, Rutland.

In 1643 many fonts were either utterly destroyed or summarily removed from our churches; substitutes were introduced in the form of pewter basins or bowls, and large ewers for the water before use. There is a pewter font basin at Wellington Church, Sussex. The church of St. Giles-in-the-Fields was provided with a pewter

font in 1644, and it was cut square on one side.

Altar crucifixes were sometimes made of tin, and the example in the museum at Nürnberg is a very fine specimen. Recognizing the soft nature of the metal, its maker mounted it on wood to protect it from injury. The cross was richly ornamented by gilding.

Other church vessels were the dishes or trays upon which the cruets or burettes were kept; ampullae of various forms for the storing of incense; ewers and basins; small boxes or chrismatories for the consecrated oil required for use in extreme unction.

Monstrances and pyxes were undoubtedly made in pewter in the sixteenth century. There is in the museum at Stonyhurst College a chalice, in the foot of which there is a pyx.

At the dissolution of the monasteries in 1537 very little pewter seems to have been confiscated, and what little there was seems to have been domestic rather than ecclesiastical in character.

At Whalley Abbey there were in the abbot's kitchen "iiij garnisste of pewter vessell, ij dosen of vessell", and in the convent kitchen "xxxi dishes, xxij doblers, and xxviij sawsers". These are not said to be pewter in so many words, but it is more than probable that they were. The same was the case at Stanlow and elsewhere.

After the Reformation, when Communion in both kinds became the rule, a change in the size of the cups was necessary, as well as in

the size of the flagons.

The 20th Canon of 1603–4 enacts as follows: "Wine we require to be brought to the Communion table in a clean and sweet standing pot or stoup of pewter—if not of purer metal." Previous to this date and this enactment, flagons were extremely scarce in churches, and it is probable that none of pewter were in use for the Communion before the last ten years or so of the sixteenth century.

There is a fine bulbous pewter flagon from an Oxfordshire church, which is believed to date from the last quarter of the sixteenth century, now in possession of the Worshipful Company of Pewterers.

The earliest known tall straight-bodied flagons, made in *silver*, were made in 1602. Some of these are still extant. There are two at New College, Oxford (1602). Brasenose has a pair dated six years later, and Salisbury Cathedral has a pair made in 1610.

These silver flagons, as was usually the case, set the fashion, and the shape was copied in pewter. At Strood, near Rochester, an inventory notes "the purchase from Robert Ewer in 1607 (for 9/6) two pewter pots to serve the wine at the Communion". These would undoubtedly have been of the type illustrated in plate 8b.

Invaluable work has been done by the compilers of the various

county histories of church plate, and to them inquirers as to existing

church plate in pewter must be referred.

Northamptonshire is especially rich in the variety of its pewter church plate, both flagons and dishes. The earliest dated example (1609) of a flagon is at Werrington. It is a tall flagon, 14 in. high, 6½ in. at the base, and 4¾ in. in diameter at the top, but it is without makers' marks of any kind. Many flagons were but II or II1 in. in height. That at Earl's Barton was especially noted in an inventory of 1647 as "a great flaggon pewter", and is 13 in. high.

There are in Northamptonshire many specimens of pewter basins

or bowls, probably used as lavabos for the celebrants to wash their hands at Holy Communion just before the consecration, a custom

which was still common in the seventeenth century.

In Dorsetshire the pewter church plate has in nearly all cases disappeared, and in the few places where it has survived it has almost invariably ceased to be used. In Nightingale's Church Plate of Dorset the earliest specimens mentioned are two flagons at Puddlelow, inscribed: "Ex dono Henrici Arnoldi, Ilsingtoniensis. 1641." These would, in all probability, have been of the type illustrated in plate 13a. At Iwerne Minster there is a dish dated 1691; at Allington a flagon of 1694; and at Winterborne St. Martin a flagon of 1698.

Of eighteenth-century pewter there are plates at Bradford Peverel, 1707 and 1713, at Wyke Regis, 1717; and of flagons a specimen inscribed "Shaston St Peters 1770".

Mr. Nightingale mentions that at Cerne Abbas in 1630 "item pd for a new pewter pott for wine for the Com' [Communion] x8." This is a high price for that date.

At Sturminster Marshall mention is made in the church-wardens' accounts: "1780. pd for A Bason to care [carry] to the vant [font]

£0 Is. 2d."

Much of the church pewter has been alienated from the churches, or, perhaps, converted to other uses, as the entry for Gatesbury shows: "In 1854 the old chalice and paten, with a very large flagon and an alms dish, all of pewter, were melted up and cast into a large ewer for Baptism." The same thing was done at Lalton in the same county.

In many cases it is to be feared that the parish clerks, or other so-called responsible persons, have parted with them for a consideration, or they have been stolen.

No one looking at the seventeenth-century pewter which has fortunately survived in some of our churches will fail to admire the stately grandeur of the average flagons, and the simplicity of the plates and dishes.

In some few cases the lids have, through wear and tear, cracked at the juncture of the lid and the hinge, and have been repaired by some over-zealous workman.

The flagons are of various types, and they might be classified either from the shape of the body of the flagons or from that of the handles.

There is the type represented by the flagon at Lockington (Leicestershire), dated 1612. It is an upright flagon, tapering upwards with a graceful curve from the foot, and capped with a simple moulded lid with a knob in the centre.

Another type is represented by the Lubenham flagon, also in Leicestershire, and dated 1635. In shape it is somewhat like the previously mentioned piece, but with some refinements.

Communion plate made of pewter is still in use in some places, either by itself, or as an adjunct to plate of either silver or silver-gilt. Express mention of such use is to be found in most of the histories of county ecclesiastical plate; but the more usual remark is to the effect that the pewter vessels are not now in use. Sometimes the note added is that, though disused, it is carefully preserved. This is as it should be, for the early seventeenth-century flagons and cups had a dignity of form that is quite lacking in those of later date.

The use of such plate was more common in poorly cultivated and sparsely populated districts, e.g. Friesland on the Continent, and the extreme northern parts of Britain. Much existed in the diocese of Carlisle and much more in Scotland. It is perhaps in Scotland that pewter lingers on still more than elsewhere in the service of the Church.

In one Scottish church (North Leith), besides the silver church plate, six pewter flagons are still used at the Communion Service. Of these four are small, and are inscribed: "North Kirk of Leith 1788." These were made by Gardner, Edinburgh, and bear his mark. They would have been of the type illustrated in plate 11a. Two others, rather larger, were made by R. W. (Robert Whyte), and are stamped with a thistle. A pewter paten was in use up to 1881. It was of Edinburgh make, dated 1762, maker W. H. The four small marks on it are a thistle, a rose, W. H. and a skull.

Mr. Ferguson, in his book on the church plate of the Carlisle diocese, quotes the Bishop of Carlisle as having said, "There is much of historic interest attaching to these pewter vessels, and they deserve a place in the treasury of the church to which they belong."

From this standpoint alone they are worthy of preservation, but more so from the artistic point of view. Most of them are superior in beauty of form to the productions of later times by which they have

unfortunately been superseded.

It is sad to read in the inventories of church plate that the simple old pewter alms-dishes have given place to so-called art-brass trays mechanically engraved, with no feeling in them, and frequently over-

loaded with sham jewels made of plain or coloured glass.

In Scotland Communion tokens, made under the superintendence of church members in a stamp or mould designed for that special purpose, were adopted, after the model of the lead tokens used as early as 1560 by the French Calvinists. Sometimes they were of lead, sometimes of brass, or tin, or pewter. Some were square, not more than an inch in width, sometimes round or hexagonal with a rim. They were quite plain, and were marked as a rule with the initial letter or letters of the parish.

In the seventeenth century they were made larger, the date and a monogram being added, and the custom grew up of recasting them in new patterns whenever there was a new minister. By the eighteenth century the minister's initials were regarded as more

important than those of the parish.

The tokens were issued by the incumbent a day or two before the Communion Service was to take place, and were officially collected before the service. Whenever a new set was required the old ones were collected and sent to the pewterer, who, from the accounts,

seems to have charged very little for the recasting and very little for the new metal. It is a curious fact that tickets of paper, or cards, were first used, and that modern feeling has now reverted to this description of token.

Communion plate has been made in Britannia metal, and a very early specimen made by Messrs. Dixon and Sons, is preserved in the Museum at York.

It is a pity that the seventeenth-century type of flagon was superseded by that of the nineteenth, for the modern flagon is painfully like a coffee-pot, both in the elaborate handle and in the knob on the lid; the spout too and the foot have been broadened, overdeveloped with heavy mouldings, and in this way the balance of the whole thing has been marred.

In the chalices the lower half is as a rule plain, but the bowl portion is too heavy, and not graceful in its curves.

The patens resemble the older plain plates, but are sometimes mounted on feet which are rather too high.

MISCELLANEOUS ARTICLES IN PEWTER

In the Middle Ages we know that badges, or tokens, of pewter, or sometimes of lead, were in great demand by pilgrims as souvenirs of their visit, and as proofs of their having made the actual pilgrimage. There are specimens extant of palmers' shells that have been buried with deceased pilgrims. A common device is a scallop-shell or a cockle-shell, in commemoration of S. James of Compostella, or in the latter case S. Michael.

Tokens commemorating Thomas à Becket, the martyr of Canterbury, bore the inscription CAPUT THOMAE. These were generally worn by pilgrims in the twelfth century, who, as Chaucer wrote,

Set their signys upon their hedes And some oppon theyr capp.

In the Guildhall Museum there are many of them of various sizes and shapes. In the same museum is a badge representing Edward Confessor, which was found at Westminster. There are also a reliquary in the form of Canterbury Cathedral; a badge to commemorate St. Hubert; and an effigy of Erasmus, who suffered martyrdom under Diocletian in A.D. 303. In the same museum is a stone mould for a twelfth-century religious badge, with the legend SIGNUM SANCTE CRUCIS DE WALTHAM. It is figured in vol. xxix of the *Journal of the B. A. Association*, page 421.

A mould for casting badges of a religious character (seventeenth century) is to be seen in the Cluny Museum. It is well carved in what looks like lithographic stone. The device consists of a heart-shaped frame of floral design, containing the initials I.H.S. and at the top a floriated cross.

Another specimen of these moulds for casting badges for pilgrims, or other signs, is to be seen in the National Museum of the Society

of Antiquaries at Edinburgh.

This custom of wearing badges prevailed, if it did not originate, in France. In the north S. Denis was the favourite saint until he was replaced by S. Michel, while the southern part of the country favoured S. Nicholas. There were, however, many local patron saints, pewter reproductions of whom were in great demand, e.g. S. Jean at Amiens.

Mont Saint-Michel was a most important centre for these badges, and the cockle-shells found on the sands there are supposed to have been the original type of the palmers' shells. This may or may not have been so, but a large trade was done in pewter or leaden shells. Besides these there were more or less rude representations of S.

Michel routing and slaying the dragon.

The trade in these articles was considerable, and in the fourteenth century a tax of "12 deniers par livre" was imposed on the sale. Naturally the pewterers and dealers protested and made out a very strong case, showing that with the tax pressing on them they could not live, that the pilgrimage was falling into disrepute, and that the personal devotion of the pilgrims was on the wane. Upon this the King, in a lucid interval, gave the people of Mont Saint-Michel exemption for ever from the objectionable tax.

Among the articles specially mentioned in the document¹ are "enseignes de Monseigneur Saint Michiel, coquilles et cornez qui sont nommez et appellez quiencailleries, avecques autre euvre de

plon et estaing, getté en moule".

This document distinctly shows that the articles were at that time made on the spot, and it states that they were cast in moulds.

¹ Ordonnances des Rois de France (Secousse), vii. pp. 590.

Monsieur Corroyer in his book on Mont Saint-Michel gives illustrations of these and of the mould in which some of them had been cast. The badges were obviously intended to be sewn upon the garments, loops in the metal being left for the purpose, or affixed by tangs left upon the back of the badge.

The adjacent island of Tombelaine had a shrine to Notre Dame de Tombelaine, and badges with her image are—in fragments—extant.

Some of these badges would seem to have been made to wear as large brooches or buckles, or, in some cases, as pendants upon the chest. After the pilgrimage was over they were often fixed up in a prominent place in the home of the pilgrim with other cherished possessions.

Monsieur Corroyer gives a restoration of a pewter horn which, from the figure upon it, must have been designed for use by the Mont Saint-Michel pilgrims. Like the *ampullae*, it bore the fleurs-delys of France, and a rough representation of S. Michel transfixing the dragon.

Another pewter badge which was much in demand was that representing the so-called *chemise* of the Virgin Mary at Chartres. It is figured in the *Grande Encyclopédie* (sub voce "Chemise"), and from the illustration it can easily be seen how the badge was to be attached to the pilgrim's dress.

Rings, too, were made in pewter; one is shown in M. Corroyer's book on Mont Saint-Michel.

Beggars' and porters' badges were sometimes made in pewter, though more generally in brass, and in later times of zinc.

At South Kensington Museum is a porter's badge of pewter, by no means a common object. There are also some few specimens in the Guildhall Museum.

Beggars in Spain, as early as 1393, had to wear badges of lead. In Edward VI's reign, by Act of Parliament, beggars were to "weare openly . . . some notable badge or token".

In the Musée Royale at Brussels there is a beggar's badge, such as was in use up to the end of the eighteenth century by the *Arme Camer* or *Chambre des pauvres*. It consists of an A and a C, with a lion rampant between, holding the A between his front paws and the C in a fold of his tail. The badge is fitted with three loops for attaching to the wearer's cloak or coat.

An ampulla, Fr. ampoule, was a small vessel for containing incense, for consecrated oil for the sacrament of extreme unction, or oil for the lamps which were kept burning in such sacred places as the tombs of saints. In form they varied, but were often circular, with two handles rather more than half-way up the side. Similar shaped bottles are still made in glass, covered with fine basket- or strawwork, and are used as travelling flasks.

The *ampullae* were used for many purposes, mainly private and devotional. Pilgrims to the Holy Land treasured in them a little dust or sand from Calvary, or some from the site of the Holy Sepulchre, or, again, from the Garden of Olives. Pilgrims to Rome collected dust from the Catacombs. Pilgrims to Mont Saint-Michel brought away some few grains from the treacherous and ever shifting sands. Originally the pilgrims had chipped off pieces of the tomb of S. Aubert, very much in the fashion of some modern tourists, but such vandalism being officially stopped, recourse was had to pewter and leaden keepsakes.

These *ampullae* had wide mouths, sometimes carried up somewhat in the shape of a funnel. They were closed merely by pressure, and were worn suspended to the person of the pilgrim by a cord.

The decoration of the ampullae varied according to the place at which the relics were collected; but the French ones almost invariably had the three fleurs-de-lys on one side. On the other side there was scope for the pewterer. M. Forgeais ("Plombs historiés de la Seine") describes a noted ampulla called "la larme de Vendôme". In this case the three fleurs-de-lys gave way to what was considered more pictorial material. On one side was an altar, and upon it a large ciborium. A saint on the left holds up a large tear over the ciborium; the saint on the right carries a lighted taper. To the left of the altar is a cross pattée, with its foot flèchée, and over it the legend: LACR | IMA DEI. On the reverse, a knight in full armour, on a horse, clothed. In the field there are leaves and small fleurs-de-lys, and above is the legend: ST. GEO | RGIUS.

A variety of pewter, as a metal for coinage, was used in the East¹—it was probably a very hard and pure alloy—and in England,

¹ The Siamese coins from the district near Tenasserim were flat and round, four inches in diameter, with rudely drawn birds or dragons.

from the time of Elizabeth up to the reign of Charles II, for tradesmen's tokens.

In the time of the Commonwealth (1653) there were pewter farthings made. They had stamped upon them "‡ of an ounce of fine pewter", and were looked upon as quite safe, being intrinsically worth their money value.

James II, in his last campaign in Ireland, was driven by lack of money to coin crowns and half-crowns in pewter. He obtained the metal cheaply by appropriating what he found in the houses of the Protestants, and the coins bore the legend: MELIORIS TESSERA FATI. When such coinage as this was current, one can hardly be surprised to hear that "people absconded for fear of being paid their debts".

In the time of James II, and of William and Mary, there were other issues of pewter coins. These had a small piece of copper, usually square, though sometimes round like a rivet, inserted in a hole in the centre, and clenched by the press when the pewter disc was struck. Some of the William and Mary coins were made entirely of pewter.

For presentation purposes the *cymaise*, *cimaise*, or *cymarre* was often in request. It was the custom when a king or prince approached a city to which he was about to pay a visit, for a deputation from the city to wait upon the king and offer him wine in a *cimaise*—very much in the way that bouquets of flowers are presented at public functions by small children. The king's attendants had the custom of appropriating as perquisites the wine-vessels so offered; hence, in a practical age, pewter became quite the usual metal for the manufacture of these vessels. They are generally from the fourteenth to the sixteenth century, and specimens are to be met with in most of the museums in the north-east of France and in Belgium.

Cimaises are mentioned as early as 1370, in the inventory of Henri

de Poitiers, Bishop of Troyes.

The *cimaise* was often fitted with two handles: one fixed at one side for holding the vessel when the contents were being poured out; and the other a swing handle, its pivot-points being near the top edge. These swing handles were elaborately wrought and often enriched with cleverly turned work, and were used for carrying the vessels.

Vessels of a similar type were offered as prizes to be competed for at shooting-matches, and both the victors and the vanquished seem to have been rewarded with pewter cups. These prizes bore the arms of the town, and a device of a gun, or a bow and arrow.

These cimaises are chiefly interesting from the fact that they are the principal representatives of the pewter of their epoch which

have come down to the present time.

Inkstands of varying form date back to an early period, though they were not in common use amongst the lower middle and lower classes. The form of the early metal inkstands is a matter of conjecture, but as the earliest of all were in horn (hence their French title of cornet) it is probable that the form was round.

Bapst, quoting from some early document, mentions that 17 sols. 6 deniers were paid to "Goupil, pintier, pour un aincrier d'estaing double d'estaing tout rond, à mettre aincre, plumes, gettouères

[jetons] et deux bobêches dedans".

The fact of its being double seems to imply that it had an outer casing to keep safely the miscellaneous items mentioned above,

though it may mean that the ink-well was also of pewter.2

They were often made of leady metal, as the specimens in South Kensington Museum, the Cluny and other museums clearly prove, and highly ornamental. Havard gives an illustration of one of the fourteenth century in lead.

The Nuremberg Chronicle represents S. Luke seated with a round pewter inkstand in his left hand.

The later form was a flat tray or dish, with two or three receptacles for the ink and the stand, or the pens and the wax.

The varieties were: the rectangular or oval standish; large, middle, small chests; large, middle and small Dutch cabinet with drawers; the "Treasury" type, so called from its usage in that particular Government office, and then the type that still survives up to about twenty years ago, particularly in schools and on the Post Office counters, i.e. the large, middle and small loggerheads. The lastmentioned were made in an alloy very little better than black-metal.

¹ Pint pots and tankards, occasionally of pewter, but frequently of Britannia metal, are still rowed for in college races at Oxford and Cambridge, and elsewhere.

² Rymer's Foedera, iii. Part 3, under date 1382, mentions an inkstand of pewter, "unum calamare de stanno".

Pewter inkstands, called "loggerheads", consist of a circular base and a circular receptacle with lid, with a chinaware well for the ink, and holes to hold the pens. In some of the early ones there was no ornament at all, or occasionally a few lines on the flat base or on the walls of the receptacle. Occasionally they are met with made of very good pewter. The inkwell was sometimes pewter, in shape something like a tall hat, but the metal was not good for the colour of the ink.

A weak point in these inkstands was the hinge of the lid, and even in most specimens not of modern make the lid is missing. The reason is not far to seek, for the lid was often placed in such a way that it could not remain open. The same force that was required to give the lid the absolutely necessary angle caused a crack near the hinge, and as force was required to make the lid shut, the perpetual see-saw was fatal. The lids were usually far too heavily weighted in their moulded edge.

This type of pewter inkstand, as we know it, is not beautiful, but its redeeming points were that it would not upset, and that it had a lid to keep out the dust. In the latest pattern, which was made for export, the makers omitted the flat base so as to make the "logger-

heads" cheaper.

XΙ

Pewter Marks

In France—we have no record of anything of the sort in England—the Paris pewterers were under the wing of the goldsmiths and their ordinances were codified by the Provost as early as 1268, and revised in some respects in 1304. Again in 1382 the pewterers of Paris were forbidden by their ordinances to sell any wares of hammered work made in Paris or in the suburbs without first stamping them with their mark according to the usual custom. As the rules of the trade were practically the same in all countries it is more than probable that the same regulation was in force in England even at that early date.

No doubt the necessity for marking arose from the insistence on a definite standard, and a maker would make his own private mark on his ware so that he would know it again. Self-preservation in fact, when the right of search was a living reality, became the chief object for the pewterer—then later, what was probably done only sporadically eventually became compulsory.

The practice may too have originated in the pewterer's desire to do the same as the goldsmiths and the silversmiths were obliged to

do by their craft rules.

By 19 Hen. VII, cap. 6 (1503-4), the makers of hollow-wares such as salts and pots which were made of the pewter called "lay metal" were required "to marke the same wares with severall markes of their owne, to the entent that the makers of such wares shal auow

the same wares by them as is above said to be wrought". Here would probably be, as before mentioned, a stamp with a device and the initials or the full name of the maker, which is the earliest mention we have found in England of the maker's mark. It is curious that no mention is made in the Act of marks to be put upon other wares made of pewter of high standard. It is probable that it had been customary to mark all other wares, but that wares of inferior pewter had not been so marked. Consequently the alloy used had become further debased, for as it was not marked the maker of such debased wares escaped detection and the usual fines. We next meet with a notice of pewterers' marks in the York ordinances of the year 1540 which prescribes a maker's mark to be placed on pewter of the higher quality, as to which the above Act is silent, confirming the opinion that this had all along been required by the laws made by the pewterers themselves; it ordains "that euery of the sayd Pewderers shall sett hys marke of all suche vessell as they shall cast hereafter and to have a counterpayne thereof to remayne in the said common chambre upon payne of euery of them that lackes such a marke, and doyth not mark ther vessell therwyth before that they putt them to sayle, to forfet therefore iij s. for euery pece to be payd as is before sayd. And euery of the sayd occupacion to have a proper mark before the feast of the nativity of our Lord (September 7th) next to come, uppon payne, of xl. s. to be payd as ys aforesayd."

The "Counterpayne" was a sheet of metal, which was kept at the Pewterers' Hall, upon which was stamped an impression of each maker's private punch with which he stamped his wares before

offering them for sale.

In the year 1599 the pewterers' ordinances of the same city were reformed and enlarged. Makers of hollow wares it says "shall mark the same with severall markes of their owne, to the intent, that they shall avowe the same accordinge to the Statute in that behalfe", the statute being the 19 Hen. VII, cap. 6, above cited. Later on is a very important clause where we first meet with a precise statement as to the description of mark to be used by the maker. It is worth while to print it in full: "Item, that every Master of the sayd Craft, nowe beinge or which hereafter shalbe, shall have a proper marke, and two Letters for his name, to marke his vessell and waire withall and shall therwith marke all suche vessell and Waires, as he shall here-

after cast and make, so sone as he shall have made up the same waires fit for saile, upon payne of everye one wanting suche a marke and Letters to forfait for every moneth that he shall want the same Is., to be payde and devided as aforesayd. And further to forefait for every pece unmarked iij s. iiij d. to be payd and divided as aforesayd."

Paris, just as London to the English, was the headquarters to which the workers all over the country looked for a lead, and the regulations of many towns mention that pewter is to be *a l'usage et façon de Paris*, just in the same way as the York Pewterers specify that their regulations are the same as those of the citizens of London.

As late as the end of the seventeenth century we find an Irish statute of William III (passed in 1697) enacting pewter vessels were to be of the same quality as those cast in London.

From a memorandum in the old Book of Inventories belonging to the Company, and quoted by Mr. Welch (i. 165), it appears that "a table of pewter, with every man's mark therein", was in existence as early as 1540. This may have been one of the earliest touch-plates that were ordered to be made, as Mr. Welch thinks that the practice of requiring the pewterers to register their marks formally originated in 1503–4, when an Act, 19 Henry VII c. 6, made it compulsory (Welch, i. 94). This touchplate unfortunately has been lost. Such touches were preserved at the Hall of the Pewterers' Company as early as 1540. But some system of marking¹ wares must have existed at a still earlier date, for in the days when work was liable to confiscation if it fell a few grains below a certain specified standard, self-protection would suggest some private mark or means of identification.

These touchplates² have been exhibited privately at various times and places, and the Pewterers' Company have had them reproduced in collotype in Mr. Welch's book. They were reproduced again in Cotterell's *Old Pewter*, its Makers and Marks. The touchplates, themselves, are of such historical importance that it

² By special permission of the Company verbal descriptions of the touches are given in Appendix A.

¹ In 1492 the Company had four new "markyng irons for Holoweware men" (Welch, i. 78). This entry shows that marking had been done before this date. The reference (on p. 75) to "pots, *sealed*", must also point to the practice of marking.

has been considered unwise to expose them to the atmosphere unnecessarily, and so the Pewterers' Company has commissioned replicas to be made in a durable black plastic material, and upon these the touches show with even greater clarity.

The register that would have been kept of the members who struck their touches on the touchplate is no longer in existence. If it had had entries no more irregular than those of the touches, it would have still been valuable as a means of throwing light on some touches which are now and will long remain riddles. Mr. Welch unfortunately found that no such register was in existence, and for that reason, no doubt, passed over the subject of the marks.

The touches are not all in chronological¹ order on the first of the existing touchplates. In 1666 the earlier touchplate and their attendant registers seem to have been lost in the Great Fire of London, and so it became necessary to attempt to record again the marks of pewterers who had survived.

About 1667 or 1678 a new touchplate (the first of those now in existence) was brought into use; this contains the marks of many pre-fire pewterers, starting with the current Master of the Company and his Wardens, followed by other notabilities of the craft. With the few exceptions mentioned above, and a few more struck as and when the pewterers could attend for the purpose, all others are in a very definite chronological order.

Many of the earlier touches are officially dated, and may be said to cover, with a few intervals, the time from 1666 to 1824. Occasionally new touches were ordered to be used by everybody, and this would account satisfactorily for the fact that quite different touches are found on the existing touch-plates for the same pewterer. The touches vary in size according to the articles on which they were stamped: the smallest punches were used on spoons and small objects, and those of larger size on dishes and chargers.

The earlier touchmarks usually contained the initials of the pewterer, together with some other device which often made a punning reference to the name, for instance, John Belson, a bell placed over the sun; John Bull, a bull's head; William Handy, an open palm; Samuel Cocks, two cockerels—there are far too many instances to quote them all.

¹ The earliest dated mark on the first touchplate is 1644.

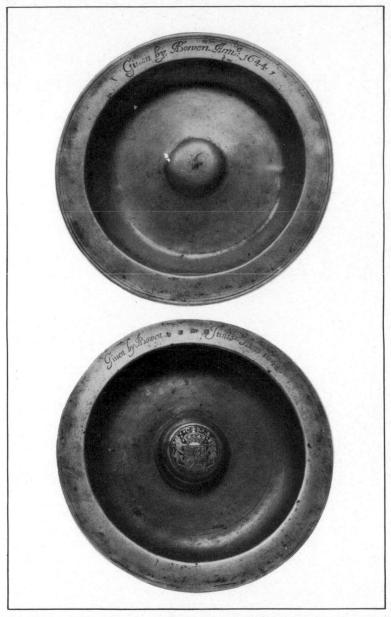

Two dishes with bossed centres (each is one of a pair) at Mildenhall Church, Suffolk. The pair at top dated 1644, and those below dated 1648. The latter pair with enamel boss in centre, bearing the arms of Charles I.

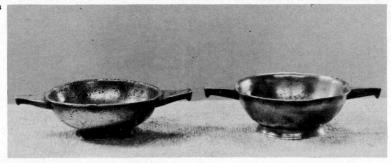

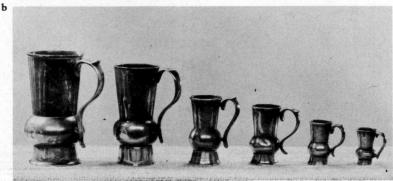

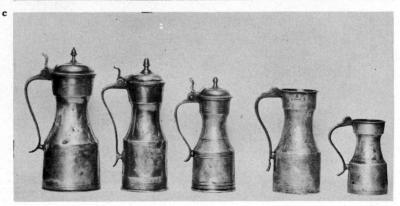

a Two quaichs; a type of vessel unique to Scotland, and exceedingly rare in pewter. Mid-eighteenth century. b A set of six rare 'thistle-shaped' Scottish spirit measures of the early nineteenth century. Due to their shape they did not always discharge their full contents, and they were, in consequence, banned by local inspectors of Weights and Measures. c Tappit-Hens; a type of Scottish measure made with plain domed covers, or crested covers (as the first three above), and, later, without a cover. Late eighteenth and early nineteenth centuries. (Collection of the late Lewis Clapperton.)

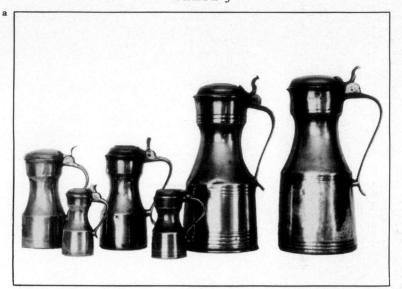

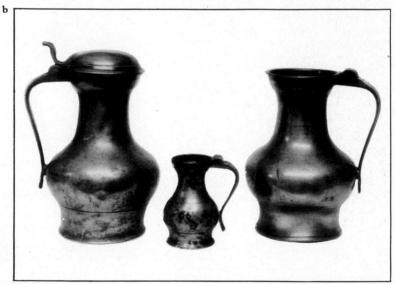

a A group of Tappit-hens with plain domed covers, including the gallon size (Imperial measure); the Scots pint (three Imperial pints); the others of various capacities made to conform to either the Scottish or Imperial scale. Late eighteenth or early nineteenth century. b Scottish pot-bellied measures, of the early eighteenth century. Made in both lidded and lidless form. (The two largest above in the Art Gallery of New South Wales).

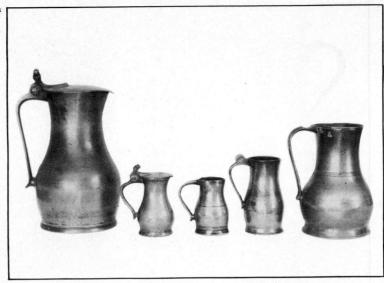

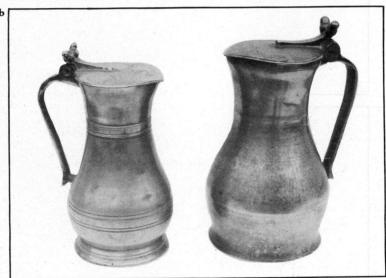

a Measures of the Channel Islands—the Jersey type, both lidded and lidless, made in a large range of sizes, including both the local standard and Imperial measure. Late eighteenth century. b Channel Islands measures; left the Guernsey type, always with hinged covers, and made in three sizes only, and right, a Jersey measure, one of a long range. Note the differences in contour which distinguish the slim Guernsey type from the plainer Jersey form.

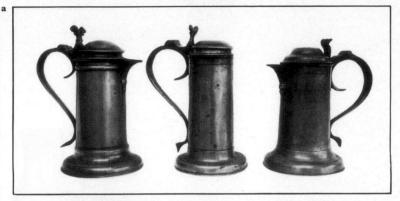

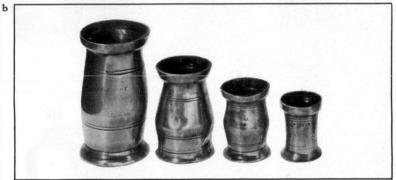

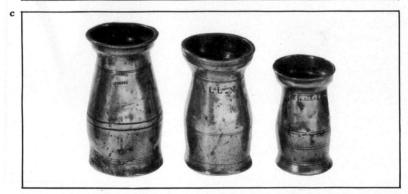

a Irish flagons. The third example is of the conventional shape most commonly associated with Ireland, c. 1750; the others are also Irish, and of the same general character, but earlier and rarer forms, c. 1690–1710. b Set of four Irish lidless spirit measures, of ½-pint, gill (noggin), ½ and ½ gill. Early nineteenth century. c Three Irish measures, titled 'Naggin' and 'Small Naggin' respectively, with a ¼ noggin of the same form.

a

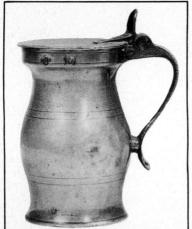

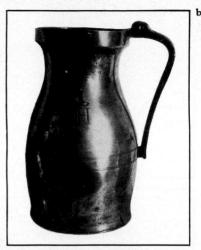

C

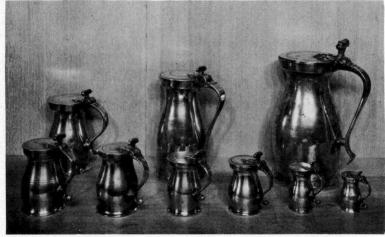

a A Scottish baluster-shaped measure, with 'embryo-shell' thumbpiece, of ½-pint capacity, c. 1820–30 b Gallon-size English Wine Measure, of c. 1720. This particular piece was illustrated by Massé (from an unknown source), in the 1921 edition; it was then without a cover (as now), but when purchased by the editor in 1946 it bore a home-made leaden cover, with a thumbpiece of entirely the wrong type. It has since been reverted to its original condition. The engraving at side is of a wheatsheaf above the letters 'H H' conjoined—no doubt to denote the name of a tavern, perhaps 'The Harvest Home'—around the neck it is stamped with the maker's mark 'I.L'; also stamped thrice with the arms of Chester (capacity seals), and once with the seal of the City of London. c A group of English Wine Measures of baluster shape, with 'double volute' thumbpiece, and 'ball' terminal to the handles, c. 1730–60 in the gallon and half-gallon sizes the handle terminal sometimes varies (no doubt cast from the mould normally used for an earlier model).

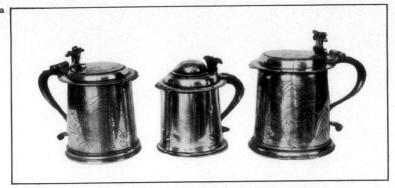

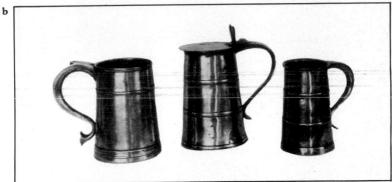

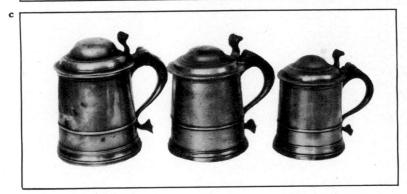

a Stuart period tankards; the first of Charles II, c. 1675, the third, James II, c. 1685, both with typical flat-topped cover and 'wriggled' engraving. In the centre an early domed-lid tankard of William and Mary period, c. 1690. **b** Three unusual tankards; the first of George I, c. 1715; the third of William III, c. 1700, and that in centre also of c. 1700, but difficult to assign to a locality with certainty—it could be Scottish. **c** Three conventional domed-lidded tankards, of quart, one and a half pints, and one pint capacities, all made by Richard Going, Bristol, c. 1720–30.

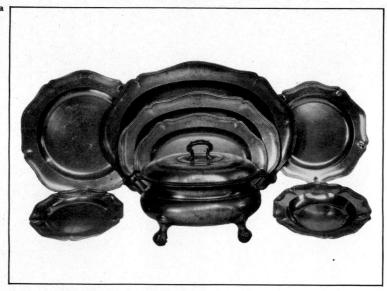

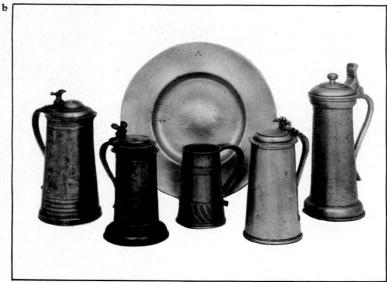

a Part of a fine 'garnish' of tableware, made by Thomas Chamberlain, London, c. 1760; each piece engraved with arms of Edgcumbe. (Photo, Sotheby's, London) b Fine pieces from a private collection. In the foreground left to right, a 'York' type flagon, c. 1700; a flagon with 'beefeater's hat' cover, c. 1650; a rare gadrooned lidless tavern mug, c. 1700–10; a Stuart flat-lidded flagon, c. 1690, and finally a sturdy James I period flagon, c. 1615. At back a broad-fimmed dish, c. 1660.

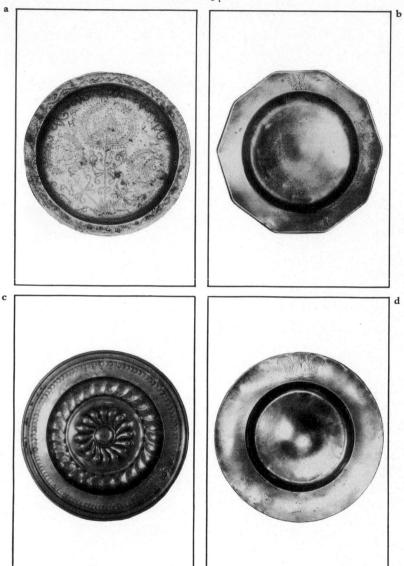

Plates and dishes of rare types. a narrow-rimmed plate, 9 in. diameter, with 'wriggled' engraving, c. 1680; **b** a decagonal (10-sided) plate, $9\frac{1}{8}$ in. diam., made by Jonas Durand, London, c. 1725–30; **c** an Alms Dish, $14\frac{1}{4}$ in. diam. bearing punched ornament on the rim, and hammered work in the well, made by Robert Clothyer, Chard, Somerset, c. 1690 (Homer collection); and **d** a fine broad-rimmed charger, $24\frac{1}{2}$ in. diam. c. 1650 (Pewterers' Company).

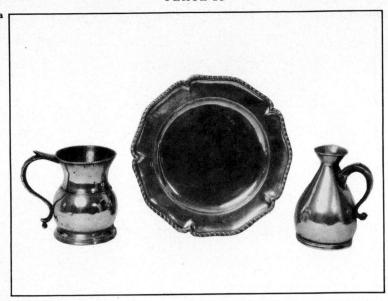

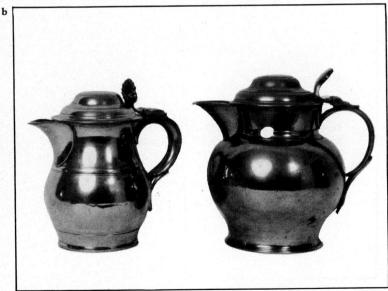

a An unusual Bristol pint tankard, by P. Llewellyn, c. 1840; a gadrooned plate, by Richard Pitt, London, c. 1750, and a Bristol spirit measure, of pint capacity, by M. Fothergill, c. 1800 (H. W. Buckell collection). b Two English Ale Pitchers, both types are to be found in several sizes, from about the 3-pints to 1-pint capacity, c. 1800–20. (Buckell coll.)

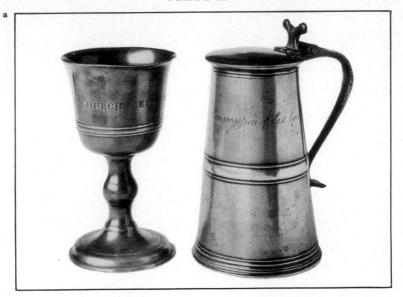

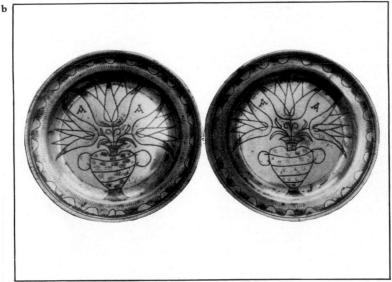

a A large Scottish Communion Cup, 9½ in. high (probably one of a set of four), engraved 'Relief Church, Leith, 1822', and a small Scottish flagon, engraved 'Belonging to the Associate Congregation of East Barrs. 1781'; 9½ in. to top of cover. (Buckell coll.) b Pair of Marriage (or betrothal) plates, 8¾ in. diam., engraved in 'wriggled work' with conventional vase of tulips, and initials of the marriage partners, made by James Hitchman, London, c. 1730. (K. W. Bradshaw collection).

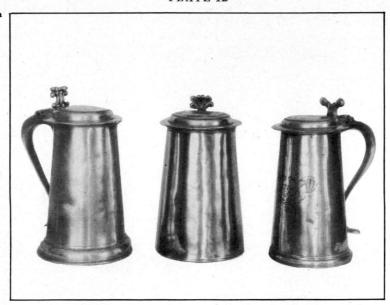

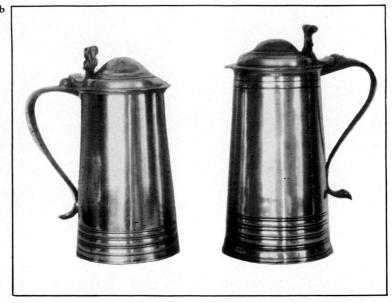

a Three Stuart period flagons; the two outer examples of York origin, c. 1680, and that in centre by George Kent, Lincoln, c. 1675. **b** Two variations of the York straight-sided flagon; a type peculiar to that area. The first by Edmund Harvey, the second by Leonard Terry, both of c. 1690–1700.

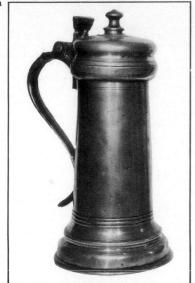

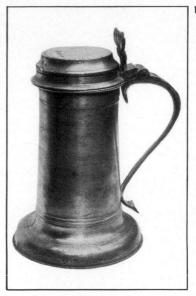

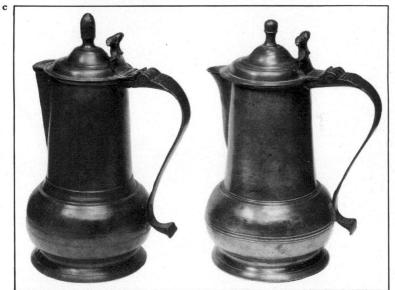

a Charles I period flagon, with knopped 'muffin' cover, height $10\frac{7}{8}$ in overall, c. 1630. b Flagon of Cromwellian period, with the 'beefeater's hat' cover, and an unusual thumbpiece for this type, c. 1650–60. c 'Acorn-shaped' flagons; a type produced only by Wigan and York makers. Both of c. 1720–30. (Castle Museum, York)

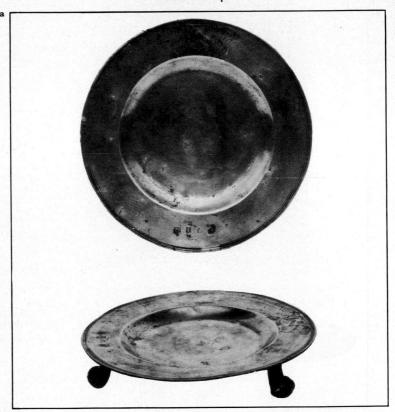

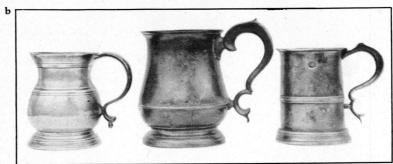

a Footed Plate, standing upon three scrolled feet; the rim engraved with the arms of (?) Alleyn. Top 10 ins. diam., height 2 ins., c. 1665–70. b Three unusual tankards; the first a Bristol form, of ½-pint capacity, made by P. Llewellyn, c. 1840; centre, a pint, by J. Austen, Cork, c. 1830; lastly, a Scottish ½-pint, marked in base 'D. SCOULER' (unrecorded), c. 1830. (The mark seen at side is a capacity seal of Lanarkshire, West).

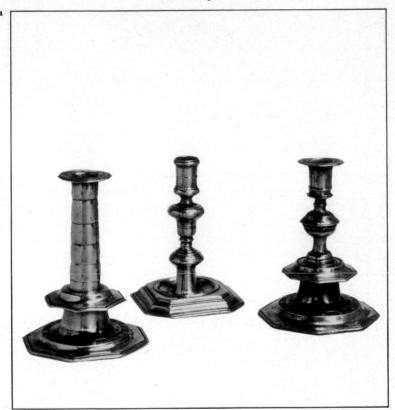

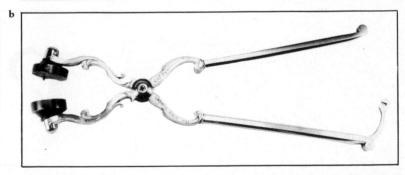

a Rare Stuart Candlesticks; the first of Charles II, c. 1680; the second and third of William and Mary, or William III, c. 1690–1700. (Coll. of the late Mr. R. W. Cooper). **b** Assay tool, owned by the Worshipful Company of Pewterers. The mould at the end used to cast pellets of tin or pewter which were then weighed against similar pellets of a known alloy or quality. This fine steel instrument inscribed with the names of the Master and Wardens, and dated 1728.

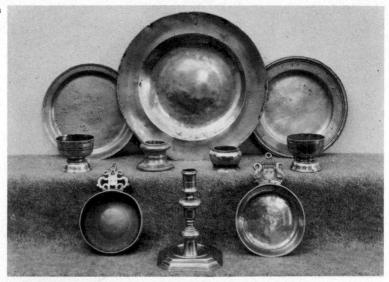

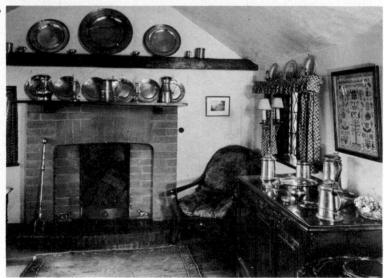

a An array of fine pieces of English pewterware, at back, *left to right* a narrow-rimmed plate, c. 1680; a dish with Crowned Feather punched on the rim, fifteenth or sixteenth century; and a gadrooned plate, c. 1730. On shelf, four salts (i) and (iv) a pair, c. 1750, (ii) a 'Capstan' salt, c. 1690, and (iii) a 'bobbin' salt, c. 1700–10. At front, a porringer, c. 1700, a William III candlestick, c. 1695, and another porringer, c. 1675. (Cooper collection) **b** LIVING WITH PEWTER. A room in an old cottage, and pewter formerly in the collection of the late Mr. Ernest Hunter.

Several of the marks on the touchplates have been punched upside down, or carelessly on the top of other marks, making both difficult to decipher; instances are known of one mark being surcharged with the name or initials of another maker, for example, Carpenter & Hamberger's mark is found with that of Stiff superimposed, to indicate that the latter had taken over the business.

Sometimes the marks show initials only, sometimes the name in full; this, however, was a matter upon which the regulations varied from time to time.

The four small marks, resembling silver "hall-marks" which are frequently seen on pieces of pewterware, especially plates, up to the end of the first quarter of the eighteenth century, were not "official" marks, and at times such marks were expressly forbidden by Company regulations; the earliest record of their use in this form was in 1638 when the Goldsmiths' Company complained of their use by pewterers, but little notice appears to have been taken, nor was the Pewterers' Company able to prevent their use for very long.

No collector should refuse a good dish because of the absence of such marks, nor need he acquire an inferior dish or plate simply because they are so adorned.

A misconception as to marks on pewter needs some explanation. The Pewterers' Company required the maker, under a penalty, to mark all the pewter he made with his own registered mark, and, if the pewter were of a certain quality, with the mark so well known of an X with a crown above it. This X is sometimes found repeated, and occasionally without the crown, whereas the London Goldsmiths' Company required all plate exposed for sale to be brought to that Company's Hall to be stamped there with the *ball-mark*.

Though eventually the Pewterers' Company did not object to the silver marks, they interfered when these were the only marks on the ware; e.g. in 1681 "John Blackwell was charged with selling trencher plates without any other mark than the silver mark and was fined 20s" (Welch, ii. 155).

Yet in 1754 two members were allowed to sell "12 dozen scalloped raised brim plates and dishes in proportion without any other touch than their Silver Touch" (Welch, ii. 194).

In 1688 complaint was made by Mr. Stone that the 17th Ordinance was frequently broken, i.e. that pewterers struck touches

upon their ware other than those they had struck on the Company's

plate of touches.

In November, 1690, complaint was made to the Court against Samuel Hancock for striking his name at length upon his trencher plates, and at each end thereof is struck his own touch and the rose and crown, and for striking the letter X upon ordinary ware, which is a mark generally used by the Mystery to distinguish extraordinary ware.

This touch of the crowned rose could only be used by express permission of the Company.¹ In 1671 it had been agreed (Welch, ii. 144) that from henceforth no person whatsoever shall presume to strike the rose and crown with any additional flourish or the letters of his own or another's name, whereby the mark which is only to be used for goods exported may in time become as other touches and

not distinguished.

After consideration the Court, in December, ordered that "no member of the Mystery shall strike any other mark upon his ware than his touch or mark struck upon the plate at the Hall, and the Rose and Crown stamp, and also the Letter X upon extraordinary ware" (Welch, ii. 164). At the same time, though, it was left open to any member to add the word London to the rose and crown stamp, or in his touch, and the proposed striking of the name in full upon hard metal or extraordinary ware was negatived.

In October, 1692-3, "such as have not their names within the compass of their touches" were allowed to put them "at length

within the same".

Six months later "this Committee, debating the matter of persons striking their names at length upon their ware within or besides their touches or marks struck on the Hall plate", held that "the practice of striking the worker's or maker's name at length within or besides their touches registered or struck at the Hall is against the general good of the Company; and that all such persons as have set their names at length within their touches now in use shall alter their several marks or touches by leaving out their name, and register and strike at the Hall their respective new or altered

¹ Certain objects of domestic use (specified in Welch, i. 228) had to be brought (in 1580–1) to the Hall to be stamped with the mark of the Hall by the beadle, after he had found the weight of each article to be 5 lb. the piece.

marks or touches without any person's name therein" (Welch, ii.

166).

This, however, was not taken as final, and on August 11th, 1697–8, it was ordered that none should strike any other mark upon ware than "his own proper touch and the rose and crown stamp"; that any member may strike his name at length between his touch and the rose and crown, also the word London, but that none may strike the letter X except upon extraordinary ware, commonly called "hard metal" ware.

A rose and crown is found on English, Scottish, Flemish, Dutch, French, German and much other continental pewter. It was stated by Bapst that it was the distinguishing mark of pewter of the second quality made at Mons.

In spite of Acts of Parliament and other stringent regulations, there seems always to have been a considerable amount of copying,

if not counterfeiting, the marks of other pewterers.

As late as 1702 (in the reign of Queen Anne) the Pewterers' Company obtained a charter giving them power to make regulations as to counterfeit. Each member was obliged to deliver to the Master for the time being "one peculiar and selected mark or touch solely and properly of itselfe and for yourselfe only, without adding thereunto any other man's mark in part or in whole, to be struck and impressed on the plate kept in the Hall of the said Company for that purpose; which said mark and none other he shall strike and sette upon his ware of whatsoever sort that he shall make and sell, without diminution or addition, and shall upon striking of such his mark or touch, pay to the renter-warden 6s. 8d. and 2s. 6d. to the clerk for entering the same, and 6d. to the beadle".

Then followed a regulation, or rather repetition of previous regulations, as to untruly mixed wrought or unmarked pewter, which was to be fined one penny a lb.; and another as to pewterers boasting of their own wares, and disparaging that of others, or improperly enticing away another man's customers. For these offences

the fine was forty shillings.

One of the chief causes which militate against the making of a complete and correct list is that, apart from the occasional public change of the touches by order of the Court of the Pewterers' Company, private changes were sometimes made. Touches, too, were

borrowed or lent in early times by permission of the Company, and for approved reasons.

The following instances from Mr. Welch's book clearly show this.

In 1622-3 Walter Picroft was ordered to change his mark of "three ears of corn" to one ear and his initials.

Thomas Hall had leave to use Mr. Sheppard's touch. Three weeks later it was granted to John Netherwood.

In 1654–5 William Pettiver, apprentice to Oliver Roberts, is not to be made free till next Court, but hath leave to strike Mr. Barnard's touch in the mean time.

[Ralph] Cox was ordered to use as a touch a rose and crown with a knot about it and 1656.

R. Goudge was ordered to make his touch R. G. with a knot about it and 1656.

Thos. Porter in 1683 was ordered to strike as his touch "the Angell and glister serreng" (Welch, ii. 156).

Sands (1689) altered his rose and crown stamp by taking out the

place of his abode.

John Blenman in 1725-6 had leave to strike the same touch as Abraham Ford, who had retired from his trade and consented to Blenman's request.

Charles Puckle Maxey (1749) to have pelican and globe instead

of James King's touch.

Richard Warde claimed the right of using as his mark a hammer and crown. He based his claim on the fact that his wife had been the widow of Wm. Hartwell, who used it before.

In 1747 a committee made a report on touches, and the following by-law, based on their recommendations, was passed on June 25th: "That all . . . wares capable of a large touch shall be touched with a large touch with the Christian name and Surname either of the maker or the vendor at full length in plain Roman letters. And . . . small wares shall be touched with the small touch—with a penalty of one penny per pound for default" (Welch, ii. 193).

This points to the fact that the old rule of one man one touch had

been found impracticable.

It must be remembered that the large touch is the most important of any impressed on any pewter. The smaller (so-called) "hall-marks" may often, however, help to give a clue, especially where

they give the initials. On the other hand the initials in the small marks may differ from those of the name in the large touch, when the ware was made by a manufacturer for resale by a dealer elsewhere.

The main touch will be that of the maker, whilst the hall-marks may be either his, or those of the factor who wished to imply that he had had some part in their manufacture.

PEWTER HALL-MARKS AND OTHER MARKS

The pewter hall-marks, for want of a better name, seem to have been made small designedly, after the manner of the silver marks; the shields containing them have often been copies of the silver hall-mark then in use; and the number of the pewter marks has been kept the same as the silver marks, the pewter stamp being repeated in some cases in four shields side by side, or in others two stamps have been repeated alternately to make up a set of four in all.

These marks being then colourable imitations of silver hall-marks often bore facsimiles of parts of the latter. In this way only is it possible to account for the presence of the leopard's head, the lion passant, a figure of Britannia—and it may be noted that the cross surmounted by a crown, a very common stamp on pewter, is in itself a silver mark that was formerly placed on silver-ware that came from Exeter.

Single letters in simulation of the date letters on silverware were sometimes used by pewterers as the device in one of the four small shields, but they have no significance so far as dating is concerned, and are merely another instance of the craze to imitate the more costly article.

On many articles of pewter there are found large plain letters punched in the ware, or sometimes smaller letters in shaped punches. These latter are occasionally found crowned, and it has been assumed that they give a clue to the date by accentuating the name of the reigning sovereign. On officially stamped standard measures this is no doubt the meaning of the crown, and the combination mark of either "A.R", "W.R" or "G.R" with a crown above does have a special significance as a "capacity seal", to indicate that the content of the pot upon which it was struck conformed to a certain "standard" of measure.

Two or more letters, struck from individual punches, may occasionally be found; these will be former owner's initials, and not pewterer's marks. When initials are shown in a triad they may be taken as those of a couple to whom the piece once belonged; one such marked example was vouched for by its erstwhile owners as follows: ^G_{1B}, "C" was the initial of the surname, "J" was for John, and "B" was for Barbara, i.e. the Christian names of the couple who possessed the pewter. The combination of three initials in this form, as an ownership mark, was in frequent use from, at least, the late Elizabeth I period to towards the end of the eighteenth century, and is found just as frequently on silverware.

XII

List of the Names of Pewterers, English, Scottish and Irish, collected from various sources, official and unofficial

To compress the list within a reasonable number of pages it has been

necessary to abbreviate considerably.

Figures in brackets (1), (2), (3) are used when the references appear to relate to two or more pewterers of the same name. In some cases the two references may belong to the same pewterer, as frequently many years elapsed between the time of joining the yeomanry and that of striking a touch.

Edinburgh means that the name is in the list of Edinburgh

Pewterers as given by Mr. L. Ingleby Wood.1

A† added to Edinburgh means that the touch of that pewterer is

to be seen on the touch-plates preserved at Edinburgh.

London pewterers will not have a location shown. Pewterers who were known to have worked or resided elsewhere are shown with

their town or county in brackets.

The names of those pewterers whose touches are impressed on one or another of the five touchplates which are still preserved at Pewterers' Hall, London, will be apparent, because following these (in brackets) will be found the number of the touch they struck on the touchplate—where this number is prefixed by a ? it means that the attribution is not absolutely certain.

The dates given are from the lists of the Yeomanry and of the Livery which have been preserved at Pewterers' Hall. Where two

¹ In his Scottish Pewterware and Pewterers.

dates are given they are the earliest and the latest known from existing records.

The Irish names were inserted by the original compilers with the very kind permission of Mr. Howard H. Cottrell and Mr. M. S. Dudley Westropp, from the list in their work mentioned in the preface.

The value of the list, which represented over forty years' work of the original author, lies in the chance that it gives a collector to date approximately work done by men not only those whose names are on the touchplates, but many more.

All the marks included herein are also to be found recorded, in many cases in much more detail, in Cotterell's *Old Pewter*, its Makers and Marks.

Editor's Note. Needless to say, this list cannot pretend to be anywhere near complete bearing in mind that Cotterell's book, which was published in 1929, contains over 6,000 references to pewterers or their marks, and that, in later years, further study and research has enabled this total to be nearly doubled. In many cases much more is known today about individual pewterers than just their starting and finishing dates. What this further study has done is to enable the editor to allot many of the touchplate marks, of which the owners were not known to either Massé or Cotterell, to known makers, many of whose names have not even been recorded elsewhere; so, too, has it been possible to give the dates of a pewterer's floreat with greater accuracy. In these respects alone the present publication is likely to be of inestimable benefit to students. R.F.M.

1663, 1674 (33) Abbott, George Abbott, John 1678, 1693 Abbott, Thomas (1) 1712 Abbott, Thomas (2) 1792, 1852 Abernethie, James (1) 1640 (Edinburgh †) Abernethie, James (2) 1660 (Edinburgh †) 1669 (Edinburgh †) Abernethie, James (3) 1678 (Edinburgh †) Abernethie, John Abernethie, William 1649 (Edinburgh †) Abram, Henry 1561, 1571 Ackerman, N. 1640 Ackland, Thomas 1720, 1743

Acton, Samuel Etheridge	1755
Adams, Henry	1686, 1732 (431)
Adams, Nathaniel	1665, 1692
Adams, Robert	1647, 1683
Adams, Thomas	1670
Adams, William (1)	1640, 1681 (59)
Adams, William (2)	1675, 1687 (280)
Ainsworth, Jeremiah	1702
Alcock, Cornelius	1808
Alder, Thomas	
	1657, 1667 (147)
Alderson, George (1)	1728 (887)
Alderson, George (2)	1817, 1823 (1084)
Alderson, John	1764, 1792 (1010)
Alderson, Thomas	1800, 1825
Alderwick, Richard (1)	1748, 1770 (959)
Alderwick, Richard (2)	1776 (1035)
Alexander, Paul	1511, 1516
Alexaunder, Thomas	1488, 1499
Alger, Robert	1666 (149)
Allanson, Edward	1682, 1728 (?418)
Allen, George	1790
Allen, Henry	1570 (York)
Allen, James	1725, 1766
Allen, John	1671, 1697 (197)
Allen, Joshua	1689
Allen, Richard	1668, 1675 (84)
Allen, Thomas	1553, 1584
Allen, William	1668, 1688 (240)
Allett, Bennett	1649 (43A)
Allom, Peter	1707
Alyssandre v. Alexander	
Alyxander, Paul	1516
Ambrose, William	1763
Amerson, Michael	1774
Amiss, Josiah	1727
Anderson, Adam	1734 (Edinburgh †)
Anderson, John	1692 (Edinburgh †)
Anderson, Robert	1697 (Edinburgh †)
Anderson, Thurston	1575 (Dublin)
Anderton, James	c. 1700 (Wigan)
Andouit, James	1682 (Dublin)
Andrews, Robert	1703
Angel, Philemon	1684, c. 1700 (414)
Angel, Thomas	1673
Annison, William Glover	1742, 1768 (933 and 947)

Ansell, John	1714, 1729 (708)
Appleton, Henry	1749 (943)
Appleton, John (1)	1768, 1819 (1032)
Appleton, John (2)	1803
Apps, John	1785, 1831
Apps, Philip	1754
Archer, William	1627, 1680
Arden, Joseph	1821, 1848
de Arlicheseye, John	1346
Armiston, Henry	1753 (Cork)
Arnott, George	1735
Arnott, Thomas	1702, c. 1710 (633)
Arthur, John	1803
Ash and Hutton	c. 1750 (London)
Ashenhurst, Peter	1759 (Cork)
Ashley, James	1824, 1851 (1083)
Ashley, Thos. J. Thurston	1821 (1090)
Ashlyn, Lawrence (Astlyn)	1563
Asplin, William	1614
Asserton, John	1495, 1506
Asshe, William	1457, d. 1541
Astlyn, John	1504, 1515
Astlyn, Lawrence W.	1487, 1527
Astlyn, Walter	1518, 1534
Atkinson, Christopher	d. 1600
Atkinson, Joseph	1763
Atkinson, William	1672, 1676 (205)
Atles Samuel	
Atlee, Samuel	1660, 1683
Atlee, William	1696 (533)
Attersley, Robert	1788
Atterton, Robert	1693 (501)
Attwood, William	1682, 1695 (377)
Augustine, John	1692
Aunsell, Stephen (Annsell)	1451
Austen, John	1800–1, 1852 (Cork)
Austen, Joseph	1795, 1845 (Cork)
Austen, Robert	1617
Austen, Robert	1812, d. 1817 (Cork)
Austen, Thomas	1610, 1623
Austen & Son	1820 (Cork)
Austin, James	1764
Austin, John	1719
Austin, J. Ralph	1796, d. 1856
Austin, Samuel	1675, 1703
Austin, William	1651, <i>d</i> . 1665

Aylif(f)e William (? Alef)	1659, 1686 (?43)
Aymes, John (Ames)	1663, 1671
Ayres, William	1663, 1670 (25)
-	
Babb, Bernard	1700 (577)
Baby, Jesse (see Baly)	
Bache, Richard	1779, 1799 (1049)
Bacon, Benjamin	1749, 1759 (979)
Bacon, George	1746, 1771 (921)
Bacon, Thomas	1717, 1746 (768)
Badcock, John	1764
Badcock, Thomas (1)	1688, 1716
Badcock, Thomas (2)	1787
Bagshaw, George	1808, <i>d</i> . 1864
Bagshaw, Richard	1772, 1814 (1058)
Bagshaw, Thomas	1800, 1827
Bailey, John	1750, d. 1809
Bainton, Jeremiah	1718
Baker, Charles	1783
Baker, Humphrey	1575, 1615
Baker, Samuel	1669, 1678
Baker, William (1)	1457
Baker, William (2)	1551, 1558
Baldwin, Robert	1677, 1690 (Wigan)
Ball, John	1826, 1830
Ballantyne, John	1755 (Edinburgh †)
Ballantyne, William (1)	1742, d.1748 (Edinburgh †)
Ballantyne, William (1) Ballantyne, William (2)	1749, 1773 (Edinburgh†)
Ballard, William	1741
Baly, Jesse	1805
Bampton, Thomas	1775
Bampton, William	1742, d. 1799 (937)
Banck(e)s, Andrew	1624–1647 (Dublin)
Banckes, Francis	1687 (Galway)
Banckes, Nicholas	1648, 1660 (Dublin)
Banckes, Peter	1713 (Dublin)
Banckes, Ralph	1610 (Dublin)
Banckes, Roger	1627 (Dublin)
Banckes, William	1583 (Dublin)
Banckes, William	1687 (Kilkenny)
Banfield, John	1732, d. 1771 (Dublin)
Bangham, William	1805
Banks, John	1620
Bannister, Thomas	1701
Barber, Joseph	1773, d. 1834
	7,37 31

Barber, Nathaniel 1777, 1788 (1037) Barber, Samuel 1782, d. 1823 Barclay, Richard 1756 Barford, Thomas 1665 (82 and ? 145) Barker, John 1550, 1571 Barlow, John 1698 (554) Barnard, — 1654 Barnes, John 1717, 1734 Barnes, Thomas 1726, 1741 (835) 1776 (1034) Barnes, William Barnett, Robert 1783, d. 1829 (1059) Barrett, Lancelot 1763 Barrington, William 1824, 1839 (Dublin) 1786, d. 1793 Barron, Robert Barrow, Richard 1667, 1688 Bartlett, Walter 1623 (Northampton) Bartlett, William 1740, 1777 (of?) 1670, 1699 (181 and 298) Barton, Daniel (1) Barton, Daniel (2) 1700 (573) Barton, Joseph 1718 1718 Barton, Richard Baskerville, John 1681, d. 1702 Baskerville, Thomas 1731 Basnett, James 1821 Basnett, Nathaniel 1767, 1797 Bassett, Isaac 1722 Batchelor, John 1762 Bate, John 1746–1780 (Dublin) Bateman, Aaron (1) 1721, 1742 Bateman, Aaron (2) 1734, 1749 Bateman, Aaron (3) 1744 Bateman, Benjamin 1719, 1751 Bateman, Francis 1708 Bateman, John 1642, 1678 Bateman, Moses 1700 Bateman, Thomas (1) 1733 Bateman, Thomas (2) 1742 Bateman, Thomas (3) 1774 Bathurst, John 1705, 1715 1797, 1805 (1070) Bathus, William Batteson, Abraham 1675–1707 (York) 1684 (York) Batteson, John (1) 1707-26 (York) Batteson, John (2) 1661, 1668 (86) Batteson, Thomas

1505, 1528

Baxter, John

D 1 77 1	(D: 1)
Beale, Humphrey	1647 (Bristol)
Beamont, William	1706 (683)
Beard, Sampson	1681, 1699
Beard, Thomas	1688, 1718
Bearsley, Allison	1704, 1728
Bearsley, Edward	1735, 1749
Bearsley, Job (1)	1673
Bearsley, Job (2)	1704
Beck, William	1725
Beckett, Thomas	1702, 1730 (611)
Beddow, Nathaniel	1730
Bee, John	1530, 1566 (York)
Beecraft, Richard	1736
Beehoe, Josias	1720
Beeslee, Francis	1693 (? 505)
Beeston, George	1743, 1765 (939)
Beeston, James	1756
Bell, John	1724
Bell, Robert	1569 (York)
Bell, Robert	1748
Bell, William	1703
Belsher, Richard	1673 (225)
Belson, John	1734, d. 1784 (890)
Belson, Richard	1724
Bennett and Chapman	c. 1760 (994)
Bennett, Edward	d. 1773 (Cork)
Bennett, John	1635, 1653
Bennett, Philip	1522, 1542
Bennett, Thomas (I)	1680
Bennett, Thomas (2)	1700 (580)
Bennett, Thomas (2) Bennett, Thomas (3)	1807
Bennett, William	1662
Bennett, William	1758 (998)
Benson, John	1740 (904)
Bentley, Christopher	1678 (? 315)
Benton, Ralph	1676, 1688 (274)
Bernard, Onesiphorus	1722
Berners, Thomas	1699
Besouth, Joseph	1759
Bessant, Nathaniel	1702 (603)
Betts, Thomas	1676 (341)
Bidmead, Jonathan	1728
Billing, Samuel	1675, <i>d.</i> 1707 (London and
	Coventry)
Bills, William	1701

Binfield, John Birch & Villers	1710 1775, 1820 (Birmingham and
	London)
Bird, John	1637, d. 1667
Birkenhead, John	1670, 1680
Bishop, James	1724 (781)
Bisshop, Piers	1452, 1479
Blackman, John	1703
Blackwell, Benjamin	1676, 1686 (320)
Blackwell, John	c. 1665, 1681 (? 14)
Blackwell, Thomas	1547
Blackwell, Thomas	1706
Blackwell, Timothy	1641, 1675 (? 45)
Blagrave, William	1648, 1668
Blake, John (1)	1690 (562)
Blake, John (2)	1699
Blake, John (3)	1786, d. 1809
Bland, Henry	1732
Bland, John	1730
Bland, William (1)	1703
Bland, William (2)	1726
Blaydes, Ralph	1535–1546 (York)
Blenman, John	1726 (797)
Blewett, John	1707 (652)
Blewett, Robert	1738
Blewett, Thomas	1736
Bliss, John	1708
Bliss, Robert	1735
Blissett, William	1697
Bloxham, Edward	1719 (Dublin)
Blundell, Peter	c. 1588
Blunt, John	1676, 1681 (323)
Blunt, Thomas	1746
Boardman, John	1738
Boardman, Thomas (1)	1728, d. 1773 (899)
Boardman, Thomas (1) Boardman, Thomas (2)	1763
Bode, Philip	1761
Bogg, John	1620, 1642 (York)
Bond, John	1775
Bonkin, Jonathan (1)	1699 (307)
Bonkin, Jonathan (2)	1720 (722)
Bonvile, John	1677 (366)
Boost, James	1744, 1767
Booth, John S.	1755
Booth, Samuel	1661, 1695 (York)

Ros	rdman, Robert (Borman)	1700 (594)
	rthwick, Andrew	1620 (Edinburgh †)
Box	rthwick, William	d. 1654 (Edinburgh †)
Bo	ss, Samuel	1695 (589)
	ston, Beza	1661, 1680 (35 and 108)
	ston, Jabez	1663 (190)
	sworth, Thomas	1699 (564)
	teler, John	1748 (910)
	ulton, James	1775 (Wigan)
	ulton, Richard	1614
Bo	ulton, Thomas	1760 (Wigan)
Bo	wal, Robert	1621 (Edinburgh †)
Bo	wcher, Richard	1727 (805)
Bo	wden, John	1701
Bo	wden, Joseph	1687 (542)
	wler, Henry (? Bowles)	1757 (974)
	wler, Richard	1755 (1001)
	wler, Samuel Salter	1779 (1038)
	wyer, John	c. 1590
Во	wyer, Nicholas	1599, 1607
	wyer, Richard	1661, 1670
	wyer, William	1620, 1642
Bo	x, Edward	1720, 1740
	yden, Benjamin	1693, 1721 (511)
Bo	ovden. Thomas (I)	1706 (650)
Bo	oyden, Thomas (1) oyden, Thomas (2)	1735
Bo	ylson, Edward	1610
	ys, Nicholas	1728
	adford, Richard	1705
	adley, John	1613, 1657 (York)
	adley, Henry	1675 (268)
	adshaw, William	1542, d. 1566
	adstreet, Edward	1720 (785)
DI.	adstreet Richard	1727 (818)
DI.	adstreet, Richard	
	afield, Richard	1659 (408)
	ailsford, Peter	1667 (63)
Br	aine, John	1725
Br	aine, William	1681 (356)
	and, Henry	1672, d. 1677
	ant, John	1818
	asted, Henry	1692 (534)
Br	avell, Mary	1712
Br	avell, William	1684, 1692 (483)
	ay, Thomas	c. 1730
Br	ereton, George	1749 (Dublin)

Brett, Thomas H.	1773
Brettell, Henry	1665 (54)
Brettell, James	1688 (477)
Bridger, Joseph	1723
Bridges, Stephen	1692 (527)
Bright, Allen	1742 (Bristol)
Brigstock, Joseph	1733
Britton, Samuel	1760 (Bristol)
Broad, John	1704
Bro(a)dhurst, Jonathan (1)	1720 (735)
Bro(a)dhurst, Jonathan (2)	1731
Bro(a)dhurst, Saul	1748
Brocklesby, Peter (1)	1584, 1641
Brocklesby, Peter (2)	1618
Brocklesby, Peter (3)	1650 (42)
Brocks, David	1702 (604)
Brodshoe, Robert	1589 (Dublin)
Bromfield, John	1745 (919)
Bromfield, William	1777
Bromley, Joseph	1603
Bromley, William	1581, <i>d</i> . 1614
Brooke, Peter	1764
Brooke, William	1598, 1603
Brooker, Joseph	1679 (367)
Brooks, John (1)	1619, 1654
Brooks, John (2)	1699
Brooks, Rice (1)	1652
Brooks, Rice (2)	1678 (? 318)
Brown, Alexander	1717 (Edinburgh†)
Brown, Benjamin	1726 (814)
Brown, Coney John	1786 (1063)
Brown, George	1709–15 (Edinburgh)
Brown, Ignatius	1671 (Dublin)
Brown, John (1)	1712
Brown, John (2)	
Brown, John (3) (with	1757
Joseph)	1759 (1002)
	1739 (1002) 1744 (Dublin)
Brown, John	
Brown, John	1761 (Edinburgh†)
Brown, Joseph (with John)	1762 (1002)
Brown, Philip	1757
Brown, Richard (1)	1729 (837)
Brown, Richard (2)	1784
Brown, Robert	1614
Brown, William	1741 (Edinburgh†)

Brown and Swanson	1753–1770 (991)
Browne, John	1777, d. 1839
Browne, Martin	1686 (517)
Browne, Ralph	1660 (160)
Browne, Robert	d. 1745 (Edinburg †)
Browne, William	1705 (629)
Broxup, Richard	1757, 1796
Bryan, Egerton	1669, 1681 (228)
Bryant, John	1749
Bryce, David	1660 (Edinburgh †)
Bryden, Alexander	1717 (Edinburgh †)
Bryers, John	1715
Buckby, Thomas	1700, 1732 (572)
Buckby, T. and Hamilton	1716
Buckley, William	1689 (504)
Buckmaster, Thomas	c. 1630
Buclennand, James	1643 (Edinburgh †)
Budden, David (1)	1668 (163)
Budden, David (2)	1702 (605)
Budding, Henry	1739
Bugby, Thomas	1694
Bull, John	1660, <i>d.</i> 1693 (97) 1660, <i>d.</i> 1690 (67)
Bullevant, James	1660, d. 1690 (67)
Bullock, Henry	1670
Bullock, James	1750, 1770 (946)
Bunkell, Edward	1729-1756 (Edinburgh †)
Bunnerbell, Robert	1633 (Edinburgh †)
Bunting, Daniel	1783
Bunting, Robert	1691
Burch, Edward	1720
Burch, Samuel	1715
Burchell, Edward	1681 (365)
Burford and Green	1748 (929)
Burford, Thomas	1746, d. 1783
Burges, Edward	1638
Burges(s), Thomas	1701 (595)
Burgum and Catcott	1768–1779 (Bristol)
Burnett, Edward	1727
Burns, Robert	1694 (Edinburgh †)
Burroughs, Edmond	1747, d. 1778 (Dublin)
Burroughs, William	1768–1771 (Dublin)
Burt, Andrew	1802, d. 1851
Burt, Thomas	1607, 1630
Burton, John	1689
Burton, Mungo	1709 (Edinburgh †)

Burton, Robert	1611, 1619
Burton, Thomas	1560, d. 1569
Burton, William	1653, 1685 (38 and 354)
Busfield, John	1656–67 (York)
Busfield, Thomas	1653–65 (York)
Bush, R. & Co.	c. 1790 (Bristol)
Bush, Robert	1755 (Bristol)
Bush and Perkins	c. 1775 (Bristol)
Bush, William	1709
Bushell, John	1728
Butcher, Gabriel	1586, d. 1645
Butcher, James	d. 1720 (Bridgwater)
Butcher, Robert	1601, 1639
Butcher, Thomas	1612, 1652
Butler, James	1812 (Bristol)
Butler, John	1770
Butler, Joseph	1739
Butterton, Jonathan	1663-1683 (Dublin)
Buttery, James	1765
Buttery, Thomas (1)	1692 (496)
Buttery, Thomas (2)	1756 (973)
Buttery, William	1686 (434)
Buxton, John	1667 (142)
Byrne, Gerald	1791 (Dublin)
0.11	-(0-(-0-)

Cable, Joseph	1682 (383)
Cable, Peter	1717
Cable, Thomas	1706
Calcott, John	1699 (590)
Callie, William	1510
Cambridge, John	1687 (460)
Campbell & Co., Belfast	c. 1850 (Belfast)
Campion, John	1662, 1681
Canby, George (? Candy)	1694 (518)
Caney, Joseph	1744
Cardwell, John (1)	1723
Cardwell, John (2)	1756
Cardwell, William	1756
Cardynall, John	1473, 1480
Carloss, Edward	1718
Carman, John	1803
Carnadyne, Alex.	1595
Carpenter, Henry (1)	1708
Carpenter, Henry (2)	1740
Carpenter, Henry (3)	1757, 1816
. , (0)	

Carpenter, John (1)	1701 (587)
Carpenter, John (2)	1711, 1747 (718)
Carpenter, Thomas	1713
Carpenter & Hamberger	1794 (1066)
Carr, John (1)	1696 (537)
Carr, John (2)	1722 (752)
Carr, John (3)	1744
Carr, John (4)	1760
Carr, Richard	1737
Carr, Robert	1736
Carron, David	1722
Carter, A.	c. 1750-70 (? Guernsey)
Carter, James	1683, 1704 (392) 1688
Carter, John	
Carter, Joseph	c. 1726 (798)
Carter, Peter	1699, 1704
Carter, Richard	1725
Carter, Samuel	1771, d. 1827
Carter, Thomas	1632, 1648
Carton, Joseph	1659 (Dublin)
Cartwright, Thomas	1712, 1743 (698)
Cary, John	1543, 1552
Cary, Thomas	1685, (429)
Casimir, Benjamin	1704, 1722 (617)
Casse, Francis (Chassey?)	1667 (? 148)
Casse, Joseph (Chassey)	1633
Castle, Jonathan	1675, 1686 (293)
Castle, George	1654
Castle, Thomas	1685 (463)
Castle, Woodnutt	1732
Catcher, Edward	1544, 1561
Catcher, John	1577, 1585
Catcher, Thomas	1584
Cater, John	1725, 1761 (792)
Catlin, John	1693
Cavanagh, John	1761, d. 1772 (Dublin)
Cave, John (1)	c. 1650–90 (Bristol)
Cave, John (2) Cave, Thomas	1705 (Bristol)
Cave, Thomas	1684 (Bristol)
Cave, William	1728
Cayford, Francis	1707
Caesar, William	1712
Certain, John	1743
Chalk(e), William	1472, 1482
Chamberlain, Johnson and,	1735 (853)

Chamberlain, Thomas Chamberlain, Thomas Chambers, Richard (1) Chambers, Richard (2) Champion, Edward Chandler, Benjamin Chapman, Catesby Chapman, George Chapman, Oxton Charlesley, J. T. Charlesley, William Charleton, George	1500, 1536 1732, 1765 1684 (York) 1691–1731 (York) 1688 (Cork) 1721 1721 (756) 1772 1760 1730 1729, d. 1770 (842) 1758
Charleton, Nicholas Chase, Richard	1759 1670
Chassey, Joseph (see Casse)	1070
Chaulkley, Arthur	1722
Chawner, Robert	1568, 1580
Chawner, William	1757, 1761
Checkett	1661, 1669
Cherry, George	1729
Chesslin, Richard	1655, 1682
Chester, George	1586, 1634
Chetwood, James	1736
Child, John (1) (Chyld)	1534
Child(e), John (2)	1611, 1643
Child, John (3)	1700 (586)
Child, Lawrence (1)	1693, 1723 (526)
Child, Lawrence (2)	1727
Child, Richard	1758
Child, Stephen	1758
Christia William	1691
Christie, William	1652 (Edinburgh †)
Churcher, Adam	c. 1690 (Petersfield)
Claridge Regionin	1735, 1754
Claridge, Benjamin	1672
Claridge, Charles	1758, 1792 (981) 1724, 1739 (810)
Claridge, Joseph Claridge, Thomas	1716 (707)
Clark, Charles	1791
Clark, Christopher	1661 (206)
Clark, James	1784
Clark, John (1)	1661, d. 1698
Clark, John (2)	1756
Clark, John (3)	1765, d. 1788

Clark, Josiah	1690 (514)
Clark, Mark	1699
Clark, Samuel	1720
Clark, William (1)	1687 (484)
Clark(e), William (2)	1695 (529)
Clark, William (3)	
Clark and Greening	1721 (733)
Clark and Greening	c. 1675 (1007)
Clarke, Charles	1790–1810 (Waterford)
Clarke, George	1634, 1647 (York)
Clarke, James	1722 (Edinburgh †)
Clarke, James	1731
Clarke, James	1745
Clarke, John (1)	1765
Clarke, John (2)	1814, d. 1869
Clarke, Mark	1699
Clarke, Nathaniel	1720
Clarke, Richard	1696 (535)
Clarke, Samuel	1720 (York)
Clark(e), Thomas	1543
Clarke, Thomas	1671, 1711 (347)
Clayton, Richard	1741
Clayton, Robert	1772
Cleeve, Alexander (1)	1689, 1727 (457)
Cleeve, Alexander (2)	1716, 1745 (791)
Cleeve, Boucher	1736, 1757 (951)
Cleeve, Edward	1716
Cleeve, Elizabeth	1742
Cleeve, Giles (1)	1706 (832)
Cleeve, Giles (2)	1740
Cleeve, Mary	1742
Cleeve, Richard	1743
Clements, Christopher	1697 (Cork)
Clements, John	1747, 1782
Clemmons, Thomas	1713
Clenaghan, William	1740–1773 (Dublin)
Cliffe, Francis	1687 (476)
Cliffe, John (Clyffe)	1586, 1607
Cliffe, Thomas	1604, 1639
Clift, Joseph	1696
Clothyer, Robert	1670, 1710 (Chard, Som.)
Cloudesley, Nehemiah	
Cloudesley, Timothy	1675, 1710
Cloudesley, Timothy	1685, 1730
Coates, Archibald and William	IZOO (Clasgow)
	1799 (Glasgow)
Cobham, Richard	1732

Cock, Humphrey	1656, 1675
Cockney, William	1740–1770 (Totnes)
Cockins(k)ell, Edward	
	1693
Cocks, Samuel	1819 (1080)
Codde, Stephen	1458, 1467
Coe, Thomas	1807
Coggs, John	1712
Coke, John	1694 (512)
Coldham, John	1456, 1465
Coldwell, George	1773 (Cork)
Cole, Benjamin	1655, 1683
Cole, Jeremiah	1676, 1692 (316)
Cole, John	c. 1722 (765)
Coleborne, Richard	1724
Coles, Alexander	1693
Collet, George	1787 (Youghal)
Collet(t), Edward	1773
Collet(t), Thomas	1735 (862)
Collier, Joseph	1669, 1712 (172)
Collier, Nicholas	1583, 1604
Collier, Peter	1720, 1725 (730)
Collier, Richard (1)	1664, 1679 (131)
Collier, Richard (2)	1706, 1742 (649)
Collings, John	1690
Collins, Charles	1734–1753 (Cork)
Collins, Daniel	1776, 1805
Collins, Daniel Thomas	1804, 1812
Collins, Henry (1)	1704
Collins, Henry (2)	1751
Collins, James	1803, 1811
Collins, John	1667 (51)
Collins, Samuel	1732, 1768
Colmer, William	1683 (502)
	1668, 1686 (179)
Colson, Joseph (1)	
Colson, Joseph (2)	1700
Comer, John	1666 (? 132)
Compere, John	1696 (563)
Compton, Thomas	1802, 1817
Coney, John	1755
Cooch, Joshua	1761
Cooch, William (1)	1731, 1761 (844)
Cooch, William (2)	1775, 1795 (1029)
Cook, Edmund	1701
Cook, Richard	1756
Cook, Thomas	1588 (York)

Cook(e), William	1704
Cooke and Freeman	c. 1731 (824)
Cooke, Edward	1769
Cooke, Isaac	1692 (487)
Cooke, John	1770
Cooke, Ralph	1536 (Newcastle-on-Tyne)
Cooke, Richard	1599 (York)
Cooke, Samuel	1727 (813)
Cooke, Thomas	1690 (565)
Cooke, White	1720
Cooke, William	1795 (Bristol)
Cooper, Benjamin (1)	1677, 1703 (339)
Cooper, Benjamin (2)	1727
Cooper, George	1777, 1819
Cooper, John (1)	1681 (378)
Cooper, John (2)	1688 (465)
Cooper, Richard	1818
Cooper, Richard Cooper, Thomas (1)	1653 (31)
Cooper, Thomas (2)	1678 (326)
Cooper, Thomas (3)	1817
Cooper, Thomas (3) Cooper, Thomas (4)	1834
Cooper, William	1727
Cordell, John	1765
Cordell, John	1729 \} see Cardwell
Cordwell, William	1756
Cormell, John	1683 (410)
Cornewall, William	1614
Cornhill, Gilbert	1669 (164)
Corse, Thomas	1694
Cortyne, John	1630 (Edinburgh †)
Cotterell, Benjamin	1679 (382)
Cotton, Jonathan (I)	1704, 1736 (624)
Cotton, Jonathan (2)	1736, 1759 (866)
Cotton, Jonathan Thomas	1750
Cotton, Thomas (1)	1716
Cotton, Thomas (2)	1747, 1778
Coulter, William	1751 (Edinburgh †)
Coulthard, Alexander	1708 (Edinburgh †)
Coulton, Charles	1711
Coulton, Robert (1)	1642–1688 (York)
	1662–1677 (York)
Coulton, Robert (1)	1677–1688 (York)
Coursey John (1)	
Coursey, John (1)	1660, 1681 (49)
Coursey, John (2)	1682 (430)
Coutie, William	1619 (Edinburgh †)

Coverham, William	1423
Cowderoy, Thomas	1689 (473)
Cowdwell, John	1598, 1620
Cowes, Henry	1612, 1645
Cowes, Thomas	1583, 1605
Cowley, John (1)	1713
Cowley, John (2)	1724, d. 1742 (838)
Cowley, John (3)	1747
Cowley, William (1)	1662, 1695 (24)
Cowley, William (2)	1690, 1734
Cowling, William	1737 (892)
Cowper, James	1704 (Edinburgh †)
Cowper, Thomas	1721
Cowper, William	1750
Cox, Charles	1724
Cox, John	1679 (262)
Cox, Ralph	1656
Cox, Richard	1713 (763)
Cox, Stephen	1735 (Bristol)
Cox, William (1)	1708 (668)
Cox, William (2)	1756
Cranley, Charles	1692 (508)
Creak, James	1738
Crellin, Philip (1)	1788, d. 1838
Crellin, Philip (2)	1824
Crichton, George	1673 (Edinburgh †)
Crichton, James	1633
Crief, Richard	1639 (Dublin)
Cripps, James	1735
Cripps, Mark	1727, d. 1776 (786)
Crisp, Ellis	1668, 1680
Crook, Richard	1710
Crooke, Robert	1738 (907)
Crooke, William	1679 (351)
Cropp John	1677 (305)
Cropp, John Cropp, William (1)	1659 (76)
Cropp, William (2)	1706
Crosby, Daniel	1730, 1784 (Dublin)
Cross, Abraham	1695 (705)
Cross, William	1641, d. 1668
Crossfield, Robert	1701 (646)
Crostwayt, Richard	
(Crosthwaite)	1541, 1550
Crostwayte, Nicholas	Teet Teen
Crowde, William	1551, 1559
Clowde, william	1454, 1474

2202 02 2122 21221	
Crowe, William	1512, 1528
Crowley, Abraham	1720, 1760 (Penrith)
Crowson, John	1586
Cuffe, Thomas	1671 (Bristol)
Cuming, Richard	1780 (? Bristol)
Curd, Thomas	1729, 1756
Curns, Robert	1486, 1491
Curtis, Benjamin	1697
Curtis, James	1770, 1793 (Bristol)
Curtis, Henry	1642 (60)
Curtis, Peter (Curtys)	1525
Curtis, Thomas	1538, 1546
Curtis, William	1558, 1586
Cuss, John (Guss)	1455 (Bristol)
Cuthbertson, John	1712-1730 (Edinburgh †)
Cutlove, Thomas	1670 (276)
Dace, John	1667 (133)
Dackombe, Aquila (1)	1742, 1761 (913)
Dackombe, Aquila (2)	1768, d. 1819
Dackombe, Daniel	1820
Dadley, Edward	1775, 1829
Dadley, Elizabeth	1829
Dadley, Mary	1815
Dadley, William	1818, d. 1881
Dafforn, Joseph	1770 (? Bristol)
Dakin, Robert	1698 (555)
Daking, Joseph	1676
Dale, Richard	1709 (667)
Daly, John	1635 (Dublin)
Daniel, Thomas	1723
Daniell, Alexander	1812
Daniell, George	1806
Darling, Thomas	1723, 1761
Darling and Meakin	c. 1732-45 (843)
Daveson, William	1659, 1667
Davidson, Thomas	1807
Davidson, William	1693 (Edinburgh †)
Davis, John (1)	1687
Davis, John (2)	1715, 1758 (795)
Davis, Joseph	1720
Davis, Richard	1648, 1693
Davis, Thomas	1788
Davis, William	1748
Davison, George	1700–1728 (Dublin)

Davison, William	1733, d. 1738 (Dublin)
Davy, Edmund	1688 (Cornish)
Daw, William	c. 1736
Dawe, Richard	1780 (Exeter)
Dawe, Robert	1690 (Exeter)
Dawes, Richard	1627, 1662
Dawkins, Policarpus	1612, 1628
Day, John	1540, 1565
Day, Thomas	
	1703
Deacon, Thomas (1)	1675 (272)
Deacon, Thomas (2) Deacon, William	1780
Deaton, William	1755
Deale, George	1711
Deane, John	1775
Deane, Robert	1692 (582)
Deane, William	1731 (864)
Deeley, William	1726
de Jersey, William	1738, d. 1785 (970)
de St. Croix, John	1729 (833)
Devey, John	1768
Devon, John	1777
Dewell, Joseph	1734
Dickinson, Charles	1770–1817 (Cork)
Dickinson, Paul	1622
Dickinson, Robert	1762
Dickinson, Thomas	1662, 1667 (12)
Digby, John	1650, 1684
Digges, William	1699 (569)
Distin, Anthony	1698
Distin, Giles	1663, d. 1685
Ditch, William	1666, 1680 (107)
Dixon, Henry	1790
Dixon, John (1)	1688
Dixon, John (2)	1739
Dixon, William (1)	c. 1612
Dixon, William (2)	1704
Dobney, John	1744
Dobson, Richard	1746
Dockron, William	1576 (Dublin)
Dockwra, John	1662, c. 1680
Dodd, Edward	1669 (188)
Dodd, William	1661, 1665
Dodson, Thomas	1769 (1026)
Dolbeare, John	1630 (Ashburton Devon
Dolbeare, Joseph	1670 (Ashburton Devon

Dolly, Francis	1698
Donne, James	1701
Donne, John	1683, 1727 (422 and 488)
Donne, Joseph	1727 (804 and 807)
Donne, William	1722
Dorman, John	1815
Dottowe, John	1460
Dove, John	1696, 1713 (295)
Downton, John	1478, 1481
Dowell, Jeremiah	1721
Doyle & Co.	1798 (Dublin)
Doyle, Patrick	1771
Drabble, William	1819
Draper, James	1598
Draper, John	1638 (Dublin)
Draper, John	1712
Drayton, Symkin	1466
Drew, Edward	1728 (836)
Drew, John	1720 (030)
Drinkwater, Richard	1712 (682)
Drinkwater, Timothy	1666 (146)
Drury, John (1)	1637, 1673
Drury, John (2)	1705
Duckmanton, John	1690
Dudley, Edward	c. 1600
Duffield, Peter (1)	1645, 1688 (41)
Duffield, Peter (2)	1697
Dunch, Mary Ann	1724
Duncomb(e), John	
Duncomb(e), Samuel	c. 1706 (Birmingham) c. 1750 (Birmingham)
Dunn, John	1736
Dunne, Richard Dunning, Thomas (1)	1677, 1696 (292)
Dunning, Thomas (2)	1590, 1617
Durand Jones (1)	1617
Durand, Jonas (1)	1692, 1726 (557)
Durand, Jonas (2)	1732, 1763
Duxell, Richard	1616, 1629
Dyer, John	1680, 1703 (432)
Dyer, Lawrence (1)	1648, 1675 (135)
Dyer, Lawrence (2)	1704, 1728 (691)
Dyer, Richard	1699 (558)
Dyer, William	1656, 1682
Dymocke, William	1696 (531)

Eames, Richard

1694

Eastham John	1748
Eastland, Blackwell, Richard	
Eastwick, Adrian	1730
Eastwick, Francis	1694
Eastwick, Henry S.	1740
Eastwick, Isaac	1736
Ebsall, John	1706
Eddon, William (Eden)	1689, 1737 (? 75 and 470)
Edgar & Co.	1850 (Bristol)
Edgar, Preston & Son	1840 (Bristol)
Edgar & Son	1840 (Bristol)
Edgar, Robert	1684 (Edinburgh †)
Edgar, Thomas	1654 (Edinburgh †)
Edgell, Simon	1709
Edward(s), Henry	c. 1790 (Bristol)
Edwards, John	1718 (742)
Edwards, John	1739 (963)
Edwards, William	1697
Eells, Levy	1744
Eells, William	1752
Egan, Andrew	1769, 1783
Eiddy, James	1600 (Edinburgh †)
Elderton, John	1693, 1731 (507)
Elderton, Savage	1740
Elice, Wm. (Ellis)	1481, 1490
Elinor, Christopher	1755
Elliot, Bartholomew	1738, 1746 (891)
Elliott, Charles	1704
Elliott, Thomas	1553, 1604
Elliott, William	1823
Ellis, Edward (1)	1700
Ellis, Edward (2)	1762
Ellis, John	1639 (Bristol)
Ellis, John (1)	1751, 1761
Ellis, John (2)	1754
Ellis, Samuel (1)	1721, d. 1773 (746)
Ellis, Samuel (2)	1754
Ellis, William (1)	1702, 1729 (606)
Ellis, William (2)	1726 (778)
Ellwood, William (1)	1693, 1733 (540)
Ellwood, William (2)	1723, 1775
Elton, John	1725
Elwick, Henry	1707 (775)
Elwood, James	1777–1790 (Dublin)
Elyot, Thomas	1557, d. 1579
, , ========	-5517517

Embry, William	1727
Emes, John (Senior)	1673, d. 1700 (244)
Emes, John (Junior)	1700 (578)
End, John, Jacob	1815
End, Richard	-
	1777
End, William	1774–1805 (Limerick)
Engley, Arthur	1710 (672)
Enos, Thomas	1612 (Dublin)
Estwicke, Francis	1694
Evans, Charles (1)	1737
Evans, Charles (2)	1760
Evans, Ellis	1690
Evans, Humphrey	1730, 1780 (Exeter)
Evans, James	1816
Evans, John	
	1720
Evans, Richard	1756
Evatt, Thomas	1795
Eve, Adam	1769
Eve, Joseph	1725
Everard, George	1696 (532)
Everett, Henry	1717
Everett, James	1711 (694)
Ewen, John (Yewen)	1700 (585)
Ewsters, Richard	1717
Ewsters, Thomas	1746, 1779
Exall, Christopher	1700
Excell, James	1718 (751)
Eyre, William	1452, 1475
Facer, Samuel	1675 (243)
Fairbrother, E.	c. 1723–50
Fairhall, Joshua	1684 (405)
Farley, John	1727
Farmer, Edward	1786
	1688
Farmer, George	_
Farmer, Henry William	1811
Farmer, John (1)	1687
Farmer, John (2)	1719
Farmer, Richard	1729
Farmer, Thomas	1688
Farmer, William (1)	1744 (914)
Farmer, William (2)	1765 (1014)
Farnan, John	1764
Farshall, Richard	1692
Farthing, Roger	1573
	-5/5

Fasson, Benjamin	1797, 1815
Fasson, John (1)	1725, 1760 (826)
Fasson, John (2)	1753, d. 1769 (964)
Fasson, John (2) Fasson, Thomas	1783, d. 1844 (1048)
Fasson, William	1758, d. 1800 (977)
Fasson & Son	c. 1785–1810
Faulkner, Thomas	1678 (321)
Fawcet, James	1749
Fawler, Daniel	1698
Febbard, Richard	1690
Febbert, William	
Feild, Henry	c. 1720
	1693 (528)
Feildar, Henry (Fieldar)	1704 (673)
Fell, George John	1796
Fennick, William	1706 (645)
Ferguson, Alexander	1678 (Edinburgh†)
Ferner, John	1595
Festam, Thomas	1749 (Dublin)
Fethers, Francis	1815
Fewtrell, Edward	1605
Fiddes, James	1754 (1003)
Field, Edward Spencer (1)	1749, 1771
Field, Edward Spencer (2)	1787
Field, Henry	1719
Field, Robert Spencer	1782
Fielding, Charles Israel	1778
Finch, John	c. 1670–80
Findlay, Robert	1717 (Edinburgh †)
Fisher, Paul	1798, d. 1857 (1071)
Fisher, Samuel	1744
Fisher, William	1771
Fitzpatrick, John	1768 (Dublin)
Fitzrere, Patrick	1559 (Dublin)
Flanagan, James	1730 (Dublin)
Fleming, William	1717 (Edinburgh)
Fletcher, Hannah	1714
Fletcher, James	1775
Fletcher, Richard	1677, 1701 (312)
Flood, John	1537
Flood, Walter	1630 (Dublin)
Floyd, John	1748, 1796
Fly and Thompson	c. 1737 (814)
Fly, Timothy Fly, William	1710, 1739 (675)
	1676, 1691 (328)
Fontain(e), James	1752, 1786 (961)

Ford, Abraham	1719, 1733 (717)
Ford, John	1694, 1726
Ford, Roger	1692–1752 (Dublin)
Ford, William	d. 1731 (Dublin)
Forman, Simon	1608
Foster, Benjamin (1)	1706, 1727 (639)
Foster, Benjamin (2)	1730 (847)
Foster, Boniface	1560, 1574
Foster, Edward	1734
Foster, John (1)	1735 (897)
Foster, John (2)	1789, 1837
Foster, Joseph	1757, 1782 (1047)
Foster, Thomas	1742
Foster, William	1675, 1683 (386)
Fothergill, M.	1745 (Bristol)
Fountain, Thomas	1626, 1685 (36)
Foull, Thomas	1541
Fowler, John	1744
Fowler, Samuel	1769
Fox, Edward	1602, 1637
Fox, Thomas	1689
Fox, William	1645, 1675
Foxon, William	1723 (846)
Foy, Philip	c. 1725 (Exeter)
Francis, John	1663, 1681 (30)
	. ,
Franklyn, Jeremiah	1729
Franklyn, Richard	1689, 1730
Freeman, Henry	1669, 1687 (124)
Freeman, James	d. 1772 (Dublin)
Freeman, Thomas Freeman, William	1694
Freeman, William	c. 1727
French, Alexander	1657, d. 1684 (10)
French, John (1)	1630, d. 1677 (9)
French, John (2)	1686 (456)
French, John	1784 (Bristol)
Frend, Nicholas	1620 (Dublin)
Frend, Robert	1625
Friend, Edward	1636 (Dublin)
Frith, Henry	1675 (242)
Frith, John	1662, 1670
Frith, John, Major	1760
Frith, Thomas,	1693, 1713 (601)
Frith, William	1700
Froome, William	1760 (987)
Frost, John	
root, Joini	1777

 Fryer, John
 1688 (Clonmel)

 Fryers, John, Sir
 1693, 1715 (498)

 Fulham, Edward
 1614

 Fulham, John
 1602, 1651

 Fulshurst, Abraham
 1689

 Funge, William
 1701

Galbraeth, Robert 1840 (Glasgow) Gamble, Nicholas 1687 Game, Hugh 1411, 1436 Gardiner, John 1764 (Edinburgh †) Gardiner, Richard 1669, c. 1680 (177) Gardner, Allen 1555, 1578 Gardner, Thomas 1679, c. 1686 (364) Garioch, Patrick 1735 (880) Garle, Christopher 1714 Garmentin, William 1613 (Edinburgh †) Garton, Joseph 1659, d. 1665 (Dublin) Gascar, Percival 1581, 1597 Gasse, James 1666, 1680 Gauls, —(?) Geary, Thomas c. 1810 (Exeter) 1740 (Cork) Gee, George 1745, 1764 (Dublin) Geffers, — 1688 (Cork) George, William 1670 Geoghegan, John 1714 (Dublin) Gepp, Matthew 1715 Geraghty, John 1816 (Dublin) Gerardin and Watson c. 1825 (London) Gery(e), John 1553, 1574 Gibbings, J. G. ? 1850 (Cork) Gibbons, Francis 1664, 1683 (65) Gibbs, Henry 1729 Gibbs, James 1741 (917) Gibbs, John 1756, 1781 Gibbs, Lawrence 1657, 1680 Gibbs, William 1804 (1077) Gibson, Edward 1719 (Edinburgh †) Gibson, Elizabeth 1762 Gibson, Robert 1668 Gibson, Thomas 1626 (Dublin) Giddings, Joseph c. 1710-25 Giffin, Jonathan 1723 Giffin, Thomas (1) 1709, 1757 (681) Giffin, Thomas (2) 1759, 1777 (1006)

Gilbert, Edward	1613, d. 1667
Giles, William	1737, d. 1771
Gill, Robert	1437–1493 (York)
Gillam, Everard	1702, 1714 (637)
Gillam, Jonas	1708
Gillam, William	1698 (550)
Gillate, George M.	1807
Gilligan, Roger	1709
Gillman, Henry	1734 (Cork) 1691, 1728 (? 486 and 640)
Gisburne, James	
Gisburne, John	1696 (536)
Gisburne, Robert	1661, 1691
Glass, William	1754
Glazebrook, James	1676 (270)
Gledstanes, George	1610 (Edinburgh †)
Glover, Edward	1610, 1620
Glover, Henry	1611, 1620
Glover, John	1779 (Edinburgh †)
Glover, Richard	1559, 1611
Glover, Roger	1605, 1615
Glover, Thomas	1814
Glynn, William Goater, Thomas	1691
Goater, Thomas	1729, 1758
Goble, Nicholas	1680 (374)
God, John	1561, 1601
Goddard, William	1655, 1670
Godeluk, Thomas	1468
Godfrey, Joseph Henry	1807 (1081)
Godfrey, Peter	1688 (Cornwall)
Godfrey, Stephen	1679
Godfrey, William	1796
Going, Richard	1715, 1766 (Bristol)
Gold, Richard	1737
Goldie, Joseph	1633 (Edinburgh †)
Gollde, Wm. (? Crowde)	1470
Good, Robert	1709
Goodale, John	1454, 1457
Goodison, Richard	1771–1788 (Dublin)
Goodluck, Robert	1771
Goodluck, William Richard	1823
Goodman, Edward	1669 (157)
Goodman, Harry	1693 (510)
Goodman, Philip	1587, 1596
Goodwin, Richard	1783
Goodwin, Thomas	1707, 1716 (671)
	-1-13-1 (*1-)

Goodyear, Thomas	
(Gudeyere)	1534, 1588
Goose, Thomas	1770
Gorwood, Joseph	1741 (York)
Goslin, Thomas	1721
Gosling, Thomas	1725 (794)
Gosling, Thomas Gosnell, William	1659, 1670
Gould, William	1712
Gowet, Robert	1621 (Edinburgh)
Graham, Basil	1699 (560)
Graham, John	1758
Graham and Wardrop	c. 1770 (Glasgow)
Grahame, Alexander	1654 (Edinburgh †)
Grainge, John	1799, 1816
Grainger, William	1597, c. 1650
Grant, Edward	1698, 1741
Grant, Joseph	1801, <i>d</i> . 1844
Gratton, Joseph	1817, 1839
Graunt, John	1626
Grave, Thomas	c. 1710
Graves, Alexander	1752
Graves, Francis	1621, 1629
Gray, John	1757
Gray, Richard	1682 (396)
Gray, Thomas	1782
Gray and King	c. 1710 (711)
Greatrakes, James	
(? Greatrix)	1780 (Cork)
Greatrix, John	1783 (Cork)
Greaves, John (1)	c. 1609
Greaves, John (2)	1733
Green, James	1748, 1778
Green, John Gray	1793 (1068)
Green, Joseph	1803
Green, Nathaniel	1722
Green, William	1676, 1688 (313)
Green, William Sandys	1725, 1737 (827)
Greene, Jacob	1670
Greenbank, William	c. 1669–1710
Greener, Thomas	1700 (602)
Greenfell, George	1757, d. 1784 (976)
Greening, Richard	1756
Greenwood, John (1)	1669 (187)
Greenwood, John (2)	1731
Greenwood, Thomas	1759 (997)

Gregge, John (Grigge) Gregg(e), Robert Gregg(e), Thomas Gregory, Edward (1) Gregory, Edward (2) Gregory, George Grendon, Daniel Greschirche, William de Grey, John Grey, Richard Gribble, William Grier, James Grier, John Griffith, John Griffith, John Griffith, Richard Grigg, Samuel Grimshaw, James Grimsted, John Groce, Thomas Groome, Randell Groome, William Grove, Edmund Grove, Edmund Groves, Edward Groves, Thomas Grunwin, Gabriel Grunwin, Richard Guld, John Gunning, James Gunthorp(e), Jonathan Gurnell, John Guy, Earle of Warwick Guy, John Guy, Samuel Gwilt, Howell	1722 1667, 1683 (215) 1639, 1677 1695 (Bristol) c. 1705–35 (Bristol) 1740 1735 (871) d. 1350 1712 1706 1688 (Cornwall) 1694 1701 (Edinburgh †) 1749 1747 (Bristol) 1762 (Cork) 1734 (879) 1714 1676 (324) 1737 (876) 1615, 1624 1698 (1076) 1753 1779 1677 (294) 1452, 1457 1681 (401) 1714, 1729 (677) 1677 (Edinburgh †) 1782 (Eyrecourt) 1699 1768 (1023) cf. Thomas Wigley 1692 1729 (845) 1607, 1709 (623)
Gwilt, Howell	1697, 1709 (623)
Gwyn, Bacon	1675
Hadley, Isaac Hagger, Stephen Kent Hair, William Hale and Sons Hale, George Hale, Thomas Halford, Simon	1656, 1682 (? 44) 1754 (1017) 1695 c. 1800-50 (Bristol) 1676 (245) 1775 (Bristol) 1726 (830)

Halifax, Charles	1669, 1685 (141)
Halifax, Francis	1690
Hall, James	1699
Hall, John (1)	1810
Hall John (2)	
Hall, John (2)	1823
Hall, Robert (1)	1639
Hall, Robert (2)	1793
Hall, Thomas (1)	1620
Hall, Thomas (2)	1711
Hall, William (1)	1666 (128)
Hall, William (2)	1680 (338)
Hall, William (3)	1687 (447)
Hamberger, John	1794, 1819
Hamberlin, John	
	1671 (186)
Hamilton, Alexander	1721, 1745 (839)
Hamilton, William Hamilton, William	1613 (Edinburgh †)
	1760–1796 (Dublin)
Hamlin, John	1678 (329)
Hammerton, Henry (1)	1706, 1733 (642)
Hammerton, Henry (2)	1748
Hammerton, Richard	1751, 1767
Hammon, Henry	1647–1691 (York)
Hammon, John	1647–1656 (York)
Ham(m)ond, George,	1693, 1709 (515)
Hamon, Samuel	1614
Liamonis Camuel	
Hancock, Samuel	1677, 1714 (375)
Hands, Edward	1704 (628)
Hands, James	1718
Hands, Richard	1727 (834)
Handy, John	1754
Handy, Thomas	1784
Handy, William (1)	1728, 1746 (884)
Handy, William (2)	1755
Hankinson, John	1693 (525)
Harbridge, William	1774
Hardeman William	1610
Hardeman, William	
Harding, Jonathan (1)	1693
Harding, Jonathan (2)	1722
Harding, Robert	1666, 1672 (121)
Hardman, John	1690, 1730 (Wigan)
Harendon, Alex	1641, 1664
Harford, Henry (1)	1677 (395)
Harford, Henry (2)	1715
Harper, Edward	1572
Harper, John	1709
ran Por, Joine	-1-3

Harraben, William	1712 (Dublin)
Harris, Daniel	1708–1729 (Cork)
Harris, Jabez	1694, 1734 (538)
Harris, John	1709 (660)
Harris, Richard	
	1763
Harris, William	1746 (966)
Harrison, John (1)	1651–1684 (York)
Harrison, John (2)	1677–1697 (York)
Harrison, John (3)	1741–1749 (York)
Harrison, Rufus	c. 1750 (York)
Harrison, William	1748 (931)
Hartshorne, Michael	1676, 1693
Hartwell, Gabriel	1667 (217)
Hartwell, Henry	1667 (98)
Hartwell, John	1736 (925)
Hartwell, Peter (1)	1667, 1686
Hartwell, Peter (2)	1688
Harvey, William	1712 (Dublin)
Harvie, James	1654 (Edinburgh †)
Harvie, John	1643 (Edinburgh †)
Harvye, John	1555
Haryson, Thomas	1483
Haslam, William	1734
Hasselborne, Jacob	1668, 1722
Hassell, Baptist	
Hassell James	1599
Hassell, James Hassell, Thomas	1792
	1554, 1566
Hastings, James	1614
Hatch, Henry	1675 (302)
Hatfield, William	1627
Hathaway, James (1)	1734
Hathaway, James (2)	1754
Hathaway, John	1725 (790)
Haveland, Miles	1660, 1668
Havering, John	1699
Haward, Thomas (1)	
(Howard)	1636, 1666 (6)
Haward, Thomas (2)	1663, 1671 (17)
Hawclif, Simon	1568
Hawford, Thomas	c. 1658 (? 85)
Hawk(e), Thomas	1564, 1588
Hawkes, Edward	1655, 1675
Hawkesford, Roger	1574, 1601
Hawkins, John	1738
Hawkins, Richard	1726
Tan is activities	-/

Hawkins, Thomas	1742
Hawkins, Thomas	1756 (975)
Hawkins, Walter	1608
Haws, John	1791
Hayes, Hugh	1697
Hayes, Thomas	1746
Haynes, John	1688
Haynes, William	1556, 1560
Hayton, John	1743, 1748 (918)
Hayton, Paul	1676 (271)
Healey, William	1752 (960)
Heaney, John	1767–1798 (Dublin)
Hearman, William	1801
Heath, Edward	1625, 1660
Heath, John (1)	1618, 1634
Heath, John (2)	1694, 1706 (519)
Heath, John (3)	1711 (744)
Heath, Richard	1666, 1699 (192)
Heath, Samuel	1715
Heath, Thomas (1)	1709
Heath, Thomas (2)	1714
Heath, William	1660, 1680
Heatley, Alexander	1700
Heaton, William	1687 (? 335, and 342)
Henley, William (? Healey)	1723
Henning, Thomas	1693
Henson, Thomas	1614
Herne, David	1756, 1793
Hernie, James	1651 (Edinburgh†)
Herrin, John	1693-1740 (Edinburgh †)
Herring, James	1692 (Edinburgh †)
Hesketh, Henry	1698
Heslopp, Richard (Heslop)	1700 (641)
Hewett, Joseph	1668, 1680 (? 112)
Hewitt, John	1723
Heydon, Samuel	1715
Heyford, William	1698 (556)
Heyrick, David	1676 (269)
Heythwaite, Michael	1553
Hickes, Daniel	1690
Hickes, Peter	1706
Hickingbotham, Francis	1693
Hickling, Thomas (1)	1676, d. 1712 (281)
Hickling, Thomas (1) Hickling, Thomas (2)	1717 (740)
Hicks, Thomas	1669, 1698 (173)

Hide, Benjamin Higdon, Joseph Highmore, William Higley, Samuel Hill, Hugh Hill, Robert Hill, Roger Hill, Thomas Hill, Thomas Hill, Thomas Hill, Walter (Hyll) Hill, William (1) Hill, William (2) Hill, William Hilton, John de Hinde, John (1)	1741 1676, 1683 (284) 1741 (894) 1775 (1033) 1597, 1625 1724 1791 1696 1741 (Dublin) 1795 1583, 1601 1607, 1641 1649, 1672 1808–1829 (Dublin) c. 1350 1767, 1796 (1024)
Hinde, John (2)	1800
Hindes, John	1760
Hinman, Benjamin	1715
Hitchcock, Evan	1708
Hitchcock, John	1690
Hitchens, John	1743, 1788
Hitchins, John	1758, 1786
Hitchins, William (1)	1705 (663)
Hitchins, William (2)	1732
Hitchins, William (3)	1759 (984)
Hitchman, James	1701, 1716, (593)
Hitchman, Robert	1737, 1761 (877)
Hoare, Richard	1655, 1693 (28)
Hoare, Thomas	1718, 1728
Hobson, Thomas	1609, 1614 (Bristol)
Hockley, Richard	1715
Hodge, Joseph	1660
Hodge, Robert Piercy	1772, 1802 (1025)
Hodge, Sampson	1707 (Tiverton)
Hodge, Thomas	1720 (Tiverton)
Hodge, Thomas Bathurst Hodgert, William Hodges, John (1) Hodges, John (2) Hodges, Joseph (1) Hodges, Joseph (2) Hodges, Joseph (3)	1810, d. 1852 1690 (Dublin) 1649, 1680 1804–1808 (Dublin) 1660, 1682 1697 1718
Hodgkin, Thomas	c. 1750–80 (Bristol)
Hodgkins, Edward	1669 (174)

TT 1 11 4 .1	
Hodgkis, Arthur	1635
Hodgson, Thomas	1676 (277)
Hogg, William	c. 1760, 1800 (Newcastle)
Holl(e)y, John	1689, 1706 (461)
Hollford, Stephen	1664, 1668
Hollinshead, William	1687
Holloway, Richard	1745
Holman, Ary	1764, 1791
Holman, Edward	1688 (454)
Holmes, George	1742, 1752 (908)
Holmes, John	1755
Holmes, Joshua	1759
Holmes, Mary Elizabeth	1751
Holmes, Thomas	1709
Holstock, John	1571
Home, John	1749, 1771 (965)
Hone, John	
	1732
Hooper, John	1765
Hooper, Thomas	1784
Hopkins, Joseph	1660, 1667 (? 136)
Hopkins, Thomas	1700 (584)
Hoppey, George	1777
Horrod, Thomas	1693 (622)
Horton, William	1725 (812)
Hoskins, John	1735
Hoskins, Thomas	1763
Hoskyn, Henry	c. 1680–1730 (Launceston)
Hoskyn, John	c. 1750 (Truro)
Houldsworth, Thomas	1653–1680 (York)
How, John	1762
How, Josiah	1713
How, Thomas	1714
Howard, William (1)	1671, 1702 (204)
Howard, William (2)	1745, d. 1785 (920)
Howe, John	1716
Howell, Ralph	1623
Hubbard, Henry	1731
Hubbard, Robert	1690, 1728
Hubert, Ísaac	1755
	1770, 1804 (1021)
Hudson, John Hudson, Thomas	1604 (York)
Hudson, William	1729
Hughes, James	1691 (493)
Hulls, John (1)	1662, 1709 (256)
Hulls, John (2)	1716
110110, Joint (2)	1,10

Hulls, John (3)	1799
Hulls, John (4)	1823
Hulls, Ralph	1653, 1682 (46 and 208)
Hulls, Samuel	1693
Hulls, Thomas	1825
Hulls, William (1)	1668 (161)
Hulls, William (2)	1717, 1744 (712)
Hulse, Charles	1690 (466)
Hume, George	1700 (598)
Hume, Robert	1790
Hummerstone, Wm.	1591
Hunt, James	1699
Hunt, John	1701
Hunt, Samuel	1743
Hunt, Thomas	1666, 1675 (194)
Hunter, Alex.	1682 (Edinburgh †)
Hunter, William	1749 (Edinburgh †)
Hunton, Nicholas	1661, 1670 (13 and 143)
Hunton, William	1682 (376)
Hurdman, William	1611, 1625
Hurst, William	1676, d. 1685 (278)
Husband, William	1712
Hussey, Thomas	
	1727
Hustwaite, Robert	1571
Hustwaite, Thomas	1521, 1523
Hustwayte, William	1538, 1559
Hutchens, James	1744
Hutchins, William	1732
Hutchinson, Katharine	1684 (York)
	1663–1684 (York)
Hutchinson, William (1) Hutchinson, William (2)	1698–1738 (York)
Hux, Elizabeth Gray	1763
Hux Thomas	1723, 1739 (754)
Hux, Thomas Hux, William (1)	
Tux, William (1)	1700, 1728 (574)
Hux, William (2)	1751
Hux, William (3)	1784
Hyatt, Humphrey	1675 (241)
Hyatt, John	1658, 1665
Hynge'stworth, N. de	1364
. 8	
Ianson, John	c. 1730
Iempson, Solomon	1696
Iles, Edward	
	1674 (257)
Iles, John	1704, 1709
Iles, Nathaniel	1702, 1719

Iles, Richard	1677
Iles, Robert	1691, 1735 (520)
Ingles, Arthur	1710
Ingles, Jonathan	1668, 1702 (19 and 170)
Ingles, Samuel	1666 (199)
Inglis, Robert	1663 (Edinburgh †)
Inglis, Thomas (1)	1616 (Edinburgh †)
Inglis, Thomas (2)	1647–1668 (Edinburgh †)
Inglis, Thomas (2) Inglis, Thomas (3)	1686 (Edinburgh †)
Inglis, Thomas (4)	1719–1732 (Edinburgh †)
Ingole, Daniel	1656, 1688 (52)
Ingram, Roger	1648 (Cork)
Ireland, Ann	1690
Irving, Henry	1750 (952)
Isade, Roger	1569, 1587
Ives, Richard	1688
Jackman, Nicholas	1699, 1735 (612)
Jackson, Henry (1)	1723 (760)
Jackson, Henry (2)	1757
Jackson, John (I)	1566, 1589
Jackson, John (2)	1674, 1712 (282)
	1728 (855)
Jackson, John (3)	
Jackson, John (4)	1731
Jackson, John (5)	1735
Jackson, Michael	1757
Jackson, Robert	1780, 1801 (1051)
Jackson, Samuel (1)	1658 (11)
Jackson, Samuel (2)	1667, 1714 (479)
Jackson, Samuel (3)	1669 (Dublin)
Jackson, Startup	1635, d. 1654
Jackson, Thomas (1)	1627
Jackson, Thomas (2)	1717
Jackson (Jaxon), William (1)	1512
Jackson, William (2)	1662, 1687 (68)
Jacob, Richard	1668 (166)
Jacobs, John	1632, d. 1683
Jacomb, Robert	1660, 1686 (236)
James, Anthony	1685, 1713 (391)
James, Daniel	1691
James, Lewis	1670 (184)
James, John	1772 (Dublin)
James, Patten	1744
James, Richard	1709 (666)
James, Thomas	1726 (777)

James, William (1)	1689
James, William (2)	1749, d. 1782
James, William (3)	c. 1750 (Dublin)
Jameson, James	1680
Jann, Thomas	1520, 1535
Jaques, John	1724
Jardeine, Nicholas	1573
Jarrett, John (1)	1620, 1656
Jarrett, John (2)	c. 1770–75 (Gloucester)
Jarrett, William	,
Jeffereys, Benjamin	1738
	1731
Jeffereys, Joseph	1757 (986)
Jeffereys, Samuel	1734, 1739 (856)
Jefferies, George	1689
Jeffin, Thomas	1709
Jenkins, Edward	1805
Jenner, Anthony	1754 (1015)
Jennings, Theodore (1)	1713, 1747 (680)
Jennings, Theodore (2)	1757
Jerome, William	1759
Jersey, William de	1738, 1773 (970)
Jeyes, John	1763
Jobson, Matthew	1634, 1666 (York)
Johns, John	1688 (Cornish)
Johnson, Alexander	1688, 1695 (Dublin)
Johnson and Chamberlain	c. 1735 (853)
Johnson, Gabriel	1785
Johnson, John (1)	1652, <i>d.</i> 1675
Johnson, John (2)	1715
Johnson, Luke	1713, 1734 (749)
Johnson, Nicholas	1667 (332)
Johnson, Richard	1688
Johnson, Samuel	1711 (Dublin)
Johnson, Thomas	1722
Johnson, William	1698
Johnston, James	1688–1719 (Dublin)
Johnston, William	1676 (361)
Jolly, John	1714 (Edinburgh †)
Jones, Charles	1786 (1062)
Jones, Christopher	1709
Jones, Clayton	1746
Jones, Henry	1675 (253)
Jones, John (1)	1700, 1745 (553)
Jones, John (2)	1707
Jones, John (3)	1727 (822)
· · · · · · · · · · · · · · · · · · ·	

Jones, Joseph	1748
Jones, Mary	1719
Jones, Nicholas	1608
Jones, Owen	1647
Jones, Philip	1733
Jones, Richard	1728
Jones, Robert	1657, 1678 (27)
Jones, Samuel	1687
Jones, Seth	1719 (714)
Jones, Thomas (1)	1613, d. 1650
Iones, Thomas (2)	1755 (990)
Jones, Thomas (2) Jones, William (1)	1648, 1676
Jones, William (2)	1668 (26)
Jordan, John	1727 (828)
Jordan, Thomas	1732
Jordon, James	1691
Joselyn, William	1734
Joseph, Henry	1736, 1771 (906)
Joseph, Henry and Richard	1775-87 (1054)
Joseph, Richard	1785, 1806 (1054)
Joseph, Sarah	1780
Joyce, John	1683 (393)
Judson, Farshall	1755
Jupe, Elizabeth	1781
Jupe, John	1736, 1761 (878)
Jupe, Robert	1697, 1737 (621)
	,,,,,,,,,,,,,,,,,,,,,,,,,,,,,,,,,,,,,,,
Keble, Thomas	1674, 1692
Kelk, James	1671, 1688
Kelk, Nicholas	1638, 1686 (5)
Kelk, Thomas	1663, 1667 (319)
Kellingworth, —	cf. Hillingworth
Kellowe, Robert	1715 (Edinburgh †)
Kelsall, Arnold	1740
Kempster, John	1638, 1666
Kendale, John (Rendale)	1451
Kendrick, John	1670 (291)
Ken(d)rick, John	1737, 1754 (885)
Kent, Edward	1677, 1691 (385)
Kent, George	c. 1670-90 (Lincoln)
Kent, John	1718, 1749 (736)
Kent, Stephen	1766
Kent, William	1623
Kentish, Simon	1693
Kenton, John	1675, 1717 (250)
, ,	131-1-1 (-3-)

Kerslake, ?	c. 1720 (Crediton)
Keyborne, George	1817 (Dublin)
Keyte, Hastings	1730
Killingworth, Clement	1553
Kimberley, Francis	1609, 1634
Kimpton, Nathaniel	1697
King, Abraham	1663, 1693
King, Anthony	1745–1763 (Dublin)
King, Charles	1830 (Cork)
King, Denis	1618 (Dublin)
King, James	1716 (711)
King, John	1632 (Dublin)
King, John (1)	1669, 1694
King, John (2)	1757, 1761 (995)
King, Joseph	1682, 1709 (379)
King, Richard (1)	1704, 1738 (648)
King, Richard (2)	1714, 1746 (723)
King, Richard (3)	1745, d. 1798 (same mark as above)
King, Robert	1698, 1711
King, Thomas (1)	1675 (259)
King, Thomas (2)	1719
King, William (1)	1706
King, William (2)	1732
King, William Harrison	1786 (1057)
Kinge, John	1632 (Dublin)
Kinnear, Andrew	1750 (Edinburgh †)
Kinnieburgh and Sons	1823 (Edinburgh †)
Kinnieburgh, Robert	1794 (Edinburgh †)
Kinnieburgh, Sheriff	1803 (Edinburgh †)
Kirby, Thomas	1722 (806)
Kirke, Thomas	1728 (773)
Kirton, John	1699 (579)
Knight, Alex.	1696 (Dublin)
Knight, Francis	1678, 1692 (345)
Knight, James (1)	1675 (261)
Knight, James (2)	1704
Knight, Richard	1730
Knight, Robert	1770 (1053)
Knight, Robert Benjamin	1808
Knight, Samuel	1703 (689)
Knipe, Stephen	1718
Knowles, Tobias	1625, d. 1668
Kymbley, Francis	c. 1614
, ,,	20000 C 2000000000000000000000000000000

Taalafand Talan	
Lackford, John	1636, 1675
Laffar, John	1706, 1714 (684)
Lake, Richard	1692
Lamb, Catherine	1737
Lamb, James	1737 (Dublin)
Lamb, Joseph	1708, 1738
Lamb, Penelope	1734
Lambert, John	1739
Lancaster, Alexander	1711, 1729 (750)
Langdale, John	1663 (? 23)
Langford, John (1)	1719, 1757 (713)
Langford, John (2)	1780
Langford, Thomas	1751 (969)
Langford, William	1671, 1681
Langley, Adam	1656, 1680 (91)
Langley, John (1)	1692
Langley, John (2)	1716 (727)
Langtoft, Robert	1499, 1520
Langtoft, Thomas	1472
Langton, John	1731, d. 1757 (865)
Lansdown, William	c. 1740 (Bristol)
Lanyon, Thomas	c. 1715 (Bristol)
Large, William	1455, 1477
Larkin, Francis	1677, 1698 (? 309)
Lasas, Lewis de	1696
Lather, James	1691 (Dublin)
Latomes, George	1737
Laughton, John	1668, 1692 (297 and 480)
Law, John	1660 (Edinburgh †)
Law, John	1759
Law, Samuel	1768 (1020)
Lawe, George	1553
Lawlor, John	1770 (Carlow)
Lawrance, Edward	1713, 1727 (741)
Lawrence, John (1)	1684, 1723 (426)
Lawrence, John (2)	1724, 1749
Lawrence, Stephen (1)	1661, 1689 (123 and 357)
Lawrence, Stephen (2)	1708
Lawson, Daniel	1749, 1755 (938 and 942)
Lawson, John	1713
Lawton, Richard	1453
Lay, Henry	1724
Laycock, John	1755
Layton, William	1729
Lea, Francis	1651, 1675 (18, 39 and 40)
,	5 , == 15 (== , 5)

Leach, Jonathan (1)	1732
Leach, Jonathan (2)	1742, 1769 (992)
Leach, Thomas (I)	1677, 1691 (304)
Leach, Thomas (1) Leach, Thomas (2)	1721, 1747 (725)
Leach, William	1770
Leadbetter, Edmund	1699
Leadbetter, John	1763
Leak, William	1703
Leapidge, Edward (1)	1699, 1724 (568)
Leapidge, Edward (2)	1728
Leapidge, John	1737, 1763
Leapidge, Thomas	1691, d. 1709 (492)
Lee, Benjamin	c. 1750 (Bristol)
Lee, Edward	1689
Lee, Thomas Charles	1785
Leeson, John (I)	1644, 1680 (15)
Leeson, John (2)	1673 (237)
Leeson, Robert	1611, 1648
Leeton, Robert	1691
Leggatt, James	1755
Leggatt, Richard	1722, 1775 (771)
Leigh, James	1655 (Dublin)
Lester, Thomas	1763–1775 (Cork)
Lestraunge, Stephen	1348
Le Keux, Peter	1779, 1805 (1061)
Letham, John	1718–1756 (Edinburgh †)
Lethard, James	1745 (932)
Letherbarrow, Thomas	c. 1690–1730 (Liverpool)
Letherbarrow, Thomas	c. 1755–67 (Wigan)
Lewis, George	1706
Lewis, John	1761 (1002)
Lewis, John Lewis, William	1667, 1680 (105)
Lickorish, Joseph	1697
Liggins, Robert	1733
Lincolne, Thomas (1)	1718 (716)
Lincolne, Thomas (2)	1740 (716, as above)
Lindsey, Greenhill	1708, 1723 (674)
Linnum, J. (Lindum)	1701
Litchfield, Francis	1697 (571)
Litchfield, Joshua	d. 1745 (Dublin)
Litchfield, Vincent	1716
Litchfield, William	1745 (Dublin)
Little, Ann	1765
	1734, 1755 (875)
Little, Henry Littlefare, Thomas	
Littleiale, Illollias	1705

Loader, Charles William	1784, 1798 (1050)
Loader, Jeremiah	1667, 1686 (156)
Lobb, William	1612
Lock, Robert	1677, 1692 (303)
Lock, Thomas	1684 (411)
Lockwood, Edward	1768, 1790 (1055)
Lockwood, George	1616 (York)
Loe, Gilbert	1668-1678 (Dublin)
Loftus, James	1661–1701 (York)
Loftus, Jane	1684 (York)
Loftus, Ralph	1684 (York)
Loftus, Richard	1684–1707 (York)
Long, Sefton	1680, 1692
Long, William	1677, 1707 (400)
Loton, William	1558, 1571
Lovell, John	1725, d. 1742 (Bristol)
Lovell, Robert	1752 (Bristol)
Lovely, John	1734
Lowe, —	1850 (Glasgow)
Lowes, George	c. 1710-65 (Newcastle)
Lowrie, Thomas	1675 (Edinburgh)
Lucas, Francis	1684 (York)
Lucas, John	1746
Lucas, Robert	1637, 1667 (1)
Lucas, Samuel	1734
Lucas, Stephen	1804, 1825
Lucas, William	1779
Ludgate, Nicholas	d. 1348
Luddington, Paul	1736
Lupton, Robert	1775 (1042)
Lussum, Henry	1760
Luton, Thomas	1742
Lydiatt, Samuel	1635, 1680
Lyford, Nathaniel	1725
Lyndsay, Alexander	1648 (Edinburgh)
Lyon, William	1747 (Cork)
3 6 1 1 1 0 1	11 10 1

Mabberley, Stephen Mabbott, William Mabbs, Samuel Mabor, Richard Macdonnel, John Machyn, Thomas Mackenzie, William Madder, William 1661, 1683 (209) 1636, d. 1680 (69) 1676, 1685 (288) 1706 1820 (Limerick)

1539 1794 1775

	• • • • • • • • • • • • • • • • • • • •
Maddox, Thomas	1727
Madgwick, Giles	1681 (371)
Maitland, James	c. 1780 (Edinburgh)
Major, John	1621, 1657
Major, Thomas	1726
Makepeace, Thomas	1660, 1665
Makyns, Walter	1522, 1559
Mallum, Lawrence (Mallam)	
Mallum, William	1493 (York)
Manley, William	1813
Mann, James	1793
Mann, John	1658, 1688 (? 151)
Manning(e) Richard	
(Mannynge)	1574
Mansell Richard	1769
Mansworth, Thomas	1585
Manwaring, Philemon	1766
March, Richard	1635
Markham, Richard	1669, 1671
Markland, John	1770
Marriott, Nicholas	1686 (435)
Marsey, William	1753
Marsh, John	1658 (363)
Marsh, Ralph (1)	1636, d. 1665 (37, used also by
	R.M.(2))
Marsh, Ralph (2)	1663, 1671 (37 and 94)
Marshall, Thomas	1684 (406)
Marston, Nathaniel	1671
Marston, Samuel	1670
Marten, Robert	1638, 1674 (7)
Martin, John	1766
Martin, William (1)	1661, 1682
Martin, William (2)	1726 (799)
Masham, Hugh	1681, 1713
Mason, Daniel	1669, 1673 (214)
Mason, John	1695, 1713
Mason, Joseph	1721
Mason, Richard	1679
Mason, Samuel (1)	1662, 1685 (? 83)
Mason, Samuel (2)	1720
Mason, Samuel	1798 (Dublin)
Massam, Robert	1735, 1740 (867)
Mastead, Richard	1666 (134)
Mastin, George	1749
Mastin, William	1748
aramotana it annulli	-/

Mathews, Abraham	1721
Mathews, Edward	1691, 1728 (472)
Mathews, James	1722, 1746 (780)
Mathew(s), John	1556, 1569
Mathews, John	1695
Mathews, Peter	1601, 1632
Mathews, Philip	1736, 1743 (869)
Mathews, Robert	1721 (783)
Mathews, Thomas	1711, 1744 (702)
Mathews, Thomas, jun.	1736, 1750 (898)
Mathews, William (1)	1655, 1689 (203)
Mathews, William (1) Mathews, William (2)	1699 (551)
Mathews, William (3)	1724, 1741
Matson, John	1570
Matteson, Thomas	1684 (York)
Maundrill, Richard	1668, 1705
Maw, John H.	1822 (1087)
Mawman, John	1710 (Cork)
Maxey, Charles Puckle	1750 (950)
Maxted, Henry	1731 (861)
Maxwell, Stephen	1781 (Glasgow)
May, William	d. 1398
Maynard, Josiah	1772 (1069)
Maynard, Thomas	1767
Mayo, Daniel (? May)	1709
Mayors, Anthony	1648, d. 1677 (3)
McCabe, Owen	d. 1769 (Dublin)
McCulla, James	1719-1729 (Dublin)
Mead, Thomas	1720
Meadows, William	1714 (704)
Meakin, Nathaniel (1)	1726, 1780 (843)
Meakin, Nathaniel (2)	1761, 1768 (1000)
Mearcer, Robert	1709
Meares, John	1657
Mear(s), John	1750
Mear(s), Ralph	1615, 1646
Mears, William	1561, 1598
Meddom(s), Richard	1672 (212)
Meggott, George	1630, 1655
Megre, John	1401, <i>d</i> . 1420
Menzies, Alexander	1675 (Edinburgh)
Meriefield, Edward	1716, 1744 (770)
Meriefield, Robert	1705
Merriott, John	1718
Merrit, Jonathan	1743

Merriweather, John	1718 (720)
Merriweather, John C.	c. 1747 (936)
Merry, Lawrence	c. 1850 (Dublin)
Merry, Lawrence and	
Richard	c. 1850 (Dublin)
Merry, Martin	1824 (Dublin)
Merry, Richard	c. 1850 (Dublin)
Middleton, Charles	1690 (524)
Middleton, Leonard	1749, 1752
Middleton, Thomas	c. 1673 (226)
Miles, Samuel	1726 (776)
Miles, William	1715, 1725 (706)
Millett, Richard (Mellett)	1627, 1665
Millin, William	1776, 1786 (1044)
Millman, John	1673 (235)
Mills, Nathaniel	1639, 1668 (47)
Mills, Nicholas	1529, 1538
Mills (Mylls), William	1557, 1571
Millward, William	1711
Milton, Walter	1634, <i>d.</i> 1656
Mister, Richard	1802, d. 1839 (1085)
Mister, William	1820
Mitchell, Humphrey	1605
Mitchell, John (1)	1603, 1619
Mitchell, John (2)	1653, 1665
Mitchell, John	1739, 1758 (893)
Mitchell, Paul	1721, 1739 (766)
Mitchell, Paul Mitchell, Thomas	1704 (Edinburgh †)
Mogg, Christopher	1708
Moir, Alex.	1675 (Edinburgh †)
Molton, John	1644, 1667
Momford, Edmund	1712
Momford, John (Mountford)	1611, d. 1644
Monk, George	1731
Monk, Joseph	1757 (1022)
Monkhouse, Edward	1715
Monroe, James	1728 (Dublin)
Monteith, James (1)	1634 (Edinburgh †)
Monteith, James (2)	1643 (Edinburgh †)
Monteith, James (3)	1778 (Edinburgh †)
Moody, J. B.	1816
Moor, Samuel	1704
Moore, Bryan	1691
Moore, John	1700
More, Benjamin	1707
	900 SE

Morgan, William	1612, 1623
Moring, Randall	1780, 1821 (1065)
Morris, Henry	1749
Morrison, John	1661 (Dublin)
Morse, Henry	1675, 1686 (265)
Morse, Robert (1)	1676 (283)
Morse, Robert (2)	1702, 1716 (643)
Morse, William	1676 (308)
Morton, Thomas	
Morton William	1672 (216)
Morton, William	1695
Moser, Roger	1806 (1078)
Moulesworth, Peter	1662, 1693 (398)
Mountford, Benjamin	1691
Mountford, John (see Momf	
Mourgue, Fulcrand	1799, 1808
Mourton, Peter	1688 (Cornish)
Moxon, Samuel	1771, 1799
Moyes, James	1875 (Edinburgh)
Mudge, Walter	1764, 1793
Mulcaster, John	1792
Mullens, John	1802
Mullins, John	1831, d. 1872
Mullins, Robert (1)	1606, 1645
Mullins, Robert (2)	1650, 1695
	1688, 1704
Mullins, Robert (3)	
Mumford, Joseph	1670 (421)
Munday, Thomas Munden, William	1754, 1774 (978)
Munden, William	1764, 1771 (992)
Munns, Nathaniel	1644, 1673
Munroe, Andrew	1677 (Edinburgh †)
Murray, William	1734, 1743 (857)
Napier, Archibald	1666 (Edinburgh †)
Napier, John	1700 (Edinburgh †)
Napton, Henry	1668 (159)
Nash, Edward	1717, 1738 (755)
Nash, John	1749
Nash, Thomas	1485
Nash, Thomas	1729
	1714 (699)
Neaton, John	
Neave, Robert	1693
Needham, Thomas	1643, <i>d</i> . 1667
Nelham, Thomas Nelham, William	1795
	1815
Netherwood, Charles	1716

Oakford, Nicholas (Okeford	1) 1600, 1732 (506)
Oliphant, George (1)	1798
Oliphant, George (2)	1826
Oliver, John	1687, 1692 (478)
Oliver, Robert	1706
Oliver, Robert Oliver, William	1681
O'Neal, Richard	
Only, William	1719, 1735
	1674, 1687 (248)
Orme, Robert	1653, 1681
Ormiston, John	1769–1796 (Dublin)
Orton, Joseph	1694
Osborne, Charles	1681 (413)
Osborne, John (1)	1701 (687)
Osborne, John (2)	1713 (721)
Osborne, John (3)	1785
Osborne, Robert	c. 1622
Osborne, Samuel	1693
Osborne, Thomas (1)	1642, d. 1685 (? 137)
Osborne, Thomas (2)	1719
Osborne, Thomas (2) Osborne, William	1733
Osgood, Edward	1653, 1669
Osgood, Joseph	1807 (Bristol)
Otway, Thomas (1)	1733
Otway, Thomas (2)	1786
Oudley, Robert	1708, 1732 (665)
Outlawe, Thomas	1504
Overend, George	d. 1733 (Dublin)
Oxden, William	1687
Oxuen, william	1007
Paddon, Thomas	7682 TEOC (422)
	1683, 1705 (433)
Page, John	1692, 1700 (494)
Page, Thomas	1456, 1470
Page, Thomas Page, Thomas	1556, 1570
Page, Thomas	1737, 1747 (Bristol)
Page, William	1748
Paine, Edward	1716
Painter, John	1718
Palmer, John (1)	1702 (693)
Palmer, John (2)	1725
Palmer, Jonn (3)	1749
Palmer, John (4)	1763
Palmer, Richard	1759–1773 (Dublin)
Palmer, Richard (1)	1771
Palmer, Richard (2)	1803, 1822
Palmer, Roger	1603, 1622
i aimer, reger	1000, 1042

D 1 (77)	-(()
Palmer, Thomas	1672 (459)
Palmer, William (1)	1730
Palmer, William (2)	1743 (911)
Paltock, John	1625
Paradice, Francis	1675, d. 1709 (306)
Pargiter, William	1658 (? 111)
Park, Thomas	1743
Parker, Daniel	1678, 1714 (441)
Parker, John	1768 (Limerick)
Parker, Joseph	1663, 1679 (180)
Parker, Thomas (1) Parker, Thomas (2)	1674 (576)
Parker, I nomas (2)	1695 (579)
Parker, William	1809
Parker, William Thomas	1802
Parkes, Peter	1641, 1669 (? 104)
Parkinson, John	c. 1680 (384)
Parr, Norton	1742–1773 (Cork)
Parr, Robert	1703, 1767 (352)
Parrett, Thomas (Parrat)	1602, 1615
Parsons, Francis	1664 (? 138)
Partridge, John	1688 (Cornish)
Partridge, Richard	1715, 1724 (700)
Parys, John	1457, 1484
Paskin, George	1730
Paskin, Jeremiah	1752
Paskin, Robert	1757
Paskin, William (1)	1695
Paskin, William (2)	1724
Paterson, Walter	1710 (Edinburgh †)
Patience, Robert	1734, d. 1777 (883)
Patrick, William	1699
Pattinson, Simon	1715, 1733 (767)
Pattison, Peter	d. 1715 (Dublin)
Paul, Peter	1791
Pauling, Henry	1659 (? 29)
Pawson, Richard	1752, 1765 (962)
Paxton, James	1698, 1725 (636)
Paxton, John	1717, 1729 (769)
Paxton, Richard	1738
Paxton, William	1668, 1696 (168)
Payne, John (1)	1677 (290)
Payne, John (2)	1725 (789)
Pea, Francis	1798–1808 (Dublin)
Peacock, John	1706 (659)
Peacock, Samuel	1763, 1785

Peacock, Thomas	1783
Peake, George	1759
Peake, Richard	1750 (953) 1806
Pearce, James	
Peck, Daniel	1720
Peck, Thomas	1674
Pecke, Nicholas	1509, 1548
Peckham, Richard	1761
Peckitt, George	1640, 1655 (York)
Pedder, Henry	1748
Pedder, Joseph	1727 (821)
Peddie, Andrew	1766 (Edinburgh)
Peel, Thomas	1740 ?
Peircy, Robert	1722, 1760 (858)
Peirson, Thomas	1464–1493
Peisley, George	1718 (709)
Peisley, Thomas (1)	1693 (635 and 670)
Peisley, Thomas (2)	1732
Pelham, John	1698
Pellett, Joseph H.	1817
Pellett, Joseph R.	1788
Pellitory, Mathew	1599, d. 1609
Penman, David	1693, 1715 (Edinburgh †)
Penn, Humphrey	1676 (279)
Pepper, John	1678 (317)
Perchard, Hellier (Hilary)	1709, 1745 (661)
Perchard, Samuel	1743, 1749
Perkins, Arthur	1734
Perkins, Francis	1674 (340)
Perkins, John	1713
Perkyns, Richard	1593
Perris, Henry	1653, 1678
Perris, James	1772
Perry, John (1)	1743, 1773 (909)
Perry, John (2)	1765, 1818 (1009)
Perry, Richard	1757
Peters, Isaac	1725
Pett, Henry	1783
Pettit, John	1683 (415)
Pettiver, John	1677 (349)
Pettiver, Samuel	1695 (616)
Pettiver, William (1)	1655, 1679 (73 and 74)
Pettiver, William (2)	1676 (322)
Phelan, Philip	1755–1767 (Kilkenny)
Philips, James	1622, 1651

D1 '11' T. 1 (-)	
Phillips, John (1)	1642, 1697
Phillips, John (2)	1784, 1815
Phillips, Thomas (1)	1621
Phillips, Thomas (2)	1727 (784)
Phillips Thomas (2)	1795, 1817 (1073)
Phillips, Thomas (2) Phillips, Thomas (3) Phillips, William (1)	
Phillips, William (1)	1719 (841)
Phillips, William (2)	1744 (949)
Phillips, William (2) Phillips, William (3)	1750, 1789 (1028)
Phillips, William (4)	1787
Phillips, William (5)	1823
Phillips, William (5) Phillips, William Augustus	1815
Phipps, Joseph	1722
Phipps, Robert	1738
Phipps, William (1)	1693
Phipps, William (2)	1743 (945)
Pickard, Joseph	1691, 1708 (500)
Pickering, Daniel	1723 (811)
Pickering, John	1727
Pickever, Benjamin Pickever, William	1773 (Dublin)
	d. 1778 (Dublin)
Pickfat, Thomas	1677, 1686 (350)
Piddle, Joseph	1684, 1692 (407)
Pidgion, John	1780
Pierce, Francis	1784
Pierce, James Henry	1798, 1825
Pierce, Tristram	1702 (607)
Pierce, William	1669 (? 139)
Pierce, Tristram Pierce, William Piercy, Thomas	d. 1749 (Dublin)
Pierie, William	1783
Piggenitt, Bertrand	c. 1685 (Dublin)
Piggott, Francis	1736, d. 1784 (886)
Piggott, John	1736, 1751 (868)
Piggott, Thomas	1698, 1725 (800)
Pight, Henry	1678, 1700
Pight, John	1693
Pilkington, John	1714
Pilkington, Robert	1704, 1716 (625)
Pistoll, Benjamin	
(Pistelly, Pistolet)	1703
Pitcher, John	1744
Pitt, Richard	1747, 1781 (924)
Pitt, Thomas	1778
Pitt & Dadley	c. 1780 (1043)
Pitt & Floyd	c. 1770 (1018)
Pixley, Joseph	1706 (638)
1 , J I	(-3-)

Platt, Thomas	1587, 1619
Plivey, William	1697 (548)
Plumber, Daniel	1720
Plummer, John	1717
Plummer, John	1732 (York)
Plummer, Robert	1689
Pole, Robert	1717 (738)
	1684 (York)
Pollard, John	
Ponder, Simon	1537, 1558
Ponton, John	1708
Ponty, James	1732 (Dublin)
Poole, John	1747
Pool(e), Richard	1747 (930)
Poole, Robert	1740 (Dublin)
Poole, Rowland	1717 (982)
Pope, John	1688
Port, Richard	1723
Porter, John	1691
Porter, Luke	1679, 1684 (327)
Porter, Thomas	1683, d. 1706 (394)
Porteus, Robert	1760, 1790 (999, see next)
Porteus, Robert & Thomas	1765 (999)
Porteus, Thomas	1762
Postgate, William	1691 (York)
Potten, William	1729
Potter, George	1814
Potter, Thomas	1783
Potterill, George	1715
Potts, Isaac	1723
Potts, John	1753–1772 (Dublin)
	1612, 1621
Powell, Ralph	
Powell, Robert (1)	1728–1769 (Cork)
Powell, Robert (2)	1787 (Cork)
Powell, Thomas	1676, 1707 (350A)
Poynton, Towndrow	1715 (York)
Pratt, Alfred	1763
Pratt, Benjamin	1730
Pratt, Cranmer	1761
Pratt, Henry	1674 (238)
Pratt, James	1724
Pratt, Joseph (1)	1670, 1720 (201)
Pratt, Joseph (2)	1709 (753)
Pratt, Thomas	1714
Prentice, Robert	1781 (Edinburgh)
Price, Benjamin	1784

Price, James	1784
Price, John	1755, 1781
Price, Thomas	1768–1807 (Dublin)
Prichard, Polydore	1606, 1649
Pridden, William	1807
Priddle, Samuel	1773, 1800 (1039)
Priest, Peter	1660, 1676 (100)
Prince, John	1697, 1713 (583)
Prior, William	1568, 1607
Probert, William	1688
Proctor, Francis	1618, 1631
Proctor, John	1752
Prosser, Peter	1755 (Cork)
Pruden, James	1750
Puddiphatt, Joseph .	1669, 1686
Pugh, Rowland	1763
Puleston, James	1752 (983)
Puller, Samuel	1702, 1714
Purcell, Balthazar	1640 (Dublin)
Purcell, Lawrence	1800, 1833 (Dublin)
Purle, Richard	1822
Pusey, Edward	1676 (314)
Pycroft, Walter	1612, 1626
Pye, Roger	1737 (882)
Pypond, John	1461, 1464
O	-600 ()
Quick, Edward (1)	1687, 1708 (451)
Quick, Edward (2)	1708, 1728 (657)
Quick, Edward (3)	1735, 1772 (900)
Quick, Hugh	1674, 1708 (230)
Quick, John	1699 (591)
Quissenborough, Samuel	1672, 1693 (213)
8,	- 7 - 73 (- 3)
Rabson, Thomas	1732
Rack, Charles	1680, 1691 (355)
Radcliff, Thomas	1671 (210)
	10/1 (210)
Rainbow, J.	c. 1690 (Edinburgh †)
Rainbow, William	1743
Rait, James	1718 (Edinburgh†)
Ralphs, Henry	1778
Ramsden, John	1795
Rance, Robert	1771
Randall, Charles	1699 (572)
Randall, Edward (1)	1677, 1711 (333)
Randall, Edward (2)	1715 (696)
randally Daward (2)	1/13 (090)

n 1 11 r 1	
Randall, John	1723 (747)
Randall, Lewis	1585, 1613
Randall, Robert	1748 (955)
Raper, Christopher	1665, 1694 (140)
Ravenhill, Thomas	1780 (Bristol)
Daves William	1602 (cco)
Raves, William	1682 (559)
Rawlins, William	1637, 1668
Rawlinson, John	1675 (249)
Rawson, James	1774
Raymond, Benjamin	1749
Raymond, James	1749
Raymond, John	1691
Raymond, Thomas	
	1756
Rayne, Joseph	1693 (530)
Raynolde, Anthony	1623 (Dublin)
Raynolde, Thomas	1545–1551 (Dublin)
Read, Isaac	1743
Read, Joseph	1727
Read, Samuel	1688
Read, Thomas	1753
Reade, Simon	1660
Reading, Roger	1668, 1686 (175)
Reading, Theophilus	1675 (4 [out of place] and
(Ridding)	
Redfearn, Thomas	1756
Redfearn, Thomas Redhead, Anthony	1756 1675, 1695 (264)
Redfearn, Thomas Redhead, Anthony Redhead, Gabriel	1756 1675, 1695 (264) 1662, 1689 (? 50 and ? 109)
Redfearn, Thomas Redhead, Anthony Redhead, Gabriel Redknap, Peter	1756 1675, 1695 (264) 1662, 1689 (? 50 and ? 109) 1713, 1720 (678)
Redfearn, Thomas Redhead, Anthony Redhead, Gabriel Redknap, Peter Redman, William	1756 1675, 1695 (264) 1662, 1689 (? 50 and ? 109) 1713, 1720 (678) 1569, 1574
Redfearn, Thomas Redhead, Anthony Redhead, Gabriel Redknap, Peter Redman, William Redshaw, John	1756 1675, 1695 (264) 1662, 1689 (? 50 and ? 109) 1713, 1720 (678) 1569, 1574 1679 (219)
Redfearn, Thomas Redhead, Anthony Redhead, Gabriel Redknap, Peter Redman, William Redshaw, John Redshaw, Mary	1756 1675, 1695 (264) 1662, 1689 (? 50 and ? 109) 1713, 1720 (678) 1569, 1574 1679 (219) 1733
Redfearn, Thomas Redhead, Anthony Redhead, Gabriel Redknap, Peter Redman, William Redshaw, John Redshaw, Mary Redworth, John	1756 1675, 1695 (264) 1662, 1689 (? 50 and ? 109) 1713, 1720 (678) 1569, 1574 1679 (219) 1733 1635 (Dublin)
Redfearn, Thomas Redhead, Anthony Redhead, Gabriel Redknap, Peter Redman, William Redshaw, John Redshaw, Mary Redworth, John Reech, Charles	1756 1675, 1695 (264) 1662, 1689 (? 50 and ? 109) 1713, 1720 (678) 1569, 1574 1679 (219) 1733 1635 (Dublin) 1723
Redfearn, Thomas Redhead, Anthony Redhead, Gabriel Redknap, Peter Redman, William Redshaw, John Redshaw, Mary Redworth, John	1756 1675, 1695 (264) 1662, 1689 (? 50 and ? 109) 1713, 1720 (678) 1569, 1574 1679 (219) 1733 1635 (Dublin)
Redfearn, Thomas Redhead, Anthony Redhead, Gabriel Redknap, Peter Redman, William Redshaw, John Redshaw, Mary Redworth, John Reech, Charles Reeve, Isaac	1756 1675, 1695 (264) 1662, 1689 (? 50 and ? 109) 1713, 1720 (678) 1569, 1574 1679 (219) 1733 1635 (Dublin) 1723
Redfearn, Thomas Redhead, Anthony Redhead, Gabriel Redknap, Peter Redman, William Redshaw, John Redshaw, Mary Redworth, John Reech, Charles Reeve, Isaac Reeve, John	1756 1675, 1695 (264) 1662, 1689 (? 50 and ? 109) 1713, 1720 (678) 1569, 1574 1679 (219) 1733 1635 (Dublin) 1723 1754, d. 1796 (972) 1714
Redfearn, Thomas Redhead, Anthony Redhead, Gabriel Redknap, Peter Redman, William Redshaw, John Redshaw, Mary Redworth, John Reech, Charles Reeve, Isaac Reeve, John Reeve, Joseph (1)	1756 1675, 1695 (264) 1662, 1689 (? 50 and ? 109) 1713, 1720 (678) 1569, 1574 1679 (219) 1733 1635 (Dublin) 1723 1754, d. 1796 (972) 1714 1786, 1812
Redfearn, Thomas Redhead, Anthony Redhead, Gabriel Redknap, Peter Redman, William Redshaw, John Redshaw, Mary Redworth, John Reech, Charles Reeve, Isaac Reeve, John Reeve, Joseph (1) Reeve, Joseph (2)	1756 1675, 1695 (264) 1662, 1689 (? 50 and ? 109) 1713, 1720 (678) 1569, 1574 1679 (219) 1733 1635 (Dublin) 1723 1754, d. 1796 (972) 1714 1786, 1812 1810, 1856
Redfearn, Thomas Redhead, Anthony Redhead, Gabriel Redknap, Peter Redman, William Redshaw, John Redshaw, Mary Redworth, John Reech, Charles Reeve, Isaac Reeve, John Reeve, Joseph (1) Reeve, Joseph (2) Reeve, William	1756 1675, 1695 (264) 1662, 1689 (? 50 and ? 109) 1713, 1720 (678) 1569, 1574 1679 (219) 1733 1635 (Dublin) 1723 1754, d. 1796 (972) 1714 1786, 1812 1810, 1856 1776, 1833
Redfearn, Thomas Redhead, Anthony Redhead, Gabriel Redknap, Peter Redman, William Redshaw, John Redshaw, Mary Redworth, John Reech, Charles Reeve, Isaac Reeve, Joseph (1) Reeve, Joseph (2) Reeve, William Reeves, John	1756 1675, 1695 (264) 1662, 1689 (? 50 and ? 109) 1713, 1720 (678) 1569, 1574 1679 (219) 1733 1635 (Dublin) 1723 1754, d. 1796 (972) 1714 1786, 1812 1810, 1856 1776, 1833 1714
Redfearn, Thomas Redhead, Anthony Redhead, Gabriel Redknap, Peter Redman, William Redshaw, John Redshaw, Mary Redworth, John Reech, Charles Reeve, Isaac Reeve, Joseph (1) Reeve, Joseph (2) Reeve, William Reeves, John Reid, H.	1756 1675, 1695 (264) 1662, 1689 (? 50 and ? 109) 1713, 1720 (678) 1569, 1574 1679 (219) 1733 1635 (Dublin) 1723 1754, d. 1796 (972) 1714 1786, 1812 1810, 1856 1776, 1833 1714 1850 (Glasgow)
Redfearn, Thomas Redhead, Anthony Redhead, Gabriel Redknap, Peter Redman, William Redshaw, John Redshaw, Mary Redworth, John Reech, Charles Reeve, Isaac Reeve, John Reeve, Joseph (1) Reeve, Joseph (2) Reeve, William Reeves, John Reid, H. Reid, Robert	1756 1675, 1695 (264) 1662, 1689 (? 50 and ? 109) 1713, 1720 (678) 1569, 1574 1679 (219) 1733 1635 (Dublin) 1723 1754, d. 1796 (972) 1714 1786, 1812 1810, 1856 1776, 1833 1714 1850 (Glasgow) 1718 (Edinburgh†)
Redfearn, Thomas Redhead, Anthony Redhead, Gabriel Redknap, Peter Redman, William Redshaw, John Redshaw, Mary Redworth, John Reech, Charles Reeve, Isaac Reeve, John Reeve, Joseph (1) Reeve, Joseph (2) Reeve, William Reeves, John Reid, H. Reid, Robert Relfe, Edward	1756 1675, 1695 (264) 1662, 1689 (? 50 and ? 109) 1713, 1720 (678) 1569, 1574 1679 (219) 1733 1635 (Dublin) 1723 1754, d. 1796 (972) 1714 1786, 1812 1810, 1856 1776, 1833 1714 1850 (Glasgow) 1718 (Edinburgh †) 1668 (202)
Redfearn, Thomas Redhead, Anthony Redhead, Gabriel Redknap, Peter Redman, William Redshaw, John Redshaw, Mary Redworth, John Reech, Charles Reeve, Isaac Reeve, John Reeve, Joseph (1) Reeve, Joseph (2) Reeve, William Reeves, John Reid, H. Reid, Robert Relfe, Edward Rendale, John (? Kendale)	1756 1675, 1695 (264) 1662, 1689 (? 50 and ? 109) 1713, 1720 (678) 1569, 1574 1679 (219) 1733 1635 (Dublin) 1723 1754, d. 1796 (972) 1714 1786, 1812 1810, 1856 1776, 1833 1714 1850 (Glasgow) 1718 (Edinburgh†)
Redfearn, Thomas Redhead, Anthony Redhead, Gabriel Redknap, Peter Redman, William Redshaw, John Redshaw, Mary Redworth, John Reech, Charles Reeve, Isaac Reeve, John Reeve, Joseph (1) Reeve, Joseph (2) Reeve, William Reeves, John Reid, H. Reid, Robert Relfe, Edward	1756 1675, 1695 (264) 1662, 1689 (? 50 and ? 109) 1713, 1720 (678) 1569, 1574 1679 (219) 1733 1635 (Dublin) 1723 1754, d. 1796 (972) 1714 1786, 1812 1810, 1856 1776, 1833 1714 1850 (Glasgow) 1718 (Edinburgh †) 1668 (202)
Redfearn, Thomas Redhead, Anthony Redhead, Gabriel Redknap, Peter Redman, William Redshaw, John Redshaw, Mary Redworth, John Reech, Charles Reeve, Isaac Reeve, John Reeve, Joseph (1) Reeve, Joseph (2) Reeve, William Reeves, John Reid, H. Reid, Robert Relfe, Edward Rendale, John (? Kendale)	1756 1675, 1695 (264) 1662, 1689 (? 50 and ? 109) 1713, 1720 (678) 1569, 1574 1679 (219) 1733 1635 (Dublin) 1723 1754, d. 1796 (972) 1714 1786, 1812 1810, 1856 1776, 1833 1714 1850 (Glasgow) 1718 (Edinburgh †) 1668 (202) 1451, 1462

	* J
Reo, Edward	1560, 1588
Rewcastle, Morgan	1687
Reymers, James,	1703
Reynolds, Henry	1746-1796 (Kilkenny)
Reynolds, John	1693 (Dublin)
Reynolds, Robert (1)	1704 (618)
Reynolds, Robert (2)	1761, 1794 (see 1012)
Reynolds, Thomas (1)	1663, 1689
Reynolds, Thomas (2)	1716
	1693
Reynoldson, John Rhodes, Thomas	
	1721, 1746
Rice, Matthew	1719
Rice, Richard	1595 (Dublin)
Rich, Charles	1807, 1812 (Bristol)
Rich, Daniel	1818 (Bristol)
Rich, George	1812 (Bristol)
Rich, Robert	1781 (Bristol)
Rich, William	1820 (Bristol)
Richards, Richard	1709
Richards, Timothy	1699 (647)
Richards, William	1664 (193)
Richards, William	1768
Richardson, Charles	1667 (? 150, and 220)
Richardson, Edmund	1542, 1576 (York)
Richardson, John	1709
Ridding, Joseph	1701, 1735
Ridding, Theophilus (see	
Reading)	
Ridding, Thomas (1)	1674, 1697 (233)
Ridding, Thomas (2)	1699, 1705
Rider, Nathaniel	1675 (331)
Ridge, Gabriel	1698
Ridgeway, William	1691
Righton, Samuel	1732, 1743 (851)
	1583, 1600
Roaffe, George	1600
Roaffe, Jasper	d. 1759 (Dublin)
Roane, George	
Roberts, Abraham	1687 (619)
Roberts, Edward	1679 (425)
Roberts, George (1)	1722
Roberts, George (2)	1801
Roberts, Jeremiah	1685 (Bristol)
Roberts, John	1574, 1614
Roberts, Oliver	1605, 1644
Roberts, Philip	1738, 1753

Roberts, Richard	1733
Roberts, Thomas (1)	1688 (443)
Roberts, Thomas (2)	1693
Roberts, Thomas (3)	1727
Roberts, William (1)	1727
Roberts, Thomas (2) Roberts, Thomas (3) Roberts, William (1) Roberts, William (2)	1762
Robeson, Richard	c. 1598
Robins, James	1714, 1725
Robins, John	1601, d 1647
Robins, Joseph	1819
Robins, J. & Sons	1802 (Birmingham)
Robins, Luke	1761
Robins, Obedience	1671, d. 1712 (260)
Robins, Thomas	1740
Robinson, Christopher	d. 1759 (Dublin)
Robinson, George (I)	1783, d. 1834
Robinson, George (2)	•
	1819
Robinson, James	1776
Robinson, John	1659 (183)
Robinson, John H.	1802
Robinson, William	d. 1652 (Newcastle)
Robinson, William	1740 (Dublin)
Roden, John	1696
Rodwell, Henry	1665–1683 (York)
Rodwell, Thomas	1697 (York)
Rodwell, William	1677–1684 (York)
Roe, Thomas	1749
Rogers, John	1717 (793)
Rogers, John	d. 1762 (Cork)
Rogers, John Smith	1764–1779 (Cork)
Rogers, Philip	1708 (653)
Rogers, Thomas Rogers, William (1)	1774
Rogers, William (1)	1758–1780 (Cork)
Rogers, William (2)	1774 (Cork)
Rolls, Anthony	1645 (96)
Rolls, Thomas (1)	1690
Rolls, Thomas (2)	1713
Rolt, John	1716, d. 1727 (710)
Rooke, George	1668, d. 1673 (152)
Rooke, Richard	1748, 1777
Rose, Edward	1691
Ross, Edward	1803
Rothwell, John (1)	1669, 1681 (195)
Rothwell, John (2)	1756
Rowe, Francis	1691
	55

LIST OF THE NAM	ES OF PEWTERERS
Rowe, William	1507
Rowell, William	1726, 1735 (816)
Rowlandson, Stephen	1550, 1563
Royce, Charles	1684 (423)
Royd(en), Elizabeth	c. 1720
Royedon, John (Roysdon)	1519, 1532
Royse, Lawrence	1742
Royston, Ambrose	1580, 1620
Rudd, Anthony	1617, 1632
Ruddock, Philip	1690 (495)
Rudsby, Andrew (1)	1677, d. 1715 (330)
Rudsby, Andrew (2)	1712
Rudsby, John	1712
Ruffin, Thomas	1790, 1808
Rumbold, John (1)	1645, 1699
Rumbold, John (2)	1696
Rumbold, Robert	1691
Russell, Francis	1766 (Limerick)
Russell, John	d. 1676 (275)
Russell, Thomas	1611, d. 1620
Russell & Laugher	c. 1760
Rutland, Robert	1806
Rydge, William	1612
Ry(e)croft, Walter	1614
Rymill, Thomas	1691
Sadler, Robert	1684–1692 (York)
Sall, George	1775 (Dublin)
Sall, John	1771 (Dublin)
Salmon, Ferdinando	1699
Calmon Thomas	T/7/12

Salmon, Thomas c. 1700 (Bideford) Sanders, Simon Sanderson, John 1684 (York) 1674 (234) 1680 (491) Sandford, Joseph Sandys, William (Sands) 1710 (669) Sankey, Humphrey Sansby, John 1810 Sarney, Richard 1745 1674 (239) Saunders, John Saunders, Thomas 1684 (404) Savage, John (1) 1699 (620) Savage, John (2) 1711, 1741 Savage, John (3) 1746, 1758 1788-1827 (Dublin) Savage, Silvester Savell, Jacob 1748

Savidg(e), John Sayers, Robert (Seares)	1678 (369) 1667, 1711 (165)
Sayers, William (Seares)	1705 (634)
Scarlet, Samuel	1744, 1756
Scatchard, Robert	1756, 1761 (980)
Scattergood, John	1732 (859)
Scattergood, Thomas (1)	1700, 1733 (610)
Scattergood, Thomas (1) Scattergood, Thomas (2)	1736, 1775 (873)
Schleicher, J. H.	1802
Scott, Benjamin	1649, 1664
Scott, George	1675 (348)
Scott, James	1708
Scott, Richard	1562
Scott, Samuel (1)	1647, 1680
Scott, Samuel (2)	1705
Scott, William (1)	1779 (Edinburgh †)
Scott, William (2)	1794 (Edinburgh †)
Seabright, Charles	1683
Seabright, White	1707
Seabroke, Robert	1776, 1794
Seabrook, John	1812, d. 1839
Seager, James	1706 (Dublin)
Seaman, Timothy	1764
Seaton, Samuel	1679 (387)
Seawell, Edward	1779, 1797 (1064)
Secker, James	1663–1692 (York)
Seddon, Charles	1662, 1673
Sedgwick, John	c. 1730 (Leeds)
Seeling, John	1627, 1665
Selby, Richard	1571
Selby, Robert	1712
Sellman, Thomas	1614
Sellon, John	1740 (935)
Sewdley, Henry	1706, 1738 (658)
Sexteyn, William	1476, 1503
Seymour, George	1754-1795 (Cork)
Seymour, Henry	1793-1817 (Cork)
Seymour, John	1779 (Cork)
Seymour, Nicholas (1)	1739-1763 (Cork)
Seymour, Nicholas (2) Seymour, William	1790–1817 (Cork)
Seymour, William	1817 (Cork)
Seymour, W. & Son	1820 (Cork)
Shaboe, Thomas	1773
Shackle, Thomas (1)	
(Shakle?) 1680, 1686 (287)

Shackle, Thomas (2)

(Shakle?) 1701 Shakle, John (Shackle?) 1672 (416) Shakle, Tobias 1685 Sharp, Durham 1754 Sharp, John 1692 (489) Sharrock, Edmund 1737, 1742 (881) Shaw, James (1) 1675, 1693 Shaw, James (2) 1693 Shaw, James (3) 1785 Shaw, John (1) 1726 (779) Shaw, John (2) 1776 Shayler, William 1734 (849) Shearman, Francis 1772 (Dublin) Sheffield, Thomas 1583, 1615 Shelton, Elias 1600, 1624 Shene, John 1768–1796 (Dublin) Shephard, Andrew 1692 Shepherd, David 1810 (Cork) Sheppard, Robert 1579, 1619 Sheppard, Samuel 1683, (419) Sheppard, Thomas 1705, 1718 (654) 1786 (Dublin) Shercliffe, Hector Sherstone, Thomas 1693 Sherwin, Joseph 1726 (809) Sherwin, Stephen 1709 Sherwood, James 1748, 1776 Sherwood, William (1) 1700 Sherwood, William (2) 1731 (895) Sherwood, William H. 1774 Sherwyn, John (1) 1528, 1547 Sherwyn, John (2) 1572, 1578 Shirley, James 1818–1840 (Dublin) Shorey, Bartholomew 1721, 1749 Shorey, John (1) 1683, 1720 (390) Shorey, John (2) 1708, 1725 Shorey, John (3) 1738 Short, John 1694 Shortgrave, Nathaniel 1689 (452) Shoswell, James 1736 Shryve, Thomas 1591 (Dublin) Shurmer, Richard 1678 (346) Shygan, Nicholas 1640 (Dublin) Shypwaysshe, Arnold d. 1350 Siar, William 1616, 1641

Sibbald, Alexander	1605 (Edinburgh)
Sibbett, James	1600 (Edinburgh †)
Sibley, Henry	1682 (372)
Sibthern Joseph	
Sibthorp, Joseph	1699
Sidey, Edward	1772 (1027)
Silk, John (1)	1627, 1668 (2)
Silk, John (2)	1693, 1700 (499)
Silk, Vincent	1654, 1663 (71)
Silver, David	1744
Silvester, William	1746
Simkin, James	1659
Simms, Thomas	1675 (337)
Simpkin, James	1639 (Dublin)
Simpkins, Thomas	1637, 1670
Simpson, George	1757 (Dublin)
Simpson, George	1796 (Perth)
Simpson, John (1)	1760
Simpson, John (2)	1771
Simpson, Ralph	1512–1538
	1512-1550
Simpson, Robert	1631 (Edinburgh †)
Simpson, Thomas	1728 (Edinburgh†)
Singleton, Leonard	1595, 1624
Sisson, —	1754 (Dublin)
Sivedall, Henry	1699
Skepper, Robert	1692
Skin(n), John	1670, 1686 (176)
Skin(n), Thomas	c. 1673 (223)
Skinner, Patrick	1738 (Perth)
Skinner, Robert	1738 (889)
Slacke, John	1522
Slade, Charles	d. 1754 (Dublin)
Slade, William	
	1754 (Dublin)
Slaughter, Nathaniel	1781
Slaughter, Richard	1711, 1746
Slow, John	1672, 1724 (231)
Slow, Joseph	1702 (614)
Slow, William	1716
Smackergill, William	1585, d. 1615
Smalley, John	1691
Smalley, Samuel	1683, 1701 (469)
Smallwood, William	1462, 1486
Smalman, Arthur	1713 (726)
	1/13 (/20)
Smalpiece, Richard	-600 (00-)
(Smallpece)	
Smalpiece, William	1710

Smart John	1768
Smart, John Smite, George	1672
Smith, Anthony	1698 (575)
Smith, Benjamin (1)	1714
Smith, Benjamin (2)	1730
Smith, Carrington	1801
Smith, Charles	1765, 1789 (1011)
Smith, Christopher	1730
Smith, Daniel	c. 1620
Smith, Daniel	1731
Smith, Edward	1680 (467 and 468)
	1651, d. 1695 (353)
Smith, George (1)	
Smith, George (2)	1712 (676)
Smith, George (3)	1768, 1795
Smith, Henry	1724 (787)
Smith, Isaac	1795, 1813
Smith, James	1732 (840)
Smith, James Edward	1764
Smith, John (1)	1675 (252)
Smith, John (2)	1685 (420)
Smith, John (3)	1702, 1709 (613)
Smith, John (4)	1724 (788)
Smith, John (5)	1765
Smith, John (6)	1770
Smith, Joseph (1)	1675, 1706 (522)
Smith, Joseph (2)	1811
Smith, Laurence	1810 (Cork)
Smith, Maurice	1770
Smith, Richard (1)	1677, 1705 (301)
Smith, Richard (2)	1733 (860)
Smith, Robert	1661, 1675 (York)
Smith, Rowland	1734 (948)
Smith, Samuel	1727, 1753 (796)
Smith, Thomas (1)	1675, 1703 (258, 258B and 428)
Smith, Thomas (2)	1677 (? 388)
Smith, Thomas (3)	1682, 1689 (362)
Smith, Thomas (4)	1686 (436)
Smith, Thomas (5)	1705 (632)
Smith, Thomas (6)	1709
Smith, Thomas (7)	1739 (989)
Smith, Thomas (8)	1755 (1005)
Smith, Thomas (9)	1761 (1016)
Smith, Thomas (10)	1771
Smith, William (1)	1668 (167)
Smith, William (2)	1691 (497)

Smith, William (3)	1732 (829)
Smith & Leapidge	c. 1730 (808) (Samuel & Anne Smith and Ed. Leapidge)
Smithe, Thomas	1616, 1632
Smyth, George	c. 1660
Smyther, George	1612
Snape, William	1764 (1013)
Snell, Lambard	1475
Snow, Samuel	1647
Snoxell, Edward	1706
Snoxell, John	1675, 1685 (251)
Snoxell, Richard	1709
Sogrove, John	1451
Somers, Robert	1571
Somerton, William	1730
Somervell, James	1616 (Edinburgh)
Southall, Charles	1713
Southey, William	1811, d. 1836
Spackman & Grant	1731 (662)
Spackman, James (1)	1704, 1742
Spackman, James (2)	1781
Spackman, John	1723
Spackman, Joseph (1)	1749, 1761 (982)
Spackman, Joseph (2)	1784
Spackman, Joseph & Co.	c. 1780
Spackman, Joseph & James	c. 1790
Sparling, Joseph	1714
Sparrow, Francis	1746
Spateman, John	1755
Spateman, Samuel	1719, 1750
Spencer, Thomas	1702 (600)
Spicer, John	1699, 1732 (631)
Spicer, Richard	1735
Spiller, Joseph	1818
Spilsbury, James	1773
Spinks, John	1815
Spinks, Thomas	1793
Spooner, Richard	1719, d. 1761 (764)
Spring, Pendlebury	1717 (724)
Spring, Thomas (1)	1710, d. 1743
Spring, Thomas (2)	1756
Spring, Thomas (3)	1776 (523)
Squires, Benjamin	1815
Squires, Nicholas	1716
Stacey, Edward	1715
otacoj, La nara	-1-3

Stafford, George Stanbrow, John Stanbrow, Samuel Stanley, Francis (1) Stanley, Francis (2) Stanton, James Stanton, Robert (1) Stanton, Robert (2) Stanton, William Staples, Henry Staples, Richard Staples, William Starkey, Benjamin	1730, 1740 (820) 1694 1728 1690 1722 1815, d. 1835 (1089) 1773 1810, d. 1842 (1082) 1810 1817 1590, d. 1656 1698 1753
Starkey, James (1)	1708
Starkey, James (2)	1748
Statham, Robert	1690
Steel, Peter Steevens, James	1797 1753 (968)
Stent, John	1709
Stephens, Daniel	1685 (440)
Stephens, John	1771
Stevens, John (1)	1724
Stevens, John (2)	1756
Stevens, John (3)	1771
Stevens, John (4)	1821
Stevens, Jonathan	1744 (915)
Stevens, Philip	1709, 1716 (664)
Stevens, Thomas	1716, 1732 (757)
Stevens, William (1)	1697, 1722 (552)
Stevens, William (2)	1729, 1738 (817)
Steventon, Richard	1578, 1614
Steward, John (1)	1590, 1608
Steward, John (2)	1634
Steward, Moses	1712
Steward, Rowland (1)	1676, 1694
Steward, Rowland (2)	1720
Steward, Thomas	1694
Steward, Toby (Tobias) Stewart, Thomas	1626, 1630 1781 (Edinburgh)
Stiff, William	1761, 1790
Stiles, Henry	1760
Stile(s), John	1688, 1730 (453)
Stock, John	1616 (York)
Stode, John (Stood)	1527, 1537
Stizzeken, Thomas	1726

Stone, Edward	1605 (547)
Stone, Edward	1695 (547) d. 1702 (Dublin)
Stone, Isaac	1736 (Dublin)
Stone, John	
Stone, Thomas	1768 (Belfast)
Stoneley, William	1664, 1692
	1766
Stout, Alexander	1733 (872)
Stray(e), Ralph	1578, 1594
Street, Robert	1742
Street, Thomas	1750
Stribblehill, John	1676, 1722 (300)
Stribblehill, Thomas (1)	1668 (3 110)
Stribblehill, Thomas (2) Stribblehill, Thomas (3)	1704 (722)
	1742
Strickland, John	1703 (703)
Stringfellow, William	1756
Strong, Francis	1759
Sturrop, Robert	1677 (389)
Sturt, Walter	1668, 1679 (221)
Sturton, Anthony	1686, 1702 (599)
Styan, Henry Sullivan, Thomas	1723
Summers, John	1820 (Waterford)
Sutton, William	1697, 1747 (543) 1697 (Cork)
Swaine, Lawrence	1660, 1665
Swan, R.	c. 1762 (Dundee)
Swanborough, Thomas	1741
Swanson, Thomas	1753, 1777 (991 and 1008)
Sweatman, John	1827
Sweatman, Nicholas	1698 (561)
Sweatman, Samuel	1728, 1741 (901)
Sweeting, Charles (1)	1633, 1658 (? 22)
Sweeting, Charles (2)	1685, d. 1707
Sweeting, Charles (3)	1688
Sweeting, Charles (4)	1716
Sweeting, Henry	1606, 1662
Sweeting, John (1)	1627, d. 1683
Sweeting, John (2)	1707
Swift, Cornelius	1770, 1814 (1036)
Swift, William Cornelius	1809 (1088)
Swindell, Thomas	1705 (802)
Swingland, Joshua	1723
Swinnerton, Richard	c. 1608, 1625
Swinton, Thomas	1713
Syde, John	1680 (Edinburgh †)

Sykes, Anthony Symmer, David Symontoun, James Symons, William Syward, John Syward, Roger	1610 1692 (Edinburgh†) 1694 (Edinburgh†) 1457 1350 1348, d. 1368
	1729 (Cork) 1706 1747 (Edinburgh †) 1700 (Edinburgh †) 1748 1776 c. 1599 1666 (127) 1702
Taudin, James (2) Taylor, Abraham Taylor, Anthony Taylor, Cornelius Taylor, Ebenezer Taylor, George (1) Taylor, George (2)	1673 (344) 1616, 1651 1595, 1614 1610 (Edinburgh †) 1819 1722 (745, 748 repeated) 1764, 1783
Taylor, George (3) Taylor, James Taylor, John Taylor, Richard Taylor, Richard Taylor, Robert	1791 1666 (129) 1783 1509, 1529 1670 1535, 1551
Taylor, Samuel Taylor, Thomas (1) Taylor, Thomas (2) Taylor, Timothy Taylor, William (1) Taylor, William (2) Taylor, William Gardiner	1731, 1748 (850) 1676, 1716 (178) 1737 1760 1641 1728 1819
Teale, John Tedder, Richard Templeman, Thomas Tennent, George Terrall, Francis Terry, Leonard Theobald, John	1685, 1690 (255) 1688 (Cornish) 1667, 1697 (122) 1706 (Edinburgh †) 1712 1684–1708 (York)

1764, 1791
1736
1698 (545)
1717
1731
1756
1602 (Wales)
1760
1669, 1674 (222)
1668 (Edinburgh)
1733
1643-1663 (Edinburgh)
1755, 1764 (1004)
1722, 1738 (874)
1752
1675 (247)
1634
1497, 1529
1684 (York)
1738
1662, 1685 (334)
1728 (803)
1701 (615)
1734, 1750 (852)
1713, 1752 (697)
1714
1677, 1721 (296)
1709
1676 (286)
1698, 1711 (549)
1695
1688, 1757 (449)
1733, 1764 (854)
1764
1733, 1774
1805
1708
1735
1765
1576
1744, 1783 (912)
1749, d. 1755 (941)
1684 (York)
1739
1654, 1680 (?57)

Tough, Charles (2)	1687, 1705 (442)
Toulmin, George	1797, 1805
Tovey, William	1787, 1801
Towers, John G.	1809
Towers, Robert	1771, 1807
Towers, William	1781
Towgood, George	1764–1797 (Cork)
Towns, William G.	1808, d. 1859
Townsend & Compton	1770–18—
Townsend, Benjamin	1744 (967)
Townsend, Edward	1730
Townsend, Geo. Herbert	1810
Townsend, John (I)	1748, 1784 (928)
Townsend, John (2)	1778
Townsend, J., and	
	c. 1766 (1012)
Townsend, Richard	1648, 1670
Townsend, William	1699, 1707 (644)
Trahern(e), Edward	1679, 1718 (336)
Trapp, John	1695 (731)
Travers, Henry	1720
Treasure, John	1758
Tredaway, William	1710
Tregian, Alexander	1688 (Cornish)
Tregian, Richard	1688 (Cornish)
Trenchfield, William	1696
Trew, James	1667 (227)
Trewalla, Charles	1689
Trewallon, Charles	1731
Triggs, John	1763 (Cork)
Triggs, Nathaniel	1688 (Cornish)
Tristam, Robert	1757
Trout, John	1689 (464)
Tubb, John	1686
Tunwell, Richard	1804
Turberville, Daubeny	1703, 1714 (626)
Turner, Benjamin	1765
Turner, Nicholas (1)	1537, 1561
Turner, Nicholas (2)	1579, 1606
Turner, Peter	c. 1540–50 (London and Norfolk)
Turner, Samuel	1790 (1075)
	1686
Turner, Stephen Turner, William	1702 (627)
Turner, William Robert	1815
Turnour, John	1453, 1457

Turnour, Robert Twiddell, Nicholas Twist, John Tylsh, Nicholas	1498 1741 1611 1581 (Dublin)
Ubly, Edward Ubly, John (1) Ubly, John (2) Ubly, Thomas Underwood, George Underwood, Jonathan Underwood, Matthew Urswyke, Thomas Usher, Thomas	1716, 1744 (759) 1722 1748, 1755 (944) 1741, 1751 (896) 1712 (686) 1698 1752, 1761 (958) 1516, 1540 c. 1739 (Banbury)
Vallat, Richard Vaughan, John Vaughan, Thomas Vaughan, Walter Vaughan, William Venables, William Veitch, Robert Verdon, Thomas Vernon, Richard Vernon, Samuel Vibart, George Vickers, T. Vile, Thomas (1) Vile, Thomas (2) Villers & Wilkes Villers, William Vincent, John Vinmont, William Virgin, George Viveash, Simeon Vokins, Bartholomew Vooght, James	1637 (Cork) 1753, 1792 (985) c. 1705 (Brecknock) c. 1603 1773 1772 1725 (Edinburgh †) 1732 1635, 1650 (93) 1674 (232) 1668 (273) 176-? (Sheffield) 1641, 1675 (80) 1664 (106) 1818–1825 (Birmingham) c. 1760–1825 (Birmingham) 1685 1678 (310) 1817 1756 1670 (182)
Waddle, Alexander Waddoce, Thomas Wade, William Wadsworth, William Waid, Jane Waidson, George Waight, Thomas	1714 (Edinburgh †) 1549, 1565 1785 1780 (1060) 1684–1699 (York) 1709 1677, 1702 (325)

Waite, John (1)	1670 (224)
Waite, John (2)	1706 (688)
Wakefield, John	1809
Wakefield, Richard	1720
Waldby, Dionysius	
Walley, Dionysius	1759
Walker, Alexander	1676 (Edinburgh †)
Walker, Edward	1682 (380)
Walker, James	1745
Walker, John (1)	1585, 1617
Walker, John (2)	1713, 1728 (695)
Walker, John (3)	1748 (957)
Walker, Nicholas	1457, 1473
Walker, Patrick	1607 (Edinburgh †)
Walker, Patrick	1631
Walker, Ralph	1588, 1614
Walker, Richard	1616 (York)
Walker, Samuel	1660 (Edinburgh †)
Walker, William (1)	1739
Walker, William (2)	1787, d. 1840 (1079)
Wall, Christopher	1704
Wallbank, Miles	1657, 1670
Wallden, Thomas	1797
Waller, Robert	1779 (1046)
Walley, Allen	1668 (? 79, and 154)
Wallis, Robert	1738
Walmsley, Edward	1685 (445)
Walmsley, John	1702 (679) (Gainsboro' and
waimsicy, John	London)
Walmalar Cimon	,
Walmsley, Simon	1716
Walsh, Piers	1685 (Dublin)
Walsh, Walter	1483, 1489
Walter, John	c. 1603
Walter, Thomas	1620 (Huntingdon)
Waltham, Thomas	1669
Walton, Richard	1675 (246)
Wandsworth, Thomas	1575, 1585
Waple, Thomas	1698
Ward, James (1)	1693
Ward, James (2)	1711
Ward, John	1457
Wardrop, J. and H.	c. 1800–40 (Glasgow)
Wardman, Baldwin	1743
Wareing, John	1698
Wareing, Samuel	1714
Warham, Peter	1759

Waring	, Charles	1685
	an, Richard	1697, 1727 (546)
	an, William	1713 (719)
Warren		1697, 1732 (566)
Warren	, Laurence	1669 (207)
Wass, I		1712 (748) (London and
,		Gainsborough)
Wastell	, Clement	1630, 1655
	nan, Henry	1693
	, Anthony	1685 (544)
	, William	1670, 1694 (289)
	s, William	1668 (Bristol)
	uth, William	1704
	, David	1660–1679 (Dublin)
	, George	1697
Watson		1671 (Edinburgh †)
Watson	, Joseph	1713 (732)
Watt, V	William	1783
	er, Thomas	1674, 1709 (370)
Watts,		1749
	John (1)	1725, 1760 (801)
	John (2)	1749, 1780
	Thomas	1744
	& Harton	c. 1800
Waylet	t, William	1701 (609)
	, William	1801
	Christopher	1633, 1669
Webb,	George	1641 (Dublin)
Webb,	Isaac	1705
Webb,	Joseph	1691, 1726
Webb,	Richard	1685 (458)
Webb,	Thomas	1714 (701)
Webb,	William	1569, 1600
Webb,	William	1751
Webber	r, John	c. 1640–80 (Barnstaple)
Weir, Jo	ohn	1701 (Edinburgh †)
Weir, R		1646 (Edinburgh†)
Weir, T	Chomas	1596 (Edinburgh †)
Welford	l, James	1727, 1754
Welford		1760, 1788
	Edmund	1772
Wells, J	ames	1777
	orth, Moses (see	
	worth)	
	t, Henry	1608, 1640

Wescott, John	1670 (171)
Wescott, Wilson	1752
West, John	1729
West, Moses	1677, 1696 (285)
Westcott, Thomas	1761
Westcott, William	1637, 1684
Westwood, Joseph	1682, 1728
Wetter, William	1666 (72, 78 and 402)
Wetwood, Humphrey	1602
Wetwood, Katharine	1633
Wharram, Ralph	1756 (996)
Wharton, Arthur	1726 (York)
Wheeler, George	1732
Wheeler, Thomas	1692 (692)
Wheeler, Thomas Wheeler, William (I)	1701
Wheeler, William (2)	1728
Wheelwright, Francis	1683–1686 (Dublin)
Wheely, Robert	1666
Whitaker, Benjamin	1691, 1712 (485)
White, Daniel	1676, 1699 (403)
White, John	1652, 1680
White, John	1755, d. 1772 (971)
White, John	1684–1726 (York)
White, Joseph	1652, d. 1665
White, Joseph	1747 (927)
White, Philip	1778 (1056)
White, Richard	1477–1487 (Dublin)
White, Richard	1686, 1729 (448)
White, Samuel (1)	1696
White, Samuel (2)	1729
White, William	1608 (Rotherham)
White, William (1)	1661
White, William (2)	1702
White, William (3)	1714, 1748
White, William (4)	1751, d. 1783 (954)
White & Bernard	c. 1722 (743)
(Samuel White 1606Y as	nd Onisephorous Bernard, 1722Y.)
Whitear, William	1749
Whitebread, James	
Whitehead, Joseph	1735
	1463, 1475
Whitehede, John	
Whiteman, Benjamin	1692
Whiteman, see also	
Wightman Whitfield, Christopher	c. 1740 (of ?)
wintheld, Christopher	0. 1/40 (01 1)

Whiting, John	1480
Whiting, Thomas	1701
Whittington, Robert	1757
Whittle, Francis	1715, 1740 (715)
Whittle, William	1760
Whittome, John	1701
Whitwood, Humphrey	1592
Whyt, George	1676 (Edinburgh †)
Whyt, John	1619 (Dublin)
Whytbe, Thomas	1551
Whyte, Robert	1805 (Edinburgh)
Widdowes, John	1670 (191)
Wiggin, Abraham	1707 (651)
Wiggin, Henry	1679, 1690 (373)
Wiggin, John	1738
Wigginton, Thomas	1730
Wightman, William	1758, 1801 (993)
Wigley, John	1713
Wigley, Thomas	1699 (630)
Wikelin, William	1758
Wilb(e)y, William	1467, 1498
Wildash, George	1820
Wildman, Richard	1728 (831)
Wilkes, Edward Villers	1825–1835 (Birmingham)
Wilkes, Matthew	d. 1642 (Cork)
Wilkes, Richard (Wilks)	1708 (655)
Wilkinson, George	1742
Wilkinson, John (I)	1764 (Dublin)
Wilkinson, John (2)	1764–1775 (Dublin)
Wilkinson, Oliver	d. 1762 (Dublin)
Willett, Edward	1681 (409 and 412)
Willett, Richard	1666
Willey, Mary	1760 (988)
Williams, A.	c. 1730 (Bideford)
Williams, Anthony	1608, 1616
Williams, Edward	1697
Williams, George	1731
Williams, John (1)	1675, 1697 (299)
Williams, John (2)	1697, 1719
Williams, John (3)	1724 (819)
Williams, John (4)	1729 (903)
Williams, John	c. 1730, 1750 (Falmouth)
Williams, Robert	1689 (482)
Williams, Roger	1755 (Cork)
	-/ -/ / ()
Williams, Thomas (1)	1649, 1670

Williams, Thomas (2)	1698
Williams, Thomas (2) Williams, Thomas (3)	1741
Williamson, Charles	d. 1715 (? Birmingham)
Williamson, James	1647–1677 (York)
Williamson, Richard	1677–1700 (York)
Williamson, Richard	1553
Willis, Nicholas	1529
Willison, Thomas W.	1795
Wills, William	1733
Willshire, Thomas	c. 1780, 1795 (Bristol)
Willson, Edward	1684 (York)
Wilmore, Samuel	1758
Wilson, Daniel	1690 (481)
Wilson, George	1773 (Lurgan)
Wilson, Henry	1749
Wilson, John	1502
Wilson, John	1732 (Edinburgh)
Wilson, Joseph	c. 1760-75 (Lurgan)
Wilson, Thomas	1801
Wilson, William	1758
Winchcombe, Thomas	1691, 1697 (509)
Wingod, John	1748, 1766 (934)
Wingod, Joseph (1)	1721, 1767 (774)
Wingod, Joseph (2)	1811
Winkworth, Moses	1671, d. 1693 (218)
Winter, George	1701 (608)
Wintle, Charles	1785
Wiseman, Robert	1747
Withebed, Richard	1669, 1678 (162)
Withers, Benjamin	1719, 1730 (729)
Withers, William (1)	1654, 1669 (53)
Withers, William (2)	1684, 1692 (438)
Witte, Ludwig	1815
Witter, Elizabeth	1691 (475)
Witter, Samuel	1671, 1682 (196)
Wittich, J. Christian	1820
Wood, Henry	1768, 1786 (1019)
Wood, John	1612, 1618
Wood, Robert	1551
Wood, Robert (1)	1671, 1701 (200)
Wood, Robert (2) Wood, Thomas	1700
Wood, Thomas	1580, 1596
Wood, Thomas	1705
Wood, Thomas Wood, William	1792
Wood, William	1589

Wood, William (1) Wood, William (2) Wood & Hill Wood & Mitchell	1726 1736 c. 1798 (1067) c. 1742 (893)
(Wm. Wood, 1744Y., and	John Mitchell, 1739Y.)
Woodehouse, Nicholas	c. 1541
Woodeson, John	1708 (690)
Woodford, John	1669
Woodhouse, Thomas	1549, 1584
Woodley, Thomas	1743
Woods, Samuel	1820–1840 (Waterford)
Woodward, Robert	1681, 1699
Wooldridge, Robert (1)	1749
Wooldridge, Robert (2)	1795
Wormlayton, Joseph	1691
Wormlayton, Fulk	
Humphrey	1701 (588)
Wratten, Richard	1749
Wratten, Robert	1718
Wright, Alexander	1732 (Edinburgh †)
Wright, Harman	1766
Wright, James	1780 (Edinburgh †)
Wright, John	1717, 1743 (870)
Wright, Nicholas	1614, 1630
Wright, Richard	1712 (737)
Wright, Thomas	1683, d. 1685 (399)
Wright, Thomas Wright, Thomas S.	1803
Wright, William	1764, 1772 (1041)
Wroghan, Richard	1645–1665 (York)
Wyatt, John (1)	1685 (439)
Wyatt, John (2)	1718 (739)
Wyatt, Thomas	1723 (761)
Wyatt, Thomas Wyatt, William	1688 (Cornish)
Wycherley, Thomas	1593, 1627
Wyer, Daniel	1754 (Dublin)
Wyeth, William	1733
Wylie, J.	1852 (Glasgow)
Wylls, Charles	1734
Wynder, Richard	1474–1499 (York)
Wynn, Jacob	1687
Wynn, John	1746, 1763 (923)
Wynslaye, John (Wynsley)	1525
	us 25
Yalden, Martin	1691
Yates, James	1826 (Birmingham)

Yates, James Edward	1802
Yates, John	1741
Yates, Lawrence	1738, 1757 (905)
Yates & Greenways	c. 1870 (Birmingham)
Yates, Richard (1)	1772, 1783 (1031)
Yates, Richard (2)	1803
Yates & Birch	(Pii)
Yates, Birch & Son	c. 1800 (Birmingham)
Yeates, George Allinson	1763
Yewen, John (see Ewen)	
Yorke, Edward	1732, 1772 (848)
Yorke, James Samuel	1773
Young, Thomas	1693
Young, William	c. 1590
Younghusband, John	d. 1700 (Newcastle)

XIII

The London Touchplates

The following list is compiled of the touches in the order in which they were struck on the touchplates, and the descriptions arrived at by a careful study of the originals which are still preserved at Pewterers' Hall; if this list is used in conjunction with the drawings which follow, it should help the student to check any recorded London mark which comes to his notice.

Some of the marks on the touchplates are imperfectly struck, and therefore either the device, initials or name(s) therein are indistinct—in some of these cases the details have been completed from whole touches of the same maker found on actual pewterware.

The drawings were made originally from good photographs of the touchplate marks, and were as accurate as they could reasonably be at the time; since then there has been an opportunity to study the marks more carefully from either the plates themselves, or from excellent replicas which the Company has had made in a plastic material (in the latter the marks are, in fact, even more legible!).

When Massé compiled the original list of these marks the owners of many of them were unknown, and so he was unable to make the list as complete as it might otherwise have been. The present editor has had the opportunity of examining additional records from which the ownership of many more marks can now be allocated to known pewterers, and several others to pewterers who had formerly not been recorded by either Massé or Cotterell.

Following the description of each mark will be given the name of the striker (when known), and his date of "freedom" (i.e. when he came out of his apprenticeship and was admitted to the Yeomanry of the Pewterers' Company).

A newly fledged pewterer did not necessarily strike a touchmark then, nor was he allowed to trade on his own account until he had satisfied the Pewterers' Court that he had the requisite skill and capital. In some cases it was several years after freedom that a man was given "leave to strike (a touch) and open shop".

After some years of successful trading a pewterer could be invited to "take his clothing" (or to become a Liveryman); from this exalted group would be chosen the Steward and Wardens and, of course, the Master of the Company. The "Court" consisted of the Master for the time being, all Past Masters, and the current wardens of the craft.

In this list is given only a brief description of the device(s) within the touch, and the name of the pewterer (where known) together with the date upon which he became "free"; for information on the period during which he is known to have been working one may turn to the alphabetical list in the previous chapter. Where a name on a touch is unreadable, but is, nevertheless, known for certain from examination of other marks of that particular maker, the missing parts are included in brackets.

Abbreviations used are "Y" for date of admission to Yeomanry; b.c. or b.o. for beaded circle or beaded oval; s.b.c, or s.b.o. for small beaded circle or oval, respectively, and p.o. or p.c. for plain oval or circle.

Touchplate No. 1 (Dimensions $19\frac{1}{6}$ in. $\times 13\frac{3}{8}$ in.)

- R.L. in an oval; a comet between the letters. (Robert Lucas, Y., 1637, M., 1667, restruck.)
- 2. JOHN SILKE in b.c.; below a device, probably a silkworm on a leaf. (Y., 1627, restruck.)
- 2a. Illegible except IOHN (badly struck touch of above)
- 3. A.M. in s.b.c.; two pewter pots with date between (16)63. (Anthony Mayors, Y., 1648, restruck.)
- 4. THEOPHILUS READING; a winged caduceus with two stars above, struck in 1687, and out of place; see also 263, with notes thereunder. (Y., 1675.)

- 5. N.K. in b.c.; a hand grasping a slipped rose. (Nicholas Kelk, Y., 1638.)
- 6. T.H. in b.o.; a crowned heart. (Thomas Howard, or Haward, Y., 1636.)
- 7. R.M.; a beaded circle with bird and (16)63.1 (Robert Martin, Y., 1638.)
- 8. W.G.; a dolphin in b.c.
- 9. I.F. in s.b.c.; a harp. (John French, Y., 1638, restruck.)
- 10. A.F. in s.b.c.; a harp rising out of a crown. (Alex. French, Y., 1657.)
- 11. S.I. in s.b.c.; a lamb and flag. (Samuel Jackson, Y., 1658.)
- 12. T.D. in b.c.; a griffin's head erased on a torse, with crown above. (Thomas Dickinson, Y., 1662.)
- 13. N.H. in s.b.c.; a talbot, with date 1662. (Nicholas Hunton, Y., 1661.)
- 14. I.B., with crowned rose-en-soleil. (? John Blackwell, Y., 1660.)
- 15. I.L. in s.b.c.; six flowers beneath the rays of an estoile. (John Leeson, Y., 1644, restruck.)
- 16. In p.o., at the top E. SONNANT² in a label; below this, in a cartouche between two palm-branches, a rose with larg. crown above it; and on a scroll above, I. TAUDIN [JAQUES TAUDIN]. (This man was a Frenchman, naturalized, who became a freeman in 1657.) His name is often misspelled. (Cf No. 344 and 557.)
- 17. T. H.; in a p.o. a fleur-de-lys, with a palm-spray on either side; at the top a crown, with the letters. T. H. (Thomas Haward (2), Y., 1663.)
- 18. FRA. LEA; a pomegranate with p. I. (He seems to have had two similar punches, but of different sizes.) (Cf. 39 and 40.) (Y., 1651.)

 1 "It was ordered by the Court Dec. 11th 1662–3 that all Laymen doe alter there tutches within fourteene dayes $w^{th}\,y^e$ date of 1663", and on the 17th it was ordered that "all tutches bee . . . registered in a booke at y^e hall w^{th} in a month". (Welch, ii. 130.)

² It is probable that TAUDIN inserted E. SONNANT in order to show the quality of his pewter. Later TAUDINS, and also JONAS DURAND, did the same, and the E is often badly stamped and looks like H or R. It does, in fact, refer to Etain. Somant.

- 19. Jo. INGLES in a b.o. on a scroll in the upper part of a cartouche; below this 1671 and two hands grasped. (See also 170.) (Y., 1668.)
- 20. W.A., a very small touch in a heart shaped outline.

21. I.I. in a very small b.c., with a mermaid.

- 22. C.S. in s.b.c. with a spray of rose. (? Charles Sweeting, Y., 1633.)
- 23. I.L. with a cockle shell between, and the date 1663. (? John Langdale, Y., 1663.)
- 24. W.C. in b.c., with date 1663. (William Cowley, Y., 1662.)
- 25. W.A. in b.c.; a female figure with an anchor, W.A. and date (16)63.
- 26. W.I. in b.c., with a tree in centre. (William Jones, Y., 1668.)
- 27. R.I. in c.; with a shepherd's crook surmounted with a crown, and the date 1657. (Robert Jones, Y., 1657.)
- 28. R.H. in b.c.; two naked boys (? Gemini) holding hands; above them a sun in splendour, between them the date (16)64. (Richard Hoare, Y., 1655.)
- 29. H.P. in b.o., with foliage; below it an interlaced knot and a letter (very indistinct). (Henry Pauling, Y., 1659.)
- 30. I.F. in b.c.; with a cardoon on a stalk, and date 166(?). (John Francis, Y., 1663.)
- 31. T.C. in s.b.c. with an eel, curled, and date (16)63. (Thos. Cooper, Y., 1653.)
- 32. I.C., with griffin's head erased in a shaped rectangle.
- 33. G.A. in b.c.; a unicorn gorged with a mural crown and a rose near the forefeet. (George Abbott, Y., 1664.)
- 34. S.A. in b.c.; a griffin's head erased, two stars and (16)66.
- 35. B.B. in b.c., with 1664 and a flaming heart. (Beza Boston, Y., 1661.)
- 36. T.F. in b.o., and a fountain. (Thomas Fountain, Y., 1626.)
- 37. R.M. in b.c., with a wheatsheaf and R.M., one letter either side. (Ralph Marsh, senior used also by Ralph Marsh, Jr.) (See also 94.)
- 38. WILLIAM BURTON in b.c.; a hand holding a sceptre. (Y., 1653.)

- 39. F.L. in s.b.c.; a pomegranate. (Francis Lea, Y., 1651.) (See also 18.)
- 40. Close to above is another touch with pomegranate, though smaller; this would be Francis Lea's smaller touch, probably for spoons.
- 41. P.D. in s.b.c.; an hourglass with P.D., (one either side). (Peter Duffield, Y., 1645.)
- 42. P.B. in b.c.; with a leaf. (Peter Brocklesby, Y., 1650.)
- 43. W.A. in s.b.c., with a hand grasping a dagger. (? William Ayliffe, Y., 1659.)
- 43a. B.A. and a hand holding a sheaf of arrows with a crown above in b.o. (shown on page 263, last line).
- 44. I.H. in b.c., with a crown and two crescents. (? Isaac Hadley, Y., 1656.)
- 45. T.B. in b.c., with a bell. (Timothy Blackwell, Y., 1641.)
- 46. R.H. in b.c.; a locust or grasshopper, with three stars and date (16)56. (Ralph Hulls, Y., 1653, cf. No. 208.)
- 47. N.M. in an octagon, with a windmill and 1640. (Nathaniel Mills, Y., 1639, restruck.)
- 48. T.S. in b.c.; a portcullis crowned; each initial is also crowned.
- 49. I.C. in b.c.; a cock with a crown above. (John Coursey, Y., 1660.)
- 50. G.R. in s.b.c., with double-headed eagle and date (16)63. (Gabriel Redhead, Y., 1662.) See also 109.
- 51. I.C. in b.c.; a Queen's head, crowned. (John Collins, Y., 1667.)
- 52. D.I. in b.c., with the lion and lamb lying down together. (Daniel Ingole, Y., 1656.)
- 53. W.W. in b.c., a cock and date (16)55. (William Withers, Y., 1654.)
- 54. H.B. in b.c. between three pears. (Henry Brettell, Y., 1665.)
- 55. T.A. in s.b.c.; a talbot.
- 56. E.A. in b.c.; a hand grasping an anchor.
- 57. C.T. in s.b.c., with a lion rampant. (? Charles Tough, Y., 1654.)
- 58. W.M. in s.b.c., with two voided lozenges, one above another, and date 1666.

59. W.A. in b.c.; Adam and Eve under a tree. (William Adams, Y., 1646.)

60. H.C. in b.o., with a Crown and a sword, also a portcullis and two stars, and date (16)66. (Henry Curtis, Y., 1662.)

61. E.H. in s.b.c.; a ploughshare and a star.

62. E.H. in s.b.c.; a sword surmounted by a crown.

- 63. PETER BRAILSFORD, in oval; a shield charged with cinquefoil berries, with palm-spray on each side; above a ducal coronet with the name. (Y., 1667.)
- 64. T (or I). C. in b.c. (device illegible).
- 65. F.G. in b.c., with a crescent. (Francis Gibbons, Y., 1664.)
- 66. W.B. in b.c., with a pegasus (and illegible date below).
- 67. I.B. in s.b.c., with a boar and (16)65. (James Bullevant, Y., 1660.)
- 68. W.I., in very small b.c., with 1665. (William Jackson, Y., 1662.)
- 69. W.M. in circle, with a crescent and star. (Wm. Mabbutt, Y., 1636, restruck.)
- 70. T.S. in very small b.c., with a pellet and 1663.
- 71. VINCENT SILK, in b.c., device, a bale of silk. (Y., 1654.)
- 72. W.W. in very small b.c., with a sword in centre. (William Wetter, Y., 1666.) (See also 78 and 402.)
- 73. W.P. in small b.c. with a spray of leaves and date (16)63. (William Pettiver, Y., 1655.) (This is his original touch, restruck, and (below) his later dated touch.)
- 74. W.P. in b.c. with a spray of leaves, and date 1655. (Wm. Pettiver.)
- 75. W.B. in b.o.; Father Time with scythe and hourglass. (Wm. Eddon, or Eden, Y., 1689.)
- 76. W.C. in s.b.c., a heron with open wings. (Wm. Cropp, Y., 1659.)
- 77. W.A., a pelican in piety, dated 164?.
- 78. W.W.; two thistles and initials in s.b.c., with date (16)66. (Wm. Wetter, see 72.)
- 79. A.W. in s.b.c., with three roses. (Allen Walley, Y., 1668) (repeated at No. 154).
- 80. T.V. in small b.c., with a spray of stalks and fruit. (Thos. Vile, Y., 1641.)

- 81. W.D., with an antelopes head within a crown, in s.b.c.
- T.B., with talbot's head erased on a torse, in s.b.c. (Thomas 82. Barford, Y., 1665.)
- S.M., with a dolphin, in s.b.c. (? Samuel Mason, Y., 83.
- R.A., with a standing squirrel, in b.c. (Richard Allen, Y., 84. 1668.)
- T.H. in b.c.; on a torse an arm erect with a heart held in the 85. hand. (Each initial is crowned). (? Thos. Hawford, Y., c. 1658.)
- T.B. in s.b.c., with a bird flying, above a sun or star. (Thomas 86. Batteson, Y., 1661.)
- I.N., in b.o.; device illegible (? a hydra erased). (James 87. Nicholls, Y., 1651.)
- R.I., in s.b.c.; a key and a sword, crossed, with star above. 88.
- E.H., in s.b.c., with two spoons, crossed. 89.
- I.I., with a key, in s.b.c. 90.
- A.L., in b.c.; a hand grasping a hammer, with (above it) 91. the word GRADATIM. (Adam Langley, Y., 1656.)
 I.H., with two keys, crossed, and the date (16)63, in
- 92. s.b.c.
- R.V. in oval, with a cockatrice on a cap of estate. (Richd. 93. Vernon, Y., 1635, restruck.)
- R.M. in b.c., a rabbit standing before a wheatsheaf. (Ralph 94. Marsh, Jr., Y., 1663.)
- B.C. in b.o., with crowned thistle at foot, and a pegasus' 95. head and wings above.
- A.R., in b.c., device, a sleeved arm holding aloft a scroll, or 96. roll, with date 1646. (Anthony Rolls, Y., 1645, restruck.)
- JOHN BULL, a bull's head, with two stars, in b.c. (Y., 97. 1660.)
- H.H. in oval, with three hearts (one and two), surmounted 98. by a crown. (Henry Hartwell, Y., 1667), cf. 217.
- I.H. in b.c.; a strake, with fret (? or checker board), with 99. date 1663.
- P.P. in b.c.; a cardinal's hat. (Peter Priest, Y., 1667.) 100.
- E.H. in small shield, with two keys, crossed. IOI.
- R.I. in diamond outline, with two swords, crossed. 102.

103. I.I. in a small shield, with a key and date (16)68.

104. P.P. with a beacon, and the date 1668, in a plain circle. (Peter Parkes, Y., 1641, restruck.)

105. W.L. in shield, and the date 1668.

106. T.V. in an oval, with an anchor and legend SPES EST, in a frame of two palm leaves. (Thomas Vile, Jr., Y., 1664.)

107. W.D., with date 1668, in very small b.c. (William Ditch, Y., 1666.)

108. B.B., with a peacock, and date (16)68, in b.c. (Spoonmark.) (See also 35.) (Beza Boston, Y., 1661.)

109. G.R. with a two-headed eagle, with date (16)68, in s.b.c. (Gabriel Redhead, Y., 1662, see also 50.)

110. T.S. with rose, and date 1668, in b.c. (? Thos. Stribblehill, Y., 1668.)

111. W.P. with spray of leaves, and 1668, in s.b.c. (? Wm. Pargeter, Y., 1658.)

112. I.H. with a crook and a key, and (16)68, in pointed shield. (? Joseph Hewett, Y., 1668.)

113. W.A. with a hand grasping a crook or hook, and date (16)68, in a diamond outline.

114. W.D. with a fleur-de-lys and (16)68.

115. S.W. and a lion rampant, in b.c.

116. I.I. with crowned hammer and 1666, in b.c.

117. T.R. and a ? Woolsack, and 1668, in s.b.c.

118. W.?., with a slipped rose and two stars above, in b.c.

119. T.S. with a star in splendour, and 1663, in s.b.c.

120. I.A. a rampant lion facing towards a thistle at left, in a plain circle.

121. R.H. with a portcullis, and (16)66, in s.b.o. (Robert Harding, Y., 1666.)

122. THOMAS TEMPLEMAN, a temple with a small man in front, in a large headed oval. (Y., 1667.)

123. S.L. a knot with crown above, in shaped outline. (Stephen Lawrence, Y., 1661, see also 357.)

124. H.F. with date 1668, in s.b.c. (Henry Freeman, Y., 1665.)

125. T.E. and a limbeck (still) on a stand, in b.c. (Thomas Elphick, Y., 1667.)

126. E.N., with a bird bolt, in s.b.c. (Edward Newbolt, Y., 1668.)

- R.T. with a stags head, couped, and date (16)68. (Richard 127. Talver, Y., 1666.)
- WILLIAM HALL, with a globe and the signs of the zodiac, 128. in b.c. (Y., 1666.)
- I.T. with a pair scissors, in b.c. (Jas. Taylor, Y., 1667.) 129.
- I.H. with a hawk, between two palm leaves, in plain oval. 130.
- RICHARD COLLIER, a collier with a coal sack, in b.c. (Y., 131. 1664.)
- I.C. with a thistle, in s.b.c. (? John Comer, Y., 1666.) 132.
- L.D. with a heart transfixed with two arrows, and date 133. 1668.
- R.M. with a closed helmet, in b.c. (Richard Mastead, Y., 134. 1666.)
- L. DYER, a shield with three anchors upon it; palm spray 135. at either side and, the word LONDINI above DYER, (Lawrence Dyer, Y., 1648, restruck.)
 I.H. in plain circle, with a wheatsheaf and the date (16)63.
 T.O. with a crown, in a small shield. (Probably Thomas
- 136.
- 137. Osborne, Y., 1642.)
- F.P. with a pelican in her piety, in b.c. (? Francis Parsons, 138. Y., 1666.)
- 139.
- W.P. with a pear, in b.c. (? Wm. Pierce, Y., 1669.) CHRIS. RAPER in circle, with a dagger between three castles, 140. palm fronds below. (Y., 1665.)
- C.H., and a swan with wings raised, in b.c. (Charles Halifax, 141. Y., 1669.)
- JOHN BYXTON in oval at top, below a dog and a crown. (Y., 142. 1667.)
- Nich. HUNTON; beneath a crown, below this, on a torse, a 143. talbot with demi-stag's head in his paws. (Y., 1661, see also 13.)
- 144.
- C.C. with two cinquefoils, in s.b.c. This touch is almost illegible, except for a shield with a 145. greyhound's head, erased, on a torse; above a crown and the word LONDINI (?). (? Thomas Barford, Y., 1665.)
 T.D. and a castle, in b.c. (Timothy Drinkwater, Y., 1666.)
 T.A. beneath a crown, below a plough, in plain oval.
- 146.
- 147. (Thomas Alder, Y., 1657.)

- 148. F.C., and a crowned female head, in b.c. (? Francis Casse, Y., 1667.)
- 149. R.A. at top, below this a harp and a crown with an anchor between, palm leaves at sides, in plain oval. (Robert Alger, Y., 1666.)
- 150. C.R. with a lotus flower. (A similar touch, with date 1674 will be seen at No. 220). (? Charles Richardson, Y., 1667.)
- 151. I.M. placed one letter each side of a man's face, and with date (16)68. (John Mann, Y., 1658.)
- 152. G. ROOKE, and a bird with a trumpet. (Y., 1668.)
- 153. I.C. with a ship in full sail. (Probably a badly struck impression of No. 465.) (? John Cooper.)
- 154. A.W. with three roses, repeat of No. 79. (Allen Walley.)
- 155. I.G. with a bugle and a star.
- 156. IERE. LOADER with a sun in splendour on an anchor, in b.c. (Y., 1667.)
- 157. E.G. with a star and a fleur-de lis in a shield. (Edward Goodman Y., 1669.)
- 158. R.P. with a bird, and the date (16)71.
- 159. H.N. with Neptune and a trident, riding upon a sea-horse. (Henry Napton, Y., 1668.)
- 160. R.B. with a skull surmounted by a crown, and with both initials crowned, in an oval. (Ralph Browne, Y., 1660.)
- 161. W.H. with St. George and the dragon, in oval. (William Hulls, Y., 1668.)
- 162. R.W. with a dancing female figure, and date (16)69. (Richard Withebed, Y., 1669.)
- 163. DAVID BUDDEN, and a hand grasping a scroll, in a large oval. (Y., 1668.)
- 164. G.C. with an ostrich, in oval. (Gilbert Cornhill, Y., 1669.)
- 165. R.S. either side of a small book, and the date (16)69. (Robert Sayers (Seare), Y., 1667.)
- 166. R.I. with a windlass and well, in b.c. (Richard Jacob, Y., 1668.)
- 167. W. SMITH with LONDINI below, device, the Prince of Wales feathers. (William Smith, Y., 1668.)
- 168. WILLIAM PAXTON above a crown, below this a small shield emblazoned with a crowned flower (? marigold), in a plain oval. (Y., 1668.)

- 169. T.W. in monogram with four stars and the date (16)70, in a shaped octagon.
- 170. I.I. with two hands clasped, and 1670, in b.c. (Jonathan Ingles, Y., 1668.)
- 171. IOHN WESTCOTT in two scrolls at top, and a crowned shield bearing three crowns. (Y., 1670.)
- 172. I.C. and an open left hand, crowned, in b.c. (Joseph Collier, Y., 1669.)
- T.H., with crossed sceptres, and with a bird perched above, a crown overall, and date 1670 below, in b.c. (Thomas Hicks, Y., 1669.)
- 174. E.H. with crossed sword and key, in diamond shaped outline, (Edward Hodgkins, Y., 1669.)
- 175. ROGER READING, with a mermaid on a shield, crowned, in plain oval. (Y., 1668.)
- 176. I.S. with the worm of a still, in s.b.c. (John Skinn, Y., 1670.)
- 177. R.G. with a large crown, in b.c. (Richard Gardiner, Y., 1669.)
- 178. THOMAS TAYLOR in two scrolls, and a shield depicting a lion passant. (Y., 1676.)
- 179. I.C. and a sun in splendour rising from clouds, in b.c. (Joseph Alson, Y., 1668.)
- 180. IOSEPH PARKER on a crown, with two hands above, each with a hammer. (Y., 1663.)
- 181. D.B. with a helmet, and date 1670. (Daniel Barton, Y., 1670.) (See also 298.)
- 182. B. VOKINS, the name on a scroll with crown above, and three fleurs-des-lys below, in large b.c. (Bartholomew Vokins, Y., 1670.)
- 183. I.R. and a Roebuck, in b.c. (John Robinson, Y., 1659.)
- 184. LEWIS IAMES on scrolls, and a hand grasping a thistle. (Y., 1674.)
- 185. B.E. and a hawk with raised wings, in b.c.
- 186. I.H. and a harp with hammer above it, in b.c. (John Hamberlin, Y., 1671.)
- 187. I.G. with three trees, in b.c. (John Greenwood, Y., 1669.)
- 188. E.D. in an eight-foiled stamp, with four large pellets and twelve smaller ones, and date 1672. (Edward Dodd, Y., 1669.)

189. S.W. with a crescent and ? (touch scored through).

190. I.B. and a flaming heart, crowned, in s.b.c. (Jabez Boston, Y., 1663.)

191. I. WIDDOWES, and a mitre with a crown above. (John Widdowes, Y., 1670.)

192. R.H. in spider's web, a spider in centre, in plain circle. (Richard Heath, Y., 1666.)

193. W.R., with a shepherd's crook, sheep and dog, in b.c. (Wm. Richards, Y., 1664.)

194. THO: HUNT above a running greyhound. (Y., 1666.)

195. IOHN ROTHWELL, a hand holding a fleur-de-lys. (Y., 1662.)

196. S.W. with a harp, in b.o. (Samuel Witter, Y., 1671.)

197. JOHN ALLEN, ANNO 1671, and a swan with outstretched wings. (Y., 1671.)

198. E.L. with a palm tree ? (Nearly illegible owing to double striking.)

199. S.I., and a dove with olive branch in beak, and (16)71, in b.c. (Samuel Ingles, Y., 1666.)

200. Ro. WOOD in a scroll with a crown above, below this a man with a bow (? Robin Hood) and a child. (Robert Wood, Y., 1671.)

201. I.P. with Father Time with an hourglass and scythe. (Joseph Pratt, Y., 1670.)

202. EDWARD RELFE, LONDON; device, a child playing with a dog. (Y., 1668.)

203. W.M. and a crowned heart, in oval. (William Matthews, Y., 1655.)

204. WILL: HOWARD; a leopard's head, ducally coronetted. (Y., 1671.)

205. Wm. ATKINSON, a cupid with bow and arrow. (Y., 1672.)

206. C.C. interlaced, with a dolphin embowed, crowned, and date 1672. (Christopher Clark, Y., 1661.)

207. L.W. with a large pellet, crowned, in b.c. (Lawrence Warren, Y., 1669.)

208. RALPH HULLS, and a grasshopper, in plain oval. (Y., 1653.)

209. MABBERLE(Y); an eagle perched on a knotted snake. (Stephen Mabberley, Y., 1661.)

- T.R. in exergue Charing Cross; Queen Eleanor's Cross, 1672. (Thomas Radcliffe, Y., 1671.)
- 211. I.L. with a spray of flowers, and date (16)72. (John Lilley, Y., 1666.)
- 212. RIC. MEDDOW on scrolls in a large crown, and a shield with a curled snake and bird as the device. (Y., 1672.)
- 213. S.Q. in a beaded heart-shaped punch, with an arrow and a key, and date (16)73. (Samuel Quissenborough, Y., 1672.)
- 214. DANIEL MASON in an oval with floral border, device a strong man (? Hercules) between two pillars. Y., 1669.)
- 215. ROBERT GREGGE, device, a slipped trefoil on a shield. (Y., 1667.)
- 216. T.M. and a negro's head. (Thomas Morton, Y., 1672.)
- 217. G.H. and three hearts with a crown above, in plain oval. (Gabriel Hartwell, Y., 1667.)
- 218. M.W.; a hand grasping a crook, in pointed shield-shaped touch. (Moses Winkworth, Y., 1671.)
- 219. IOHN REDSHAW, a running greyhound. (Y., 1669.)
- 220. C.R. with a tulip bloom, and (16)74. (? Charles Richardson, Y., 1667.) (see also 150.)
- 221. W.S. on a shield with three fleurs-des-lys, above this a crown on a cushion. (Walter Sturt, Y., 1668.)
- 222. B.T., crossed sword and sceptre, crowned. (Benedictus Thompson, Y., 1669.)
- 223. Tho: Skinn, London in a scroll at top, with a crown; below this an angel with palm frond, and date (16)73. (Y., 1672/3.)
- 224. I.W. with a pair of scales, in s.b.c. (John Waite, Y., 1670.)
- 225. In a beaded circle, a still and a bell (no wording or initials). (Richard Belsher, Y., 1673.)
- 226. Tho: MIDDLETON, and a man standing behind a barrel (or tun) holding aloft, in one hand a bunch of grapes, and in the other a footed cup. (Y., 1673.)
- 227. IAMES TREW; a scallop shell and five pellets. (Y., 1667.)
- 228. EGERTON BRYAN, device, the heraldic arms of Bryan, three piles. (Used also by W. Tibbing, No. 334.) (Y., 1669.)
- 229. EDMUND MOMFORD, a griffin's head erased, and a crown. (Y., 1712.)

230. H.Q., with a cross paty and 1674, in s.b.c. (Hugh Quick, Y., 1674.)

I.S., with a fruit tree (sloe?) and (16)74. (John Slow, Y., 231. 1672.)

SAMUEL VERNON on a circular band, a wheatsheaf, a crown 232. and two stars. (Y., 1674.)

THOMAS RIDDING in two scrolls, device, a pelican in her 233. piety in a shield. (Y., 1674.)

I. SANDFORD in oval surrounding a hogshead, nose upper-234. most. (Y., 1674.)

I.M. with a mill and a wheel, in b.c. (John Millman, Y., 1673.) 235.

I. IACOMB in a scroll above a dove with olive branch. (Rob-236. ert [alias Jacob] Jackombe, Y., 1660.)

IOHN LEESON, LONDINI in two scrolls, device, the crescent 237. moon and seven stars. (Y., 1673.)

HENRY PRATT, a cat, seated. (Y., 1674.) 238.

I. SAUNDERS, device, an elephant's head erased. (Y., 1674.) 239.

W.A. and an acorn crowned, in a beaded octagon. (William 240. Allen, Y., 1668.)

H.H. LONDON, an anchor with a ship imposed thereon. 241. (Humphrey Hyatt, Y., 1675.)

H.F. and a boar's head, in b.c. (Henry Frith, Y., 1675.) 242.

S.F. and a running hare and word LONDON, in large oval. 243. (Samuel Facer, Y., 1675.)

I.E. a bird and (16)75. (John Emes, Senior, Y., 1673.) 244.

GEORGE HALE, 1675, device, a running hare. (Y., 1675.) 245.

R.W. and (16)75, device, a tun, in a small beaded octagon. 246. (Richard Walton, Y., 1675.)

C.T. and date (16)75, in a diamond shaped punch with 247. beaded edge. (Christopher Thorne, Y., 1675.)

WILL: ONLY above a phoenix. (Y., 1674.) 248.

IOHN RAWLINSON, LONDINI, device, a mitre. (Y., 1675.) 249.

I.K. with two stars, in s.b.c. (John Kenton, Y., 1675.) 250.

IOHN SNOXELL; device, a globe, and date 1675 (Y., 1675.) 251.

JOHN SMITH; device, two hearts, one above the other, point 252. to point, and date 1675, in oval. (Y., 1675.)

H.I. with three horseshoes, and (16)75. (Henry Jones, Y., 253. 1675.)

- 254. . . . TON, LONDON; device, a stag tripping. (John Horton, Y., 1675.)
- 255. IOHN TEALE, CHARING CROSS; device, the monument of Charles I, on horseback. (Y., 1685.)
- 256. IOHN HULLS, LONDINI, and Prince of Wales feathers issuing from a crown. (Y., 1662.)
- 257. E.I. with an antelope's head, couped, in circle. (Edward Iles, Y., 1674.)
- 258. T.S. with a pomegranate, and 1675 (struck twice). (Thomas Smith, Y., 1675.) (See also 428.)
- 259. THO: KING, with two hands holding an anchor, crowned, and 1675. (Y., 1675.)
- 260. O.R., and a hand holding a spear (or perhaps intended for a turncock), and date (16)76. (Obedience Robins, Y., 1671.)
 261. IAM: KNIGHT, device, a beehive. (James Knight, Y.,
- 261. IAM: KNIGHT, device, a beehive. (James Knight, Y., 1675.)
- 262. I. COX, LONDINI, two cocks facing, with a crown over. (John Cox, Y., 1679.)
- 263. T.R. with three tulips, and (16)75. (Theophilus Reading, Y., 1675.) He was allowed to strike a new touch (No. 4) in 1687 (this should have been at the foot of the first touchplate; as there was no room then in that position it was struck, out of position, at top.)
- 264. A.R. with a diamond lozenge, in a small shield, and (16)76. Anthony Redhead, (Y., 1675.)
- 265. HEN. MORSE; device, a winged griffin. (Y., 1675.)
- 266. G.C. with crown and horseshoe, and 1676.
- 267. T.G. with a key between, in s.b.c.
- 268. H.B. with a lion's head erased, crowned, in shaped oval. Henry Bradley, (Y., 1675.)
- 269. D.H. with a key between, and '76. (David Heyrick, Y., 1676.)
- 270. I.G. above a small shield of arms of City of London, in a very small b.c. (James Glazebrook, Y., 1676.)
- 271. P.H. with half length bust of a Cavalier between, and '76. (Paul Hayton, Y., 1676.)
- 272. THO. DEACON, and a flaming beacon, in a large oval with unbroken rim. (Y., 1675.)

273. G.V. with an anchor and a heart, in s.b.c. (George Vibart, Y., 1668.)

274. RALPH BENTON, with LONDON below, and '76, with three barrels. (Y., 1676.)

275. I.R. over a castellated tower, with star above, and '76. (John Russell, Y., 1676.)

276. T. CVTLOVE, three fleurs-de-lys in shield crowned, within a large oval. (Y., 1670.)

277. T.H. with three bunches of grapes, in b.c. (Thos. Hodgson, Y., 1676.)

278. WILL: HURST, and a peacock. (Y., 1676.)

279. H.P., a dexter hand holding a quill pen, with date 1677. (Humphrey Penn, Y., 1676.)

280. WIL: ADAMS, with a unicorn's head, in a large oval. (Y., 1675.)

281. T.H. with a still, and 1676. (Thos. Hickling, Y., 1674.)

282. I.I. in a small diamond shaped touch with a leaf in centre, with '77.

283. ROBERT MORSE, LONDON in a circular band and with a skull inside and a hedgehog at top, within a large b.o. (Y., 1676.)

284. I.H. with two keys, crossed, in s.b.c. (Joseph Higden, Y., 1676.)

285. Moses West, London, over a shield with a chevron and three leopards' heads. (Y., 1677.)

286. R.T. a goat in centre, and LONDON below. (Robert Tillott, Y., 1676.)

287. To: Shakle, and a large crown, between two ostrich feathers. (Thos. Shakle, Y., 1680.)

288. SA. MABBS, LONDON, with a fleur-de-lys issuing from a rose. (Y., 1676.)

289. W.W. with a double knot (two trefoils joined by a loop), and date (16)77. (William Waters, Y., 1670.)

290. I.P. and a maiden's head, crowned. (John Payne, Y., 1677.)

291. W.K. and ? a date below, with three mullets at top. (Wm. Kendrick, Y., 1670.)

292. R.D. with a star between, and date 1677. (Richard Dunne, Y., 1677.)

- 293. Io. CASTLE, LONDINI, a castle tower, with a demi-lion above. (Jonathan Castle, Y., 1675.)
- 294. ED. GROVES, a man in a grove, with LONDINI below. (Y., 1677.)
- 295. I. DOVE at top, LONDINI below, over a dove on a knotted snake. (John Dove, Y., 1676.)
- 296. T.T. with a crown above, and 1677. (Thomas Tidmarsh, Y., 1677.)
- 297. I.L. and a lily-pot, with date 1678 below. (John Laughton, Y., 1668.) (See also 480.)
- 298. DA. BARTON, and a closed helmet, with '78. (Daniel Barton, Y., 1670.) (See also 181 and 573.)
- 299. I.W. with four stars, and 1678. (John Williams, Y., 1675.)
- 300. IOHN STRIBLEHILL, device a Bishop's Mitre. (Y., 1676.)
- 301. RICHARD SMITH, and date 1677, in circle, with three tudor roses, in s.b.c. (Richard Smith, Y., 1677.)
- 302. HENRY HATCH in a label over an earl's coronet, below this a shield with a wolf(?) in centre. (Y., 1675.)
- 303. ROB. LOCK and date 1678 in scrolls at top, above a padlock. (Y., 1677.)
- 304. THOMAS LEACH, with a two-headed eagle, crowned. (Y., 1677.)
- 305. I.C. a fox carrying off a goose. (John Cropp, Y., 1677.)
- 306. FRA. PARADICE—78 and a star in exergue of an octagon, device in centre, two angels with swords, guarding the Tree of Life. (Y., 1675.)
- 307. IONAT BONKIN in scroll over two slipped flowers (? teazels). (Y., 1699.)
- 308. WILLIAM MORS, device obscure, perhaps a circular trivet. (William Morse, Y., 1676.)
- 309. F.L. with skull and crossbones, within a circle, at top of which is a porcupine, or hedgehog. (John Larkin, Y., 1677.)
- 310. W.V. with '78, and a monumental pillar. (Wm. Vinmont, Y., 1678.)
- 311. I.N. above a fleur-de-lys, and '78, in a small shield.
- 312. R.F. with a windmill, in b.c. (Richard Fletcher, Y., 1677.)
- 313. W.G. with a winged Pegasus, in b.c. (William Green, Y., 1676.)

- 314. E.P. and a horse with a crown above, and date 1678. (Edward Pusey, Y., 1676.)
- 315. C.B.; device a building (? the Royal Exchange). (? Chris. Bentley, Y., 1678.)
- 316. IER. COLE, a crowned maiden's bust, with a dagger below. (Jeremiah Cole, Y., 1676.)
- 317. I.P. with three roundels, in b.c. (John Pepper, Y., 1678.)
- 318. R.B. with a flory cross and date '78, in a diamond-shaped punch with scalloped edge. (? Rice Brooks, Jr., Y., 1678.)
- 319. Indecipherable monogram below a lion passant. (Thomas Kelk, Y., 1663, restruck.)
- 320. BEN. BLACKWELL, in a circular beaded touch, the centre of which is an ornamented bell. (Y., 1676.)
- 321. T.F., and a belled falcon on a torse, with a crown above, and date '79. (Thos. Falconer (Faulkner), Y., 1678.)
- 322. W.P. with fleur-de-lys and '79, in b.c. (William Pettiver, Y., 1676.)
- 323. J.B. in a script monogram, framed by two ostrich plumes. (John Blunt, Y., 1676.)
- 324. I. GRIMSTED, with a wheatsheaf, crowned. (Y., 1676.)
- 325. T.W., with a woolweight, and 1679. (Thos. Waite, Y., 1677.)
- 326. T.C. with a coiled snake, in s.b.c. (Thos. Cooper, Y., 1678.)
- 327. LUKE PORTER, a man carrying a load (? a porter), and date '79. (Y., 1679.)
- 328. WILL. FLY, device a fly. (Y., 1676.)
- 329. I.H. with a thistle, crowned, and with a bird perched on each leaf. (John Hamlin, Y., 1678.)
- 330. A.R. with three crosses, paty, in bordered circle. (Andrew Rudsby, Y., 1677.)
- 331. N.R. (with N reversed) in lozenge shaped touch, with date 1679. (Nathaniel Rider, Y., 1675.)
- 332. N.I. with three lozenges above, and date (16)79. (Nicholas Johnson, Y., 1667.)
- 333. (Edward) RANDALL; device a leopard's face (this touch only partially visible). (Y., 1677.)
- 334. WILLIAM TIBBING, a pheon (or ? arrowhead). (Y., 1662.)
- 335. W.H. with a crescent and two stars, and '87. (William Heaton, Y., 1687.) The same touch struck again, at 342.

- 336. E.T. and three herons, one and two, in b.o. (Edward Treherne, Y., 1679.)
- 337. T.S. with a mermaid. (Thomas Simms, Y., 1675.)
- 338. WILLIAM HALL, with a dexter arm grasping some object in the hand. (Y., 1680.)
- 339. B.C. a bird on a torse and 16(?87), in b.o. (Benjamin Cooper, Y., 1677.)
- 340. F.P. in b.c., with plough; 1680. (Francis Perkins, Y., 1678.)
- 341. THOMAS BETTS in b.c.; device, an ass's head erased, with a bugle-horn. (Y., 1676.)
- 342. Below this is a tiny punch upside down, with W.H. and [16]87. (See 335, above.)
- 343. H.T. with a pair of shears and a hammer above, and [16]80. (badly punched.)
- 344. IAQUES TAUDIN; on another scroll E. SONNANT; rose and crown. (Cf. Nos. 16 and 557.)
- 345. FRÃCIS KNIGHT; device, a spur. (Cf. No. 261.)
- 346. RIC. SHURME[R] on a shield, crowned; a cinquefoil ornament. (Y., 1678.)
- 347. THOMAS CLARKE; in centre a two-tailed merman with hands uplifted. (Y., 1671.)
- 348. G. Scott, a hand holding a thistle. (Y., 1675.)
- 349. I.P. in b.c.; a fleur-de-lys and 1680. (John Pettiver, Y., 1677.)
- 350. T. PICKFAT, LONDINI; device, three lions rampant; and four roundels. (Y., 1677.)
- 350a. T. (?), with a rose-en-soleil crowned. (Thomas Powell, Y., 1676.) This mark is shown on page 263.
- 350b. WILLIAM (Sandys), (the surname illegible), device a shield of arms, with field of three crosslets and a fess. (Wm. Sandys, Y., 1680.) This mark is shown on page 263.
- 351. WILLIAM CROOK(ES), device two swords in saltire. (Y., 1679.)

Touchplate No. 2 (Dimensions 17 in. \times 12 $\frac{7}{8}$ in.)

352. OLD PARR, Aged 152 around edge, and in centre an old man, with R.P. at sides. (Robert Parr, Y., 1703.) (Robert Parr was a descendant of "Old Parr".) This touch is struck

out of place; it should have been at the end of T.P. No. 2, or at beginning of T.P. No. 3.

353. G. SMITH with a plough, and three roundels, in oval.

(George Smith, Y., 1651, restruck.)

354. WILLIAM BURTON, device a hand holding a sceptre. (Y., 1653.) (W.B. struck an earlier touch, No. 38 on first t.p.)

355. C.R., a dexter hand holding a mace, in b.c (Charles Rack, Y., 1681.)

356. WILLIAM (BRAY)NE, a snail, with a large ducal coronet above. (Y., 1681.)

357. S. LAWRENCE, with a crown, in centre a knot with S.L. (see also 123).

358. M.C. with a sugar-loaf, and date (16)76.

359. W.H., with goat's head erased and gorged, with a coronet, in s.b.c.

360. H.D. with a spray of oak leaves and an acorn, in s.b.c.

361. W. IOHNSON at top, device, St. George and the dragon. (Wm. Johnson, Y., 1676.)

362. T.S. with a domed-lid tankard. (Thomas Smith, Y., 1682.)

363. I.M. with a key, in a small b.c. (John Marsh, Y., 1658.)

364. THOS. GARDINER, device, a beacon (similar touch to that of Tho. Deacon, No. 272). (Y., 1679.)

365. EDWARD BURCHELL, a grasshopper with a crown above. (Y., 1681.)

366. IOHN BONVILE, a crown and six five-pointed stars. (Y., 1677.)

367. IOSEPH BROOKER, a unicorn's head erased. (Y., 1679.)

368. T.R. with a Saracen's head, in b.c.

369. I. SAVIDGE, device Gog and Magog, with a bell between. (Y., 1678.)

370. T. WATTERER, LONDON, a hand supporting a crowned anchor. (Y., 1670.)

371. GILES MADGWICK, with a skull, crowned. (Y., 1681.)

372. HENREY at top, SIBLEY at bottom, in centre, a crowned wheel. (Y., 1682.)

373. H. WIGGIN with a dagger, in b.c. (Y., 1679.)

374. N (reversed). GOBLE, with three cinquefoils. (Y., 1680.)

375. SAMVELL HANCOCK, device a cock standing on a hand. (Y., 1677.)

- 376. . . . HVNTON at top, below LONDON, device a demi-talbot holding a stag's head. (William Hunton, Y., 1682.)
- 377. W.A. with date (16)82, device, a man-at-arms bearing a boar's head on a pike. (Wm. Attwood, Y., 1675.)
- 378. I.C. with a floral ornament above, and date 1683 beneath, in small b.o. (John Cooper, Y., 1681.)
- 379. I.K. with crescent and two stars. (Joseph King, Y., 1682.)
- 380. E.W. a man with a staff, in plain oval. (Edward Walker, Y., 1682.)
- 381. R.H. and a right-hand, gloved, with date 1682. (Robert Hands, Y., 1682.)
- 382. B.C. in a heart-shaped touch, with a mullet at base. (Benjamin Cotterell, Y., 1679.)
- 383. I.C. in a spiral cable, in b.c. (Joseph Cable, Y., 1682.)
- 384. I.P. with a heart and an orb, and '83. (John Parkinson, Y., 1680.)
- 385. Edw. Kent, London, a wheatsheaf and a rabbit. (Y., 1668.)
- 386. WIL.,...(?),abirdonaposthorn.(WilliamFoster, Y., 1675.)
- 387. SAMVEL (SEA)TON, device, a seahorse. (Y., 1679.)
- 388. T.S. with a tudor rose, LONDON at top. (Thos. Smith, Y., 1677.)
- 389. R.S. with a stirrup, LONDINI at top. (Robert Sturrop, Y., 1677.)
- 390. I.S. with a small four-petalled flower, a bird above, and date '83 below, in a small shield.
- 391. (Anthony) James, A squirrel in a shield. (Y., 1685.)
- 392. IAMES CARTER, device, a horse and cart. (Y., 1683.)
- 393. I.I. at base, a goose and three goslings above. (John Joyce, Y., 1683.)
- 394. T.D. (or P), a winged figure (? angel) with an object like a caduceus.
- 395. (HENRY HAR)FORD, an animal (possibly a cow) facing to left with a large crown above. (Y., 1677.)
- 396. R.G. with a daisy, in b.c. (Richard Grey, Y., 1682.)
- 397. RICHARD SMALPIECE, in scrolls at top and base, device, a crowned bust of (?) Charles II. (Y., 1682.)
- 398. P.M. with an archer between, LONDON at top. (Peter Moulesworth, Y., 1662.)

- 399. THO. WRIGHT, device, a woolweight. (Y., 1683.)
- 400. WILL. LONG, a shield, crowned; on the shield a thistle and a lion rampant. (Y., 1677.)
- 401. G.G. and a bust of a cleric. (Gabriel Grunwin, Y., 1681.)
- 402. (top of touch illegible), below two thistles. (William Wetter, Y., 1666.)
- 403. D.W. at base, the device is Daniel in the lion's den, with date 1684. (Daniel White, Y., 1676.)
- 404. TH(OMAS) SAUNDERS, device in centre the moon in splendour (face of the man in the moon). (Y., 1684.)
- 405. I.F. with a lantern, in a small circular touch. (Joshua Fairhall, Y., 1684.)
- 406. THOMAS MARSHALL, device, a crowned tulip. (Y., 1684.)
- 407. IOSEPH PIDDEL, an elephant. (Y., 1684.)
- 408. (AB)RAHAM BRAFI(ELD) in scroll at base; device Adam and Eve in Garden of Eden. (Y., 1684.)
- 409. Ed. Willett, a bird with outstretched wings, issuing from a crown. (Y., 1681.) (cf. 412.)
- 410. I.C. and Adam and Eve picking the forbidden fruit, and CORMELL in scroll at base, in an oval touch. (John Cormell, Y., 1683.)
- 411. T.L. with a lock and key, and date (16)84. (Thomas Lock, Y., 1684.)
- 412. ED. WILLETT, No. 409 repeated.
- 413. C.O. with a dagger, in small shield. (Charles Osborne, Y., 1681.)
- 414. A circular touch depicting a flying angel, with LONDON at base, and '84. (Philemon Angel, Y., 1684.)
- 415. IOHN PETTIT, and a unicorn, in large oval. (Y., 1683.)
- 416. IOHN SHAKLE with date 1685, and in centre a many pointed star. (Y., 1672.)
- 417. WILLIAM NICHOLLS, a castle tower with fleur-de-lys at top. (Y., 1685.)
- 418. E.A. and the worm of a still (?). (? Edward Allanson, Y., 1682.)
- 419. S.S. a shepherd with his crook, and sheep. (Samuel Sheppard, Y., 1683.)
- 420. I.S. with a covered tankard, and date (16)85. (John Smith, Y., 1685.)

- 421. I.M. with (16)85, in s.b.c. (John Mumford, Y., 1670.)
- 422. I.D. with a dexter hand holding a chesspawn between thumb and forefinger, and 1685. (John Done, Y., 1683.) (See also 488.)
- 423. C.R. with griffin, passant. (Charles Royce, Y., 1684.)
- 424. I. Nicholls, with dragon's head erased. (Y., 1684.)
- 425. EDWARD ROBERTS, a portcullis. (Y., 1679.)
- 426. IOHN LAWRANCE, and a statue of a Roman ruler. (Y., 1684.)
- 427. I.S. and a slim tree between two stars, and date 1685.
- 428. THOMAS (SMITH), LONDON, 1675, device a seeded pomegranate, or a cocoa pod. (Y., 1686.)
- 429. Tho. CARY, a dexter hand holding a key, crowned. (Y., 1685.)
- 430. IOHN CO(UR)SEY, Jr., device, a cock with large crown at top and '86. (Y., 1685.)
- 431. HEN. ADAMS, PICKADILLY, Adam and Eve and the Temptation. (Y., 1686.)
- 432. I.D. with a flower, and date (16)86. (John Dyer, Y., 1680.)
- 433. THO. PADDON, LONDON, a shield with three fruits, a bend between. (Y., 1683.)
- 434. W.B. with a lion sejant holding a key, and '85. (William Buttery, Y., 1686.)
- 435. N.M. and a Mortar, with 1687. (Nicholas Marriott, Y., 1686.)
- 436. THOMAS SMITH, a salamander with large crown above. (Y., 1686.)
- 437. No name or initials; a circular touch with a shield of arms, on a bend three closed helmets, and the rest a field of ermine.
- 438. W.W. with a cockerell, and '85. (William Withers, Y., 1684.)
- 439. I.W. with a worm and a still, and '86. (John Wyatt, Y., 1685.)
- 440. D.S. device, a small figure on his knees, being stoned by three others (? St. Stephen). (? Daniel Stephens, Y., 1685.)
- 441. DANIELL PARKER, a large Earl's coronet at top, and, below, two hands grasping hammers. (Y., 1678.)
- 442. CHARLES (TOUGH), a winged arrow. (Y., 1687.)

- 443. THOMAS ROBERTS, a lion rampant, a crown and two stars above. (Y., 1688.)
- 444. W.B. with a cinquefoil, a star and two roundels.
- 445. E.W. with a lily, crowned, in b.c. (Edward Walmsley, Y., 1685.)
- 446. T.B. in a diamond lozenge, with triangular ornaments in border.
- 447. WILL. HALL at top, LONDON at base, with a female figure with a crook(?). (Y., 1687.)
- 448. RICHARD WHITE, device, a pelican in piety, and '89. (Y., 1686.)
- 449. IAMES TISOE, and a portcullis. (Y., 1688.)
- 450. H.I. in centre, with a rose and two roundels above, in s.b.c.
- 451. E.Q. either side of a wheel of fortune, with LONDON below, and date 1688 at top, in oval. (Edward Quick, Y., 1687.)
- 452. N. SHORTGRAVE, device a demi-boar on a torse. (Nathaniel Shortgrave, Y., 1687.)
- 453. Io. STILE, a dove perched on a nowed snake. (Y., 1688.)
- 454. E.H. and a large crown over a lion rampant, holding a harp, also the date 1689. (Edward Holman, Y., 1688.)
- 455. I.V. with a crown and wheatsheaf arising therefrom, in s.b.c.
- 456. IOHN FRENCH, 1687, and LONDON in scrolls at top above a harp, in oval. (Y., 1686.)
- 457. A.C. and a hand holding a slipped rose. (Alexander Cleeve, Y., 1688.)
- 458. RICHARD (W)EBB, device in centre, a Queen robed and throned. (Y., 1690.)
- 459. T.P. with three horseshoes, two and one, in b.c., with date '89. (Thomas Palmer, Y., 1672.)
- 460. IOHN CAMBRIDGE, device, a heart with palm leaves at sides, over a clasped book, all within a large oval, with date 1687. (Y., 1687.)
- 461. IOHN HOLLY, LONDON, a comet and various roundels. (Y., 1689.)
- 462. ROBERT NICHOLS(ON), an eagle on a globe. (Y., 1690.)
- 463. T. CASTLE, LONDON, a castle tower. (Thos. Castle, Y., 1685.)
- 464. IOHN TROUT, a trout with crown above. (Y., 1689.)

- 465. IO. COOPER, LONDON; a ship in full sail. (Y., 1688.)
- 466. CHARLES HULSE, 1690; device, three fleurs-des-lys and five small roundels. (Y., 1690.)
- 467. E.S. and a tudor rose, with LONDON over, in large oval. (See below.)
- 468. E.S. at sides, and 90 (top and bottom) with tudor rose in centre of a very small b.c. (This and the former touch are of Edward Smith, Y., 1680.)
- 469. SAMUEL (SMALLEY), a wheatsheaf on an interlaced knot. (Y., 1683.)
- 470. W.E. and a hourglass, in s.b.c. (William Eden, or Eddon, Y., 1687.)
- 471. (?) a monogram of T.A.O.B., in s.b.c.
- 472. E.M. with two busts of sovereigns, a crown above (? William & Mary). (Edward Matthews, Y., 1691.)
- 473. THOMAS COWDEROY, a swan with upraised wings. (Y., 1689.)
- 474. IOHN BASKERVILE, device a tudor rose and a thistle, both halved and conjoined, crowned. (Y., 1681.)
- 475. E.W. with a triangle below, in a small shield. (Elizabeth Witter, Y., 1691.)
- 476. F.C. in b.c., with a nude figure of Venus standing in a shell on the waves. (Francis Cliffe. Y., 1687.)
- 477. JAMES BRETTELL, device, three pears and three roundels. (Y., 1688.)
- 478. IOHN OLIVER, LONDON, device, a seven-branched candlestick and [16]89. (Y., 1687.)
- 479. SAMUELL JACKSON, device, a shield of arms, a chevron indented and three griffins' heads. (Y., 1667.)
- 480. IOHN LAUGHTON in b.o., device, a vase of flowers. (See also 297.)
- 481. DANIEL WILSON, device, a shield of arms; three coiled snakes. (Y., 1690.)
- 482. R.W. in b.o., with five stars; below, a cock and a fox sejant, facing; 1692. (Robert Williams, Y., 1689.)
- 483. WILLIAM BRAVELL, a crowned beacon and [16]92. (Y., 1684.)
- 484. WILLIAM CLARKE, device, a rose and two buds. (Y., 1687.)

- 485. BENJAMIN WHITAKER, device, a shield of arms, three voided lozenges. (Y., 1691.) (In the list of the Yeomanry it is given Whiteacre.)
- 486. I.G. in b.c., a lion rampant bearing an orb, and date [16]92. (? James Gisburne, Y., 1691.)
- 487. I. COOKE, LONDON, a stag tripping, similar to the indistinct touch on Plate II, No. 254. (Isaac Cooke, Y., 1690.)
- 488. IOHN DONNE, device, a hand with a pawn. (Y., 1685.) (See also 422.)
- 489. I.S. in b.c., a fox or cat, (16)92.
- 490. IOHN KENTON, device, two large six-rayed stars, I.K. (Y., 1675.)
- 491. WILLIAM SANDYS, on a torse a griffin rampant. (Y., 1680.)
- 492. THOMAS LEAPIDGE, LONDON, device, a rabbit and a wheatsheaf. (Y., 1691.)
- 493. IAMES HUGHES, device, a goat and ducal coronet. (Y., 1691.)
- 494. IOHN PAGE, device, a lion passant under a tree, in oval. (Y., 1692.)
- 495. PHILIP (RUDDU)CK, device a duck and date 1690. (Y., 1690.)
- 496. T.B. and a bee with spread wings. (Thomas Buttery, Y., 1692.)
- 497. WILLIAM SMITH, three Prince of Wales feathers, with crown above, '92. (Y., 1691.)
- 498. IOHN FRYER, a two-headed eagle with crown above, and '92. (Y., 1692.)
- 499. I.S. and a lion lying down with a lamb. (John Silk, Y., 1693.)
- 500. I.P. with a pickaxe, and date '93. (Joseph Pickard, Y., 1691.)
- 501. ROBERT above, and date 1693 in scrolls, and ATTERTON below; device, a sun in splendour. (Y., 1693.)
- 502. W.C. and a syringe and worm of a still. (William Colman, Y., 1683.)
- 503. E (or R).M. and a full length figure of a man with bow and sheaf of arrows, with date '93, in b.c.
- 504. WILLIAM RIDGLEY, device Atlas supporting the world, in a large oval. (Y., 1691.)
- 505. F.B. above the shield of arms of Bainbrigge, i.e. a chevron and three battleaxes. (? Francis Beesley, Y., 1693.)

- 506. H.M. device, a marigold between two ears of barley, at top a star.
- 507. IOHN ELDERTON, 169-, three tuns. (Y., 1693.)
- 508. CHARLES CRANLEY, a tent and a lion of England, the arms of the Merchant Taylors' Company, on the field nine pellets. (Y., 1692.)
- 509. Т. WINCHCOMBE, a demi-lion. (Ү., 1691.)
- 510. HARRY GOODMAN, a hen and chickens. (Y., 1693.)
- 511. BENJAMIN BOYDEN, a figure of Justice, with a sword and a pair of scales. (Y., 1693.)
- 512. I.C. in b.c., with a cock. (John Coke, Y., 1694.)
- 513. I.R. in b.c., a fox leaping over a heart. (John Reynolds, Y., 1692.)
- 514. IOSIAH (CLA)RK, within a l.b.o. band inclosing seven stars. (Y., 1690.)
- 515. GEO. HAMMOND in b.c., a dexter arm and hand holding a two-edged dagger. (Y., 1693.)
- 516. SAMUELL NEWELL, device, a rose ensigned by a mitre. (Y., 1689.)
- 517. MARTIN BROWNE in shaped oval, a boat with spread mainsail, with moon and seven stars above. (Y., 1686.)
- 518. GEORGE CANBY, device, a blazing castle or gatehouse and (16)95. (Y., 1694.)
- 519. JOHN HEATH in b.o., a child or dwarf bearing palmleaf. (Y., 1694.)
- 520. R.I. in b.c., a spray of acorn; (16)96. (Robert Iles, Y., 1691.)
- 521. D.I. in centre of a dial face; (16)94. (Daniel James. Y., 1691.) (Obviously out of its place.)
- 522. JOSEPH SMITH in l.p.o., with a wreath of leaves as a border; in centre the Monument. (Y., 1695.)
- 523. THOMAS SPRING, device, a fountain with two small birds. (Y., 1676.)
- 524. C.M. in s.c., and a barrel or tun. (Charles Middleton, Y., 1690.)
- 525. I.H. in small shield, with a rose and a glove below. (John Hankinson, Y., 1693.)
- 526. L.C. in s.b.c., a doll or puppet (?), crowned; (16)95. (Lawrence Child, Y., 1693.)

527. S.B. in a wheel inside a s.b.c. (Stephen Bridges, Y., 1692.)

528. HENRY FEILD, a mailed arm holding out a sphere. (Y., 1693.)

529. W. CLARK, LONDON, device, a naked boy holding a heart and a pansy; (16)96. (Y., 1696.)

530. I.R. in b.c., with a crescent, surmounted by a rainbow. (Joseph Rayne, Y., 1693.)

531. WILLIAM DYMOCKE, device, a squirrel beneath a crown. (Y., 1696.)

532. GEORGE EVERARD in p.c., within a small b.c., three stars; (16)96. (Y., 1696.)

533. W. ATLEE, device, an anchor, a rose, and two stars above. (Y., 1696.)

534. H. Brasted in b.o., a sun in splendour, crowned. (Y., 1692.)

535. RICHARD CLARKE, a crown, with a dolphin beneath; (16)96. (Y., 1696.)

536. IOHN GISBURNE, device, coat of arms, a lion rampant. (Y., 1691.)

537. I.C. in s.b.c., a wheel; 1697. (John Carr, Y., 1696.)

538. IABEZ HARRIS, a leopard's head jessant-de-lys (p.c.). (Y., 1694.)

539. GEORGE NORTH in b.o., crest, on a torse a griffin's head ducally gorged. (Y., 1693.)

540. WILLIAM ELLWOOD, the King's head; (16)97. (Y., 1693.)

541. SOLOMON IEMPSON, a lion rampant. (Y., 1696.)

542. IOSEPH BOWDEN, a cherub's head and wings (p. 1.). (Y., 1687.)

543. IOHN SVMMERS, two keys in saltire, with a crown at the crossing (p. 1.). (Y., 1697.)

544. A.W. in lozenge with beaded edge; 1698. (Anthony Waters, Y., 1685.)

545. I.T. in lozenge with beaded edge, with a star and two cinquefoils; 1698. (John Thomas, Y., 1698.)

546. R.W. in c., with lion rampant. (Richard Warkman, Y., 1697.)

547. EDWARD STONE, (16)98, for device, London Stone. (Y., 1695.)

- 548. W.P. in b.c., (16)98, with two hearts. (William Plivey, Y., 1697.)
- 549. THOMAS TILYARD, device, a spur, (16)98. (Y., 1698.)
- 550. WILLIAM GILLAM, device, a sword, point downwards. (Y., 1698.)
- 551. W.M. in b.o., a crowned heart and eight pellets. (Wm. Mathews, Y., 1698.)
- 552. W.S. in b.c., with a hand outstretched grasping a tulip or lily. (William Stevens, Y., 1697.)
- 553. I.I., an ox, with an open book above, 1700. (John Jones, Y., 1700.)
- 554. IOHN BARLOW, a tulip on a plough. (Y., 1698.)
- 555. ROBERT DAKEN, a unicorn rampant and arms of City of London. (Y., 1698.)
- 556. WILLIAM HEYFORD, device, a bull. (Y., 1698.)
- 557. IONAS DURAND, device, a rose, above the rose 1699, and a label with E. SONNANT. (Y., 1692.) (DURAND was a newphew of JAMES TAUDIN, whose touch is twice given on Touchplate I, (a) No. 16, and (b) No. 344, in each case with E. SONNANT in small extra scrolls.
- 558. RICHARD DYER in b.o., device, a crown. (Y., 1699.)
- 559. W.R. in s.b.c., above, a sword and a pistol in saltire; below a star. (William Rayes, Y., 1682.)
- 560. BASILL GRAHAM, a hand grasping a cup or cl. iice. (Y., 1699.)
- 561. NICHOLAS S(WEA)TMAN, device, the Boscobel Oak, with the head of Charles II, crowned, in centre. (Y., 1698.)
- 562. I.B. in s.b.c., with a gull; (16)99. (John Blake, Y., 1690.)
- 563. I.C. in b.c., a girl's head, wreathed. (John Compere, Y., 1696.)
- 564. T.B. in b.c., a hand holding a baluster-shaped measure, (16)99. (Thomas Bosworth, Y., 1699.)
- 565. THOMAS COOKE, a bird in a hand, and a bush below. (Y., 1690.)
- 566. I.W. in b.c., a fleur-de-lys, crowned, and date 1699. (John Warren, Y., 1697.)
- 567. P.C. in b.c., a handcart; (16)99. (Peter Carter, Y., 1699.)
- 568. EDW. LEAPIDGE, LONDON, device, a rabbit and a wheat-sheaf. (Y., 1699.)

WILLIAM DIGGES, device, a cinquefoil on a shield, 569. crowned. (Y., 1699.)

CHARLES RENDER, device, a horse's head, couped. (Y., 570. 1699.)

F.L. in floral wreath. (Francis Litchfield, Y., 1697.) 571.

CHARLES RANDALL, device, seven stars and a crescent. 572. (Y., 1699).

DA. BARTON, LONDON, device, a helmet; over it a hand 573. grasping a dagger (p. 1. c.). (Y., 1700.) (Cf. Nos. 191 and 298.)

W.H. in b.c., with a fleur-de-lys; 1700. (William Hux, Y., 574. 1700.)

ANT. SMITH, a crescent, crowned. (Y., 1698.) 575.

T.P. in b.c., with a stag's head, crowned; 1700. (Thomas 576. Parker, Y., 1694.)

BERNARD BABB, arms, a cross crosslet and three crescents. 577. (Y., 1700.)

578. I.E. in b.c., with a bird; (16)86. (John Emes, Junior, Y., 1700.)

THOMAS PARKER, device, a lion rampant, and seven stars, 579. with a coronet above. (Y., 1694.)

THOMAS BENNET, crest, on a torse a demi-lion holding a 580. crown. (Y., 1700.)

IOHN NEWHAM, a lion passant; above, a glove (p. 1. c.t.). 581. (Y., 1699.)

ROBERT DEANE, a statue like that of Charles I at Charing 582. Cross. (Y., 1692.)

JOHN PRINCE, a dexter arm, mailed, issuing from a coronet, 583. and grasping three ladles, or flowers. (Y., 1697.)

THOMAS HOPKINS, a bear and ragged staff. (Y., 1700.) 584.

IOHN YEWEN, LONDON, a hand holding out a crowned 585. thistle. (Y., 1700.)

IOHN CHILD, a naked boy holding up a sceptre and a 586. sword. (Y., 1700.)

I.C. in s.b.c., with a hand grasping a tool like a tacklifter, 587. 1701. (Y., 1711.)

In plain circle, a two-headed eagle, with two crescents. In a 588. label portion of the name WORMLAYTON. (Fulk H. Wormlayton, Y., 1701.)

- 589. SAMUELL Boss, a tulip, crowned; 1701 (Y., 1695.)
- IOHN CALCOTT, device, St. George and the dragon. (Y., 590. 1699.)
- I.Q. in s.b.c., with harp and a star. (John Quick. Y., 1699.) 591.
- Tно. Buckby, a buck's head erased. (Ү., 1700.) 592.
- I.H. in b.c., with a lion holding a key. (James Hitchman, Y., 593. 1701.)
- ROBERT BORMAN, a boar's head couped; 1701. (BORD-594. MAN in the list of Yeomanry.) (Y., 1700.)
- THO. BURGES, LONDON, a gunner and cannon. (Y., 1701.) 595.
- NICHOLAS OKEFORD, device, a man's head. (Y., 1699.) 596.
- IOHN KIR(TON), 1702, a shield with five ermine bars. (Y., 597. 1699.)
- GEORGE HUME, an interlaced knot and a wheatsheaf. (Y., 598. 1700.) (Cf. No. 469.)
- Anthony Sturton, a rose and a mitre; 1702. (Y., 1686.) 599.
- T.S. 1702, sheild of the arms of Spencer: quarterly 1 and 4 600. argent, 2 and 3 gules fretty or, over all a bend sable, and three escallops or on the bend. (Thos. Spencer. Y., 1702.) THOMAS FRITH, device illegible (?a kettle). (Y., 1693.)
- 601.
- THOMAS (GREENER), device, bust of Queen Anne. (Y., 602. 1700.)
- N. BES(SANT), the arms of the Cinque Ports: the three 603. leopards of England dimidiated with the hulls of three ships. (Y., 1702.)
- D.B. in b.c., a woolsack, crowned. (David Brooks, Y., 1702.) 604.
- DAVID BUDDEN, a hand grasping a staff. (Y., 1702.) 605.
- WILLIAM ELLIS, device, a man's bust with letters P. G. 606. (Y., 1702.)
- TRISTRAM PIERCE, device, a rose and thistle dimidiated 607. and crowned. (Y., 1702.)
- 608. GEORGE WINTER, a star, a heart, and a marquis's coronet (p. 1.). (Y., 1701.)
- 609. W.W. in s.b.c., a skull surmounted by an eye. (William Waylett, Y., 1701.)
- THOMAS SCATTERGOOD, two hands with hammers and a 610. rose. (Y., 1700.)
- 611. THOMAS BECKETT, a rose within a monogram. (Y., 1702.)

612. NICHOLAS JACKMAN, a man working a handpress or jack. (Y., 1699.)

IOHN SMITH, a chevron engrailed and six crosslets fitchy, 613. with three fleurs-de-lys on the chevron. (Y., 1702.)

I.S. in b.o., with a flower and sun, and a date (1)703. (Joseph 614. Slow, Y., 1702.)

This is the end of the second touch-plate. Many of the last two rows of touches are almost illegible owing to their having been carelessly punched.

Touchplate No. 3.1 (Dimensions, 18 in. \times 13\frac{5}{8} in.)

I.T. in s.b.c., with a pear and (1)704. (James Tidmarsh, Y., 615. 1701.)

S.P. in b.c., with heart and flowers issuing from it. (Samuel 616.

Pettiver, Y., 1695.)

B.C. in small stamp, with a flying bird. (Benjamin Casimer, 617. Y., 1704.)

R.R. in b.c., with fox running off with a goose, and date 618. 1704. (Robt. Reynolds, Y., 1704.)

- ABR.R(OBERTS), a man grasping a boy by his hair and 619. about to punish him; in the exergue PATER FIDE(LIS). (Abraham Roberts, Y., 1687.)
- IOHN SAVAGE, a unicorn; a star above. (Y., 1699.) 620.

ROBERT IU(PE), a rose and a crown. (Y., 1697.) 621.

T.H. in s.b.c., two naked boys (? the sign Gemini) holding 622. up a sun between them, and date 1705. (Thomas Horrod, Y., 1693.)

(HOWELL) GWILT, punch illegible, as a hole has been made 623. here to suspend the touchplate. (Y., 1697.)

IONATHAN COTTON. A bird between a spray of flowers and 624. a spread eagle; date 1704. (Y., 1704.) (Cf. No. 866.)

ROBERT PILKINGTON, a man carrying a bird on his back. 625. (Y., 1704.)

DAW(BENY) TURBERVILE, a lion rampant on a crescent. 626. (Y., 1703.)

¹ This plate is probably the one referred to in Welch, ii. 174, as follows: "Paid John ffrith for a plate to Strike Touches on 8s. 9d."

Here follows a small shaped punch, with a grasshopper and 627. 1705. (William Turner, Y., 1702.)

E.H. in s.b.c., a figure of a man (? a pikeman and his dog). 628.

(Edward Hands, Y., 1704.)

W.B. in s.b.c., with (16)75, crest, a greyhound's head, couped, 629. with crescent over its head. (Wm. Browne, Y., 1705.)
GUY, EARLE OF WARWICK. Guy of Warwick as an armed

- 630. figure holding the boar's head between initials T.W. (Thomas Wigley, Y., 1699.)
- I.S., with a pear and a heart, 1706. (John Spicer, Y., 1699.) 631.
- THOMAS SMITH, a seated figure, apparently with a mitre. 632. (Y., 1705.)
- THOMAS ARNOTT, (? the flower of a leek). (Y., 1702.) 633.
- W.S., with a small book, crowned, 1706. (Wm. Sayers, Y., 634. 1705.)
- T.P. in a small touch, no device. (Thomas Peisley, Y., 1693.) IAMES PAXTON, a sun and a marigold. (Y., 1698.) 635.
- 636.
- 637.
- 638.
- EVERARD GILLAM, a dagger or short sword. (Y., 1702.)
 I.P. with a bear and a ragged staff. (Joseph Pixley, Y., 1706.)
 BENJAMIN F(OST)ER, arms, a chevron ermine and three phaeons. (Y., 1706.) (Cf. No. 847.)
 JAMES (GISBURNE), arms, barry ermine and a lion rampant. 639.
- 640. (Y., 1691.)
- RICHARD (H)ESLOPP, two sheep with long tails. (Y., 1700.) 641.
- H.H. in b.c., a crown and tun, 1707. (Henry Hammerton, 642. Y., 1706.)
- ROBERT MORSE, a lion passant and crown above. (Y., 643. 1702.)
- WILLIAM TOWNSEND, Neptune (? Father Thames) with 644. a trident. (Y., 1699.)
- W.F. in top of shaped punch, with star; below, a phœnix 645. surrounded by flames; below, three fleurs-de-lys. (Wm. Fenwick, Y., 1706.)
- ROBERT CROSFEILD in large circular punch; in centre a 646. clock-face; within the rim of the figures of the hours a crescent, a sun, and 1707. (Y., 1701.)
 TIMOTHY RICHARDS (fecit in interior scroll); device, a rose
- 647. with Prince of Wales's plumes. (Y., 1699.)

- 648. R. KING in b.o., device, a horse's head. (Richard King, Y., 1704.)
- 649. RICHARD COLLIER, arms, three cocks. (Y., 1706.)
- 650. T.B., in b.c., with a crescent. (Thomas Boyden. Y., 1708.)
- 651. ABRAHAM WIGGIN, a sword-hilt (?) and a crown. (Y., 1707.)
- 652. IOHN (BLE)WETT, a lion rampant and a pierced mullet. (Y., 1707.)
- 653. PHILIP ROGERS, a saltire with a stag above; at each side a rose. (Y., 1708.)
- 654. THOMAS SHEPPARD, a shepherd, with sheep, piping to a shepherdess. (Y., 1705.)
- 655. RICHARD WILKS, a lion rampant, leaning against a tree. (Y., 1708.)
- 656. W.K. in s.b.c., a star in centre with a fleur-de-lys above, a crescent below; in the other spaces two roundels, two smaller stars. (William King, Y., 1706.)
- 657. EDWARD QUICK, two heads (? Queen Anne and Prince George). (Y., 1714.)
- 658. HENRY SEW(DLEY), a heart pierced by two arrows, crossed; below, an eagle with two heads. (Y., 1706.)
- 659. I.P. in b.c., two matchlocks crossed with a spiral roll or match. (John Peacock, Y., 1706.)
- 660. JOHN HARRIS, crest, a dog, seated. (Y., 1709.)
- 661. HELLARY PERCHARD, an anchor encircled with a G, and 1709. (Y., 1709.)
- 662. SPACKMAN & GRANT, a fleur-de-lys, with a cross paty on either side of it; below, a crown, with a cross paty under it.
- 663. W.H. in b.c., two hands clasped with a crown above, 1709. (Wm. Hitchens, Y., 1705.)
- 664. PHILIP STEVENS, a grasshopper; above, two keys crosswise, with a roundel between them. (Y., 1709.)
- 665. ROBERT OUDLEY, a rose with an acorn-spray above it. (Y., 1708.)
- 666. R.I. in shaped punch; a small boat in full sail. (Richard James, Y., 1709.)
- 667. RICHARD DALE, device, a pump, or a beacon, or possibly a still. (Y., 1709.) (Cf. No. 704.)

- 668. WILLIAM COX, crest, a goat's head couped, transfixed with a spear, a crown and a tent behind. (Y., 1708.)
- 669. H.S. in b.o., ? an Eleanor Cross, or that in Cheapside, 1710. (Humphrey Sankey, Y., 1710.)
- 670. THOMAS PEISLEY, arms, a lion rampant, with two tails, with a mullet. (Y., 1693.) (See also 635.)
- 671. THOMAS GOODWIN, crest, a demi-griffin. (Y., 1707.)
- 672. ARTHUR ENGLEY, two crescents, with a ducal coronet above them. (Y., 1710.)
- 673. HENRY FEILDAR, a spray of rose-tree, with a sun shining thereon, between two pillars. (Y., 1704.)
- 674. G. LINDSEY, a female figure, seated, with a lance and holding the rose and the thistle; by her side the arms of the City of London, and a coronet over. (Greenhill Lindsey, Y., 1708.)
- 675. TIM. FLY, device, a fly. (Y., 1710.)
- 676. GEORGE SMITH, a bust of Queen Anne, facing left. (Y., 1712.)
- 677. RICHARD GRUNWIN, a portrait, full face. (Y., 1713.)
- 678. PETER REDKNAP, St. Peter bearing two keys. (Y., 1713.)
- 679. IOHN WALMSLEY, a heart, crowned. (Y., 1702.)
- 680. T.I., a rose, 1713. (Theodore Jennings, Y., 1713.)
- 681. THOMAS GRIFFIN, a crown, a heart and a hammer, and six stars. (Y., 1709.)
- 682. RIC. DRINKWATER, a bird bearing an olive-branch on a wheatsheaf; at the sides, a snake tied in a knot, and a lion passant. (Y., 1712.)
- 683. W. BEAMONT, a lion on a cap of estate. (Wm. Beaument, Y., 1706.)
- 684. I. LAFFAR, Atlas, supporting the world, between two mullets. (Y., 1706.)
- 685. WILLIAM NEWHAM, b.p. a rose and a thistle on the same stem. (Y., 1708.)
- 686. G.V. in p.o., a female, nude, skipping, and date 1712. (George Underwood, Y., 1712.)
- 687. IOHN OSBORNE in large punch; a crown; and below, rose and thistle on same stem; at the bottom *Semper Eadem*. (Y., 1701.)

¹ The rose and the thistle were the badge of Queen Anne, and they occur on many of the touches.

A small touch is stamped at the side of No. 687, with I.W., 688. and date (17)07. (John Waite, Y., 1706.)

SAMUEL KNIGHT, b.p. an arm holding a dart. (Y., 1703.) 689.

I. WOODDESON, a wood with the sun shining upon it. (Y., 690. 1708.)

LAW. DYER, three anchors. (Y., 1704.) 691.

THOMAS WHEELER, Queen Anne with sceptre and orb, 692. standing up. (Y., 1692.)

IN°. PALMER, 1714; three horseshoes (Y., 1702.) 693.

I.E. in b.c., a hand with a heart in it, 1714. (James Everett, 694. Y., 1711.)

I.W. in b.c., 1715; a man walking (John Walker, Y., 695.

1713.)

In an oval without a rim, a lion's head, issuing from a mar-696. quis's coronet. (No name or initials.) (Edward Randall, Y., 1715.)

JOHN TIDMARSH, a ship in full sail. (Y., 1713.) 697.

THO(MAS) CART(WRIG)HT, crest, a bird on a torse. (Y., 698. 1712.)

JOHN NE(ATON) in b.c., a crescent and two mullets. (Y., 699. 1714.)

RICHARD PARTRIDGE, three partridges, and a large mitre 700. above. (Y., 1715.)

THOMAS WEBB, two swords crosswise, with a crown and 701. three fleurs-de-lys in the under spaces. (Y., 1713.)

THOMAS MATHEWS, a mermaid, with six roundels. (Y., 702. 1711.)

I.S. in b.c., a stork with wings displayed, 1716. (John Strick-703. land, Y., 1703.)

WILLIAM MEADOWS. (This touch resembles that of Rich-704. ard Dale, No. 667.) (Y., 1714.)

A.C., in plain stamp, a saltire between a rose and a thistle, 705. with a crown above. (Abraham Cross, Y., 1695.)

WILLIAM MILES, a wheatsheaf and a sun. (Y., 1715.) 706.

THOMAS CLARIDGE, a griffin's head, erased, and two frets. 707. (Y., 1716.)

I.A. in a small shaped punch, with a bunch of grapes and two 708. mullets. (John Ansell, Y., 1714.)

709. GEORGE PEISLEY, a shield with a right hand bearing a dagger. (Y., 1718.)

710. IOHN ROLT, a dolphin; above, crest: a griffin's head, couped.

(Y., 1716.)

711. {Io. GRAY} a pelican in her piety. (John Gray, Y., 1712 IA. KING and James King, Y., 1716.)

712. In p.o., a griffin's head couped with a snake in its mouth. (No name or initials.) (William Hulls, Y., 1717.)

713. JOHN LANGFORD, a hand with hammer, and below, a barrel. (Y., 1719.)

714. SETH JONES, the Archangel Michael, crowned with scales and a sword. (Y., 1719.)

715. FRANCIS WHITTLE, a dove with an olive-spray; below, an olive-tree. (Y., 1715.)

716. THOMAS LIN(COLN)E, a rose and a leaved thistle above it. (Y., 1718.)

717. ABRAHAM FORD, b.p. a sun in splendour shining on a wheatsheaf. (Y., 1719.)

718. IOHN CARPENTER, with globe and compasses. (Y., 1711.)

719. W.W. in small lozenge, 1721. (Wm. Warkman, Y., 1713.)

720. I.M. in shaped punch, with a sheep and 1718 (John Merrieweather, Y., 1718.)

721. IOHN OSBORNE, a lion rampant, holding a rose or other flower. (John Osborne, Jun., Y., 1713.)

722. IONATHAN BONKIN, a shepherd on foot with a crook and a dog; in his left hand a rose. (Cf. No. 307.)

723. RICHARD KING, a demi-ostrich with outspread wings and horseshoe in its beak. (Y., 1714.)

724. PENRY. SPRING, a fountain with three basins; on the top a sun. (Pendlebury Spring, Y., 1717.)

725. THOMAS LEACH, arms of London, with but a sword in both upper quarters. (Y., 1721.)

726. ARTHUR SMALMAN, two nude figures holding up a crown. (Y., 1713.)

727. JOHN LANGLEY, a fleur-de-lys and two roundels, with a crown above. (Y., 1716.)

728. W.N. in shaped punch, with fleur-de-lys and a sun in splendour. (Wm. Nicholson, Y., 1720.)

BENIAMIN (WITH)ERS, a cock, and a small crown above. 729. (Y., 1719.)

COLLYER in oblong label, above which is a globe on a 730. stand. (Somewhat similar to that of J. Watts, No. 801.) (Peter Collier, Y., 1720.)

IOHN TRAPP, a dove with olive-branch. (Y., 1695.) 731.

Ios. WATSON in b.o., a soldier (? a grenadier), with a mus-732. ket. (Y., 1713.)

W. CLARKE, an artichoke with a mullet. (Y., 1721.) 733.

THOMAS RHODES, b.p. a sun in splendour shining on a dove 734. with olive-branch. (Y., 1721.)

IONATHAN BRODHURST, b.p. a stag and a bell. (Y., 1719.) 735.

JOHN KENT, a lion holding up a crown. (Y., 1718.) 736.

RICHARD WRIGHT, a peacock in his pride. (Y., 1712.) 737.

ROBERT POLE, a cock, pecking at a wheatsheaf. (Cf. No. 738. 762.) (Y., 1717.)

I.W., each with a mullet above; a wheatsheaf and a rose. 739. (John Wyatt, Y., 1718.)

T.H. with a lamp, in a plain circle. (Thos. Hickling, Y., 740.

EDWARD LAWRENCE, b.p. St. Lawrence with his gridiron, 741. and a sun. (Y., 1713.)

I.E. in shaped punch; a crown and pear. (John Edwards, Y., 742. 1718.)

WHITE AND BERNARD, an eagle issuing from a rose. 743. (Samuel White. Y., 1696, and Onesiphorus Bernard. Y., 1722.)

JOHN HEATH in moulded oval; three cocks and six mullets. 744. (Y., 1711.)

GEORGE TAYLOR, with a figure of Neptune and two mullets. (Y., 1722.) (Cf. No. 758.)

SAMUEL ELLIS, with golden fleece. The rim contains two 746. panels of very florid ornament. (Y., 1721.)

IOHN RANDALL, a leopard's head. (Y., 1723.) 747.

ROBERT WASS, b.p. a crown, a woolsack, a rose. (Y., 1712.) 748.

LUKE IOHNSON, a crowned arrow, point downwards, bet-749. ween a 2 and a 3 (i.e. 1723), between two wings. (Y., 1713.)

ALEXANDER LANCASTER, a swan with collar and chain. 750. (Y., 1711.)

- 751. I.E. in b.c., with a head, wreathed. (John Excell, Y., 1718.)
- 752. I.C., with a wheel, crowned, 1723 (p. l.).
- 753. IOSEPH PRATT, Time, with scythe and hour-glass. (Y., 1709.)
- 754. T. Hux, in a guilloche border; a fleur-de-lys within a crescent. (Y., 1723.)
- 755. EDWARD NASH, three fleurs-de-lys. (Y., 1717.)
- 756. CATESBY CHAPMAN, a ship in full sail. (Y., 1721.)
- 757. THOMAS STEVENS, a dexter hand holding a small globe, also a star or sun. (Y., 1716.)
- 758. GEORGE TAYLOR, Neptune, with a trident. (Also struck badly, above, cf. No. 745.) (Y., 1722.)
- 759. EDWARD UBLY, a stag trippant. (Y., 1716.)
- 760. HENRY IACKSON, b.p. three beehives, with eleven bees volant. (Y., 1723.)
- 761. T.W. in small shaped punch, with crown; rest illegible; below it vertically an oblong punch, LONDON, with beaded edge. (Thomas Wyatt, Y., 1723.)
- 762. IOHN NORGROVE, a cock pecking at a wheatsheaf. (Similar to Robert Pole's touch, No. 738.) (Y., 1722.)
- 763. RICHARD COX, a cock perching on a helmet. (Y., 1712.)
- 764. R.S. in s.c., and a worm from a still. (Richard Spooner, Y., 1719.)
- 765. IOHN COLE, a bull. (Y., 1722.)
- 766. P.M. in s.b.c., with scallop-shell. (Paul Mitchell, Y., 1721.)
- 767. SIMON PATTINSON, three crowns. (Y., 1715.)
- 768. THOMAS BACON, with a boar. In interior scroll, the word FECIT. (Y., 1717.)
- 769. IOHN PAXTON, sun shining on a marigold. (Y., 1717.)
- 770. EDWARD MERRIEFIELD, a hand, sleeved, holding a marigold or daisy. (Y., 1716.)
- 771. RICHARD LEGGATT, a horse walking. (Y., 1722.)
- 772. THO. STRIBBLEHILL, David slaying Goliath. (Y., 1704.)
- 773. To. KIRKE, a bonnet with strings and an upright feather in front. (Tho. Kirke, Y., 1728.)
- 774. IOSEPH WINGOD, b.p. a beadle leading away an offending child. (Y., 1721.) (His name is given as WINGARD in the List of the Yeomanry.)

775. HENRY ELWICK, a fountain between two dolphins, all spouting water. (Y., 1707.)

776. SAMUEL MILES, a sun in splendour and a wheatsheaf. (Y., 1726.)

(1., 1/20.)

777. THOMAS JAMES, a squirrel sejant. (Y., 1726.)

778. WILLIAM ELLIS, a lion rampant bearing a heart in its paws. (Y., 1726.)

779. IOHN SHAW, a fleur-de-lys with crown above, between two roundels. (Y., 1726.)

780. IAMES MATTHEWS, crest, two arms holding up a plate. (Y., 1722.)

781. IAMES BISHOP, a bishop's bust between two crossed crosiers and a mitre. (Y., 1724.)

782. ROWLAND POOLE, two hands interlocked, with a crown above. (Y., 1717.)

783. R.M. in oval; a large daisy, with a sun and six roundels. (Robert Matthews, Y., 1721.)

784. THOMAS PHILLIPS, a cock perched on a rose. (Y., 1727.)

785. (EDWARD) BRADSTREET, the name at the top and also at the bottom. For device, the star of the Order of the Garter. (For the name cf. Welch, ii. 186.) (Y., 1720.)

786. MARK CRIPPS, a sun shining through a cloud on a wheat-

sheaf. (Y., 1727.)

787. HENRY SMITH, a rose ensigned by a mitre. (Y., 1724.)

788. I. SMITH, a rose. (Y., 1724.)

789. IOHN PAYNE, a crescent or moon and seven stars. (Y., 1725.)

790. IOHN HATHAWAY, a crown, with two sceptres through the crown. (Y., 1724.)

791. ALEX CLEEVE, a hand grasping a rose spray, and one mullet. (Y., 1715.)

792. IOHN CATER, LONDON, a lion issuing from a crescent. (Y., 1725.)

793. IOHN ROGERS, a sun in splendour. (Y., 1717.)

794. THOMAS GOSLING, a gosling. (Y., 1721.)

795. I.D., Time, with scythe and hour-glass; above, a crown. (Below these follows a half-line of touches.)

796. SAMVEL SMITH, a holy lamb and flag. (Y., 1727.)

- 797. IOHN BLENMAN, a sun in splendour shining on a wheat-sheaf. (Welch, ii. 185.) (Y., 1726.)
- 798. JOSEPH CARTER, a carter with his cart, and date 1726. (Y., 1726.)
- 799. Here follows a small punch, with the device very indistinct, with initials W.M. (William Martin, Y., 1726.)
- 800. THOMAS PIGGOTT, device, a Roman. (Y., 1698.) (Cf. No. 809.)
- 801. In Watts in oblong punch; upon it a globe, mounted in a stand. (Somewhat similar to the stamp of Peter Collyer, No. 730.) (John Watts, Y., 1725.)
- 802. TH(OMAS) SWINDELL, crest, a mitre. (Y., 1705.)
- 803. ANN TIDMARSH, a ducal coronet. (Y., 1728.)
- 804. IOSPH. DONNE, a hand holding a chess pawn between the finger and the thumb. (Y., 1727.)
- 805. R.B. in s. shield, with a flower and a wheel and four roundels. (Richard Bowcher, Y., 1727.)
- 806. T.K. in oblong punch; a heart surmounted by a rose, with three stars, and date 1729 (?). (Thomas Kirby, Y., 1722.)
- 807. IOSPH. DONNE (No. 804, repeated, but defaced).
- 808. SMITH & LEAPIDGE in a square touch; a rabbit and a wheat-sheaf.
- 809. IOSEPH SHERWIN, same device as Thomas Piggott, No. 800. (Y., 1726.)
- 810. IOSEPH CLARIDGE, a hand grasping a dove with olivebranch. (Y., 1724.)
- 811. DANIEL (PICKER)ING, a lion rampant, and below, a dolphin. (Y., 1723.)
- 812. W.H. a Bacchus astride a barrel. (William Horton, Y., 1725.)
- 813. SAMUEL COOKE, a lion rampant holding a crown in its paws. (Y., 1727.)
- 814. BENJAMIN BROWNE, arms, a two-headed eagle, and above the crest, a hand grasping a bird's foot and a wing. (Y., 1726.)
- 815. WILLIAM NORWOOD, a hammer, crowned, between two fleurs-de-lys. (Y., 1727.)
- 816. WILLIAM ROWELL, arms, two chevrons engrailed, and on each three roundels. (Y., 1726.)

817. WILLIAM STEVENS, a hand, with a tulip. (Y., 1729.)

818. Below this, RICHARD BRADSTREET, two naked figures supporting a crown. (Y., 1727.)

819. IOHN WILLIAMS in b.o., with a crescent; in a border, the signs of the Zodiac. (Y., 1724.) (Cf. No. 903.)

820. GEORGE (STAFFO)RD, a hand holding a chess pawn. (Y., 1730.)

821. IOSEPH PEDDER, a cock, standing over two crossed keys. In the margin four mullets. (Y., 1727.)

822. I. IONES, LONDON, an angel. (Y., 1727.)

823. ANDREW RUDSBY, a dove with olive-branch, perched on a wheatsheaf. (Y., 1712.)

824. COOKE AND FREEMAN, no device, merely names in two scrolls. (Samuel Cooke. Y., 1720. and William Freeman. Y., 1727.)

825. SAMUEL SP(ATEMAN), a sun, with a wheatsheaf and a cock below. (Y., 1719.) In the list of Yeomen it is sometimes spelled SPADEMAN

826. I.F. in b.o., with a bit within a horseshoe. (John Fasson, Y., 1725.)

827. WM. SANDYS (at top), Green at foot, a griffin rampant. (Y., 1725.)

828. Jo. JORDAN, a dove perched on a snake. (Y., 1727.)

829. WILLIAM (SMITH), device, a tankard. (Y., 1732.)

830. SIMON HALFORD, crest, a griffin. (Y., 1726.)

831. RICHARD WILDMAN, Hercules and his club. (Y., 1728.)

832. GILES CLEEVE, three griffin's heads erased. (Y., 1706.)

833. JOHN DE ST. (CROIX), three leopards. (Y., 1729.)

834. RICHARD HANDS, a shepherd with a crook and a dog. (Y., 1727.)

835. THOMAS BARNES, a unicorn rampant, with collar and chain and two mullets. (Y., 1726.)

836. E.D., in p.o., a mermaid, with comb and mirror. (Edward Drew, Y., 1728.)

837. RICHARD BROWN 1731, a lion sejant affronté, with one paw on a lamb. (Y., 1729.)

838. I.C. in b.c., with a worm. (John Cowley, Y., 1724.)

- 839. ALEXANDER HAMILTON, St. Andrew, holding a cross; at the sides a thistle and a rose. (Y., 1721.)
- 840. IAMES SMITH, a rose and acorn. (Y., 1732.)
- 841. WILLIAM PHILLIPS, a hand holding a gillyflower. (Y., 1744.)
- 842. W.C. in square touch with corners cut off, with rose and thistle on one stem. (William Charlesley, Y., 1729.)
- 843. TD. NM. 1732, a snake coiled like the worm of a still, crowned. (Thos. Darling and Nath. Meakin.)
- 844. WILLIAM COOCH, a wyvern above a star of eight points within a crescent. (? Wm. Couch in list of Yeomanry, 1731.)
- 845. SAM. GUY, LONDON, device, a kilted figure holding a grotesque animal (Warwick). (Y., 1729.) (Cf. No. 630.)
- 846. WILLIAM (FOX), a fox. (Y., 1670.)
- 847. BEN FOSTER, LONDON, arms, a chevron engrailed ermine and three pheons, with a label of three points. (Y., 1730.) (Cf. No. 639.)
- 848. EDWD. YORKE, on a cross, five lions rampant. (Y., 1732.)
- 849. W.S., an earl's coronet; above, a mullet within a crescent. (William Shayler, Y., 1734.)
 This is the end of the third touchplate.

Touchplate No. 4. (Dimensions, $21\frac{3}{8}$ in. \times 14 in.)

- 850. SAMUEL TAYLOR, a cock on a plough. (Y., 1731.)
- 851. SAMUEL RIGHTON, a cock, two crossed sprigs of olive below. (Y., 1732.)
- 852. I.T. with a pear and 1704. (James Tidmarsh, Y., 1734; the date 1704 relates to his father's freedom.)
- 853. IOHNSON (AND) CHAMBERLAIN, the Prince of Wales's feathers, crowned.
- 854. IAMES TISOE, portcullis. (Y., 1733.) (Cf. No. 449.)
- 855. IOHN IACKSON, an hour-glass and three fleurs-de-lys. (Y., 1689.)
- 856. SAMUEL JEFFERYS, a rose and two fleurs-de-lys above. (Y., 1734.) (Cf. No. 986.)
- 857. WILLIAM MURRAY, a crested bird on nowed serpent, a star above. (Y., 1734.)
- 858. R.P. in the centre of a clock-face. (Robert Peircey, Y., 1722.)

859. IOHN SCATTERGOOD, two hands with hammers and a rose. (Y., 1716.)

860. RICHARD SMITH, device, a plough and a star. (Y., 1733.)

(Cf. No. 301.)

861. HENRY MAXTED, b.p. a sun (in part) shining on a rose. (Y., 1731.)

862. THOMAS COLLET, a crown above, a woolsack and a rose

below. (Y., 1735.)

863. An illegible punch follows here, being an attempt at the next.

864. W.D. and a star above. (William Deane, Y., 1731.)

865. A crowned rose-en-soleil. No name or letters are in this touch. (John Langton, Y., 1731.)

866. IONATHAN CO(TT)ON, 1705; an eagle displayed, a crescent, a hand with flower-spray, and dove. (Y., 1704.) (Cf. No. 624.)

867. ROBERT MASSAM, three fleurs-de-lys and a rose below.

(Y., 1735.)

868. IOHN PIGGOTT, a figure of a Roman. (Y., 1736.)

869. P.M. in b.o., with a boy naked to the waist, holding a popgun and a rattle. (Philip Mathews, Y., 1736.)

870. I.W. in p.c., with a star above a bell. (John Wright, Y., 1717.)

871. DANIEL GRENDON, crest, on a torse a bird. (Y., 1735.)

872. ALEXANDER STOUT, a cock on a globe mounted on a stand. (Y., 1733.)

873. THOMAS SCATTERGOOD, arms, two bars and three hands, with helm and mantling; and crest, an open hand. (Y., 1736.) (Cf. No. 610.)

874. FLY AND THOMPSON in oval; device, a fly. (Timothy Fly was Y., 1710 and Wm. Thompson became Yeoman in 1723.)

875. HENRY LITTLE, a cock, with crown above. (Y., 1734.)

876. THOMAS GROCE, three crowns. (Y., 1737.)

877. ROBERT HITCHMAN, a lion rampant bearing a key. (Y., 1737.)

878. IOHN IUPE, a fleur-de-lys issuing from a rose (p. l.). (Y., 1736.)

¹ With this punch the series begins with pillars at either side, of evervarying forms, the palm-leaves becoming somewhat more scarce.

- 879. SAMUEL GRIGG, a sun in splendour and a snake. (Y., 1734.)
- 880. PATRICK GARIOCH, two leopards' heads point to point, one above, the other below; a curious saltire device. (Y., 1735.)
- 881. EDMUND SHARROCK, arms, a chevron and three human heads. (Y., 1737.)
- 882. R.P., with a cock and a pheasant. (Roger Pye, Y., 1737.)
- 883. ROBERT PATIENCE, a standing figure of a queen. (Y., 1734.)
- 884. WILLIAM HANDY, device, an open hand, and a small dice above. (Y., 1728.)
- 885. IOHN KENRICK, a stork. (Y., 1737.)
- 886. Francis Piggott, a teazle and a crescent above. (Y., 1736.)
- 887. GEORGE ALDERSON, a lion issuant from a mural crown, looking back and holding an orb; on the field a crescent and a star. (Y., 1728.) (Other Aldersons bore the same device.)
- 888. PHILIP ROBERTS, arms, a lion rampant, and a crescent for difference. (Y., 1738.)
- 889. ROBERT SKYNNER, crest, on a torse a unicorn sejant, and a star. (Y., 1738.)
- 890. JOHN BELSON, a bell over a sun. (Y., 1734.)
- 891. BARTHOLOMEW ELLIOT, a female figure pointing with a sceptre. (Y., 1738.)
- 892. WILLIAM COWLING, crest, on a torse a demi-griffin sejant. (Y., 1737.)
- 893. WOOD & MICHELL, device, bust of a man in a wig.
- 894. WILLIAM HIGHMORE, three fleurs-de-lys. (Y., 1741.)
- 895. W.S., with Britannia. (William Sherwood, Y., 1731.)
- 896. THOMAS UBLY, a stag holding up a wheatsheaf. (Y., 1741.)
- 897. IOHN FOSTER, a crowned book or Bible. (Y., 1735.)
- 898. T.M., an oval with demi-mermaid (?) holding up two double balls, the whole surrounded with palm-leaves. (Thos. Matthews, Y., 1736.)
- 899. Thomas Boardman b.p., arms, a lion passant and three stars, impaling a chief ermine with a demi-lion on the chief. (Y., 1728.)
- 900. EDWARD QUICK, arms, a chevron vair (?) and three griffins' heads erased; crest: a demi-stag. (Y. 1735.) (Cf. No. 657.)

S.S. in oval, with crown, and two small stars beneath it. 901. (Samuel Sweatman, Y., 1728.)

R°. NORFOLK IN LONDON, arms, a lion passant and three 902.

fleurs-de-lys. (Y., 1726.)

IOHN WILLIAMS, arms, a stag's head couped, with a crown 903. between the horns. (Y., 1729.) (Cf. No. 819.)

IOHN BENSON, arms, a double-headed eagle, with a crown 904.

in chief. (Y., 1740.)

L.Y. in b. oval; a griffin's head couped, with a crown over. 905. (Lawrence Yates, Y., 1738.) (Cf. No. 1031.)

HENRY IOSEPH, a scallop-shell. (Y., 1736.) 906.

R.C. in b.c., a lamb with a crook. (Robt. Crooke, Y., 907. 1738.)

GEORGE HOLMES, arms, a rose and four fleurs-de-lys. (Y., 908. 1742.)

I. PERRY, a female figure, seated. (Y., 1743.) 909.

IOHN (B)OTELER, a lion passant and a sun in chief. (Y., 910. 1743.)

W.P. in b.c., with a crescent in centre and six stars. (William 911. Palmer, Y., 1743.)

EDWARD TOMS, a wheatsheaf and a plough. (Y., 1744.) 912.

AQUILA DACKOMBE, device, a bee or fly. (Y., 1742.) 913.

(No christian name) FARMER in b.o., a bundle of faggots 914. tied. (Y., 1725.) (? Wm. Farmer, Y., 1744.)

I.S. in b.o., device, a whale. (Jonathan Stevens, Y., 1744.) 915.

W.T. in b.o., a crescent. (Wm. Taylor, Y., 1728.) 916.

I.G. in p.o., a tree. (James Gibbs, Y., 1741.) 917.

IOHN HAYTON, a blazing star with an earl's coronet above. 918. (Y., 1743.) (Cf. No. 939.)

IOHN BROMFIELD, the sun, the moon, and seven stars. (Y., 919.

1745.)

WILLIAM HOWARD, a mounted soldier with drawn sword 920. between the letters D. C. (probably for the Duke of Cumberland). (Y., 1745.)

GEORGE BACON, crest, on a torse a boar. (Y., 1748.) 921.

IONATHAN LEACH, a shield of arms: quarterly, (I) a rose; 922. (2) a sprig of laurel; (3) a lamb and flag; (4) illegible; over all a cross. (Y., 1732.)

- IOHN WYNN arms, a lion rampant with three mullets. (Y., 923. 1746.)
- RICHARD PITTS, a running hare. (Y., 1747.) 924.
- IOHN HARTWELL, a saltire and four castles, and a compass 925. point on the saltire. (Y., 1736.)
- RICHARD NEWMAN, a Bishop's mitre. (Y., 1747.) 926.
- IOSEPH WHITE, a man holding a cup, standing in a cres-927. cent. (Y., 1747.)
- IOHN TOWNSEND, a lamb and a flying bird above. (Y., 1748.) 928.
- BURFORD & GREEN, arms, a cross with two crosslets fitchy in chief, for Burford, impaling three stags tripping, for Green. (Thos. Burford. Y., 1746, and James Green. Y., 929. 1746.)
- RICHARD POOLE, a rose with spray of leaves on either side, 930.
- and three fleurs-de-lys above. (Y., 1749.)
 VILLIAM HARRISSON, an acorn on a stalk with two leaves, 931. one pointing downwards; above the acorn a flaming star. (William Harrison. Y., 1748.)
- 932.
- IAMES LETHARD, a hand holding a mallet. (Y., 1745.)
 WM. GLOVER ANNISON, arms of Oxford City impaling those of Oxford University. (Y., 1742.) (Cf. No. 947.)
 IOHN WINGOD, a square and compasses. (Y., 1748.)
 IOHN SELLON, a unicorn supporting a classical head-piece. 933.
- 934.
- 935. (Y., 1740.)
- 936. I.M. in a small, plain, oblong touch, with domed top, with a rose, a wheatsheaf and two stars and a rose above. (John Merriweather, Y., 1747.)
- WILLIAM BAMPTON, a rose and a blazing star. (Y., 1742.) 937.
- DANIEL LAWSON, crest, on a torse two arms issuing from a cloud and holding a sun in splendour. (Y., 1749.) (Repeated 938. at 942.)
- GEORGE BEESTON, a blazing star and an earl's coronet (the same touch as that of John Hayton; No. 918). (Y., 1743.)
 ISAAC READ, a man fishing. (Y., 1743.)
 MATHEW TONKIN, a miner (?) at work. (Y., 1749.) 939.
- 940.
- 941.
- 942.
- DANIEL LAWSON, repeated at 938. HENRY APPLETON, arms, a fess engrailed, and three apples 943. slipped in the stalks. (Y., 1749.)

944. JOHN UBLY, a stag tripping. (Y., 1748.)

945. WILLIAM PHIPPS, arms, a trefoil and an orb of eight mullets. (Y., 1743.)

946. IAMES BULLOCK, crest, a beehive surmounted by a bee.

(Y., 1750.)

947. (W. GLOVER) ANNISON, the arms of Oxford City impaling those of Oxford University. (Cf. No. 933.) There is an indecipherable word in the lower scroll.

948. ROWLAND SMITH, a rose and an acorn slipped in the stalks.

(Y., 1734.)

949. WILLIAM PHILLIPS, a hand holding a clove-pink or gilly-flower. (Y., 1759.)

950. CHARLES MAXEY, a pelican vulning herself and standing

on a globe. (Y., 1750.)

951. BOURCHIER CLEEVE, a hand holding a slipped rose. (Y.,

1736.)

952. The next touch consists of an oval beaded band, with a Latin motto, HAUD ULLIS LABENTIA VENTIS, and the name, H. IRVING in the exergue, badly punched; and crest, an arm embowed, with the hand grasping a spray of holly. (Henry Irving, Y., 1750.)

953. RICHD. PEAKE in b.o., a lion's head erased. (Y., 1750.)

954. WILLIAM WHITE, on a torse a demi-stag. (Y., 1751.)

955. ROBERT RANDALL in b.o., three fleurs-de-lys. (Y., 1748.)

956. IAMES BOOST, device, a crescent and six stars. (Y., 1744.)

957. JOHN WALKER, a man crowned, walking. (Y., 1748.)

958. MATTHEW UNDERWOOD, 1752, a lion and a lamb. (Y.1752.)

959. RICHARD ALDERWICK, a falconer or man hawking. (Y., 1748.) (Cf. No. 1035.)

960. WILLIAM HEALEY, arms, a chevron cotised indented and three lions, with three crosses paty on the chevron; crest, a demi-lion holding a cross-paty. (Y., 1752.)

961. IAMES FONTAINE, an elephant. (Y., 1752.)

962. RD PAWSON, a rose spray with a ducal coronet over. (Y., 1752.)

963. IOHN EDWARDS, a horse. (Y., 1739.)

964. IOHN FASSON, a horseshoe. (Y., 1753.) (Cf. Nos. 977 and 1048.)

- 965. IOHN HOME, arms, a lion rampant, impaling party per band sinister six martlets. (Y., 1749.) (Cf. No. 1037.)
- 966. WILLIAM HARRIS, crest, on a torse a demi-griffin with expanded wings. (Y., 1746.)
- 967. BENJ: TOWNSEND, arms, fretty and a cross, and five mullets on the cross. (Y., 1744.) (Cf. No. 1058.)
- 968. IAMES STEEVENS, a Britannia, seated, 1754. (Y., 1753.)
- 969. THOMAS LANGFORD, a vase of flowers. i.e. the lily pot and lilies. (Y., 1751.)
- 970. Wm. de Iersey, arms, party per fess azure and gules an eagle displayed. (Y., 1738.)
- 971. IOHN WHITE, b.p. a man holding a cup, standing in a crescent. (Y., 1755.)
- 972. I.R. in b.c., with griffin's head erased, and a crown and two stars above. (Isaac Reeve, Y., 1754.)
- 973. THOMAS BUTTERY, a bee and a rose above it. (Y., 1756.)
- 974. HENRY BOWLER, a man bowling. (Y., 1757.)
- 975. THOMAS HAWKINS, in circle, a hawk perched upon a woolsack. (Y., 1756.)
- 976. GEORGE GRE(EN)FELL, a griffin standing on a ragged staff (?). (Y., 1757.)
- 977. WILLIAM F(ASSON), a rose within a horseshoe. (Y., 1758.) (Cf. Nos. 964 and 1048.)
- 978. THOMAS MUNDAY, bust of a man in a wig (1767). (Y., 1754.)
- 979. BENJAMIN BACON, arms, gules and on a chief two mullets; crest, a boar. (Y., 1749.)
- 980. ROBERT SCATCHARD, arms, a lion rampant and in chief three mullets (1761); crest, a demi-lion. (Y., 1756.)
- 981. CHARLES CLARIDGE, an outstretched hand holding a bird bearing a spray (1758). (Y., 1756.) (Cf. No. 810.)
 982. JOSEPH SPACKMAN, a ducal coronet between a fleur-de-lys
- 982. JOSEPH SPACKMAN, a ducal coronet between a fleur-de-lys and two crosses paty above; a cross paty and two crossed palm-branches below. (Y., 1749.) (Cf. No. 1045.)
 983. JAMES PULESTON, a lion's paw erased, grasping a battle-
- 983. JAMES PULESTON, a lion's paw erased, grasping a battle-axe. (Y., 1752.)
- 984. W.H. two hands interlocked, with a crown above and 1709 below. (Wm. Hitchens, Y., 1759.)
- 985. IOHN VAUGHAN, a holy lamb and a flag. (Y., 1753.)

IOSEPH IEFFERYS, a rose with two fleurs-de-lys above. (Y., 986.

1757.)

W.F. in shaped and indented oblong touch; crest, a lion 987. rampant with a crescent between the legs. (Wm. Frome, Y., 1760.)

MARY WILLEY, a rose and four fleurs-de-lys. (Y., 1760.) 988.

T.S. in s.b.c., with two hearts, point to point. (Thomas 989. Smith, Y., 1739.) (Cf. No. 1044.)

THO. IONES, in an oval, a gun on a carriage and five mul-990. lets. (Y., 1755.)

BROWNE & SW(ANSON) (device in both a talbot. (? John 991.

991a. THOMAS SWANSON¹ Brown. Thomas Swanson. Y., (1753.) (Cf. No. 1008.)

W.M.,E.G. in square punch, with corners cut off; a rose 992. and a thistle on one stem (a badge of Queen Anne). (Wm. Munden and Ed. Grove, c. 1760.)

WILLIAM WRIGHTMAN, in an inner circle a cross crosslet 993. between two roses and two stags' heads. (Y., 1758.)

BENNETT & CHAPMAN, arms, three demi-lions and a roun-994. del; impaling party per chevron, a crescent and two leopards' heads. (? Wm. Bennett. Y., 1758; and Oxton Chapman. Y., 1760.) (Cf. No. 998.)

IOHN KING, a female figure of Hope, draped, with an an-995.

chor. (Y., 1757.)

RALPH WHARRAM, arms, a fess between a goat's head 996. couped and three scallop-shells in base. (Y., 1756.)

THOMAS GREENWOOD, device, a still, with a worm at-997. tached, and a sun. (Y., 1759.)

WILLIAM BENNETT, arms, three demi-lions and a roundel. 998. (Y., 1758.) (Cf. No. 994.)

ROBT. AND THO. PORTEUS, device, an ostrich. (Robt. 999. Porteus, Y., 1760; and Thomas Porteus, Y., 1762.)

N.M. in b.c., 1732; a worm, crowned. (Nathaniel Meakin. 1000. Y., 1761.)

R.B. in b.c., a nude man with the worm of a still (? Hercules IOOI. and a snake.) (Richard Bowler, Y., 1755.)

¹ Nos. 991 and 991a. These two touches are identical except for the names therein.

- IOO2. IOHN BROWN, IOHN LEWIS, & IOSEPH BROWN in the exergue of a large circle; device, an angel holding a palmbranch in one hand, the other leaning upon a worm.
- 1003. IAMES FI(DD)ES, a tun and a hammer. (Y., 1754.)
- THOMAS THOMPSON, in the centre a sun in splendour, upon the clouds between the two scrolls, with a thistle on one side, a crown on the other. (Y., 1755.)
- 1005. THOMAS SMITH, a set of masonic emblems between two masonic pillars. (Y., 1761.)
- 1006. THOMAS GIFFIN a dagger piecing a heart and ensigned with a ducal coronet between six mullets. (Y., 1759.)
- 1007. CLARK & GREENING, a flower (? a teasle) displayed, surmounted by a star. (J. Clarke. Y., 1756. Richd. Greening. Y., 1756.)
- 1008. THOMAS SWANSON, the Golden Fleece between four rings and a fleur-de-lys. (Y., 1753.) (Cf. No. 991.)
- IOO9. JOHN PERRY, arms, gules a bend cotised ermine and three leopards on the bend. (Y., 1743.)
- 1010. JOHN ALDERSON, a demi-lion between a crescent and a star, looking back, issuant from a mural crown. (Y., 1764.)
- IOII. CHARLES SMITH, a mailed fist with sword; a lion rampant and three horseshoes. (Y., 1765.)
- IO12. I. TOWNSEND & R. REYNOLDS, a lamb and a dove with olive branch. (J. Townsend. Y., 1748, and Robert Reynolds, Y., 1761.)
- 1013. WILLIAM SNAPE, a horse. (Y., 1764.)
- 1014. W. FARMER in b.c., with two muskets in saltire and a powder-flask. (Y., 1765.)
- 1015. A. JENNER in plain rectangle. (Anth. Jenner; Y., 1754.)
- 1016. THOMAS SMITH, a cock treading a hen. (Y., 1761.)
- 1017. STEPHEN KENT HAGGER, a hand with hammer and a barrel. (Repeated.) (Y., 1754.)
- 1018. PITT & FLOYD, a running hare. (R. Pitt and John Floyd, c. 1769.)
- 1019. H. WOOD in b.c., two dogs fighting. (Y., 1768.)
- 1020a. SAML. LAW in b.c., a dove with olive-branch. (This punch
- and b. is repeated.) (Y., 1768.)

IO21. IOHN HUDSON, arms, quarterly per chevron embattled, or and vert, and three martlets. (Y., 1770.)

1022. IOSEPH MONK, crest, a griffin. (Y., 1757.)

1023. IOHN GURNELL, LONDON, a camel with a star. (Y., 1768.)

1024. IOHN HINDE, a female figure of Hope, with an anchor in her left hand. (Y., 1760.)

1025. R. P. HODGE, with a clock-face. (Robert Piercy Hodge was Y., 1772.)

1026. THOMAS DODSON, 1775, a ship in full sail. (Y., 1769.)

1027. EDWARDS SIDEY in b.o., with large hour-glass. (Y., 1772.)

1028. W. PHILLIPS in p.o., a cock crowing. (Y., 1750.)

1029. WILLIAM COOCH, a fox running; a star and a crescent above. (This touch is given thrice, the first two being badly struck.) (Y., 1775.)

1030. JOSEPH MONK (repeated). See above, No. 1022.

1031. RICHARD YATES, a griffin's head erased, with a marquis's coronet above; at each side, between the scrolls, a star. (Y., 1772.) (Cf. No. 905.)

1032. JNO. APPLETON in a p.o., with a still and a worm. (Y., 1768.)

1033. SAMUEL HIGLEY, arms, a cross engrailed, and a crescent on the cross; also a crescent in the quarter for difference; crest, an eagle with two heads. (Repeated). (Y., 1775.)

1034. WILLIAM BARNES, a standing figure of a Queen with orb and sceptre. (Y., 1770.)

1035. RICHARD ALDERWICK, a man hawking. See also No. 959. (Y., 1776.)

1036. C. SWIFT, on a square punch with regular indentations, with a spray of a thistle and a rose on one stem, the badge of Queen Anne. (Y., 1770.)

1037. NATHANIEL BARBER, with the arms of John Home. (Y., 1777.) (Cf. No. 965.)

1038. SAM^L. SALTER BOWLER, a running greyhound; above, a star. (Y., 1779.)

1039. SAMUEL PRIDDLE, in the centre in b.o. a flower displayed and a crescent. (Y., 1773.)

1040. ROBERT JUPE, a rose and a fleur-de-lys. (Y., 1776.)

- 1041. WILLIAM WRIGHT in exergue of a plain shield-shaped punch; on inner shield, a griffin's head issuing from a crown. (Y., 1764.)
- 1042. ROB^T. LUPTON, crest, a griffin's head erased, on a torse. (Y., 1775.)
- 1043. PITT & DADLEY, a running hare. (E. Dadley was Y., 1781, and Rich^d. Pitt, Y., 1747.)
- 1044. WILLIAM MILLIN, two hearts, point to point. (Y., 1776.) (*Vide* touch of T. S., No. 989.)
- 1045. JOSh. AND JAS. SPACKMAN. (James S. was Y. 1781, and had no individual touch.) (For touch of Joseph Spackman cf. No. 982.)
- 1046. ROBERT WALLER, a woman in a gown standing. (Y., 1779.)
- IO47. JOSEPH FOSTER in exergue of oval; within, a unicorn rampant. (Y., 1757.)
- THOMAS FASSON, a horseshoe encircling a heart; above, a dagger (a variant of the touches of John and William Fasson, Nos. 964, 977.) (Y., 1783.)
- 1049. RICHARD BACHE, b.p., an angel with a palm branch in the left hand; also a scroll in the right hand. (Y., 1779.)
- 1050. CHARLES LOADER, in a large shield-shaped punch, a swan swimming. (Y., 1784.)
- IO51. ROBERT JACKSON, three beehives and eleven bees volant. (Y., 1780.) (Cf. No. 780.)
- 1052. IOSEPH SPACKMAN & Co., device as No. 1045 (J. Spackman, Jr., Y., 1784.)
- 1053. ROBERT KNIGHT, in inner oval, a compass and an eight-pointed star. (Y., 1770.)
- 1054. HENRY & RICHARD JOSEPH, device, a large scallop-shell. (Henry Joseph, Y., 1763; Richard Joseph, Y., 1785.)
- 1055. EDWARD LOCKWOOD, a wheatsheaf and a dove. (Y., 1768.)
- 1056. PHILIP WHITE, in a b.c., a lion rampant between two stars. (Y., 1778.)
- 1057. W.H. KING, 1786, a hand holding a bird (? pigeon). (Wm. Harrison King, Y., 1786.)
- 1058. RICHARD BAGSHAW, same arms as Benjn. Townsend on touch, No. 967.

- 1059. ROBERT BARNETT, a rose and a fleur-de-lys. (Y., 1783.)
- 1060. WADSWORTH, a rose spray with coronet over. (Wm. Wadsworth, Y., 1780.)
- 1061. PETER LE KEUX in attenuated oval; a man on a race-horse. (Y., 1779.)
- 1062. C. Jones, a holy lamb with a flag, and LONDON below (Charles Jones, Y., 1786.)
- IO63. IOHN BROWN, a Pegasus volant, a star above. (Repeated.) (Coney John Brown, Y., 1786.)
- 1064. EDWARD SEAWELL, in large circle, a seagull. (Y., 1779.)
- 1065. R.M. in small plain oblong. (Randall Moring, Y., 1794.)
- IOGO. CARPENTER & HAMBERGER, a pair of compasses and a globe. (Henry Carpenter, Y., 1757; John Hamberger, Y., 1794.)
- 1067. WOOD & HILL, two sheep in a shield without border. (Thos. Wood, Y., 1792; Roger Hill, Y., 1791.)
- IO68. JOHN GRAY GREEN, a female figure (? Hope) with an anchor and two mullets. (Y., 1793.)
- 1069. I.M., a dove, and below, an anchor. (Joshua Maynard, Y., 1772.)

(Most of the last twenty or so touches have been repeated for clarity).

This is the end of the fourth touchplate.

Touchplate No. 5. (Dimensions $21\frac{3}{4}$ in. $\times 14\frac{1}{8}$ in.)

On this plate all the touches are repeated, with the exception of No. 1074. There are twenty-one touches, from 1798 to 1824, and then a gap of many years until the striking by William J. Englefield in 1913, followed by that of his son, Ralph H. Englefield in 1935. (See note on page 235.)

- 1070. WILLIAM BATHUS, a heart, with a rose above it. (Y., 1797.)
- 1071. PAUL FISHER, a fisher in a boat. (Y., 1798.)
- 1072. WILLIAM NETTLEFOLD, LONDON, 1799; a dove with olive-branch, perched on a worm of a still. (Y., 1785.)
- 1073. THOMAS PHILLIPS, a hand bearing a gillyflower (1800 is scratched on the plate). (Y., 1795.)
- 1074. I.F. in plain ringed oval with two clasped hands.

S.T. in oval, with sun. (Samuel Turner, Y., 1790.) 1075.

W. GROOME, a draw-knife, with a hammer and a compass. 1076. (Y., 1798.)

1077. WILL^m. GIBBS, a soldier. (Y., 1804.)

ROGER MOSER, three beehives, nine bees flying. (Y., 1078. 1806.)

WILLIAM WALKER, a woolsack. (Y., 1787.) 1079.

COCKS, LONDON, device, two cocks facing one another. 1080. (Samuel Cocks. Y., 1819.)

Josh. HENRY GODFREY, a tea-tray with a tea service dis-1081. played. (Y., 1807.)

R. STANTON, 37, BLACKMAN ST., BORO, a banner of the 1082. royal arms of England. (Y., 1810.)

ASHLEY, MINORIES, Britannia, with ship in the offing. 1083. (James Allison, Y., 1824.)

SIR GEORGE ALDERSON, crest, a lion issuing from a battle-mented crown, looking back and holding an orb. (Y., 1817.) 1084.

RICHARD MISTER, BERMONDSEY STREET. Device, a 1085. square and compasses, with 86 in the central space. (Y., 1802.)

W.M. in oval; a dove with olive-branch. 1086.

MAW in small oval, a camel couchant. (John H. Maw, Y., 1087. 1822.)

W.C. SWIFT, in square touch, a rose and thistle on the same 1088. stalk. (Y., 1809.)

1089.

J. STANTON, SHOE LANE, a scallop-shell. (Y., 1815.) E.J.T. ASHLEY, LONDON, a beehive and a tree. (Date 1090. scratched in plate, 1824.) (Y., 1821.)

W. J. ENGLEFIELD, LONDON, a dove with olive branch, flying above a horse, in plain oval. 1091.

R. H. ENGLEFIELD, LONDON, device as No. 1091. 1092.

The London Touchplates

The marks from the Touchplates 1, 2, 3 and 4 have been reproduced by special permission of the Worshipful Company of Pewterers, London, from the originals in its possession.

These were redrawn to a uniform scale by Sheila McEwan (with

some later amendments by the editor).

Touchplate 5 has not been reproduced as, with the exception of pewter by Samuel Cocks, very little of this late date is met with.

In some of the first drawings the beaded edge of the mark has been drawn as it appears, but in others the drawings show only a portion of the beading at top; in such cases this is only for convenience, and to save unnecessary repetition.

MARKS FROM TOUCH PLATE 1 No.3504)

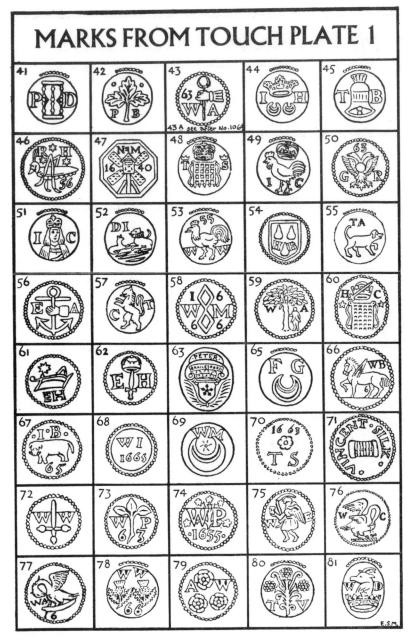

Note: See also last line of page 263 for mark 43a and two additional marks from touch-plate 1.

MARKS FROM TOUCH PLATE 1 ESM

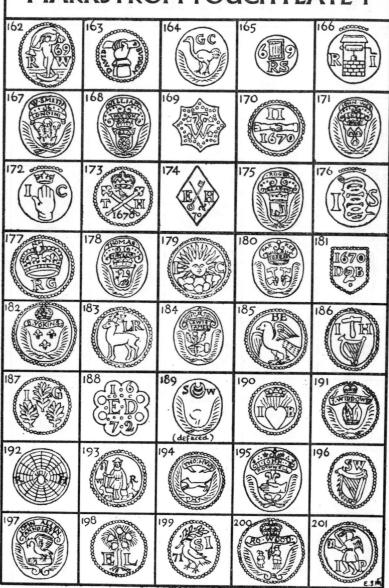

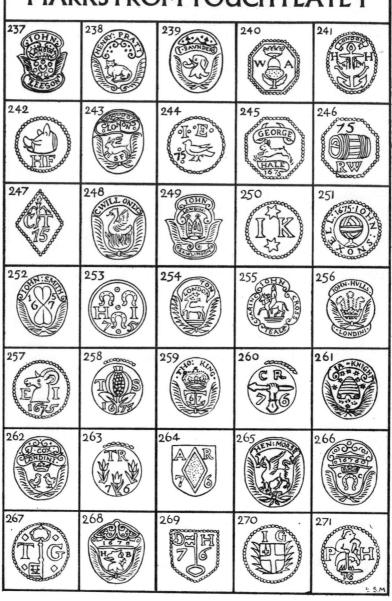

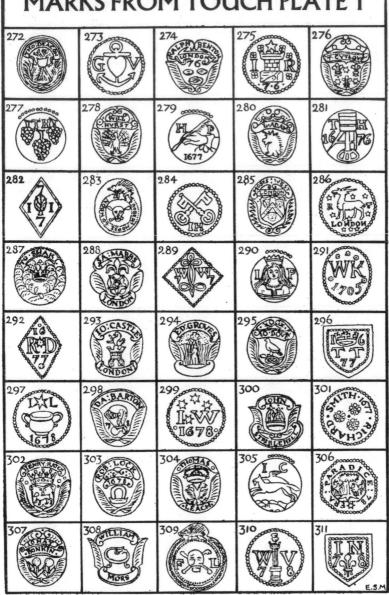

Nos. 350A and 350B will be found after No. 1069 on page 263. No. 350A appears to be similar to No. 14, but with initial "T" at left. R.F.M.

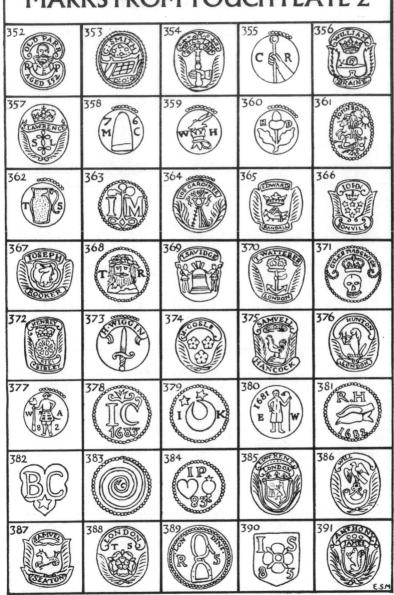

MARKS FROM TOUCH PLATE 2 defaced at top)

MARKS FROM TOUCH PLATE 2 567 00000

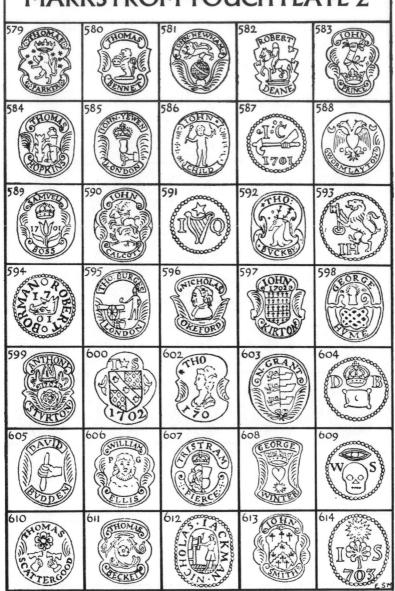

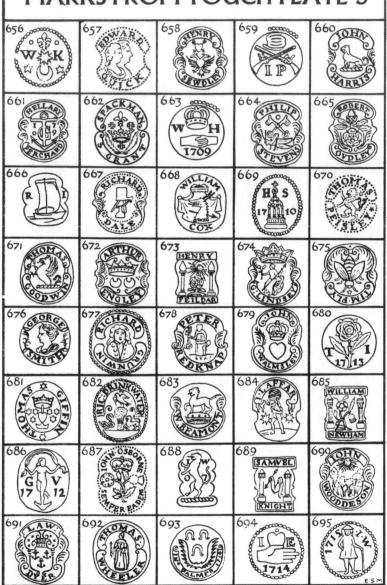

MARKS FROM TOUCH PLATE 4 863/4

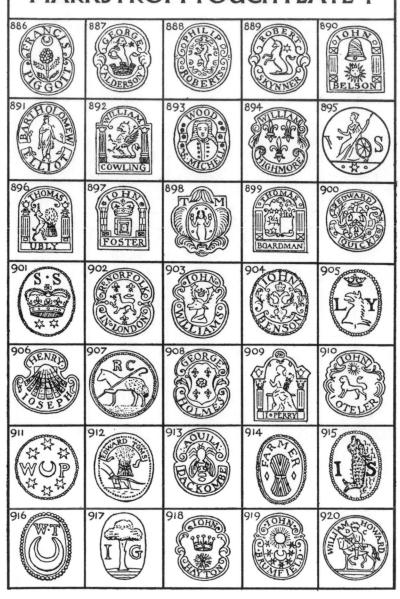

MARKS FROM TOUCH PLATE 4 CLEEVE

MARKS FROM TOUCH PLATE 4 1015 **AJENNER**

MARKS FROM TOUCH PLATE 4 43A 350A 350B

Note: The last three marks shown on this page are from touchplate 1.

XIV

Prices

The good old days when any collector, no matter what his bent might be, could hope to light upon a "find", or several of them, when on his holiday, have probably gone never to return. It is partly the collector's own fault in the case of pewter and partly the fault of the pewter.

It is the fault of the pewter because the number of articles that can be collected is limited by their very nature, and by the wanton destruction of all weakened or damaged pieces. A cracked china plate could be joined and made fit to handle by an expert; glass could be cemented, so too could lustre and other breakable wares; but pewter was known to have a certain value as metal of a kind, and when once cracked, damaged or apparently beyond use it was withdrawn from the stage and sold as "scrap".

At the date of my first exhibition of pewter in 1904 it was most interesting to hear the various collectors comparing notes and mentioning the prices they had paid for some of their treasures—in many cases literally a few pence for small things like buckles, snuffboxes, or a few shillings for spoons in the early days, spice-boxes, mugs and plates.

Plates 9 in. in diameter certainly will never again be bought—if in good condition—for three or four shillings, and 15-in. dishes or larger will run into pounds sterling.

The value of the articles even with tin at its price in 1921 of

PRICES 265

over £300 per ton, a fraction over 2s. 8d. per lb., does not warrant the high prices realized for some of the less important pieces.

The fault lies with the collectors themselves. In olden days the collector used to collect quietly, without bragging too much, except to one or two special friends; and pewter rarely found its way into the auction room, for it was neither understood nor appreciated.

In later years auction-room sales have been the undoing and the despair of the small collector, and the employment of agents to bid—with a limit—has had the result of sending up the price to the limit set by the anxious buyer. It could not be otherwise.

Then, again, the keenness of two or more rival collectors has

naturally been the cause of an upward trend in prices.

Take at the present time (1971) an article such as a tappit-hen. If it is in good condition it may command anything up to £50. At that price the coveted article may be knocked down to the wealthy collector who has half a dozen or more of them already in his collection.

Prices in the country used generally to average about one-third less than in towns, but the country dealers generally know what they can reasonably ask, and they are well equipped with a know-ledge of local history that will enable them to sell plates with armorial bearings at enhanced rates.

Even Victorian tankards, today may fetch £10 or more, whereas twenty years ago they were to be bought for, say, 5s. I have seen a William and Mary tankard with the lid loose that was bought for 3s. 6d. Today it would probably be £100 or more.

The collector today will have to make up his mind to pay these inflated prices; if he does not he will lose his chance; but the fact that people will pay them is to be regretted.

Pewter collecting has become a craze. It is no longer a hobby for

the collector with a slender purse—the more is the pity.

It is perhaps inevitable that prices should have risen. The original writer had been told that they began to go up immediately after he had organized the Clifford's Inn Exhibition in 1904, as soon as a genuine interest had been aroused in the ware; but it may honestly be said that they have gone up beyond the bounds of what is reasonable, bearing in mind the small intrinsic worth of the material and the simplicity of the methods of manufacture.

There is no real reason why a pewter spoon—not absolutely in perfect order—should be sold at something above the price of a similar spoon in silver. As long as this kind of thing goes on collecting becomes restricted in its range if not altogether out of the question for the average collector.

There is a consciousness among all antique and secondhand dealers today of the "collectability" of pewter, and almost anything in a metal which looks like pewter is offered only at an exorbitant price. The fault, if such it can be termed, must lie at the door of those collectors who have paid big money for rare items in the leading sale-rooms, where publicity has been given to the prices paid. The unknowledgeable small trader hears of, for example, a rare lidded tankard or flagon fetching a big figure at auction, and from then on almost anything with a lid—even though it might be only an inferior-quality foreign measure—will have that value in his estimation. Consequently, there are few bargains to be found in the open market.

The collector who is able to repair or clean the pieces which come his way may fare a little better, for there are many persons today, not collectors in the proper sense of the word, who buy pewterware merely because it is "fashionable", and makes for a good ornamental display with the antique furniture which they are now able to afford, and so they will pay a premium for bright, clean-looking examples.

Not so many years ago—up to, say, the early 1940s—it was possible to find good examples of pewterware in country shops, and prices were never really high. There was a limited number of knowledgeable and serious collectors who were able to find enough of the better items, and so they tended to ignore many of the later things which were then in amazing profusion; such things as late eighteenth and early nineteenth-century tavern pots, ordinary 8 in. or 9 in plates, and a host of other interesting items. In the war years, however, the influx of American troops, and their desire to send home "souvenirs", caused them to buy up this surplus, simply because the prices were so much less than they would have been at home. It was not an intentional "clean sweep" in the first instance, but it very soon became so. Dealers in their own country began to realize that there was an abundance of good antiques—not only pewterware

PRICES 267

—to be had for very low prices here, and from then onwards, right up to the present day, they have come over, sometimes several times a year, on buying trips, and have taken back large quantities of desirable items.

The keenness of the English dealer to find material to sell in bulk led him to pay more and more each time for his consignment for the U.S.A. market, and so prices rose steadily and inexorably. At about this time, too, the now receptive British public were regaled with a host of information on antiques through the media of books, magazine articles, radio and television talks, and museum lectures, and they, themselves, began to take more note of the things around them; albeit too late to "get in on the ground floor". The plain fact is, therefore, that the demand now exceeds the supply, and it seems that high prices have come to stay.

The new collector must realize that the acquisition of rare pewter is no longer a poor man's hobby, and so he will need to explore new fields, and be content with things which have hitherto been neglected. Fortunately for him there are still sufficient of the later pewter items available for study, and if he buys wisely today his collection will, undoubtedly, in the years to come, turn out to be as profitable an investment as has been that of his forerunners. The true collector does not, in the first instance, amass his pieces with the idea of profitmaking, but it is a very pleasurable experience to find, from year to year, that what he has bought for his own pleasure has

increased in value to such an extent that, in his old age, he may have

a valuable property to pass to his heirs.

Glossary

ACORN-KNOPPED. Spoons bearing an acorn at the end of the stem.
ALLOY. A mixture of two or more metals.

AMPULLA. A small vessel to contain incense or the oil for Extreme Unction.

APOSTLE SPOONS. Spoons with knops representing the Apostles. They are extremely rare in Pewter.

APPLIQUÉ. A piece of material cut out and fastened on the surface of another is termed appliqué.

ASHBERRY METAL. A very hard alloy, containing about 25 per cent of antimony. It was used for buckles, snuffboxes, forks, spoons, teapots, coasters.

Assay. To put to the test.

BADGES. Signs worn on their sleeve or breast by beggars, pilgrims, porters and by some servants.

BALL-KNOPPED. Spoons having a small ball at the top end of the stem.

BALUSTER-KNOPS. A type of knops on spoons having a small button on the stem end of the baluster. (Sixteenth century.)

BALUSTER MEASURE. A type of pewter measure with the body of this shape, and with a flat, hinged cover, used specifically for wine.

BALUSTER-STEMS. Candlesticks or cups with a swelled boss in the stem or shaft.

BEAKER. A drinking-vessel, with sides tapering outwards as they rise from the foot.

BÉNITIERS. Small stoups for holy water.

BILLET. Another name for the thumb-piece or purchase.

BISMUTH. A metal which is added to pewter to harden it.

BLACK METAL. An alloy of 60 parts of tin and 40 of lead.

BLEEDING-DISHES. BLOOD-PORRINGER. Bowls to hold blood. Sometimes graduated.

BOOGE. The curved part of a plate or bowl between the rim and the flat bottom.

BRITANNIA METAL. A varying alloy of tin, antimony, copper, and bismuth.

BURETTES. Pewter bottles for sacramental wine, or for water. They are in pairs: one marked "A" for aqua (water), and the other "V" for vinum (wine).

BURNISHER. A tool for surfacing metal. Burnishers are made of agate, bloodstone, or steel.

CARDINALS' HATS. A name given to flat, broad-rimmed dishes from their resemblance to hats of this shape.

CASSOLETTE. A vessel or box for perfumes, with an elaborately perforated lid so as to allow the dispersion of the perfume.

CHALICE. A cup especially for sacramental use.

CHAPNET. A name applied to a kind of salt-cellar.

CHASED. Decoration produced on the surface of metal by fine lining tools. No metal is removed as is the case in engraving.

CHOPIN. A Scottish measure containing 1½ pints (Imperial measure), or four Scots. gills.

CHRISMATORY. A vessel for the oil for Extreme Unction.

CLAW-BALL. A common ornament for the feet of large tureens and hanaps.

COASTER. A stand for a decanter.

COSTREL. A harvest or pilgrim's bottle, usually of wood, or earthenware, but sometimes of pewter.

CRI. The name given to the sound given by tin, and by the best pewter when bent backwards and forwards.

CRUETS. Small sacramental vessels on feet, with lids, usually found in pairs, one marked "A" for aqua, and the other "V" for vinum.

CUPPING-DISH. Vide Bleeding-Dish.

CUP-FOOT. A semi-spherical foot used for inkstands.

Danske Pots. In all probability pots of a Danish pattern.

DIAMOND-POINTED KNOP. A name given to an early type of spoon. (Fifteenth century.)

DOBLER. A large dish.

EAR-DISH. A shallow dish with one or two flat projecting handles.

ECUELLES. Bowls and porringers. (French.)

EMBOSSED. V. Repoussé.

ENGRAVED. Decorated by a design which is cut with a burin or other sharp tool.

EWER. A jug.

FASHION. The making.

FLAGON. The name given to large vessels from which wine or ale is served.

GADROON. A geometrical design consisting of curved lines radiating from a centre, the space between them being generally repoussé.

GALENA. A sulphide of lead, sometimes containing traces of silver. GARNISH. The old name for a complete set of vessels in pewter, consisting of 12 platters, 12 dishes or flat bowls, and 12 saucers, i.e. small flat plates.

GRATER. A tool for scraping pewter.

GUT. Vessels for holding and cooling wine. (German.)

HAWKSBILL. A ewer of large size, possibly with a spout.

HEXAGONAL KNOPS. A common type of knop found on spoons. (Sixteenth century.)

HIND'S FOOT. V. Pied-de-biche. The shaped end of the flat stem of a spoon.

HOLLOW-WARE. The generic name given to large pots, measures, tankards, and flagons.

HORNED HEAD-DRESS. A type of knop found on spoons. (Fifteenth century.)

HORSE-HOOF KNOP. A rare type of knop found on spoons. (Sixteenth century.)

LATTEN. A brass alloy of a pleasant colour, and of good quality. (Copper and tin, as distinct from copper and zinc.)

LAY. Tin mixed with lead so as to be of lower quality.

LAY-MEN. The name given to men who worked in such metal.

LION SEJANT KNOP. A form of knop in which the lion is sejant, or sitting. (Sixteenth century.)

LOGGERHEADS. Circular inkstands, usually with a flat disc for a base.

MAIDENHEAD. A type of knop in the form of a female bust, found on spoons. (Fifteenth century.)

MONK'S HEAD. A very rare type of knop found on spoons. (Sixteenth century.)

MUTCHKIN. A Scottish measure holding ³/₄ pint (Imperial), or two Scots. gills.

PALE. The pewterers' name for solder of inferior quality.

PANE. That part of the hammer with which the pewterer strikes the object that he is making.

PATINA. A form of oxidation.

PEAK. The old pewterers' name for lead.

PECHKRÜGE. Wooden tankards, with pitch lining.

PEG-TANKARD. A tankard with pegs on the inside, at regular intervals.

PIED-DE-BICHE. A type of spoon so called because the end is split like a deer's foot.

PITCHER. The old term for any vessel with a handle and an open spout.

PLANISH. To smooth and harden a plate of metal by means of blows of a special hammer.

PLATE-METAL. Pewter of good quality.

PLATTER. A flat disk of metal with a slightly raised rim.

POINTILLÉ. Ornament produced by stabbing the metal with a pointed tool.

PORRINGER. A porridge dish.

POUNCE-Box. V. Sand-box.

PRICKET. A candlestick with a spike to hold the candle.

PURCHASE. The thumbpiece by means of which a tankard lid is raised.

QUAIGH. A word used of a shallow circular drinking vessel, somewhat like a deep saucer, with two handles. (Scottish.)

RAVENSBILL. A ewer, perhaps with a spout.

REPOUSSÉ. A design raised up by repeated blows on the under side of a piece of metal by means of special hammers and raisingtools. The work is fixed to a pitch-block.

SADWARE. The trade name for the flat heavier articles, e.g. plates, trenchers, dishes, and chargers.

SALER. A salt container.

SAND-BOX. A box with a perforated lid, by means of which fine sand was sprinkled on documents to dry the ink.

SCOURING. The proper name for the cleaning of pewter.

SEAL. A mark impressed on a measure by an inspector, to indicate that the vessel had been checked for capacity, and conformed to the "standard" then in force.

SEAL TOPS. A type of knop found on spoons.

SILVORUM. A sham-silver alloy of seventeenth century.

SLIPPED IN THE STALK. A variety of spoons in which the stem is cut (or slipped) on the slant. (Sixteenth century.)

SOLDER. An alloy of low fusing-point used for joining two or more pieces of metal.

SPINNING. Process by which a thin plate of metal in a lathe is forced to take the shape of a solid or built-up wooden core.

STIPPLED. Ornament produced by marking or pricking the surface with small dots.

STUMP-END, OR STUMP-TOP. A rare type of spoon. (Sixteenth century.)

TAPPIT-HENS. The name given to Scottish vessels of a certain form, and of three pints capacity. Other sizes in the same shape are said to be "of tappit-hen shape".

TEMPER. The name given to tin when alloyed with copper.

THUMB-PIECE. The name given to the lever by which the lid of a jug or tankard is raised. It is often called a purchase.

TOKENS. Small pieces of pewter formerly issued in Scotland to intending Communicants. They were sometimes circular, sometimes square, sometimes octagonal, or sometimes oval.

TOUCH. A private mark (or trade mark) impressed on pewter ware by the pewterer.

TOUCHPLATES. Five plates of pewter preserved at Pewterers' Hall, on which all the touches or private marks of pewterers were supposed to be stamped. (London.)

TREEN. The old name for wooden bowls, wooden plates.

TRIFLE. Pewter of common quality is usually called trifle.

TRIFLERS. The trade name given to the men who made spoons, forks, buckles, buttons and toys.

TUNDISH. A funnel.

VOIDER (Voyder). A large dish.

WRIGGLED. A broken-line pattern produced by pushing the tool with a regular rocking from side to side is termed "wriggled".

Writhen-knop. A very rare form of knop found on spoons. (Sixteenth century.)

The Reference Literature of Pewter

In *Pewter Plate* published in 1904 and in its second edition of 1910, there was a Bibliography, possibly more full than the Collector wants in the ordinary way.

For anyone who wants to study the History of the Pewterers' Company mainly, and who at the same time wishes to possess reproductions of the existing touchplates, the *History of the Worshipful Company of Pewterers of the City of London*, by Charles Welch, published in 1902, is indispensable. Though the work is mainly, as its title implies, historical, there is a certain amount of technical information contained in the two volumes. There is one feeling of regret which must enter the mind of the reader, and that is that the compiler was not more interested in the Pewterer and his art. The historical interest would not have been diminished at all, but how much more alive it would have been for us today.

The five touchplates—reproduced in collotype—are almost better cut out and framed, though there is not much interest in the fifth of the series. Frequent reference to the plates is bound to cause speedy havoc and decay.¹

The two Charters which are also given as illustrations, are worth framing.

Pewter Plate published by Messrs. Bell & Sons in 1904, and in a second edition in 1910, was the result of over eight years of almost continuous research and investigation of authorities. The book tried to fill the gap that had been left by Mr. Welch and to some extent

¹ The touchplates were again reproduced in Cotterell's *Old Pewter*, its makers and marks (1929).

succeeded. There were bound to be mistakes, errors in facts and errors in judgments, especially in any attempt to decipher the touches on the touchplates, many of these touches being almost if not quite illegible. Conjectures were made with some amount of confidence, but it was never pretended that they were infallible, and the mistaken readings were never intended to be slavishly copied and certainly not without acknowledgment.

In the year following its publication, Mr. L. Ingleby Wood brought out his *Scottish Pewterware and Pewterers*, a most careful work and worthy of a place of honour in the Collector's library.

The illustrations of the existing Scottish touch plates are particularly valuable.

Another Scottish book—and of great interest to pewter-lovers, is *Old Scottish Communion Plate*, by Rev. Thomas Burns (1892). The portion dealing with Communion Tokens is likely to be of most interest to the Pewter Collector.

Chats on Old Pewter (by the writer of this volume) was published in 1910–11, and being designed to serve as a supplement to Pewter Plate, contained various special features. It had a list of all the Pewterers who were then known to have existed between the middle of the sixteenth to the beginning of the nineteenth century, and this list contained all the names of Pewterers that were legible in the MS. list of the Yeomanry preserved at Pewterers' Hall. In addition to this were added the names of various Scottish and Irish Pewterers, chiefly obtained from rubbings or drawings sent by those interested in the subject, and from Mr. R. C. Hope's MS. notes on Old English Pewter, an interesting book of considerable value. It was this MS. which led Mr. Massé to number the touches on the touch plates for greater ease in reference.

Chats on Old Pewter was reprinted, with numerous amendments to the original text, and brought entirely up to date, in 1949, by the present editor, and a further revised edition is due for publication in 1971.

Mr. A. de Navarro, published his delightful *Causeries on English Pewter* in 1911. It is invaluable as a stimulating influence to the Collector, and moreover is a most thoughtful and suggestive book, enriched with many excellent illustrations.

After each of the Exhibitions of Pewter organized in 1904 and

1908 in the Hall of Clifford's Inn, Fleet Street, illustrated catalogues were brought out dealing mainly with the specimens exhibited at those two exhibitions. The Catalogue of 1904 is now a somewhat rare book, and that of 1908 is becoming scarce.

Shortly before his death, Mr. F. G. Hilton Price (Dir. S.A.) published a monograph called Old Base Metal Spoons, 1908. It deals with both latten and pewter spoons, and is indispensable to any Collector of spoons and should be studied carefully.

Many articles, some authoritative, some very speculative, have appeared in periodicals and magazines, but it is not proposed to refer to them here in detail. The files of the magazines, etc., will give the necessary clues. Those in the journals Apollo, Antique Collector and The Connoisseur in England, and in the American magazine Antiques, are well worth reading.

Of other publications which, may be some help to others, there may be mentioned the various books on the church plate of the various counties. The first and best of these was Old Church Plate of the Diocese of Carlisle (1882), by R. S. Ferguson. Others are Church Plate of Carmarthenshire, Church Plate of Gloucestershire, Church Plate of Pembrokeshire, Church Plate of Radnorshire, all by the Rev. J. H. Evans.

Mr. R. C. Hope gave us the Church Plate of the County of Rutland. Mr. Halliday compiled a similar survey of the Diocese of St. David's

and St. Asaph's.

Mr. J. M. Fallow wrote on the Plate of the East Riding of Yorkshire, the Rev. James E. Nightingale on the Church Plate of Dorset the Church Plate of Wilts, and the Church Plate of Norfolk; the Rev. A. Trollope took in hand the inventory of the church plate of Leicestershire. The Hon. B. S. Stanhope and Mr. H. C. Moffatt wrote The Church Plate of the County of Hereford.

In all of these books there are scattered references to the pewter-plate once so common in the various dioceses. Often the chronicler can only record that there used to be a pewter flagon, or a paten, or else that the specimens preserved are in a state of neglect or decay. It is something in these days of progress to find that what was once a cherished gift is allowed to remain as rubbish in a disused cupboard.

For information as to pewter in earlier days in England, reference may be made to Halliwell's Ancient Inventories, William Harrison's Elizabethan England, reprinted in the Walter Scott Library; Havard's Dictionnaire de l'Ameublement, Vol. II, under "Estaimier" and "Étain", also Jules Labarthe's Histoire des arts industriels au moyen âge et à l'époque de la renaissance, Paris, 1873, and also to T. H. King's Orfévrerie et ouvrages en metal du Moyen Âge, published at Bruges in 1852-5.

Viollet-le-duc in his *Dictionnaire du Mobilier français*, under the words Bénitier, Assiette, Cuiller, Ecuelle, Fourchette, gives much interesting information.

Of the books published in 1929 and since, the chief is, of course, Howard H. Cotterell's *Old Pewter*, its Makers and Marks, reprinted several times since that date. It is, and is likely to remain for many years, the standard work on British pewterers' marks (over 6,000 makers and their marks being recorded).

The editor of this revised edition of *The Pewter Collector* has, himself, produced several works on pewter, the chief of which is his Antique Pewter of the British Isles (1955), which went quickly out of print, and is to be reprinted in its original form by an American publisher in 1971. In 1968 Mr. Michaelis was privileged to be commissioned to write *A Brief History of the Worshipful Company of Pewterers (and a Catalogue of its Pewterware)*, a book which is recommended to all students. In 1969 appeared his *British Pewter*, a well-illustrated book, full of information for the student and collector alike.

Other publications include:

C. A. Peal's British Pewter, for Pleasure and Profit (1971) and K. Ullyett's Pewter, Collecting for Amateurs (1967).

Index

Chargers 36

Abbreviations used (for touch-

Chalices 81

eaux) 82

Chapnut, Chapnet (Choppin-

plates) 181 Chastleton House, inventory of Advertisement prohibited 43 1632 68 Church pewter 80-94 Alloys 3, 34, 45, 50-52 American Pewter Centre 69 Cleaning and repair of pewter Ampullae (Ampoules) 91 15-25 Coins, pewter 92 Antimony 3 Cotterell, Howard H. xiv, 106 Assay 45, 51-52 "Crooked Lane Men" 49 Badges Cruets 34 Beggars' 90 Cymaise (Cimaise, Cymarre) Pilgrims' 88-90 92-93 Porters' 90 Beakers 5, 75, 77 Decoration—see Ornamentation Beer mugs 4 Dishes 36 Benitiers 82 Display of pewter 12-14 Bewdley Pewterers 45 Bismuth 3 Écuelles 66 Bleeding bowls and dishes 71 Edelzinn (Demiani quoted) 61 Bowls (Bolles) 37, 71 Enamelled pewter 58 Briot, Francois 66 Enderlein, Caspar 61, 66 Britannia metal 4, 52, 88 Engraving on pewter—see Orna-Buckles 37 mentation Buttons 37 Exhibitions xiii, 265 Candlesticks 74, 82 "Cardinal's Hat" dishes and "Faculty" for selling Church Plate 26 plates 37

"Fine Pewter" 51

Florentine dishes 57

Flagons 84

Fonts (font basins and ewers)
83-84
Foreign pewterers 41
ware 44-45
workmen 45

Galley dishes 37 Garnish 64, 65–67 Gilding of pewter 59 Girdlers' Company 49 Glossary 268–273 Goldsmiths' Company 99 Guild Cups (Hanaps) 2, 7 Guy's Hospital (finds) 8

"Hallmarks" 99
Hanaps 2, 8
Harrison, William, quoted 47,
65, 66, 71, 76
Hawkers 39, 40, 41
Hawkesbills 77
Henry VII 8, 38, 40, 44
Henry VIII 39, 40, 44, 50, 66
Hollow-ware men 37, 39, 95–96

Initials of owners 104 Inkstands 93 Inlay of pewter 59

"Joggled" work 55

Latten (Laiton, laton) 2, 3, 72 Lay (ley) metal 39, 51 Lead vessels 63 Loggerheads 93–94

Marks on pewter 38, 43, 95–104, 106, 180

Marks, of disgrace 47

"fleur-de-lis" 76

compulsory in 1503 38, 95

of quality 76, 100

drawings of marks on touchplates 236–263

Monstrances 84 Moulds 3, 45, 51, 70 Mustard pots 4

Ornamentation on pewter 55–62
"Wriggled" work 55
"bright cut" 58
lacquered pewter 58
pewter with brass 57
inlay of pewter 59
gilding of pewter 59
appliqué 60
Oxidation see Scale, removal of

Patens 81 Pechkrügs 57 Pepper-pots 4 Pewter, quality in 1348 34, 36-37 Pewterers' craft 30-49 Pewterers' Company xiv, 30 Ordinances 31 et seq. Oiling of pewter 15 Right of Search 37, 43 Statute reprinted in 1741 39 Pewtering centres 45 Pilgrims' bottles 24 Plates, "bossed" centre 5 broad, flat rim 5 decagonal rim 6 hexagonal rim θ "lobed", "petalled" or "wavy edged" 6 narrow rim 6 reeded rim 5, 6 Platters 34, 36, 70 Polishing 18 Porringers 34, 71 Pounce-pots 4 Prices 264-267 for old ware 42 Pyxes 84

Quaichs (Scottish) 71

Ravensbills 77

Repairs 4, 15-25, 53-54
Roman pewterware 7-8, 9, 1920, 73
Rose and Crown see Marks
Rosewater dishes 8, 58
Rubbings 10-11
Russian pewter 60

Sadware (Sadware-men) 37, 70 Salers (Salts) 4, 34 Salvers 34, 70 Saucers 37 Scale, removal of 15–18 Scottish pewterware 28, 78–79, "Seals" of verification 75, 103 Search, Right of 37 Sepulchral chalices 81 "Silvorum" 3 Snuff-boxes 5 Spoons 3, 37, 72, 266 Standards for pewter 50-54 Standish see Inkstands Stone pots 7 pot lids 77

Tankards 5, 75, 265

Tappit-hens 78-79, 265
Testing of pewter see Assay
Thirdendale (thurndell, etc.) 77
Tin 42
Tokens (Communion) 87-88
Touchplates 96-99, 180 et seq.
Touches see Marks
Toys (pewter) 37, 73, 74
Trifle, and "Tryfflers" 37, 38, 51

Welch, Charles (quoted throughout) 7
Westminster, Council of, in 1175
80
Westropp, M. S. Dudley xiv, 106
Women pewterers 47–48
"Wriggled" ornament 55
Wrythen (writhen) ornament 60

"X" and Crown, Quality mark

Yates, James (moulds) 45–46 York pewterers 45

Zinc 3